· ·

In Praise of Commercial Culture

In Praise of
COMMERCIAL
CULTURE

Tyler Cowen

HARVARD UNIVERSITY PRESS
Cambridge, Massachusetts
London, England

First Harvard University Press paperback edition, 2000

Library of Congress Cataloging-in-Publication Data
Cowen, Tyler.
 In praise of commercial culture / Tyler Cowen.
 p. cm.
 Includes bibliographical references and index.
 ISBN 0-674-44591-0 (cloth)
 ISBN 0-674-00188-5 (pbk.)
 1. Arts—Marketing. 2. Arts and society. I. Title.
NX634.C68 1998
700'.68'8—dc21 97-40445

Acknowledgments

I have received an unusual amount of assistance with this book. I would like to give special thanks to Michael Aronson and Kate Brick for their work as editors. A number of other individuals also have been of special help, including Colin Day, Martin Kessler, Daniel Klein, Thelma Klein, and Titus Levi. Andrew Levy gave especially useful comments on the literature chapter and Eric Lyon gave especially useful comments on the music chapter. Several anonymous referees offered very useful feedback as well. I also would like to thank Michael Aronson, Andrea Rich, and Thomas Schelling for their encouragement and support during the publication process. I also have received useful comments from Hans Albert, Milton Babbitt, William Baumol, Marvin Becker, Mark Blaug, David Boaz, Peter Boettke, David Bromwich, Peter Brook, Meyer Burstein, Penelope Brook Cowen, Jerome Ellig, H. Bruce Franklin, Jeffrey Friedman, Elisa George, Richard Goldthwaite, Dan Green, Kevin and Robin Grier, David Henderson, George Hwang, Tom Jenney, Paul Keating, Alvin Kernan, Susanne Kernan, Paul Korshin, Randall Kroszner, Timur Kuran, Don Lavoie, David Levy, John Majewski, Julius Margolis, Alice Goldfarb Marquis, Carrie Meyer, John Michael Montias, Fabio Padovano, Pam Regis, David Schmidtz, Daniel Sutter, Alex Tabarrok, Turok of *Turok's Choice,* Karen Vaughn, Fred Wall, Eugene Webb, Katarina Zajc, Marty Zupan, and seminar participants at New York University and the Institute for Humane Studies. I wish to thank Richard Fink, Charles Koch, and David Koch for assistance with funding, through the Center for Market Processes and the Koch Foundation. General thanks are due also to Walter Grinder and Roy Childs. Katarina Zajc and Sarah Jennings provided invaluable research assistance.

v

Acknowledgments ...

Reader feedback is welcome. I can be reached at Department of Economics, George Mason University, Fairfax, VA 22030, or tcowen@gmu.edu.

Contents

There is no great work of art which does not convey a new message to humanity; there is no great artist who fails in this respect. This is the code of honor of all the great in art, and consequently in all great works of the great we will find that newness which never perishes, whether it be of Josquin des Pres, of Bach or Haydn, or of any other great master. *Because: Art means New Art.*

<div align="right">

Arnold Schoenberg, *Style and Idea,*
Selected Writings of Arnold Schoenberg

</div>

I have many times asked myself, not without wonder, the source of a certain error which, since it is committed by all the old without exception, can be believed to be proper and natural to man: namely, that they nearly all praise the past and blame the present, revile our actions and behaviour and everything which they themselves did not do when they were young, and affirm, too, that every good custom and way of life, every virtue and, in short, all things imaginable are always going from bad to worse.

<div align="right">

Baldesar Castiglione, *The Book of the Courtier*

</div>

Introduction

Does a market economy encourage or discourage music, literature, and the visual arts? Do economic forces of supply and demand help or harm the pursuit of creativity?

I present market enterprise and productive wealth as allies of cultural production. I seek to redress the current intellectual and popular balance and to encourage a more favorable attitude towards the commercialization of culture that we associate with modernity. The capitalist market economy is a vital but underappreciated institutional framework for supporting a plurality of coexisting artistic visions, providing a steady stream of new and satisfying creations, helping consumers and artists refine their tastes, and paying homage to the eclipsed past by capturing, reproducing, and disseminating it. This book presents some social mechanisms that link markets, wealth, and creativity, examines how these mechanisms have operated throughout cultural history, and attempts to account for the widespread perception that modernity suffers from a cultural malaise.

I develop several related themes concerning culture. First, I contrast cultural optimism with some opposing philosophies of cultural pessimism. Differing varieties of cultural pessimism are found among conservatives, neo-conservatives, the Frankfurt School, and some versions of the political correctness and multiculturalist movements, as well as in the history of ideas more generally. The first four chapters offer a critique of these views, and the final chapter offers a deconstruction of them.

Second, I redefine the distinction between popular or "low" culture, and "high" culture from a cultural optimist perspective. When viewed in the long term, successful high culture usually comes out of a

1

healthy and prosperous popular culture. Forces for popular culture therefore serve as forces supporting the eventual emergence of high culture as well. I also question the common identification of quality culture with high culture, and of popular culture with low-level or accessible culture. Shakespeare, Mozart, and Beethoven thought of their work as popular, while much of today's so-called popular culture is in fact a highly refined product that appeals only to a distinct minority. Rather than trying to use aesthetic criteria to order artworks on a high/low spectrum, I examine how economic incentives affect the artist's choice of audience. Poetry costs very little to write, and therefore can appeal to minority tastes. Most movies, in contrast, must cover their high capital costs by appealing to a larger number of viewers.

Third, I focus on the role of markets and economic factors, including technology, in influencing culture. I do *not* present a monocausal materialist theory of culture, but I do outline some ways in which economic forces have shaped Western art, literature, and music since the Renaissance. Without dismissing the role of non-economic forces, I argue that economic forces have had stronger effects on culture than is commonly believed. The printing press paved the way for classical music, while electricity made rock and roll possible. For better or worse, artists are subject to economic constraints, just as other businessmen are.

Fourth, I attempt to account for why the philosophy of cultural pessimism has proven so persuasive and has attracted so many adherents. The fifth and final chapter outlines a series of social mechanisms that help explain why cultural pessimism has remained such a successful and popular philosophy. For a variety of reasons discussed in that chapter, contemporary culture tends to appear degenerate even when it is thriving. This deconstruction of cultural pessimism does not prove the worth of contemporary creations, but does encourage a more critical stance toward views that culture is corrupt or declining.

Capitalism and the Market Economy

I define capitalism as a legal framework based on private property and voluntary exchange; this framework supports an advanced system of commerce, industry, technology, and markets. I take it for granted that

capitalism supports these institutions, and I focus on the more controversial question of how culture will fare in such a world.

The word capitalism refers to the private ownership of capital goods that is found under such a regime. I also use the term "market economy" to refer more generally to a nexus of voluntary exchanges. Beethoven and Michelangelo, who sold their artworks for a profit, were entrepreneurs and capitalists. Rembrandt, who ran a studio and employed other artists, fits the designation as well. I treat capitalism in terms of its underlying economic logic, rather than in terms of a particular historical epoch, as do many Marxists. Nonetheless I do not assume that capitalism has operated in the same fashion across historical eras. In reality, different kinds of markets (and states) have shaped the arts in radically different ways. The greater ability of modern performers to reach large audiences has given popular music a relative boost over classical music, for instance. The declining financial power of the church led to a diminution of interest in religious art. In this book I present numerous examples of how cross-sectional variations in forms of capitalism have influenced accompanying artistic productions.

I do not define capitalism in terms of a pure market model, as do many libertarians. Historically capitalism and powerful states have risen hand-in-hand; this connection will not be severed in the imaginable future. I am concerned more with particular features of the capitalist model than with the purity of market freedom. Specifically, I focus on the following features, which I identify with our modern, commercialized society: profit and fame incentives, decentralized financial support, the possibility of financial independence for some artists, the entrepreneurial discovery of new artistic technologies and media, and the ability to profit by preserving the cultural creations of the past.

I do distinguish capitalism from societies whose wealth is based on outright plunder, fortuitous discovery of a natural resource, tax haven status, or other accidental features. These societies may develop wealth, but they will not reap the full benefit of the mechanisms discussed below. Stealing or "lucking into" wealth typically will stimulate the demand for culture, but the supply capacity for cultural production will not be favored as well as under capitalism. Artistic masterpieces usually stem from favorable conditions on both the demand and supply sides of the market, as I will illustrate throughout the text.

I do not argue that capitalism is a monocausal or even a primary determinant of artistic success. If Beethoven's parents had not met, married, and slept together when they did, the market could not have produced another Beethoven some other way. Pure, dumb luck is one of many factors in cultural success. The greater cultural vitality of Renaissance Florence than modern Singapore does not serve as a counterexample to my thesis, even though Singapore is wealthier and arguably more capitalistic as well. Singapore and Florence differ in many important regards, including their cultural heritage, degree of government censorship, and intellectual climate. Culture is a problem of joint production involving both economic and non-economic forces; I am arguing that we should upgrade our estimate of the efficacy of the market, not that the market is all-important.

Counterexamples to my version of cultural optimism arise to the extent that cultural successes come about in spite of the market, and to the extent that cultural failures come about because of the market. I present a number of counterexamples, including the failure of the modern world to support contemporary classical composers, the declining quality of the best-seller lists, and the dubious quality of much of American television, among many others. I view these counterexamples as real rather than apparent, and I seek to explain them rather than to explain them away. An optimistic perspective should not blind us to failures or hinder the identification of the mechanisms that cause cultural markets to misfire.

It is obvious to most observers that new art faces significant obstacles in a market economy. Large numbers of consumers are ignorant, poorly educated, and sometimes even hostile to innovation. Many creators are confronted by large corporate conglomerates that demand a proven track record or prior contacts. Complex networks of retail distribution, advertising, and media make some products profitable and others unprofitable, often without regard for artistic quality. Art lovers who revere aesthetic merit often dislike or resent market exchange for these reasons. No social system, however, elevates "Goodness" to a deciding principle, whether the realm be art, politics, or economics. Rather than comparing the market for art to a Platonic alternative, I seek to uncover the social mechanisms that encourage and discourage creative artistic achievement and therefore shed light on the production of culture.

Culture and Art

I use the terms culture and art interchangeably to cover man-made artifacts or performances that move us and expand our awareness of the world and of ourselves. I have in mind painting, sculpture, music, film, architecture, photography, theater, literature, and dance. What counts as culture is a matter of degree; broadly, culture ought to broaden our horizons and help us see the world in a new way. Culture stands above the concept of entertainment, although broadening our horizons is often entertaining.[1]

I will devote special attention to visual art, literature, and music, arguably the three arts most central to the Western tradition. Each of these receives a chapter of its own. These arts come closest to providing a common knowledge base and have provided the primary field of debate for the economics of the arts.

No single book can consider artistic production as a whole. Furthermore, the question "What is art?" has become increasingly less fruitful with the growing diversity of production. Numerous activities hold a blurred, in-between status. Fashion, decoration, cuisine, sports, product design, computer graphics, and commercial art—to name just a few—bring beauty and drama into our lives. Even if these genres do not fit a narrow definition of art they nonetheless stimulate our aesthetic sense. Most have met with great success in the contemporary world, yet I do not address them directly in this book. I hope to show some illustrative factors in the history of the major arts, rather than cover each and every cultural episode.

In addition, I focus on Western culture, although I am currently working on a more systematic treatment of non-Western, tribal, and indigenous cultures. Some foreign cultures appear to provide counterexamples to the view that markets benefit the arts. Haiti, for instance, has produced much painting and music of note, despite being the poorest country in the Western hemisphere. My preliminary research indicates two conclusions, which I will only mention here. First, some of the mechanisms regulating artistic success may differ in countries with very small degrees of division of labor, both in consumption and production. To that extent the arguments of this book do not hold in all circumstances. Second, many non-Western arts have relied more

heavily on markets and wealth than it may first appear. The market for Haitian Naive paintings, for instance, has been driven largely by tourists from wealthier, capitalist countries. Much of the growth in third world art, music, and literature has been supported by modernization, growing wealth, and cultural exchange. A more complete approach to the matter must, however, await future research and writing.

What Is Good Culture?

The case for cultural optimism relies partly on judgments about the quality of contemporary cultural creations. Skeptics who dislike all contemporary culture usually cannot be convinced to weaken their pessimism. Cultural assessments contain an irreducibly subjective component and for this reason it is not possible to present a knockdown argument for (or against) cultural optimism. Rather than tackling cultural pessimism head on, I attempt to chip away at its plausibility, while keeping debate over the quality of particular artworks from dominating the analysis.

My approach to cultural pessimism runs as follows. First, I present a number of social mechanisms through which a healthy, growing economy tends to support cultural creativity. While these mechanisms do not prove the intrinsic aesthetic worth of any particular creations, they do weaken the expectation that commerce should corrupt culture. The three subsequent chapters outline the successful operation of these mechanisms in the past, and show that criticisms of contemporary culture resemble the criticisms leveled at past masterworks. Finally, I discuss some particular developments in our contemporary culture that I see as healthy and creative.

The discussions of contemporary culture will entail both a value-neutral aspect and a value-laden aspect. The value-neutral aspect attempts to show that market wealth supports creative artworks of many different kinds, appealing to many different tastes. My favored variety of aesthetic pluralism admits the validity of contrasting perspectives on culture, values diversity, and recognizes the ultimate incommensurability of many artistic values.

Orson Welles argued for the supremacy of consumer opinion in judging aesthetic value. He once said: "We must not forget the audi-

ence. The audience votes by buying tickets. An audience is more intel-
ligent than the individuals who create their entertainment. I can think
of *nothing* that an audience won't understand. The only problem is to
interest them. Once they are interested, they understand anything in
the world. That must be in the feeling of the moviemaker."[2]

Harold Bloom advocates a different point of view. He considers
the true masterpieces of the Western canon to be inaccessible to most
readers. Culture, Bloom's substitute for religion, requires a Gnostic
rather than Catholic view of the truth. Only those who read, reread,
and study the classic works can hope to unlock their secrets. A work
easily accessible on first reading is unlikely to be truly great. The best
writers know far more than their audiences, who are wrongly tempted
to dismiss *Finnegans Wake* as nonsense. The elitist venture of criticism
can proceed without much regard for the preferences of the audience.

Rather than attempting to adjudicate between these two provoca-
tive perspectives, the value-neutral aspect of my analysis considers the
ability of capitalism to support each kind of art. The market brings
crowd-pleasing artists such as Michael Jackson or Steven Spielberg in
touch with their audiences, while at the same time securing niches for
more obscure visions, such as those of Brian Eno or Peter Greenaway.
The categories commonly labeled high and low art often are comple-
ments rather than alternatives that we must choose between.

The value-neutral approach to cultural evaluation also stresses
how the wealth, commercialization, and technology of the modern
world provide the means and the incentives to preserve past culture.
Cultural optimism does not suggest that any modern playwright is the
superior or even the equal of William Shakespeare. It will never be the
case that our favorite works, or the very best works, all were produced
just yesterday. Rather, cultural optimism receives some of its support
from the unparalleled ability of the modern world to preserve, main-
tain, disseminate, and interpret past masterworks. Artistic preservation
and dissemination are supported by market mechanisms, just as artistic
creativity is. Artistic production is not a single event, but rather is an
ongoing process, often stretching over centuries, and requiring contin-
ued societal cooperation.

William Hazlitt wrote a famous essay—"Why the Arts are not
Progressive—A Fragment"—that has been cited as ammunition against
the idea of cultural progress. Hazlitt argued that the arts do not experi-

ence progress in the same manner that the natural sciences do. In the arts, later inventions do not typically render earlier inventions obsolete. To give a modern example, we cannot establish that Gabriel García Márquez is objectively "better" or "worse" than Charles Dickens. I do not, however, accept Hazlitt's total rejection of the idea of cultural progress. Today's art consumers enjoy more choice and greater diversity than ever before. Regardless of how aesthetic philosophy judges García Márquez versus Dickens, modern readers can now enjoy both for a pittance.

Market exchange and capitalism produce diverse art, rather than art that appeals to one particular set of tastes. Mid-to-late twentieth-century Western culture, although a favorite target of many critics, will go down in history as a fabulously creative and fertile epoch. The culture of our era has produced lasting achievements in cinema, rhythm and blues, rock and roll, Abstract Expressionism, Pop Art, architecture, dance, graphic and commercial design, fashion, jazz, the proliferation of classical, early music, and "original instrument" recordings, the short story, Latin American fiction, genre fiction, and the biography, to name but a few examples. These genres have offered a wide variety of styles, aesthetics, and moods. An individual need not have a very particular set of tastes to love contemporary creations.

The second part of the book's aesthetic argument requires a greater role for subjective judgments about artistic value. Are Jasper Johns, Steven Spielberg, Karlheinz Stockhausen, and the Beatles frauds, mediocrities, or geniuses? Dare we go one step further and ask the same question about even more controversial (and lesser known) figures, such as Robert Gober, John Woo, Robert Ashley, and My Bloody Valentine?

Although I am not providing a treatise on aesthetics, I do, throughout the chapters, raise the possibility that these artists and others are in fact notable masters who may last the ages. The three chapters on art, literature, and music suggest that the contemporary world has produced a very large number of excellent creators and works. I do not, and cannot, provide knockdown arguments for these aesthetic views, but I hope that the book as a whole will persuade the reader to take a closer look at these and other artists. Despite the subjective component behind these judgments, I try to persuade the reader to see widespread support for the cultural optimist vision, as I do.

The tastes and recommendations that comprise the value-laden part of the argument will appear odd or idiosyncratic to some readers. Nonetheless I have deliberately tried to restrict myself to figures and works that have already achieved recognition from the specialists in their fields. Most lovers of Mozart and Haydn react with skepticism or disagreement when Ashley, Feldman, Scelsi, and Glass are cited as notable composers of our age. Yet the highly respected *Fanfare,* a journal of music reviewing, promotes precisely these names and rejects the notion that music composition is dead, as do I. Observers tend to be cultural optimists in areas where they specialize, and cultural pessimists when they serve as outsiders or general critics.

The cultural optimist position does not seek to make the achievements of modern creators commensurable with the achievements of the past, just as we cannot rank Dickens and Garcia Marquez, or ascertain whether five or ten Beatles songs might add up in value to one Haydn string quartet. It can be said, however, that modern creators have offered the world a large variety of deep and lasting creations that are universal in their scope and significant in their import. These creations delight and enrich large numbers of intelligent listeners, and continue to influence subsequent artists. We can expect many modern and contemporary works to stand the test of time, and indeed many have already. Alfred Hitchcock, once considered a purely commercial filmmaker for the masses, now is revered as an artistic genius by audiences, film critics, and other movie directors. We can expect many more recent creators to pass the test of time in a similar manner.

Cultural Pessimism

One significant class of critics, whom I call the cultural pessimists, take a strongly negative view of modernity and of market exchange. They typically believe that the market economy corrupts culture. The modern age is often compared unfavorably to some earlier time, such as the classical period, the Enlightenment, the nineteenth century, or even the early twentieth century. T. S. Eliot exemplified the pessimistic view when he wrote: "We can assert with some confidence that our own period is one of decline; that the standards of culture are lower than

9

they were fifty years ago; and that the evidences of this decline are visible in every department of human activity."[3]

Cultural pessimism comes from various points along the political spectrum and transcends traditional left-wing/right-wing distinctions. Its roots, in intellectual history, include Plato, Augustine, Rousseau, Pope, Schopenhauer, Nietzsche, and Spengler. Cultural pessimism received its most explicit statement in the seventeenth and eighteenth centuries, in the so-called "Battle of the Books." In these debates, William Temple, Jonathan Swift, and others argued that modern writings and achievements were inferior to those of antiquity. In the contemporary scene, various forms of cultural pessimism exert wide intellectual influence.[4]

Neo-conservative intellectuals, such as Daniel Bell and Irving Kristol, have questioned whether a market economy supports healthy artistic tendencies. Bell, for instance, favors artistic modernism but views it as exhausted and superseded by less constructive movements. Allan Bloom, in *Closing of the American Mind,* provides a Straussian slant on cultural pessimism. Bloom blames left-wing academics, youth culture, and the philosophy of moral relativism for our supposed cultural malaise. In the American political realm the new religious Right and Republican Right have attacked the moral values exhibited by contemporary culture. Nationalist parties in Europe have criticized the loss of cultural unity brought by a market economy.

The pessimism of the neo-conservatives often extends beyond culture in the narrow sense. Many neo-conservatives believe that Western civilization is collapsing under a plague of permissiveness, crime, loss of community, and related ailments. Robert Bork, in his latest book *Slouching towards Gomorrah,* provides an extreme statement of this view. The supposedly sorry state of the modern arts is both a cause and reflection of the deeper plight of modernity. As I consider cultural pessimism, however, I focus only on the charges about culture in the narrower sense of artistic production.

Neo-Marxists and critics of mass culture, including the Frankfurt School, also adhere to largely pessimistic views. Max Horkheimer, Theodor Adorno, and Herbert Marcuse, among many others, believe that market exchange damages the quality of cultural production. The commodification of culture stifles our critical faculties, induces alienation, degrades artworks, and protects the capitalist system against inter-

nal challenges. Adorno advocates atonal music, and regards jazz and rock and roll as abominable corruptions. Frankfurt School writers tend to dislike popular culture, which they perceive as hostile to the project of a society built on modernist reason.[5]

Jürgen Habermas, also associated with the Frankfurt School, stakes out a positive position on modernity but holds unsympathetic attitudes toward the culture of capitalism. On one hand, Habermas views modernity as explicitly progressive, as did Marx. Habermas believes in the utopian potential of modernity, based on objective reason and the Enlightenment project of a good society. On the other hand, Habermas is highly critical of modernity as we experience it in contemporary capitalist society. He sees Western reason, when combined with capitalism, technology, and the media, as a force of domination and manipulation rather than a force of liberation or free expression. Critical social theory is needed to reform communicative discourse and bring about a more fully progressive modernity. Habermas sees the market as hindering rather than aiding critical communication.

Many neo-liberal writers echo the concerns of the Frankfurt School, although they do not accept Marxist solutions. Neil Postman emphasizes how modern technology and media corrupt our culture. The title of Herbert Schiller's book summarizes the views of many: *Culture, Inc.: The Corporate Takeover of Public Expression*. Pierre Bourdieu, one of the leading sociologists of culture, argues against the corporate control of culture that he associates with a market economy. Even the mainstream American case for liberal social democracy portrays capitalism as an uneasy ally of culture, at best.[6]

The political correctness movement often identifies market culture with the suppression of women and minorities. Puritan feminist Catherine MacKinnon, in her book *Only Words,* argues that sexually explicit literature and art create harm and should be banned. Some branches of multiculturalist thought argue that free cultural exchange leads to cultural homogenization and a culture of the least common denominator. Marshall McLuhan raised the specter of a "global village," in which we all consume the same products. In the political realm we find cultural protectionism practiced around the world.

Many left-wing "cultural studies" scholars stake out a mixed position. These individuals tend to look sympathetically on modern popular culture but they dislike capitalism and the forces of the market.

11

Fredric Jameson exemplifies these attitudes. He describes himself as a "relatively enthusiastic consumer of postmodernism," but he also promises us that central planning someday will return in superior form. Only then will our culture become a "project" to be planned by free individuals.[7]

Writers from the British Birmingham school (such as Richard Hoggart, Raymond Williams, and Stuart Hall) tend to reject the distinction between high and low culture and propose a unified methodological approach to the two. Like much of the cultural studies movement, writers in that tradition have helped legitimize popular culture and have shown sympathy for cultural optimism. Unlike the Frankfurt School, Birmingham writers see popular culture as containing liberating influences against otherwise elitist capitalist structures. When it comes to the market, however, the Birmingham school uses neo-Marxist economic analysis and emphasizes mechanisms of hegemony, rather than innovation and freedom of expression.[8]

Finally, to conclude this discussion of sources, cultural pessimism is by no means an exclusively intellectual phenomenon. The final chapter of this book examines the criticisms of contemporary culture coming from parents, churches, artists themselves, and other sources.

Cultural Optimism

The cultural optimists are a less prominent group in intellectual history than the pessimists. Cultural optimism nonetheless has attracted a number of prominent defenders in the history of ideas. Charles Perrault, a seventeenth-century French believer in cultural progress, wrote "Mother Goose" and other tales in a deliberate attempt to match *Aesop's Fables*. Baldassare Castiglione defended cultural progress in his *Book of the Courtier*. He argued that the modern age (1478–1529 for him) compared favorably to the world of the ancients. In the eighteenth century, Samuel Johnson defended the civilizing aspects of books, printing, and commercial bookselling. The Marquis de Condorcet, a classical liberal Girondist and victim of the French Revolution, argued that human reason provides a strong impetus for cultural progress.

We find at least three versions of the cultural optimist position in the history of ideas. The first view suggests that the arts tend to flourish in a modern liberal order (today, democratic capitalism, although not all the cultural optimists of the past were democrats). I promote that position in this book. This view does not predict that any single geographic area necessarily produces great culture in a particular genre. As discussed above, artistic creativity is highly contingent upon many factors, including luck. Nonetheless the world as a whole is highly diverse and we can expect a flourishing of creativity in the aggregate. Bad luck or intervening causes may influence a specific culture for the worse, but cultural optimism nonetheless suggests that a preponderance of factors favor positive outcomes for the free world as a whole.

The second version of cultural optimism goes further and makes the political prediction that a liberal order will remain prominent for many years to come. I have sympathies for this view as well, but it lies beyond the purview of this book (in its defense, see Francis Fukayama, *The End of History*). The third version of cultural optimism argues that the arts will flourish precisely because capitalism is doomed and will be replaced by a superior system, such as socialism or communism. This is the classic Marxian statement of cultural optimism, which I reject.

My favored version of cultural optimism draws upon a wide variety of contemporary writers, many of whom work outside a purely academic context. Camille Paglia defends the Rolling Stones and Hollywood cinema as artistically vital forces in the modern world. She even writes favorably about how capitalist wealth has stimulated artistic production. Robert Pattison's *The Triumph of Vulgarity* takes the supposed aesthetic defects of rock and roll and interprets them as virtues; his book *On Literacy* argues that literacy has been increasing over time, rather than decreasing. Herbert Gans, in his *Popular Culture and High Culture,* praises popular culture and argues that modernity has produced increasing diversity of culture. Cultural studies theorist Paul Willis, in his *Common Culture,* praises the "symbolic creativity" of capitalist consumerism. Nelson George, well-known author and critic for the *Village Voice,* defends rap music and argues the importance of "black capitalism" for contemporary music. Wendy Steiner, in *The Scandal of Pleasure,* defends contemporary culture and the autonomy of art against moralizing critics, from both left and right. William Grampp, economist and author of *Pricing the Priceless,* argues that artistic production is

not necessarily subject to market failure. Terence Kealey's *The Economic Laws of Scientific Research* deals with science rather than culture, but makes analogous arguments about the benefits of commerce. Alvin Toffler, in his book *The Culture Consumers,* chronicled the growth of art and culture in America; his later book *The Third Wave* writes of the tendency of mass media to decline in the face of decentralized competitive forces. The postmodern theorists, while they do not necessarily hold optimistic attitudes toward either culture or capitalism, have insightfully analyzed the forces behind the proliferation of cultures in a market economy and the breakdown of absolutist cultural standards.[9]

I proceed in the next chapter by considering how markets influence artistic creation. Material wealth helps relax external constraints on internal artistic creativity, motivates artists to reach new heights, and enables a diversity of artistic forms and styles to flourish. I then turn to high and low culture. The same forces that encourage artistic production for the market also help explain why high and low culture have split.

1 ..
The Arts in a Market Economy

Art markets consist of artists, consumers, and middlemen, or distributors. Artists work to achieve self-fulfillment, fame, and riches. The complex motivations behind artistic creation include love of the beautiful, love of money, love of fame, personal arrogance, and inner compulsions. Creators hold strong desires to be heard and witnessed. Joshua Reynolds, in his *Discourses on Art,* pronounced that "The highest ambition of every Artist is to be thought a man of Genius." More generally, I treat artists as pursuing a complex mix of pecuniary and nonpecuniary returns.

Consumers and patrons stand as the artist's silent partners. We support creators with our money, our time, our emotions, and our approbation. We discover subtle nuances in their work that the artists had not noticed or consciously intended. Inspired consumption is a creative act that further enriches the viewer and the work itself. Art works provoke us to reexamine or reaffirm what we think and feel, and consumer and patron demands for artworks finance the market.

Distributors bring together producer and consumer, whether the product be beauty soap, bread, or Beethoven. The resultant meeting of supply and demand fuels the creative drive and disseminates its results. Neither producers nor consumers of art can flourish without the other side of the market. No distributor can profit without attracting both artists and consumers. The interactions between producers, consumers, and distributors provide the basic setting for the analysis of this book.

Creators respond to both internal and external forces. Internal forces include the artist's love of creating, demands for money and fame, and the desire to work out styles, aesthetics, and problems posed by previous works. External forces include the artistic materials and

media available, the conditions of patronage, the distribution network, and opportunities for earning income. When translated into the terminology of economics or rational choice theory, the internal forces correspond to preferences and external forces represent opportunities and constraints. These internal and external forces interact to shape artistic production.

Psychological motivations, though a driving force behind many great artworks, do not operate in a vacuum, independent of external constraints. Economic circumstances influence the ability of artists to express their aesthetic aspirations. Specifically, artistic independence requires financial independence and a strong commercial market. Beethoven wrote: "I am not out to be a musical usurer as you think, who writes only to become rich, by no means! Yet, I love an independent life, and this I cannot have without a small income."[1]

Capitalism generates the wealth that enables individuals to support themselves through art. The artistic professions, a relatively recent development in human history, flourish with economic growth. Increasing levels of wealth and comfort have freed creative individuals from tiresome physical labor and have supplied them with the means to pursue their flights of fancy. Wealthy societies usually consume the greatest quantities of non-pecuniary enjoyments. The ability of wealth to fulfill our basic physical needs elevates our goals and our interest in the aesthetic. In accord with this mechanism, the number of individuals who can support themselves as full-time creators has risen steadily for centuries.

Perhaps ironically, the market economy increases the independence of the artist from the immediate demands of the culture-consuming public. Capitalism funds alternative sources of financial support, allowing artists to invest in skills, undertake long-term projects, pursue the internal logic of their chosen genre or niche, and develop their marketing abilities. A commercial society is a prosperous and comfortable society, and offers a rich variety of niches in which artists can find the means to satisfy their creative desires.

Many artists cannot make a living from their craft, and require external sources of financial support. Contrary to many other commentators, I do not interpret this as a sign of market failure. Art markets sometimes fail to recognize the merits of great creators, but a wealthy economy, taken as a whole, is more robust to that kind of failure in

judgment than is a poor economy. A wealthy economy gives artists a greater number of other sources of potential financial support.

Private foundations, universities, bequests from wealthy relatives, and ordinary jobs, that bane of the artistic impulse, all have supported budding creators. Jane Austen lived from the wealth of her family, T. S. Eliot worked in Lloyd's bank, James Joyce taught languages, Paul Gauguin accumulated a financial cushion through his work as a stockbroker, Charles Ives was an insurance executive, Vincent van Gogh received support from his brother, William Faulkner worked in a power plant and later as a Hollywood screenwriter, and Philip Glass drove a taxi in New York City. William Carlos Williams worked as a physician in Rutherford, New Jersey, and wrote poetry between the visits of his patients.[2]

Wallace Stevens, the American poet, pursued a full-time career in the insurance industry. "He was a very imaginative claims man," noted one former colleague. When offered an endowed chair to teach and write poetry at Harvard University, Stevens declined. He preferred insurance work to lecturing and did not wish to sacrifice his position in the firm. At one point a co-worker accused Stevens of working on his poetry during company time. He replied: "I'm thinking about surety problems Saturdays and Sundays when I'm strolling through Elizabeth Park, so it all evens out."[3]

Parents and elderly relations have financed many an anti-establishment cultural revolution. Most of the leading French artists of the nineteenth century lived off family funds—usually generated by mercantile activity—for at least part of their careers. The list includes Delacroix, Corot, Courbet, Seurat, Degas, Manet, Monet, Cézanne, Toulouse-Lautrec, and Moreau. French writers Charles Baudelaire, Paul Verlaine, and Gustave Flaubert went even further in their anti-establishment attitudes, again at their parents' expense.[4]

Even the most seclusive artists sometimes rely furtively on capitalist wealth. Marcel Proust sequestered himself in a cork-lined room to write, covering himself in blankets and venturing outside no more than fifteen minutes a day. Yet he relied on his family's wealth, obtained through the Parisian stock exchange. Paul Gauguin left the French art world for the tropical island of Tahiti, knowing that his pictures would appreciate in value in his absence, allowing for a triumphal return. Gauguin never ceased his tireless self-promotion, and

during his Pacific stays he constantly monitored the value of his pictures in France.[5]

Wealth and financial security give artists the scope to reject societal values. The bohemian, the avant-garde, and the nihilist are all products of capitalism. They have pursued forms of liberty and inventiveness that are unique to the modern world.

Pecuniary Incentives

Many artists reject the bohemian lifestyle and pursue profits. The artists of the Italian Renaissance were businessmen first and foremost. They produced for profit, wrote commercial contracts, and did not hesitate to walk away from a job if the remuneration was not sufficient. Renaissance sculptor Benvenuto Cellini, in his autobiography, remarked, "You poor idiots, I'm a poor goldsmith, and I work for anyone who pays me."[6]

Bach, Mozart, Haydn, and Beethoven were all obsessed with earning money through their art, as a reading of their letters reveals. Mozart even wrote: "Believe me, my sole purpose is to make as much money as possible; for after good health it is the best thing to have." When accepting an Academy Award in 1972, Charlie Chaplin remarked: "I went into the business for money and the art grew out of it. If people are disillusioned by that remark, I can't help it. It's the truth." The massive pecuniary rewards available to the most successful creators encourage many individuals to try their hand at entering the market.[7]

Profits signal where the artist finds the largest and most enthusiastic audience. British "punk violinist" Nigel Kennedy has written: "I think if you're playing music or doing art you can in some way measure the amount of communication you are achieving by how much money it is bringing in for you and for those around you." Creators desiring to communicate a message to others thus pay heed to market earnings, even if they have little intrinsic interest in material riches. The millions earned by Prince and Bruce Springsteen indicate how successfully they have spread their influence.[8]

Beethoven cared about money as a means of helping others. When approached by a friend in need, he sometimes composed for money: "I have only to sit down at my desk and in a short time help

for him is forthcoming." Money, as a general medium of exchange, serves many different ends, not just greedy or materialistic ones.[9]

Funding Artistic Materials

Artists who chase profits are not always accumulating wealth for its own sake. An artist's income allows him or her to purchase the necessary materials for artistic creation. Budding sculptors must pay for bronze, aluminum, and stone. Writers wish to travel for ideas and background, and musicians need studio time. J. S. Bach used his outside income, obtained from playing at weddings and funerals, to buy himself out of his commitment to teach Latin, so that he would have more time to compose. Robert Townsend produced the hit film *Hollywood Shuffle* by selling the use of his credit cards to his friends. Money is a means to the ends of creative expression and artistic communication.[10]

Capitalist wealth supports the accouterments of artistic production. Elizabethan theaters, the venues for Shakespeare's plays, were run for profit and funded from ticket receipts. For the first time in English history, the theater employed full-time professional actors, production companies, and playwrights. Buildings were designed specifically for dramatic productions. Shakespeare, who wrote for money, earned a good living as an actor and playwright.[11]

Pianos, violins, synthesizers, and mixers have all been falling in price, relative to general inflation, since their invention. With the advent of the home camcorder, even rudimentary movie-making equipment is now widely available. Photography blossomed in the late nineteenth century with technological innovations. Equipment fell drastically in price and developing pictures became much easier. Photographers suddenly were able to work with hand cameras, and no longer needed to process pictures immediately after they were taken. Photographic equipment no longer weighed fifty to seventy pounds, and the expense of maintaining a traveling darkroom was removed.[12]

Falling prices for materials have made the arts affordable to millions of enthusiasts and would-be professionals. In previous eras, even paper was costly, limiting the development of both writing and drawing skills to relatively well-off families. Vincent van Gogh, an ascetic

loner who ignored public taste, could not have managed his very poor lifestyle at an earlier time in history. His nonconformism was possible because technological progress had lowered the costs of paints and canvas and enabled him to persist as an artist.

Female artists, like Berthe Morisot and Mary Cassatt, also took advantage of falling materials costs to move into the market. In the late nineteenth century women suddenly could paint in their spare time without having to spend exorbitant sums on materials. Artistic willpower became more important than external financial support. This shift gave victims of discrimination greater access to the art world. The presence of women in the visual arts, literature, and music has risen steadily as capitalism has advanced.

Falling materials costs help explain why art has been able to move away from popular taste in the twentieth century. In the early history of art, paint and materials were very expensive; artists were constrained by the need to generate immediate commissions and sales. When these costs fell, artists could aim more at innovation and personal expression, and less at pleasing buyers and critics. Modern art became possible. The impressionists did not require immediate acceptance from the French Salon, and the abstract expressionists could continue even when Peggy Guggenheim was their only buyer.

The artist's own health and well-being, a form of "human capital," provides an especially important asset. Modernity has improved the health and lengthened the lives of artists. John Keats would not have died at age twenty-six of tuberculosis with access to modern medicine. Paula Modersohn-Becker, one of the most talented painters Germany has produced, died from complications following childbirth, at the age of thirty-one. Mozart, Schubert, Emily Brontë, and many others who never even made their start also count as medical tragedies who would have survived in the modern era. The ability of a wealthy society to support life for greater numbers of people, compared to premodern societies, has provided significant stimulus to both the supply and demand sides of art markets.

Most advances in health and life expectancy have come quite recently. In the United States of 1855, one of the wealthiest and healthiest countries in the world at that time, a newly born male child could expect no more than 39 years of life. Yet many of the greatest composers, writers, and painters peak well after their fortieth year.[13]

Birth control technologies, generally available only for the last few decades, have given female creators greater control over their lives and domestic conditions. Most of the renowned female painters of the past, for various intentional or accidental reasons, had either few children or no children at all. Childbearing responsibilities kept most women out of the art world. Today, budding female artists can exercise far greater control over whether and when they wish to have children. The increasing prominence of women in music, literature, and the visual arts provides one of the most compelling arguments for cultural optimism. For much of human history, at least half of the human race has been shut out from many prominent artistic forms, and women are only beginning to redress the balance.[14]

Do the Arts Lag in Productivity?

William Baumol and William Bowen, two economists who have analyzed the performing arts, believe that economic growth imposes a "cost disease" on artistic production. They claim that rising productivity causes the arts to increase in relative cost, as a share of national income. The arts supposedly do not enjoy the benefits of technical progress to equal degree. It took forty minutes to produce a Mozart string quartet in 1780, and still takes forty minutes today. As wages rise in the economy, the relative cost of supporting the arts will increase, according to this hypothesis.[15]

Contrary to Baumol and Bowen, the evidence presented in this book suggests that the arts benefit greatly from technological progress. The printing press, innovations in paper production, and now the World Wide Web have increased the availability of the written word. The French impressionists drew their new colors from innovations in the chemical industry. Recording and radio, both capital technologies, have improved the productivity of the symphony orchestra. Symphonic productions now reach millions of listeners more easily than ever before. These technological improvements are not once-and-for-all events that only postpone the onset of the cost disease. Rather, technological progress benefits the arts in an ongoing and cumulative fashion.[16]

The cost disease argument neglects other beneficial aspects of economic growth. The arts benefit more from technological advances than it may at first appear. Production of a symphonic concert, for instance, involves more than sitting an orchestra in a room and having them play Shostakovich. The players must discover each other's existence, maintain their health and mental composure, arrange transportation for rehearsals and concerts, and receive quality feedback from critics and teachers. In each of these regards the modern world vastly surpasses the productivity of earlier times, largely because of technological advances.

Other productivity advances arise from new ideas. A string quartet in 1800 could play Mozart, but a string quartet today can play Brahms, Bartók, and Shostakovich; the Kronos Quartet even plays Jimi Hendrix's "Purple Haze." Creativity—a form of human capital—pervades cultural industries. Most productivity improvements, whether in the arts or not, come from human creativity, the "performing art" of the scientist, engineer, or inventor. Our entertainment and leisure industries have generated productivity increases that would put many computer companies or engineering firms to shame.

Mechanisms in Support of Artistic Diversity

Well-developed markets support cultural diversity. A quick walk through any compact disc or book superstore belies the view that today's musical and literary tastes are becoming increasingly homogeneous. Retail outlets use product selection and diversity as primary strategies for bringing consumers through the door. Even items that do not turn a direct profit will help attract business and store visits, thereby supporting the ability of the business to offer a wide variety of products.

The successive relaxation of external constraints on internal creativity tends to give rise to a wide gamut of emotions and styles. Contemporary culture has proved itself optimistic, celebratory, and life-affirming. The songs of Buddy Holly, Howard Hodgkin's paintings, and Steven Spielberg's *Close Encounters of the Third Kind* show positive cultural forces with great vigor. The songs of Hank Williams, Isaac Bashevis Singer's stories, and Ingmar Bergman's *Persona* depict a sadder, more shattering aesthetic, although not without the possibility of re-

demption. And for a dark and ecstatic experience we are drawn to the works of Mark Rothko. Depravity and excess, exquisitely executed, can be found in the photography of Robert Mapplethorpe, the Sex Pistols's music, and Bernardo Bertolucci's *Last Tango in Paris.*

The available variety of artistic products should come as no surprise. Adam Smith emphasized that the division of labor, and thus the degree of specialization, is limited by the extent of the market. In the case of art, a large market lowers the costs of creative pursuits and makes market niches easier to find. In the contrary case of a single patron, the artist must meet the tastes of that patron or earn no income.

Growing markets in music, literature, and the fine arts have moved creators away from dependence on patronage. A patron, as opposed to a customer, supports an artist with his or her own money, without necessarily purchasing the artistic output. Samuel Johnson, writing in the eighteenth century, referred to a patron as "a wretch who supports with insolence, and is paid with flattery." Even Johnson, however, did not believe that patrons were intrinsically bad; the problem arises only when artists are completely dependent upon a single patron. Patronage relationships, which today stand at an all-time high, have become more beneficial to artistic creativity over time. The size and diversity of modern funding sources gives artists bargaining power to create space for their creative freedom.[17]

Growth of the market has liberated artists, not only from the patron, but also from the potential tyranny of mainstream market taste. Unlike in the eighteenth century, today's books need not top the best-seller list to remunerate their authors handsomely. Artists who believe that they know better than the crowd can indulge their own tastes and lead fashion. Today it is easier than ever before to make a living by marketing to an artistic niche and rejecting mainstream taste.

The wealth and diversity of capitalism have increased the latitude of artists to educate their critics and audiences. Starting in the late nineteenth century, many painters deliberately refused to produce works that were easily accessible to viewers. At first Manet, Monet, and Cézanne shocked the art world with their paintings but eventually they converted it. The financial support they received from their families and customers was crucial to this struggle. The twentieth-century American Pop artists, such as Andy Warhol, Roy Lichtenstein, Robert Rauschenberg, and Jasper Johns, also made initial sacrifices to elevate

23

our tastes. Today we enjoy their brilliant pictures while taking the once-shocking approach for granted.

In the realm of culture, market mechanisms do more than simply give consumers what they want. Markets give producers the greatest latitude to educate their audiences. Art consists of a continual dialogue between producer and consumer; this dialogue helps both parties decide what they want. The market incentive to conclude a profitable sale simultaneously provides an incentive to engage consumers and producers in a process of want refinement. Economic growth increases our ability to develop sophisticated and specialized tastes.

Many commentators, such as Jürgen Habermas, see the development of "critical theory" as vital to the reform of social and individual wants. Habermas's critical theorist stands outside the market order and attempts to deconstruct and dehegemonize the presuppositions upon which modern society is based. Rational communicative discourse and want refinement provide keys to his philosophy. I differ from Habermas in terms of how I conceive the cultural discovery process. Rather than seeing communicative reason as a project that stands outside and evaluates the market, I conceive of communicative reason within a concrete institutional framework with market incentives and property rights. Habermas wishes to step outside of that framework to direct culture from above by reason and clear communication. I see his "ideal speech community" as a Platonic myth, and instead place greater emphasis on the competition of contrasting notions of cultural reason within regimes ruled by incentives.[18]

Competition and Complementarity as Forces for Innovation

Artists offer new products to increase their income, their fame, and their audience exposure. They seek to avoid duplicating older media and styles, which become played out and filled with previous achievements. Picasso had the talent to master many styles, but won greater accolades with his innovations than he would have achieved by copying the French impressionists. Rather than safely performing Haydn and Beethoven, four young talented performers decided to become the Kronos Quartet, and to perform music by Glass and Riley and African music. As a leader in a new line of production, the quartet has earned especially high profits. The Arditti Quartet has not earned the profits of

Kronos, but nonetheless has staked out its position as a preeminent string quartet for contemporary chamber music.

Innovation enables artists to overcome their fear of being compared to previous giants. A century of German and Austrian musicians—Schumann, Schubert, Brahms, and Bruckner—dreaded comparison with Beethoven and pursued new directions. Brahms avoided composing symphonies for many years, instead writing songs and vocal ensembles. These works surpassed Beethoven's vocal music. Brahms turned to symphonies much later in life: He had once written, "You don't know what it is like always to hear that giant marching along behind me." Beethoven refused to hear the operas of Mozart for this reason, but even Beethoven could not escape being intimidated by his own achievements. Rather than finishing a tenth symphony, which might have paled in comparison to his ninth, he wrote his innovative late string quartets.[19]

Walter Jackson Bate coined the phrase *The Burden of the Past.* Harold Bloom produced a theory of poetry based on *The Anxiety of Influence.* In another book, *A Map of Misreading,* Bloom suggests another response to the past—deliberate misunderstanding of previous contributions. These tactics allow artists to overcome the quantity and quality of accumulated past masterworks.[20]

Creators sometimes respond to past masterworks with emulation rather than with product differentiation. The impressionist painters saw many of their innovations with sharp colors, flatness of field, and verticality of perspective in Japanese woodblock prints. They responded by collecting and promoting such prints; Mary Cassatt even copied the style literally. Similarly, the Rolling Stones were encouraged by the possibility of following in the footsteps of Muddy Waters, not scared off. Raphael favored the preservation of antiquities to "keep alive the examples of the ancients so as to equal and surpass them."[21]

Many of the newest cultural permutations emulate the very old and the sometimes forgotten. Tribal or "primitive" modes of art have exercised a strong influence throughout our century. Picasso took much inspiration from African masks, Brancusi and Modigliani drew upon Cycladic art, the Surrealists looked to the South Pacific, and the Art Deco movement was influenced by the Mayan temple. Both rock-and-rollers and contemporary "classical" composers explore originally African rhythmic traditions.

25

Critics often write premature obituaries for changing styles and genres. The writing of epic poetry has not ceased but lives on in the works of Derek Walcott, who emulates Homer. Lawrence Kasdan's *Body Heat* and Paul Verhoeven's *Basic Instinct* follow the film noir tradition of the 1940s or 1950s. Many of the most popular bands of the last several years—like Nirvana, Pearl Jam, and Smashing Pumpkins—have created a deliberately retrograde sound, hearkening back to the 1970s. In classical music, Arvo Pärt resurrects the medieval tradition and in jazz George Gruntz has revitalized the big band.[22]

The pastiche of today's so-called "postmodern" style responds to two market incentives. First, an increasing number of past styles accumulate over time. It becomes harder to create works that do not refer to past styles in some fashion. Second, both creators and audiences come to know more past styles over time, due to the success of markets in preserving and disseminating cultural creations. Performers find themselves increasingly able to establish rapport with their audiences by referring to past works. Warhol could reproduce Chairman Mao, Marilyn Monroe, or the Mona Lisa in silkscreen form, but Leonardo da Vinci had a smaller number of established icons—primarily religious— to draw upon.

Some new artistic developments turn their back on the futuristic and high-tech and embrace earlier, more naturalistic forms of art. Witness the recent trend of rock stars to go "unplugged" and produce acoustic albums and concerts. Andy Goldsworthy and Robert Smithson, two contemporary sculptors, have worked with objects taken from nature, such as stones, tree branches, and ice. The artist Cy Twombly uses crayon to great effect. Artists increase their income and fame by reaching audiences, and they will not hesitate to cast off electronic gadgetry and draw upon earlier styles to achieve that end.

Standing still is one tactic that artists cannot prosper by in a dynamic market economy. Artists stake out niche positions but they are not protected against competition for long. Picasso and Braque introduced cubism but eventually had to contend with competitors who built on their work. Declining eminence and profits, combined with threatening competition, often induce the original artist to innovate again. Stravinsky, Picasso, and the Beatles outpaced their competitors, at least for a while, by undergoing several metamorphoses of style.

Eventually most artists lose the drive or depth to meet challenges and consequently give up their place as industry leaders. Andy Warhol set up The Factory and sold studio-made prints and silkscreens under his own name, Maria Callas did not take sufficient care with her voice, and Rossini ceased composing operas altogether. E. M. Forster published his last novels in the 1920s, even though he did not die until 1970. "I have nothing more to say," was his explanation. These artists ceded their places on the cutting edge of their respective fields.[23]

New innovations do not always eclipse older, more established artistic forms, but they do inevitably change them. Outside competition shakes up older forms and spurs ingenuity. Renaissance sculpture communicated the idea of depth perspective to painters, jazz crept into the rhythms of classical music, and movies have sped up the pacing of the best-selling novel. Sometimes a new medium pushes other works in the opposite direction. The need to compete with television prompted film directors to develop the big-screen movie with spectacular special effects. Photography created a cheap substitute for portraiture, which induced painters to direct their talents to more abstract and less realistic themes.[24]

Artistic fertilizations and innovations also occur backwards in time, as later works improve the quality of earlier ones by changing their meaning. Verdi's opera *Otello* and Orson Welles's film *Othello* tell us more about Shakespeare's *Othello* than does any piece of literary criticism. These variations on the work, through different media and presentation, enable us to see Shakespeare's work anew. Verdi's music brings out the aspect of terror in the text and influences how we read the play. Subsequent contributions and adaptations thus make Shakespeare's work richer, just as Shakespeare's original *Othello* now contributes to the depth of the later versions. Art Tatum's piano improvisations, Lichtenstein's takeoffs on French and abstract expressionist paintings, and Beethoven's *Diabelli Variations* all shed light on previous artworks to an especially high degree. T. S. Eliot, who focused on this mechanism in his essay "Tradition and the Individual Talent," has been prominent on both sides of such exchanges.

Art creates an interdependent language whose whole exceeds the sum of the parts. Masterpieces therefore provide more satisfaction and insight as we accumulate artistic experience. Rossini's operas were once viewed as "too Germanic" and "too intellectual," because he used the

27

orchestra to frame the melodic line. The eventual adoption of this practice by opera composers all over Europe illuminated the universality of Rossini's original conception. Arthur Danto observes that Andy Warhol's Brillo Boxes would not have qualified as a work of art, had they been created one hundred years ago. Not only would these works have passed unappreciated, but they would not provide compelling images outside of a modern commercial context.[25]

The importance of context and the possibility of ex post "reinterpretations" make the best artworks truly inexhaustible. The more music we know, the more we can hear in the compositions of Bach and Beethoven. The very best creators manage to anticipate the future development of their genre and to produce works that will subsequently exhibit an ever greater richness. In these cases both the consumption and production of art are subject to increasing returns to scale. The more notable works that are produced, the greater the significance of the best works from the past. The present therefore deserves at least partial credit for our understanding of the past. Ironically, if modern culture were so poor, it would not be able to produce so many cultural pessimists with such a fine appreciation of past masterworks.

Successive creations increase the potency of some works but devalue others. We now find Richardson's *Pamela* to be implausible and chauvinist; the heroine submits to a forced marriage to an unsavory character and eventually grows to enjoy it. Contemporary audiences might best enjoy James Dean in *Rebel Without a Cause* as unintended farce, rather than as a rousing story of an angry young man. Markets have preserved the physical substance of these works but have devalued their original force and meaning.[26]

Cultural critics and commentators contribute powerfully to the vitality of market art. Critics put artistic consumers in touch with artistic producers, and help us separate the wheat from the chaff. They support the process of taste refinement. Listeners who take a sudden interest in classical music do not have to sort through the entire eighteenth century repertoire, but can listen to Mozart and Haydn. Harold Rosenberg and Clement Greenberg helped the American abstract expressionist painters find a public audience and win their way into museums. Pauline Kael directs our attention to the best of recent film. I hope my own commentary—in the form of this book—boosts interest in contemporary art and music. These forms of professional cultural

criticism, all relatively new professions, owe their thanks to capitalist wealth. The modern world can support many thousands of intellectuals who specialize in arguing the merits of artistic products.

Outsiders as Innovators

Outsiders and marginalized minorities often drive artistic innovation. Much of the dynamic element in American culture, for instance, has been due to blacks, Jews, and gays, as Camille Paglia has noted.

Outsiders have less stake in the status quo and are more willing to take chances. They face disadvantages when competing on mainstream turf, but a differentiated product gives them some chance of obtaining a market foothold. Individuals who will not otherwise break into the market are more inclined to take risks, since they have less to lose. Were an all-black orchestra or black conductor to record the umpteenth version of Mozart's *Jupiter* symphony, the racially prejudiced would have no reason to promote or purchase the product. (Few individuals know the name or the works of the most critically renowned black conductor of our century, Dean Dixon.) The cost of indulging discriminatory taste is low when the market offers the virtuosic Herbert von Karajan and Karl Boehm, both former Nazi supporters. But when black performers played "Take the A Train" or "Maybellene," even many racists were impelled to support the outsider with their dollars.

The most influential African-American contributions have not come in the most established cultural forms, such as letters and landscape paintings. Instead, America's black minority has dominated new cultural areas—jazz, rhythm and blues, breakdancing, and rap.

Minority innovators bring novel insights to cultural productions. Their atypical background provides ideas and aesthetics that the mainstream does not have and, initially, cannot comprehend. Minorities also must rationalize their outsider status. They deconstruct their detractors, reexamine fundamentals, and explore how things might otherwise be. They tend to bring the upstart, parvenu mentality necessary for innovation. Jazz musician Max Roach pointed out: "Innovation is in our blood. We [blacks] are not people who can sit back and say what happened a hundred years ago was great, because what was happening a hundred years ago was shit: slavery. Black people have to keep moving."[27]

Capitalism has allowed minority groups to achieve market access, despite systematic discrimination and persecution. Black rhythm and blues musicians, when they were turned down by the major record companies, marketed their product through the independents, such as Chess, Sun, Stax, and Motown. The radio stations that favored Tin Pan Alley over rhythm and blues found themselves circumvented by the jukebox and the phonograph. These decentralized means of product delivery allowed the consumer to choose what kind of music would be played.

The French impressionist painters, rejected by the government-sponsored academy, financed and ran their own exhibitions. In the process modern art markets were born. Jews were kept out of many American businesses early in this century, but they developed the movie industry with their own capital, usually earned through commercial retail activity. Women cracked the fiction market in eighteenth century England once a wide public readership replaced the system of patronage. Innovators with a potentially appealing message usually can find profit-seeking distributors who are willing to place money above prejudice or grudges.

Innovations in Preserving Past Culture

The diversity of the contemporary world includes our unparalleled ability to preserve and market the cultural contributions of the past. Markets provide profits to those who successfully preserve and market the cultural contributions of previous artists.

Today's consumers have much better access to the creations of Mozart than listeners of that time did, even if we restrict the comparison to Europe. More people saw Wagner's Ring cycle on public television in 1990 than had seen it live in all Ring productions since the premiere in 1876. Recorded boxed sets and complete editions of little-known composers are now common. Once-obscure operas and symphonies are available in profusion. Compact disc reissues of classic performances have exceeded all expectations; record companies eagerly reissue obscure recordings that sell only a few thousand copies.[28]

Old movies, including many silents, can be rented on videocassette for a pittance. The video laser disc, likely to fall drastically in price, will provide new and better access to movies and musical performances. Many classic symphonic and instrumental performances have been reis-

sued on compact disc. New and definitive editions of many literary works, or better translations, are being published for the first time. The classics are available in cheap paperback editions. Television, video stores, and bookstores give modern fans much better access to Shakespeare than the Elizabethans had.

Even lesser painters now have their own one-man shows with published catalogs full of beautiful color plates. Wealthy American art collectors have enabled New York's Museum of Modern Art and Metropolitan Museum of Art to become world leaders in preserving the art of our century and of centuries past. The Getty and Norton Simon museums in California have been assembled in recent times from two large private donations. Even the government-run National Gallery of Art assembled most of its holdings from private collections like those of the Mellon, Kress, Dale, and Widener families—paintings that were headed for museums in any case.

Live performance, as a means of preserving the past, also has flourished. Today's concertgoers can sample a range of musical periods, instruments, and styles with an ease that previous ages would have envied. While conductors are mastering twentieth century idioms, they are also refining "original performance" presentations of Renaissance, baroque, and classical styles. American symphony orchestras in Cleveland, Boston, New York, Philadelphia, and other cities have outpaced many of their European competitors. From 1965 to 1990 America grew from having 58 symphony orchestras to having nearly 300, from 27 opera companies to more than 150, and from 22 non-profit regional theaters to 500.[29]

Our increasing facility at preservation accelerates the rate of artistic innovation. As extant products are spread and assimilated with greater ease, newer innovations are demanded and thus spurred to arrive more quickly. Artists can satisfy these demands through their quicker access to a wide variety of ideas and inspirations. Beethoven's late string quartets remained inaccessible to most listeners for long periods of time, whereas Bartók's string quartets received quick fame because of the Juilliard Quartet recordings. That is one reason why Bartók's innovations were assimilated more rapidly than were Beethoven's. Musicians, critics, and listeners could hear Bartók's quartets whenever they chose, and they assimilated the new ideas speedily; Beethoven's contributions took more time to sort out.

31

New methods of communication and preservation have been arising and spreading at an increasing pace. Print took at least two centuries to become a generally used means of storing and communicating information. Radio took thirty-five years. Cinema and television each took less than twenty years. The compact disc, the VCR, and now the Internet have caught on even more quickly. As new media spread with greater rapidity, so do new artistic products and genres.

Learning from the past requires preservation and reproduction. Many of the artistic creations of antiquity, which were not maintained in sufficiently durable form, have been lost to the world forever. The onset of the Dark Ages caused the market for cultural preservation to dry up; during early medieval times, for instance, many sculptures were worth more for their bronze, and therefore were melted down and destroyed. The market for cultural preservation was not fully revived until the spur of Renaissance wealth supported the markets for old artworks, manuscripts, and artifacts. Many of the Greek and Roman manuscripts that did survive came to the West through Islamic civilization, the wealthiest and most market-oriented region of its day.

Is Modernity an Age of Mass Culture?

Many commentators see the modern age as the age of mass culture, where large numbers of individuals unthinkingly consume the same products. But the mass culture model applies, at most, to the fields of television and sports. These areas are highly visible and therefore easy to focus on. I see television and sports as special cases where competitive pressures have been partially stifled; they do not, therefore, represent the vanguard or the high points of modern culture.

Post-war American television, by and large, has not provided cultural riches. Television programs entertain us and present appealing characters, but a canonic list of the best television programs would not, in this author's opinion, stand up to a comparable list from music, painting, or literature. My personal and purely idiosyncratic nominations for the best television products ever—Britain's Monty Python troupe and Ingmar Bergman's *The Magic Flute*—both were produced for government-owned stations, rather than for the market-based American system. I concur with Robert Hughes, who notes that sev-

eral hours of American television provide the best argument against market-supplied culture.

The influence of the television market also has had some consequences for other cultural media, such as motion pictures. Today a considerable percentage of the profits from a movie come from the sale of television rights. Moviemakers, to some degree, have shifted their attention away from more specialized moviegoers to the more general television audience. Television helps fund movies that would otherwise not be made, but it also exerts a negative influence on movie quality.[30]

I do not intend the above remarks as an anti-television polemic. Television—even its lower brow forms—provides a useful medium for presenting social issues and showing audiences by example how people can deal with their personal problems. The rapid and healthy increase in social and sexual openness, which blossomed in the 1960s and 1970s, is due partly to television. Television also provides a variety of other non-artistic services, ranging from news to Sesame Street in Spanish to nature documentaries.

Legal restrictions on cable television are partly to blame for the cultural shortcomings of television. For many years the American government gave monopoly power to the three major networks and certain privileged local stations. The Federal Communications Commission also holds the power to revoke the licenses of stations that do not broadcast in the so-called "public interest." Television has not been able to develop the diversity necessary to support innovative and visionary cultural products. The quality of television is especially vulnerable to restrictions on competition because TV programs have no other outlet. Music, in contrast, has been less affected by the limitations of radio. Live performance, phonographs, and jukeboxes have provided alternate marketing outlets. There are also more radio stations than television channels.

If mass taste had controlled other genres as it has controlled television, they too would fare little or no better. A society with three major outlets for books, distributing common products for all who wish to read, would not have produced Vladimir Nabokov's *Lolita* or Franz Kafka's *Metamorphosis*. The virtues of cultural markets lie not in the quality of mass taste but rather in the ability of artists to find minority support for their own conceptions. Even Michael Jackson, an unparalleled cultural phenomenon whose *Thriller* album has sold fifty million

copies worldwide, has never commanded the allegiance of most Americans.

With the widespread advent of cable and satellite television, the reign of mass taste in television programming has begun to decline. The competitive rivalry of market forces tends to "de-massify" the media, to borrow a phrase from Alvin Toffler. The television audience is fragmenting as special interest stations proliferate on cable. In the last fifteen years, the three major networks have lost thirty million viewers—a third of their audience. Diverse products appealing to market niches can exploit the vulnerability of bland products aimed at mass audiences. Cable subscriptions frequently give individuals access to 150 stations or more, and the number is growing steadily.[31]

It nonetheless remains an open question how much cultural inspiration television will produce in the future. The American experience with cable television has disappointed many expectations. Many cable channels focus on repackaging traditional network programs; we now can view reruns of situation comedies at all times of the day. Much of cable's diversity has supported evangelists, Home Shopping Network, personal advertisements in search of romance, ongoing weather reports, airline schedules, and soap operas in various languages. These products are useful to consumers but they are unlikely to provide culture that will stand the test of time. Cable channels have produced fewer new programs than many observers had expected. Even when the number of available channels is large, creators still must cover their production and marketing costs by bringing in a sizable audience.[32]

On the brighter side, cable now offers a smorgasbord of the world's greatest movies, the modern drama of sporting events, MTV, and a smattering of the high arts. The Discovery channel provides quasi-cultural services through portraying the beauties of the natural world. The educational functions of cable bring indirect cultural benefits. Individuals can now take a class in Shakespeare without leaving their living rooms, or can use foreign language channels to improve their linguistic skills, thereby enlarging their access to the world's cultural treasures.

It remains to be seen whether the failures of cable TV will prove temporary or permanent. The advent of digital compression will bring the number of cable stations to at least 500 in the near future. The future may bring interactive cable systems that will allow each viewer to

choose the program that he or she prefers from a large program menu. It is possible that cable television, like the printing press, radio, and the phonograph in their early days, is just beginning to realize its potential.[33]

The introduction of the video cassette and laser disc have expanded viewing diversity further. Viewers can now choose what will appear on their screen, drawing on a wide range of video stores and tape producers. In addition to movies, these outlets offer tapes of travel footage, music, dance, paintings, opera, and video art. Today's video stores are treasure chests of modern cultural achievement, following along the lines of the ancient Ptolemaic library in Alexandria, but far more successful in their preservation and distribution.

Sports remain the primary arena where mass culture will survive in the future. Sports mix entertainment with live drama and a smattering of performance art and dance. Rather than hiring actors and actresses to pretend that staged events matter, we fund events whose reality does matter to the participants. Consumers are wealthy enough to create real drama with fame, money, and ego on the line. Sports—although they do not qualify as art in the narrow sense—provide a commonly observed stage to a world of many diverse and specialized performances.

Sporting leagues are a natural market monopoly rather than a monopoly created by government. Many sports fans prefer the drama of seeing a well-defined "best," such as the Super Bowl, or they prefer seeing the game that others are seeing. By following well-established sports, individuals have something they can discuss and share with others, even strangers. In both basketball and football we have seen upstart leagues (the ABA and the AFL) but the eventual result was consolidation and cooperation. Minor leagues and college teams show that sporting natural monopolies are far from absolute, but the established major leagues nonetheless possess a strong incumbency advantage.

Yet even the natural monopoly of incumbent sports leagues has not shut down diversity and innovation. Spectators can watch a greater number of sports than ever before, either in live performance or on cable television. We have round-the-clock coverage of the Olympics. Soccer and tennis can now be viewed on a regular basis, and followed on the Internet. Professional NBA basketball had been thought on the verge of extinction in the 1970s, but today acrobatic moves and slam dunks are capturing the imagination of youth around the world.

Government as Customer

Music and the arts have been moving away from government funding since the Middle Ages. The Renaissance, the Enlightenment, the nineteenth century romantic movement, and twentieth century modernism all brought art further into the market sphere. Today, most of the important work in film, music, literature, painting, and sculpture is sold as a commodity. Contemporary art is capitalist art, and the history of art has been a history of the struggle to establish markets. These trends will not be reversed in any foreseeable course for the current world, regardless of our opinion of government funding for the arts. Most countries in the world are not contemplating reversions to socialism.

The arguments of this book, taken alone, cannot determine which side is correct in the American political debates over government funding of the arts. Rather, I wish to challenge the common premise of cultural pessimism behind both sides. Funding critics argue that the National Endowment for the Arts (NEA) is corrupting American culture, while funding advocates claim that eliminating the NEA would critically damage American culture. I see American culture, and the culture of the free world, as fundamentally healthy in any case.

The real choice today is between two alternate optimistic visions of our cultural future. In one vision, government funding plays a minor but supportive role by creating niches for artists who might otherwise fall between the cracks. Government serves as one of many entrepreneurs in the cultural marketplace. In the second vision, even small amounts of government funding will more likely corrupt the arts than improve them. The costs of politicizing art might outweigh the benefits from additional government funding of art. Governments, even democratic ones, tend to favor the cultural status quo that put them in power, or to shape a new status quo that will cement their power.

Contrary to the claim of Alexis de Tocqueville, democracy need not prove an inferior system for the arts, compared to aristocracy. At most democratic *government* might be inferior for the arts, compared to aristocratic government. Democratic systems as a whole do extraordinarily well when they allow an accompanying capitalistic market to fund their artistic activities. The cultural rise of the American nation,

which occurred largely after Tocqueville wrote, provides the strongest argument against his thesis. After the second World War, America has been a clear world leader in film, painting, and popular music, and has had a strong presence, arguably second to none, in literature, poetry, and music composition. Among other factors, Tocqueville overlooked the rise of the steamship, which brought America in closer touch with Europe in the late nineteenth century, and facilitated beneficial cultural exchange.[34]

The state does best in promoting the arts when it acts as simply another customer, patron, or employer, rather than as a bureaucracy with a public mandate. Direct government funding works best when it serves as private funding in disguise, such as when Philip IV hired Velázquez to serve as his court painter. In similar fashion, the royal court of Louis XIV supported Molière and the German municipalities of Weimar, Cöthen, and Leipzig hired Johann Sebastian Bach to serve as town musician. We can find many cases where monarchs, Popes, municipalities, guilds, and other governmental or quasi-governmental institutions commissioned or otherwise supported notable works.

We should not, however, overestimate the successes of government funding. For every Velázquez, governments have supported hundreds of unknown court painters. Autocracy will sometimes place substantial resources in the hands of an artistic superstar, but, more often than not, will promote mediocre hacks. The purse strings are in the hands of politicians who seek personal power for themselves, and flattery and obedience from others. For this reason aristocratic government does not guarantee artistic success, even though we can point to some inspired aristocratic buyers.

Whether government funding for the arts should be discontinued, maintained, or extended brings two sets of incommensurable values into conflict. On one hand, the case against funding makes two valid points. First, tax-supported funding forces consumers to forgo goods and services that they would prefer more than art. Second, many individuals believe it is unjust to force conservative Christians to support an exhibit of Robert Mapplethorpe, to draw an example from the U.S. context. On the other hand, funding supporters point out that more money will support more artists, more art, and, if done with reasonable care, will improve our artistic heritage. Neither side has succeeded in

showing that its favored values are more important than the values fa-
vored by the other side.[35]

Government arts funding cannot be restructured to avoid this
clash of artistic versus non-artistic values. Artistic buyers must be liber-
ated from accountability to the masses, if they are to have a good
chance of influencing the market in a positive direction. Art and demo-
cratic politics, although both beneficial activities, operate on conflicting
principles. In the field of art new masterpieces usually bring aesthetic
revolutions, which tend to offend majority opinion or go over its head.
In the field of politics we seek stability, compromise, and consensus.
This same conservatism, so valuable in politics, stifles beauty and inno-
vation in art.

The current American political debate has confronted the NEA
with an impossible task. The NEA is supposed to deliver the benefits of
privileged spending while receiving its funding from a democratic sys-
tem based on political accountability. The result is an agency whose
best and most innovative actions—such as funding exhibits of Robert
Mapplethorpe and Andrés Serrano—are precisely those that offend its
taxpaying supporters.

Ironically, the massive publicity generated by NEA critics may
have done more for the arts than the NEA itself. Jesse Helms, with his
virulent, prejudiced attacks on Robert Mapplethorpe, did far more for
that artist than the Washington arts establishment has. Mapplethorpe's
name is now a household word. In his lifetime, Mapplethorpe did not
need government assistance; he became a millionaire by selling his
photographs in the marketplace. Jesse Helms, however, did bring
Mapplethorpe his current fame.

The American government has done a good deal to support the
arts, but most of the successes have come from outside of the NEA.
The entire NEA budget, at its peak, fell well short of the amount of
money required to produce Kevin Costner's *Waterworld* epic. NEA ex-
penditures have never exceeded seventy cents per capita, and the NEA
has never been vital to American artistic success. Before 1965, when
the NEA was created, American culture—even the preservation of high
culture—flourished. The best American symphony orchestras and mu-
seums were created well before 1965 and without NEA involvement.[36]

The bulk of American governmental support for the arts has come
in two other forms. First, the tax deduction for contributions to artistic

non-profits has greatly benefited museums, opera companies, and other artistic activities that rely on private donations. Government also exempts not-for-profit institutions from income taxation. Tax deductibility allows government to support the arts without making judgments about the relative artistic merits of different projects. Just as tax deductibility has succeeded in supporting American religion or the American housing market, so has it improved the quantity and quality of American culture.

Second, federal and state governments provide massive indirect support to the arts through subsidies to higher education. Many of today's cutting-edge composers and writers rely on university positions for part- or full-time support while they pursue their craft. While the number of writers and composers in university jobs may have overly academized American culture, professorships have been the only available source of support for many of these creators. Whether American higher educational policies have been effective, all things considered, falls outside the scope of this book. But seen as cultural policy, government subsidies for higher education are far more significant than the small sums spent by the NEA.

Governments often support creativity most effectively by providing a large number of jobs where individuals are not expected to work very hard. Many leading eighteenth century writers, for instance, worked for the government bureaucracy. These individuals pursued their creative interests either in their spare time or while "on the job." John Gay, Daniel Defoe, and Jonathan Swift, to name but a few examples, all received substantial income from government employment. Goethe spent much of his life working as a government administrator while writing in his spare time. The university has now stepped into the role once provided by the bureaucracy—in many cases teaching posts give talented individuals financial security with a relative minimum of daily responsibilities.[37]

The funding model of Western Europe differs from that of the United States. Germany and France, for instance, deliberately sacrifice contemporary popular culture to both older, high culture and to the contemporary avant-garde. These governments restore old cathedrals and subsidize classic opera and theater, while simultaneously supporting the extreme avant-garde, such as Boulez, Stockhausen, and Beuys. Yet European popular culture, especially in cinema and music, is largely

moribund and lacking in creativity. Germany and France have not escaped the bureaucratization of culture. The French Ministry of Culture, for instance, spends $3 billion a year and employs 12,000 bureaucrats. Yet France has lost her position as a world cultural leader, and few other countries embrace American popular culture with such fervor.

Government involvement in cultural preservation involves costs beyond the immediate tax burden—state support makes the arts more bureaucratic and less dynamic. Government, when it acts as customer on a very large scale, often pushes out beneficial market influences. The American market has less government funding but receives much more funding from consumers and private donors. As in the American debate, European arts funding brings a clash of potentially incommensurable values and does not admit of resolution through positive analysis alone.[38]

One alternative (minority) vision suggests that government funding can create a useful target for radical artists. American painter John Sloan said "Sure, it would be fine to have a Ministry of the Fine Arts in this country. Then we'd know where the enemy is."[39]

High and Low Culture

Sometimes we distinguish between "high" culture, the items achieving greatest critical acclaim, and "low" culture, the most popular cultural items. Economic incentives support this split between high and low culture. Capitalism supports product diversity and gives many artists the means to work outside of the popular mainstream. The resulting split between high culture and low culture indicates the sophistication of modernity, not its corruption or disintegration. A world where high and low culture were strongly integrated would be a world that devoted little effort to satisfying minority tastes.[40]

Genres that rely heavily on equipment and materials, which I describe as capital-intensive, tend to produce popular art. Genres with low capital costs, which I describe as labor-intensive, tend to produce high art. The movie spectacular with expensive special effects is likely to have a happy ending. The low-budget art film, directed and financed by an iconoclastic auteur, may leave the viewer searching.

Basic financial and economic reasons support these tendencies. Ongoing artistic endeavors must cover their costs—through sale, subsidy, or donation—if they are to persist. To the extent that costs are high, the influence of the funders increases and the artistic freedom of the creators decreases. Painting and poetry, highly labor-intensive solo activities, offer especially large room for the avant-garde. Creators in these areas can eschew the mass public and pursue creative self-expression without receiving complaints from shareholders. Capital-intensive movies, in contrast, reflect middle-class tastes more closely. Most movies must pull in large sums of money to cover their production and distribution costs. Moviemakers are therefore impelled to appeal to a relatively broad audience.

Hollywood provides an ongoing battleground for opposing high and low culture forces, as the differing goals of the participants build artistic conflict into the system. Artists are motivated by creative self-expression, fame, and money, but owners of capital goods are usually motivated by profit alone. Consider the film *Blade Runner*. Actor Harrison Ford sought fame and stature, director Ridley Scott sought creative self-expression, but the shareholders of Warner sought profit alone. Warner forced Scott to add a happy ending to his masterpiece, even though the resolution was unconvincing and diminished the quality of the picture. Only later, when the movie was reissued *(Blade Runner: The Director's Cut)*, was Scott able to restore the original, and far superior, ambiguous ending. Harrison Ford and Ridley Scott are renowned and worshiped for their talent, but the shareholders of Warner are not. Finding no other reward, the shareholders pursue profit maximization and push for mass audience appeal.

High and low culture usually appear to be diverging. New genres tend to have initially high capital costs; otherwise they would have been feasible prior to innovation. The new art of film appealed to a broad public with popular themes. At the same time painting and literature, with falling capital costs, moved away from mass taste. Charlie Chaplin's *City Lights* and James Joyce's *Finnegans Wake,* two versions of the modernist aesthetic pitched at different audiences, reflect these varying economic constraints. Some parts of capitalist culture move in the direction of popular taste while, at the same time, others become more esoteric.

Falling costs and growing demand enabled the movies to grow more rapidly in the 1920s than did other cultural media. Popular

culture appeared to be gaining at the expense of high culture. But in fact such growth eventually transforms popular culture into high culture. As popular culture genres lower their costs, they achieve the potential for greater diversity and exoticism. Art films, documentaries, and avant-garde movies have expanded since the early days of the medium.

Artistic genres or sub-genres sometimes will move back in the direction of popular taste and away from the esoteric. Even if the cost of artistic production is falling, the costs of distribution may be rising, making an apparently labor-intensive endeavor in fact highly capital-intensive. Publishers of best-selling novels, in their attempt to reach larger audiences, spend more on advertising than ever before. Publishers need to recoup these expenditures through high sales volume. The need to hit the best-seller lists helps explain why plot has achieved greater emphasis over subtlety and elegance of language. Literature as a whole has become more diverse, and provided greater room for the esoteric, but media expenditures have caused the best-seller list to emphasize mass appeal to increasing degree.

The decreasing economic importance of the family has reinforced the split between high and low culture. In previous eras individuals tended to learn job skills from older family members. Many of the most renowned creators of the past—including all of the best known classical composers and some of the leading painters—received extensive familial training at very young ages. These family mentors were often good artists and musicians, but they tended to lack creativity and they held tastes well within the mainstream. They taught their sons and daughters to produce accessible creations. Today increased wealth and division of labor have allowed expert trainers to replace family mentoring. Budding composers now seek to please genre specialists rather than a general audience.

Increasing ease of reproducibility, a fundamentally healthy market development, drives a further wedge between high and low culture. Reproducibility gives critics the option of embracing relatively unpopular creations from the past. Eighteenth-century musical audiences, for the most part, knew only the music that they could hear in live performances. Recordings did not exist and the music of earlier composers was difficult to obtain in manuscript form. High and low musical culture had to be drawn from the same limited set of options, increasing the likelihood that they would coincide.

Today's critical listener can draw his or her high culture from the music of many centuries. We can applaud the merits of Palestrina and Mahler while Top 40 stations play REM and Madonna. The increased number of past creations and our superior access to them support a greater diversity of taste. The most popular music is usually drawn from current styles, whereas the accumulation of passed time increases the likelihood that critics will favor works from the past.

High culture, however, has never been a static concept. Reproducibility and preservation allow today's low culture to evolve into tomorrow's high culture. Shakespeare, in his day, enjoyed great popularity with the masses, but he had not yet entered a cultural pantheon. Many critics had never seen the plays, considered him "low brow," or simply ignored his work. The later growth of a mass market in books allowed readers and critics to study and debate Shakespeare at their leisure. By the eighteenth century some critics were suggesting that he was one of the greatest Western writers. Drawing upon accumulated centuries of textual study and exegesis, Harold Bloom now claims, "The Western canon *is* Shakespeare . . ."

By the time a new high culture has evolved through critical debate, however, popular culture has left it far behind. Critical opinion changes slowly, only after much discussion, debate, and soul-searching. The masses, in contrast, often change their fickle tastes overnight. The turnover in Top 40 radio far outpaces the turnover in the Penguin Guide to classical music recordings. Many buyers deliberately seek out the new, but many critics seek to develop evaluations that will stand the test of time.

Taking the cultural pessimists as an intellectual foil, I seek to present in the chapters that follow a more persuasive framework for understanding the past, present, and future of our culture.

❷ The Market for the Written Word

Three related features have shaped the market for the written word, at least since the widespread use of paper and the printing press. First, books can be reproduced at great ease and with no sacrifice of quality or value. Rare book collectors aside, subsequent copies and print runs of books provide the same services as first editions. This ease of duplication sets apart the book market from the art market, which offers easy reproducibility for prints only, and from the music market, where recording became widespread only in this century. The printing press has dominated the publishing trade for hundreds of years.

In the age of the illuminated manuscript, books were created by hand and the economics of books and the economics of the visual arts were closely linked; many books *were* visual arts. The cheap reproducibility of the written word, however, caused literature and visual art to diverge, and gave literature the potential to reach a mass audience. Many of the classic Western writers—Pope, Balzac, Hugo, Dickens, Tolstoy, and Dostoyevsky—to name a few examples of many, achieved widespread renown in their lifetimes. High quality painting and sculpture do not usually capture paying audiences so broad.

Second, the ease of reproducing books lowers their per unit marginal value. Books typically sell for far less than paintings. Unlike many painters, authors cannot support themselves by selling a few hundred works to a relatively small number of wealthy buyers. Writers who target small, elite, or specialized audiences must find alternate sources of sustenance, such as part-time jobs, grant support, or university positions. Since mass sales are needed for significant profits, authors face a trade-off. They may pursue lucrative writing for larger audiences, or less lucrative writing for more specialized tastes, including their own.

The most highly acclaimed painters are often the richest painters (e.g., Picasso, Jasper Johns), but the coincidence of fame and wealth is much weaker for writers.

Third, consumers (i.e., readers) must make a relatively significant commitment of time to extract value from a book. If an author wishes to reach readers, the author must encourage them to buy the book, borrow the book, or take the book out of the library. The reader must then sit down and spend at least several hours or perhaps even several days with the product.

Enjoying a given painting need not require a comparable time commitment. Viewers can enjoy a painting simply by looking, which takes less time than reading a book. Learning to love art requires much time in museums, but once an interest is established successive works may be enjoyed without large incremental investments of time. Visual artists therefore can build their reputations through public display of a relatively small number of works, which are then reproduced in art books and magazines for publicity. They can count on their audience taking the requisite brief look. An author, in contrast, must sell a larger number of books and receive more sustained attention from his or her consumers. Unlike in the visual arts, displaying a book copy shows only a small part of the final work, the cover. Whereas the art world places great importance on the display of the image, the literary world emphasizes the purchase and consumption of the product.

The Diverse World of Commercial Literature

Today's publishing world has a tainted name. Many inferior writers earn great sums of money, prompting observers to hold a skeptical attitude about literary commercialization. Corporate booksellers tend to have a poor reputation with educated readers and writers, and most of all with editors. The large houses often prefer the sure thing to the new idea, given that they already know how to sell the sure thing. An editor receives less blame if a book by a well-known writer falls flat than if a heavily promoted book by the editor's favorite new author does not take off. Books that fall outside of traditional categories also have trouble finding a publisher, given the greater ease of targeting specific, well-defined groups of buyers with advertising. Furthermore, companies will drop worthy books if they do not sell. Publicity, rather than literary

merit, often determines how much money a book will make. Profit maximization drives all of these results, thereby creating fodder for cultural pessimism in the literary arena.

Despite these well-known drawbacks, I interpret the history of literature, and today's book market, as supporting cultural optimism. Authorship became a self-sustaining profession in the eighteenth century with the rise of widespread trade in books. Since that time enduring works of many kinds have appeared in great number. This bloom of literary creativity, unparalleled in world history, occurred within a largely capitalist world of publishing. Commercialized literature, for all its flaws, has supported and disseminated the works of many of the world's most talented writers.

Commercialized literature gives writers many possible outlets for their output. The exercise of free bookbuyer choice, while it supports the work of lesser writers, simultaneously creates a large number of market niches for masterpieces. Talented writers who do not wish to "sell out" by lowering quality can still earn a living, even if they do not become millionaires. Products that can speak to an audience, even a small one, are sought out and promoted by publishers. Conformist and establishment mentalities are rife in the publishing trade, but fresh and vital manuscripts continually find their appropriate niches. The large commercial houses, the smaller presses, and the non-profit university presses all promote and publish high quality works on a regular basis.

Finding outlets for masterpieces will always be a struggle, precisely because such works are so innovative. Even André Gide, while working as an editor, rejected Proust's *Remembrance of Things Past* manuscript. Proust took his manuscript to another publisher, where it was accepted. Proust first had to pay some of the costs of publication but shortly received more lucrative offers for the subsequent volumes. Gide's publishing house reversed its earlier position and tried to get the work.[1]

The modern commercial world decentralizes editorial decisions and financial support. In 1947 only 85,000 books were in print in the United States, but now the number has risen to 1.3 million, with 140,000 published for the first time in 1996. Both Plato and the Bible—popular books with many cultural pessimists—have gone through increasing numbers of editions. The number of publishers, over the same time span, has risen from 357 to more than 49,000 in the U.S. alone.

Most of these presses are independent small presses or university presses, rather than corporate giants. Many have a life mission of finding neglected works that have been passed over by the larger houses. Editors, who staff independent houses at relatively low salaries, often work out of creative motives, rather than the desire for cash. Many such editors are sympathetic to innovative works that fall outside of the literary mainstream.[2]

The small publishing house, the academic press, and the so-called little magazines have given a start to some of the most acclaimed writers of our century. The decentralization provided by these alternative outlets flourishes most strongly in a wealthy, commercial society. Even the largest publishing houses benefit from finding and promoting new and previously unknown authors; each of today's established best-selling writers was once unknown. Unlike established authors, newcomers do not capture most of the publishing profits in the form of high advances and royalty rates. For-profit publishing houses therefore have a continual incentive to discover and promote new writers.

Neither the literary world nor the buying public concentrates the bulk of its attention on a few best-sellers. In 1990 alone, over two billion book copies were sold in the United States. The number of copies sold of the fifteen best-selling books throughout the entire 1980s accounts for less than one percent of this figure. In today's book superstores, best-sellers account for no more than three percent of sales. In any case, the relevant question is not how many more copies Grisham sells than Faulkner, but whether notable works of high quality find their appropriate publishing outlets and readers.[3]

The most critically acclaimed artists need not earn the most money for a given set of institutions to deliver the goods. The production of literary masterpieces is motivated partially, and sometimes exclusively, by desires for creative self-expression and fame. The modern world stimulates literary production by giving talented authors appropriate outlets and some means of supporting themselves.

Money does not corrupt authors who seek creative self-expression. Production of a great work must start with the burning desire to write one. Writers who give up such desires lightly probably never had a great work in them to begin with. Money therefore tends to corrupt only those who place a low value on the non-monetary returns to creative production. Seen in this context, capitalist wealth is a means

whereby creative drives can be indulged and nourished. The publisher's advance and alternate sources of support, such as foundations, universities, and part-time jobs, increase the artistic independence of the writer. Other times, creative artists may write pulp for money to fund their attempts to produce masterworks, as did Raymond Chandler. Money did not corrupt Joyce, Mann, and Faulkner but rather helped them realize their non-pecuniary ends.

Despite the pressures of commercialization, less accessible writers, such as Claude Simon and Alain Robbe-Grillet, nonetheless find places in our libraries and bookstores. Yet even most "high-brow" readers find these writers well beyond their threshold of interest. Somewhat ironically, artists who do not care much about money have the best chance in a system based on money. The productions of such artists are · luxuries that otherwise cannot be afforded.

Monetary incentives do encourage authors to make their works clearer and more accessible, but this incentive often encourages quality and literary merit. The incentive to entertain does not necessarily conflict with an author's ability to tackle subjects of intellectual depth, subtlety, and quality. The most eminent writers of novels of ideas all succeed in delighting readers and holding their interest; deep philosophic novels do not usually provide an effective message unless the story is well-crafted. Anthony Burgess once wrote: ". . . the creative writer ought to be in Shakespeare's position, purveying what looked like popular fodder but was really more. By trickery, the novelist should seem to be providing a plain story but actually be working in other dimensions, those of symbolism, poetry, philosophy."[4]

Even that crudest of commercial literary forms, serialization through the newspaper, has been a vehicle for enduring classics. Defoe, Balzac, Dumas, Dickens, Conrad, Tolstoy, and Dostoyevsky all have used this outlet, often for their most renowned works. Common readers were thrilled by each serial installment, even though no one told them they were reading masterpieces. The authors, while entertaining a broad audience, penned wide-ranging novels of ideas, psychology, and history. Reaching out to a popular audience has not been at odds with great creativity.

The much-maligned "sequel," a blatantly commercial innovation and a favorite target of modern cultural pessimists, also has been used to great effect. Cervantes, Defoe, and Sterne penned sequels with enthusi-

asm, in each case presupposing a mass audience already familiar with their characters. Sequels need not be spinoffs that retread old ground. They often extend the characters and themes of the initial work. Like many contemporary movie sequels—*Terminator II, The Empire Strikes Back,* and *Aliens*—the second part of *Don Quixote* was better and deeper than the first.[5]

Critics often attack modern literature for using excessive sex and violence to pander to a mass audience. Artistic masterworks, however, usually concern controversial themes. The creative writers of highest stature have dealt with sex (Boccaccio and Joyce), violence (Homer, Dostoyevsky, and Shakespeare), torture (Dante and de Sade), incest (Sophocles, Fielding, Faulkner), bestiality (Ovid), obscenity and scatology (Rabelais), and grotesque monsters (Spenser). The list of writers who have explicitly treated homosexuality is especially long, including Plato, Catullus, Virgil, Michelangelo, Wilde, Verlaine, Rimbaud, Whitman, Proust, Gide, Mann, and many others.

Our contemporary world is replete with widely-read literary masterpieces. America and Canada, two of the most television-bound cultures, have supported Thomas Pynchon, Vladimir Nabokov, John Updike, Norman Mailer, William Styron, Toni Morrison, Anne Tyler, E. L. Doctorow, Wallace Stegner, Bernard Malamud, Saul Bellow, Robertson Davies, Margaret Atwood, and many other notables. The mass media has in many cases helped rather than hurt these writers. Film adaptations, shown both in the theaters and on television, have enriched them and publicized their works to millions.

Japan, now arguably the most commercialized society in the world, is just starting to move into a role of cultural leadership in literature. Yukio Mishima, Yasunari Kawabata, Shisaku Endo, Kobo Abe, and Haruki Murakami have begun to break into Western markets. In the case of the latter two writers, the Japanese popular culture traditions of comic books and science fiction have fed fruitfully into high culture.

Old World creativity has continued as well. John Fowles, Julian Barnes, Peter Ackroyd, Nicholas Mosley, Anthony Burgess, Doris Lessing, and Alasdair Gray have extended and revitalized the British tradition. The Continental novel of ideas remains alive with Michel Tournier, Günter Grass, Patrick Süskind, Georges Perec, Milan Kundera, Isaac Bashevis Singer, Italo Calvino, Umberto Eco, and Peter Hoeg.

Rising standards of living—the result of the growing commercialization of society—have favored literary creativity and diversity around the world. Salman Rushdie's *Midnight's Children* provides a highly imaginative treatment of Indian history. V. S. Naipaul, born in Trinidad of an Indian family, portrays intolerance and barbarism around the world, as exemplified by his *A Bend in the River,* and his travel accounts *A Turn in the South* and *Among the Believers.* Janet Frame and Keri Hulme of New Zealand, and Patrick White and Peter Carey of Australia, have drawn on the aesthetic of their native lands. Wole Soyinka and Ben Okri put Nigeria on the literary map, and Naguib Mahfouz wrote modern Egyptian epics. J. M. Coetzee's anti-apartheid *Waiting for the Barbarians,* along with Nadine Gordimer's works, shows that creativity did not entirely disappear during political repression in South Africa. The modern Latin writers, such as Mario Vargas Llosa, Jorge Luis Borges, Gabriel García Márquez, Julio Cortázar, and Manuel Puig, have led a Spanish-language literary revival based on myth and fantasy. Contemporary literature continues to flourish, contrary to what the philosophy of cultural pessimism would predict.

Most of these highly regarded international authors are now marketed avidly by corporate conglomerates. The large publishing houses, in their search for profit, have become today's strongest and most effective supporters of multiculturalism. They fund translations and heavily promote these works to draw readers' attention.

Many of our century's most innovative fictional concoctions have come in the most commercialized fields, such as genre writing. Many genre writers still await widespread high-brow critical recognition, and have been taken seriously only by the cultural studies movement. Corporate booksellers nonetheless have permitted genre writers to take their case directly to their readers. The mystery, crime, and spy genres illustrate the vitality of commercial writing. John le Carré's novels often reach the best-seller lists. Raymond Chandler supported himself for many years by writing detective stories for "pulp" magazines, refining his talents at the same time. Some contemporary authors have resurrected old or forgotten genres. Charles Palliser's *The Quincunx* takes on the Victorian suspense genre, in the style of Wilkie Collins. Science fiction and fantasy writers, with few models to work from, largely created their own genre in this century.

Today's commercial genre fiction often provides tomorrow's classic. Samuel Richardson's *Pamela* and *Clarissa* were epistolary romances, a genre mocked by his contemporaries, such as Henry Fielding in his *Shamela*. Cervantes's *Don Quixote,* meant to be a satire, became the ultimate example of the genre he satirized, the chivalrous romance. Norman Mailer's *The Executioner's Song,* a crime story about executed killer Gary Gilmore, won the Pulitzer Prize.

Non-fiction genres provide some of the most creative literary achievements of the modern world. Working within tighter constraints—they are supposed to stick to the truth—biographers and historians nonetheless introduce drama, memorable characters, emotional complexity, and brilliant word-smithing. Like the poetry of William Wordsworth, works by science writers such as Stephen Hawking and Richard Dawkins bring out the beauty of creation and nature. Literature is no longer restricted to a narrowly defined concept of fiction.

The astonishing variety of books available in the modern age has been accompanied by a dramatic increase in reading. Literacy stands at an all-time high and continues to increase. Between 1970 and 1990, the measured world literacy rate for adults rose from 61.5 percent to 73.5 percent. Reading has increased in each of the world's major regions. Even in industrialized countries the literacy rate has increased from 93.8 percent to 96.7 percent over this period. Although America's minority of illiterates and its poor school system remain pressing issues, American illiteracy was far worse one hundred years ago and even as recently as the middle of this century. The wealthiest and most commercial countries are, by and large, also the most literate.[6]

In America per capita book sales have increased steadily with technological progress and economic growth. In 1947 the average American bought a little over three books; in 1989, slightly more than eight. Since the late 1940s, the number of bookstores has jumped nearly tenfold, and their average size has increased. Book sales and publishing have grown throughout the 1990s, as innovative book superstores have made book shopping fun and increased the menu of choice. Increasing wealth directs individual attention to goods that will make their lives interesting and stimulating.[7]

Books were prohibitively expensive in the so-called "good old days." In colonial America, in 1760, a cheap schoolbook cost twice as

much as a good pair of leather shoes; Smollett's *Complete History of England* cost as much as eighty pairs of shoes, six head of cattle, or thirty hogs. An ordinary laborer had to work two days to earn enough money to buy the cheap schoolbook, or 144 days to buy the Smollett. The modern innovations of mass production and marketing have brought down the cost of a paperback to only slightly more than the American minimum wage.[8]

In contrast with current times of relative plenty, earlier eras in American bookselling were no consumer paradise. A landmark survey of the book trade undertaken in 1931 showed that America had only 500 legitimate bookstores and that two-thirds of America's counties had no bookstores at all. Most Americans bought books at poorly stocked drugstores and department stores. The institutions that have been criticized by the cultural pessimists—the paperback, the book club, the chain bookstore, and now the superstore—helped end this earlier drought.[9]

Contrary to popular expectation, television and electronic media have not brought about the death of the book. The printed word offers unique modes of storytelling and analysis that other media have not replaced. The Internet is supporting the written word by allowing text to be called up on command and by easing self-publishing. More generally, falling costs of electronic communication bring us into contact with a larger and more diverse set of reading recommendations and make the purchase of books even simpler. Contemporary cultural pessimists frequently claim that a "culture of visual images" is displacing the older, supposedly outmoded "culture of print." How many more book superstores must open before this pronouncement loses credibility?

The Blockbuster Complex

Contemporary literary pessimists focus on the so-called "blockbuster complex." If only a few books sell large numbers of copies, primarily through marketing and mass media support, financial support for literature may in fact be highly centralized. Rather than a patron or king, the homogeneous taste of the masses would serve as the arbiter of fame, riches, and access to readers. Large corporate publishers, working through the media, supposedly create a few large blockbusters at the

expense of diversity and quality. Mass media advertising, bookstore chains, and megabuck contracts for star authors supposedly give best-sellers an undeserved advantage over other titles.[10]

The blockbuster critique predates mass media and originates in the work of Alexis de Tocqueville. Tocqueville's *Democracy in America* (1835–1840) portrayed America as a country where cultural producers strove to meet the needs of the many at the expense of quality. In his view a free, democratic society would not support a sophisticated elite that could elevate cultural achievement. Q. D. Leavis, a later cultural pessimist, applied the blockbuster complex critique to fiction in her *Fiction and the Reading Public* (1932). According to Leavis, the quality of writing declined in the late eighteenth century with the widespread advent of the circulating library. Libraries made novels available to the masses and corrupted the incentives of the writer. Fiction was saved (temporarily) only because most writers were too incompetent to know how to write for a mass audience. Leavis wrote approvingly: "What saved the lower middle-class public for some time from a drug addiction to fiction was the simple fact of the exorbitant price of novels." In more recent times Robert Frank and Philip Cook have applied the blockbuster critique to cultural markets in their book *The Winner-Take-All Society*.[11]

Even from an optimistic perspective, the modern version of the blockbuster critique does point out matters of real concern. Media expenditures make producing best-sellers a relatively capital-intensive endeavor. Best-sellers therefore have moved closer to mainstream taste in order to recoup these high capital costs. Popular writers will tend to account for a higher relative share of the market. Of the fifteen best-selling books of the 1980s, twelve were written by either Stephen King, Danielle Steel, or Tom Clancy. The importance of marketing even has pulled the best-seller list away from traditional authors and towards media celebrities. A significant percentage of 1990s best-sellers have won their initial recognition through non-literary arenas; these books were written by celebrities or linked to popular movies and television programs. Jerry Seinfeld, Howard Stern, and O. J. Simpson sell many more books than do the winners of the Booker Prize. This trend has accelerated even since the 1980s.[12]

The commercial success of a book, more than ever before, depends upon the reception the book receives in its first few weeks. The

computerized inventory systems used by most bookstores shorten the "make or break" period for books. Retailers track which books do not sell quickly and return them to the publisher. As a result, books that receive little advance publicity face a growing disadvantage relative to books that are intensely promoted. Books that are easy to sell and that will take off quickly are not necessarily correlated with literary quality.

Despite these trends, authors who write marginal, niche, and non-mainstream books have not suffered in absolute terms. Today's world supports more and better bookstores with greater diversity of selection. The book superstore is the fastest growing segment of the book market. These superstores compete first and foremost on the basis of diversity and selection. A typical store stocks more than one hundred thousand titles, including scholarly philosophy, literary criticism, anthropology, and classics, as well as cookbooks, romances, and mysteries. And if it's not on the shelves, they will order it.

Superstores support an amazing number and variety of titles. On one visit to Borders I was surprised to discover that they even carried a book of mine—*Public Goods and Market Failures*. This work is an esoteric academic tract put out by a small publisher, and has sold relatively few copies. The book was reviewed in professional journals only. The superstores have provided a boon for the small, independent presses.[13]

The increasing diversity of the book market has followed, and has been partly funded by, the increasing popularity of best-sellers. Growing wealth and retail sophistication allow contemporary bookstores to carry both best-sellers and niche books. The niche books attract buyers who then might buy the best-seller at Borders rather than at a smaller store. The impressive array of best-sellers brings readers to Borders and induces them to look at a wider variety of literature. Superstores illustrate the market complementarity between mainstream and niche books.

When viewed in historical terms, literary and social commercialization have increased cultural diversity and decentralization. Reading and publishing have been moving away from the blockbuster concept for centuries. In the late sixteenth and early seventeenth centuries, English reading was dominated by a single book—John Foxe's *Book of Martyrs*. The *Book of Martyrs* circulated actively for at least one hundred and twenty years and outsold all English language books except the Bible. Filled with stories of gory violence and painful torture, Foxe's

work dominated the market. Another blockbuster was John Bunyan's *The Pilgrim's Progress,* published in 1678. By 1792 Bunyan's work had seen 160 editions and had circulated in England and America almost as widely as the Bible. *De Imitatione Christi* by Thomas à Kempis, *Robinson Crusoe* by Daniel Defoe, and Oliver Goldsmith's *The Vicar of Wakefield* provide other examples of books that dominated the book market for long periods of time. The Bible itself was the ultimate blockbuster of earlier ages. No such parallels can be found today, where many books receive large amounts of attention. Intense competition for reader attention and the greater diversity of reading taste prevent such market monopolization.[14]

The centralizing influence of television on literary diversity has been much exaggerated. Like most forms of art, television does not respond passively to consumer desires, but can influence tastes through programming and presentation. Phil Donahue's sway over his audience boosts Judith Krantz (although Oprah Winfrey promotes many serious writers). Yet at the same time that television "brainwashes" some of us, it makes clear to others where their real tastes lie. Potential fans of Umberto Eco's books will discover them by other means than television. Because the channel can be changed or the set turned off, the media can homogenize our tastes to a very limited degree. Surveys indicate that only one-fourth of American readers allow their book selections to be influenced by television. I have never met a critic who thought that the media biased his or her tastes; their *readers* are, in their minds, always the objects of effective media persuasion.[15]

Quality books find their appropriate audiences even when they are not highlighted on TV talk shows. Curious readers hunting for stimulation need not watch Judith Krantz on television. Instead they buy the *Times Literary Supplement, The New York Review of Books,* or numerous other periodicals that review new releases. Browsing in bookstores increases the fun and ease of discovering new books. Literary criticism, now published and distributed widely, helps us discover works from the past.

The influence of television itself supports forces that counteract the blockbuster effect. To the extent that television becomes a centralized and homogeneous medium, other media tend to become more specialized. Television supplanted many of the mass circulation magazines (e.g., *Look, Saturday Evening Post, American, Collier's,* and the pre-

vious incarnation of *Life*) while special interest magazines, including literary magazines, have flourished. Computer desktop publishing has helped small-circulation fanzines to proliferate in great numbers. The Internet provides the ultimate in freedom of entry and decentralized "publishing."[16]

The critical question is not whether television helps Judith Krantz earn more than Umberto Eco. Rather, does television, and other means of blockbuster selling, hurt Eco's sales or literary reputation? Eco made the best-seller lists and later even benefited from television advertising. The movie version of *The Name of the Rose,* promoted and later shown on TV, attracted many readers to the novel. Eco subsequently used his earnings to pursue additional projects of his choosing.

Great literature often flourishes when lower-quality best-sellers top the charts. We identify the eighteenth-century English novel with Henry Fielding, Samuel Richardson, and Laurence Sterne. Yet the best-selling names of Edward Kimber, Henry MacKenzie, Richard Sheridan, and Richard Cumberland were at least as well known in their day. Most people did not even read these low-brow authors. They preferred chapbooks, handbills, almanacs, street notices, and broadsides—the popular "street literature" of the day. We should not idolize earlier ages as a time when the common man heard only Shakespeare, read only Byron, and listened only to Beethoven. Masterpieces usually arise in a climate full of pulp and trash. William Wordsworth wrote of the error that lies in "forgetting, [in light of] the excellence of what remains, the large overbalance of worthlessness that has been swept away."[17]

The split of "high" literature and "low," or popular, literature occurred only when the growth of the market supported high levels of diversity. Before the advent of printing, only the very wealthy or politically connected could afford to hire book copyists or could benefit from their services. Popular taste in books simply did not exist: reading was the province of the wealthy and the clergy. As printing and economic progress have lowered the costs of reading, the novel that appealed to the crowd became possible. Reproducibility, by lowering costs of production and reproduction, fostered diversity of many kinds, including the trashy best-seller.

In artistic fields where reproducibility is more difficult, such as theater productions or large-scale sculpture, we see a weaker split be-

tween high and low culture. Large-scale sculpture is sold primarily to governments and large corporations, and rarely to the middle class or even to the rich. The difficulty of reproduction increases per unit cost, which limits the stratum of low culture in this genre. Theater has moved from being a common cultural event for all classes (as with the Greeks or in Shakespeare's England) to being a relatively elitist form of entertainment. Movies, with their greater ease of reproducibility and more flexible technical possibilities, captured the bulk of the former theatergoers and left live performance to the relatively wealthy.

The weaker high culture/low culture split in sculpture and theater reflects the expense and partial competitive failure of these forms, not their aesthetic virtues. The book market demonstrates a high/low culture split precisely because it has been successful in lowering costs and reaching large numbers of readers. Danielle Steel and Sidney Sheldon are symptoms of the riches we enjoy.

Literary Optimism

Opposition to literary commercialization, usually combined with cultural pessimism, has been common since the invention of the printing press. Each new development in the craft—the book, the printing press, the profession of authorship, the novel, the newspaper serialization, the contemporary mass-market paperback best-seller, and the chain bookstore—has been said to signal impending declines in literary quality. Not all writers, however, have held these pessimistic attitudes. Some have celebrated the meeting of minds that occurs when books are published, sold, and read.

The first systematic defense of the book, combined with a statement of literary optimism, dates from 1345. In this year Richard de Bury produced his extraordinary *Philobiblon*. De Bury (1287–1345) was a monk and parliamentarian born in Suffolk who studied at Oxford. He later advanced through the government ranks, taking high-ranking jobs as an administrator and ambassador. One of the greatest collectors and lovers of books, he stuffed so many books in his rooms that there was little space to move, his contemporaries claimed. De Bury kept a staff of copyists and illuminators in his house, and had books read to him during his meals. *Philobiblon* was completed shortly before his death.[18]

Philobiblon ("love of books") stands as an eloquent paean to the joys and virtues of the book. For de Bury, books were an "infinite treasure" that contained and disseminated the wisdom of the ages—"In books we climb mountains and scan the deepest gulfs of the abyss . . ." He preferred books of learning to books of law, because the latter were used to promote conflict rather than knowledge. Peace, he claimed, is the greatest friend of the book, and war, which destroys libraries, is the strongest enemy of learning.[19]

De Bury did not wish to restrict book production to copying the works of the ancients. He praised the writing of his day and hoped for many skillful new authors. Unlike most clerics, de Bury defended secular poetry and literature against their detractors. He wrote in an age when the chief power in society, the Catholic church, saw secular books as a threat to its intellectual and cultural stranglehold. Complaining of the cost and unreliability of copyists, de Bury hoped for a future of writing and book copying without limit.[20]

De Bury's wish did eventually come to pass. Circa 1440, Johann Gutenberg of Mainz applied his commercial skills of stone cutting, metal working, and mirror polishing to the technology of printing. Gutenberg, like many other early printers, had a background in the goldsmith trade. The skills of goldsmithing gave him proficiency in valuable metalworking techniques of engraving and casting. In 1457 Gutenberg printed a *Psalter,* the first dated printed book in Western history.[21]

Gutenberg and most other early printers were businessmen intent on making profits, and they viewed books as a lucrative form of commercial merchandise. From the very beginning, publishing was a capitalist enterprise driven by consumer demand and marketing considerations. Even publications of the classics of Greek and Roman literature, as directed by the firm of Aldus Manutius of Venice, were for profit. The very strength of these profit-seeking motivations accounts for the profound impact that print culture had on the Renaissance and Reformation.[22]

The late Renaissance humanists viewed printing as a wondrous invention of the human spirit. Rabelais, in Gargantua's letter to Pantagruel, argued that because of printing, "All the world is full of knowing men, of most learned Schoolmasters, and vast Libraries . . ." Education and learning are more widespread than in the days of antiq-

uity, and individuals such as "robbers, hangmen, free-booters" are now more learned than the "Doctors and Preachers" of earlier ages.[23]

Cultural optimism and the defense of the printing press went hand in hand. Participants in the seventeenth-century "Battle of the Books" debated whether the achievements of the moderns were comparable to those of the ancients, and whether the world was subject to inevitable decay. The optimists, such as William Wotton, claimed: "The Benefit of *Printing* has been so vast, that everything else wherein the Moderns have pretended to excell the Ancients, is almost entirely owing to it . . ." Printing encouraged the circulation and duplication of books, made books easier to read, made indices possible, eliminated mistakes in transcription, and allowed books to be advertised.[24]

Charles Perrault's late seventeenth-century versions of folk tales— "Mother Goose," "Little Red Riding Hood," "Cinderella," and "Sleeping Beauty"—served as a broadside in these debates. Perrault defended cultural optimism and printing with enthusiasm. By writing his fairy tales, he hoped to show that modernity could match such ancient achievements as *Aesop's Fables*. Perrault's writings combined two potentially conflicting beliefs: a strong belief in the virtues of modern civil society and a desire to promote the reign of Louis XIV as beneficial to France.[25]

Many cultural pessimists attacked publishing in the early days of the printing press. The Dominican friar Filippo di Strata, expressed his stringent opposition to books, a typical view among the clergy in the late fifteenth century. Fra Filippo noted that Venice was now so full of books that it was impossible to walk down the street without having armfuls of them thrust at you "like cats in a bag." These books were "incorrect," drove valuable copied manuscripts out of the market, and tempted the uneducated into thinking themselves learned. But worst of all, books spread immoral ideas. The world had got along for thousands of years without books and did not need them now. A statement of the time was, "The pen a virgin, the printing press a whore."[26]

The optimists, however, had their way. Printing encouraged the Protestant Reformation through the widespread circulation of individual Bibles, favored the scientific revolution by lowering the costs of communication, weakened the power of traditional authority by decentralizing the production of ideas, and enabled the works of antiquity

to be disseminated. The intensity of competition among ideas has continued to rise since that time.[27]

The print revolution was slow to take off, and access to the printed word remained extremely limited for decades after the invention of printing. Most of the European population could not read, and in the absence of a large printed literature, had little incentive to learn how to read. National languages (such as High German or French) had not yet been standardized and most individuals spoke a regional dialect as their first language. Three-quarters of all material printed before 1500 was in Latin, primarily because most literate individuals in Europe read Latin. Yet the widespread use of Latin in printed material limited the incentive to learn a national vernacular language.

Over time, the printing revolution came to fruition. Latin works were translated into the vernacular on a widespread basis. The increased use of spectacles extended reading capabilities, and prosperity expanded leisure time and thus the time spent with books. Writing itself became less arduous with the replacement of parchment by paper and with the introduction of better writing implements. Languages were standardized, often by printers themselves, and then taught in schools, in churches, or by personal instruction.[28]

The commercial cities of Italy, central Germany, and the Low Countries took the strongest interest in becoming literate. These areas had the material resources necessary to support widespread education. Furthermore, businessmen and traders found that the ability to read and write was essential for writing contracts and conducting advanced commercial activity. Literacy therefore became more common.

The size of the reading population grew slowly but steadily. Books began to fall within the price range of individuals who could not afford expensive copyists. Authors, who could now appeal to different segments of the reading population, were no longer restricted to writing for the wealthy or for the church establishment. In medieval times libraries were primarily monastic and filled with religious works. By 1600, a typical private library ranged across history, geography, and the classics, as well as religious tracts.[29]

For the most part literature remained bound to the private patron, but authors enjoyed public recognition and began to write for a general readership. Cervantes, for instance, successfully marketed *Don Quixote* to a mass audience. The work was immediately beloved by many read-

ers. Cervantes failed to achieve riches only because Spain had no copyright law. Other publishers duplicated his works without paying him any compensation. Such an absence of copyright protection, not rectified until the eighteenth and nineteenth centuries, kept authors from receiving higher financial rewards.[30]

The Literary Revolution and the Rise of Print Culture

Literary commercialization arrived later than the commercialization of painting and sculpture. A single copy of a good book is usually worth less than a single good painting. With a smaller per unit value, writers must sell a larger number of copies to support themselves. Painters could sell to a middling number of wealthy individuals, but the commercialization of literature required the rise of a numerous and literate middle class with spare time for reading.

The market for literature first blossomed on a large scale in eighteenth-century England. The Industrial Revolution also brought a literary revolution. The publisher, bookseller, and the public subscription replaced the patron as the primary means of income for authors. As works of literature became widely available through booksellers and circulating libraries, professional authors wrote for a public audience. Individuals bought more books just as they were buying more tea, sugar, fabrics, soap, candles, pottery, Wedgwood ceramics, buttons, buckles, and cutlery.[31]

Books began to displace theater as the dominant medium for literary invention. Even as late as the time of Shakespeare (1564–1616), most plays were not printed for widespread public sale. Shakespeare earned a good living as an actor and later as a playwright, but he made no attempt to market his works in written form. In the last few decades of the seventeenth century, many of England's most accomplished writers—such as Dryden, Wycherly, Otway, Behn, and Congreve—wrote for the theater. The next generation—Addison, Steele, Pope, Swift, and Defoe—eschewed live performance and focused on publication. Although eighteenth-century theater remained vital, it was integrated into the publishing market. Publishers started to acquire the rights to publish plays even before the plays were performed. They sold

the plays to meet the surge in public demand that accompanied the play's opening or success.[32]

The market turned in favor of the printed word when the middle classes, the merchant classes, and women joined upper class males and nobles in the book market. By the middle of the eighteenth century, two-thirds of the English male population and one-third of the English female population were literate. Edmund Burke estimated the active reading audience in England in 1790 at some 80,000 persons. This sufficed to support a number of professional authors.[33]

English law helped writers with a relatively effective system of copyright protection. While pirate editions were common, the author nonetheless held a legal right to royalties from subsequent editions of his or her creation. By selling this right to the publisher, a good author could receive sustenance from his or her craft. Some writers, like the historian Edward Gibbon, held on to their copyrights, accepting the risk of lower returns for the chance of greater profit.[34]

Literary production advanced on many fronts. Periodicals flourished and published the leading writers of the day. Book reviews started to cover literature and to give the public a systematic means of gleaning information about new publications. Translated imports from other countries broke into the English market in large numbers in the 1760s. French sentimental novels, especially Rousseau's *Héloïse,* led this trend. On the export side of the market, Shakespeare, Addison, Ossian, Pope, Richardson, Sterne, Swift, and others were translated and sold in an increasingly European literary market. Whereas only a few new novels were published annually in 1700, over ninety new novels appeared each year by 1800. By that time novels, essays, and newspaper serials had replaced the theater as the primary medium for literary expression and social debate.[35]

Libraries and book clubs gave books and periodicals a larger readership than sales figures alone would indicate. Privately-owned libraries, run for profit, facilitated access to literature. By the end of the eighteenth century, about 1,000 such libraries were operating in England, and they accounted for over half of the copies purchased for most books. Typically any town of 2000 inhabitants or more was capable of supporting a reasonably well-stocked public library. In addition to lending out books, the libraries often sold hats, teas, perfumes, medicines, and tobacco to draw in customers, just as today's book super-

stores typically have coffee bars. Avid readers also joined book clubs, which at that time consisted of individuals who bought and then shared the newest books in print.[36]

In the latter part of the eighteenth century even the lower middle class began to enter the reading market. One contemporary bookseller estimated that the sale of books had increased fourfold from the 1770s to the 1790s. He wrote:[37]

> The poorer sort of farmers, and even the poor country people in general, who before that period spent their winter evenings in relating stories of witches, ghosts, hobgoblins, etc., now shorten the winter nights by hearing their sons and daughters read tales, romances, etc., and on entering their houses, you may see *Tom Jones, Roderick Random,* and other entertaining books, stuck up in their bacon-racks . . . In short, all ranks and degrees now READ.

The growing book market encouraged authors to appeal to the bourgeois reading public. Most of the renowned English writers of this era, such as Samuel Johnson, Oliver Goldsmith, Henry Fielding, Laurence Sterne, and Daniel Defoe aimed their works at a wide audience. Samuel Richardson, the father of the English novel, targeted the growing market of female readers with *Pamela* and *Clarissa.*

Literature became more fervent and more diverse. Robert Darnton refers to the "epidemic of emotion" that was set off by the works of Rousseau in France, Richardson in England, and Lessing and Goethe in Germany. Nascent capitalism and consumerism turned letters in a more vivid and Romantic direction, extending into excess in the eyes of many literary pessimists. We now think of these works as high culture, but at the time they were seen as representing culture's corruption at the hands of popular sentiment.[38]

Women broke into the writing market in the early to mid eighteenth century. Eliza Haywood, Mary de la Rivière Manley, Charlotte Lennox, Charlotte Smith, Ann Radcliffe, Elizabeth Inchbald, Frances Brooke, Sarah Fielding, and Fanny Burney profitably sold their works to a wide readership. By the 1790s the woman writer was well established.

The decline of the patronage system gave women writers their foothold. Men, who held superior political and social connections, had received nearly all of the patronage support. Women writers could compete on an equal footing only when readers were the primary

source of income. The privately-run circulating library, which ordered novels for a largely female readership, was their biggest market. Women writers received a further boost from an expanding economy. Growing wealth increased leisure time and liberated middle-class women from burdensome household chores. Bread, beer, candles, and soap could now be purchased in shops. Women put their extra time to good use, often writing to supplement the family budget or, in some cases, to support their fatherless children.[39]

The opening of the market paved the way for the female stars of English literature. Jane Austen, Charlotte and Emily Brontë, George Eliot, and Mary Shelley continued the trend that had started in the previous century. Half of the English novelists published in the nineteenth century were female. In this era, writing became not only a feasible career for women, but also increased in social acceptability.[40]

Despite these advances, polemics against books continued to circulate. In the eighteenth century the novel had become a special target. Cultural pessimists accused novels of preventing readers from thinking, preaching disobedience to parents (note the contradictory charges), undermining women's sense of subservience, breaking down class distinctions, and producing a variety of medical maladies. Boarding schools were commonly attacked for encouraging the dangerous habit of novel-reading. One critic noted, "It has been well observed, that the reading of novels is to the mind, what *dram-drinking* is to the body." Even as late as 1795 we can find the charge, leveled against most cultural innovations, that reading is bad for one's health. One writer attributed to excessive reading a list of seventeen ailments, including heat rashes, indigestion, blocking of the bowels, epilepsy, and melancholy.[41]

Libraries, especially privately-run circulating libraries, were another target. Edward Mangin remarked in 1808: "There is scarcely a street of the metropolis, or a village in the country, in which a circulating library may not be found: nor is there a corner of the empire, where the English language is understood, that has not suffered from the effects of this institution."[42]

Samuel Johnson as Defender of Print Culture

Samuel Johnson's defense of capitalist publishing provided an intellectual underpinning for the British literary revolution. Johnson, one of

the first professional writers supported by a public readership, penned poetry, essays, and criticism. His *Dictionary of the English Language* (1755) was the first systematic work of its kind in English and his *Lives of the English Poets* remains a landmark of criticism. Johnson's wit, humanity, moral sincerity, and insight continue to touch readers today. Although physically weak and blind in one eye from early childhood, Johnson rose to prominence through his writing and through his irrepressible conversation.[43]

James Boswell, in his *Life of Johnson,* wittily detailed the conversations of Johnson and his circle on the business of publishing, the profession of authorship, fame and profit incentives, and human nature in general. Johnson's circle brought together a remarkable assemblage of individuals; active members included Edmund Burke, Adam Smith, Edward Gibbon, Joshua Reynolds, Oliver Goldsmith, playwright Richard Sheridan, actor and producer David Garrick, leading politicians Charles James Fox and William Windham, and John Hawkins and Charles Burney, the two seminal English-language music historians, as well as Boswell himself.[44]

Boswell's *Life of Johnson,* relying heavily on dinner-table dialogue and Johnson's conversations, is closer to a collaboration than to a traditional biography. Boswell writing about Johnson is far greater than Boswell writing about others, even the talented Rousseau or Hume. Combined with Boswell's skillful presentation, Johnson's conversation dwarfs the other characters of the book and indeed the character of Boswell himself. Boswell, the ultimate egomaniac in his private journals, knew that he had met his conversational match. He decided that he could best Johnson only by writing about him, one of the few literary topics that Johnson did not wish to cover himself.

Johnson argued that the reading public is a superior source of support to private patronage. He recognized that patrons supported literary production (see his *Lives of the English Poets*), but he objected when authors had to submit to the patron's judgment. A patron is better than no patron, but the market, which decentralizes financial support, is best of all.[45]

In his *Dictionary* Johnson exercised his literary license and defined a patron as, "commonly, a wretch who supports with insolence, and is paid with flattery." Johnson himself eschewed patrons and boasted, "No man who ever lived by literature, has lived more independently

than I have done." In his famous letter to Lord Chesterfield, a would-be patron of Johnson's, he rejected Chesterfield's assistance, comparing a patron to "one who looks with unconcern on a man struggling for life in the water, and, when he has reached ground, encumbers him with help."[46]

Johnson held that literary commercialization decentralized the production and sale of knowledge and strengthened the link between writers and their audiences. Commercial sale intensifies the competition among different ideas and opinions, with readers as the ultimate arbiters of quality. Boswell, in his *Journal of a Tour to the Hebrides,* reproduced the following debate:[47]

> Dr. Watson observed, that Glasgow University had fewer home-students, since trade increased, as learning was rather incompatible with it. —Johnson. "Why, sir, as trade is now carried on by subordinate hands, men in trade have as much leisure as others; and now learning itself is a trade. A man goes to a bookseller, and gets what he can. We have done with patronage. In the infancy of learning, we find some great man praised for it. This diffused it among others. When it becomes general, an author leaves the great, and applies to the multitude." —Boswell. "It is a shame that authors are not now better patronized." —Johnson. "No, sir. If learning cannot support a man, if he must sit with his hands across till somebody feeds him, it is as to him a bad thing, and it is better as it is. With patronage, what flattery! what falsehood! While a man is in equilibrio, he throws truth among the multitude, and lets them take it as they please: in patronage, he must say what pleases his patron, and it is an equal chance whether that be truth or falsehood." —Watson. "But is not the case now, that, instead of flattering one person, we flatter the age?" —Johnson. "No, sir. The world always lets a man tell what he thinks, his own way."

Johnson defended the market as the system most favorable for men of genius. Commerce frees men of the mind from both the patron and from the burdens of material production. Although merchants and traders were not generally men of "enlarged minds," a market economy allows intellectuals to make their learning into a livelihood. These arguments echoed the views of Adam Ferguson, a Scottish social scientist of Johnson's time. Ferguson wrote that the increasing division of

labor in commercial society spurs literary production and specialization. Adam Smith opined that prose and poetry follow naturally from the growth of commerce. Prose is the language of business, and poetry is a language of ornamentation made possible by prosperity.[48]

Johnson's stance on printing and literary commercialization led him to disparage the creative powers of the older traditional oral culture. He argued, for instance, that the Erse language of Scotland remained primitive for lack of an extensive written tradition. Johnson claimed:

> When a language begins to teem with books, it is tending to re-
> finement . . . [D]ifferent modes and phrases are compared, and the
> best obtains an establishment. By degrees one age improves upon
> another. Exactness is first obtained, and afterwards elegance. But
> diction, merely vocal, is always in its childhood. As no man leaves
> his eloquence behind him, the new generations have all to learn.
> There may possibly be books without a polished language, but
> there can be no polished language without books.

This skeptical attitude towards oral culture accounts for why Johnson doubted the authenticity of Macpherson's Ossian texts, a collection of supposedly ancient poems. In his view, oral culture could not have created works so lengthy and well-developed. Johnson even argued that the citizens of ancient Greece and Rome were barbarians because they had neither newspapers nor printing. He had tired of hearing the cultural pessimists glorify these societies excessively.[49]

Consistent with his defense of commercialization, Johnson approved of the soft-covered book, today called the paperback. Paperbacks made the printed word affordable to the masses and encouraged reading. Johnson even defended the popular "street literature" of his day as a means of spreading knowledge and stimulating public debate. Taking a highly modern tack, he urged the preservation and study of such literature as material of historic interest.[50]

Johnson's choice of projects reflected his fervor for print culture. His *Dictionary* was intended as a broadside against the older and more primitive oral tradition. The *Dictionary* used formality, codification, and categorization to elevate written culture above the ranks of the more informal folk tradition of oral culture. Johnson went on a reading blitz

and collated the various uses of words in the English language, turning these notes into systematic definitions.[51]

France and Italy had already produced dictionaries by using centralized government academies staffed with large numbers of scholars. Johnson's *Dictionary* was sponsored by a consortium of private booksellers. Johnson had a single room and only meager assistance, but finished his monumental work in nine years. Twenty years were needed by the Italian academy, and fifty-nine years were needed by the forty laborers working in the French academy.[52]

Before Johnson, English dictionaries had been lackadaisical in their definitions. A typical definition of "horse" was "a beast well known." Johnson rectified this sloppiness. His dictionary remains renowned for its accuracy and has formed an indispensable base for all English-language dictionaries since.[53]

The story behind Johnson's *Lives of the English Poets* illustrates how much markets had changed the world of literature. Johnson's *Lives,* a seminal work of literary criticism, was written for profitable sale to a public readership. The idea of Johnson's *Lives* had arisen from a conversation with the King of England. The King was speaking with Johnson in the royal library and instructed him to write "the literary biography of this country." Johnson let the project sit for ten years. He started the work only when a commission from the private sector paid for his efforts. Commercial sponsorship from thirty-six booksellers succeeded where the King had failed.[54]

Johnson's work attempted to do for English letters what Giorgio Vasari had done for Italian art. Johnson, with his commercial commissions, had the liberty of presenting his own views. Vasari pandered to his funders and patrons, the Medici family, as will be discussed in the next chapter.

Johnson later lost his credibility as a spokesman for literary laissez-faire. In 1762 he accepted a permanent pension of three hundred pounds a year from the English government. Johnson's *Dictionary* had defined a pension as "An allowance made to anyone without an equivalent. In England it is generally understood to mean pay given to a state hireling for treason to his country." According to Boswell, Johnson defended his acceptance of the pension on the grounds that he had never courted it, that it was given to him unconditionally, and that it was given to him by a government he had criticized. Johnson was in an

awkward position, however, when the government asked him to write political pamphlets on its behalf. He refused, but some of his later writings, such as *Taxation no Tyranny,* did strongly support the English government, and we cannot help but wonder if financial pressure had been exerted.[55]

The Critical Barbs of Jonathan Swift

Johnson's defense of a free literary market stood virtually alone. Writers, poets, and essayists all criticized the growing commercialization of literature and society. Jonathan Swift, the wittiest and sharpest literary pessimist, led the charge. His classic satire *Gulliver's Travels,* a biting critique of human progress, remains perhaps the most entertaining and imaginative statement of cultural pessimism.

The tales center around Gulliver, a sailor who loses his way and in his travels encounters a variety of curious societies. By contrasting contemporary life with other civilizations, Swift ridiculed the customs, mores, politics, and religion of his day. The world is portrayed as crude and barbaric precisely because it is modern. Swift questioned whether human civilization was a worthwhile project.

Printing and writing were two of Swift's favorite targets. The most civilized societies in *Gulliver's Travels,* the Brobdingnagians and the Houyhnhnms, have little use for print. The Brobdingnagians, the race of giants, have no library that exceeds one thousand volumes. The Houyhnhnms, the intelligent horses, have no books at all. Oral reasoning and debate determine all action. As a substitute for literature, the Houyhnhnms excel in oral poetry. This supremely civilized society also has no money, no material scarcity, and no profit.[56]

The society obsessed with the craft of printing, Lagado, is depicted as foolish and irresponsible. The inhabitants had recently invented a printing machine intended to generate knowledge. With a tone of evident disdain, Swift described how this machine was programmed to use words and write books. It spewed out sentences with the correct grammatical format and the correct proportion of nouns to verbs. But the machine only generated volumes of broken sentences. The apologetic printer noted that these books might be made useful if only a public subsidy could be raised to supervise their collation and correction.[57]

Swift's portrayal of Lagado also satirized how materialism corrupts language. Discourse in Lagado was conducted with material objects rather than with words, which were abolished. Rather than speaking, an individual held up the appropriate thing for the word he wished to use. In this dystopia, the ability to speak is directly proportional to one's material endowment; all speech must first be earned in the marketplace. Swift offered a *reductio ad absurdum* of a world where profit drives what is printed and what is spoken.[58]

Consistent with his satire in *Gulliver's Travels,* Swift was a confirmed cultural pessimist. He argued in his *Tale of a Tub* that the achievements of modernity could never match those of antiquity. Swift's pamphlet was one of the best-known polemics in this "Battle of the Books," but *Gulliver's Travels* offered a similar message. Not surprisingly, an insightful essay on the broader implications of Swift's *Gulliver's Travels* has been penned by the modern cultural pessimist Allan Bloom. Bloom's essay, found in his *Giants and Dwarfs,* is a model of clarity and insight.

Swift's political beliefs were consistent with his cultural pessimism. He favored a strong state church and an authoritarian government run by a hereditary landed oligarchy. He was sharply critical of liberal Whig republicanism, the financial revolution, and stock markets. This curmudgeonly attitude extended also to the English language. Swift favored establishment of a government academy that would slow down linguistic evolution and fix the character of the language.[59]

Preston Sturges Replies to Swift

Much later, one of Hollywood's cultural optimists offered another reply to Swift. Movie director Preston Sturges defended artistic commercialization and the future of art in his film *Sullivan's Travels* (1941). This optimistic film is replete with references to *Gulliver's Travels* but offers a contrary message.[60]

Sturges portrays a famous movie director, Sullivan, who undertakes a series of adventures to discover the meaning of art. As in Swift's book, the protagonist goes on four travels. The last travel (the Houyhnhnms for Swift) delivers the instructive lesson to the protagonist.

Sturges's director Sullivan starts by setting out to live among the poor. Disillusioned with the low-brow nature of his films, he wishes to

make a movie with social meaning. Sullivan intermingles with the poor in various guises but finds that he cannot escape his fame and his wealth. During his last travel, Sullivan comes down with temporary amnesia and is unjustly convicted of murder. He is sentenced to a southern prison work-camp, finally achieving the new identity that he had so desperately sought.

Sullivan's revelation comes when the prisoners are brought to a black church to watch a movie with the parishioners. The director observes the heart-rending condition of the poor, but also discovers that the poor desire entertainment, not social commentary. They laugh at a cartoon, their faces lighting up with joy. After his eventual rescue, the reborn director proudly proclaims that he will return to making entertaining movies. Sturges stands up for art that entertains, and speaks out for art that yields fame and money.

Contrary to a superficial reading of the film, Sturges does not favor entertainment at the expense of substance; for this, his most entertaining film, contains an extremely effective social commentary. Few films of the Depression era offer a more heart-rending account of poverty, or offer a more profound vision of how a life full of suffering nonetheless has meaning. Sturges produced a message of substance precisely because he was a master of entertainment and of reaching an audience. *Sullivan's Travels* fulfills his wish to become the director he portrayed—making entertaining movies that have a meaningful message as well.

Drawbacks of the Pessimistic View

Samuel Johnson also took a stand against Swift's critique of modernity, defending both humanity and the growth of commercialism. Of Swift he noted that "Wit can stand its ground against Truth only a little while."[61]

The literary pessimists were at their strongest when criticizing the bad effects of commercialization and at their weakest when suggesting alternatives. The pessimists pointed out correctly that the commercialized literary world is far from perfect. Profit incentives are sometimes corrupting, critics are often spiteful, and some great works get lost in the shuffle. Dollars need not respect aesthetic quality. The literary pessimists, however, presented only one side of the picture. They drasti-

71

cally underestimated the benefits of competitive incentives, financial independence for the writer, and decentralized literary production and criticism. The printing press, the bookstore, the book club, and the library, with their relatively small up-front costs, offer authors numerous lucrative outlets for their ideas, and help bring these ideas to readers.

The eighteenth-century cultural pessimists, brilliant as they were, offered no feasible alternative to a competitive market in publishing. Until the growth of literary markets, the market for books was small in scope, controlled by a few wealthy and powerful individuals, and manipulated by political elites. Contrary to the claims of the early pessimists, written works in the age of patronage were not evaluated primarily on their merits. The vision of the disinterested patron who rewarded only virtue is a myth. Few patrons were available, and writers who could not find a sympathetic supporter could not pursue their craft. Most writers, being dependent upon patronage, were either favored servants of the government or sons of wealthy nobles. Women or minority writers had few chances.[62]

Authors in earlier ages largely depended on governments for sustenance. In return, governments expected political support, or in some cases, passive acquiescence. Governments were not interested in subsidizing literary masterworks but in buying a writer's political opinions. Even well into the eighteenth century, political bribery took place. Defoe, Swift, Addison, Steele, Fielding, and Smollett all received money for toeing the party line in their political writings.[63]

The cessation of such bribery partially accounts for the sudden outburst of literary pessimism in England. The Walpole ministry in the 1730s had little interest in the world of letters, and severely limited subsidies to England's most established writers. Walpole chose instead to support hack political writers and politically sympathetic newspapers. Many of England's most talented writers resented being thrown on the market to earn their living, and turned against the new system.[64]

Some of the eighteenth-century pessimists harbored an agenda for cultural control. Joseph Addison, for instance, was a thoroughgoing economic and cultural mercantilist who wished to legislate his own tastes and opinions into power. Like Swift, Addison favored the monopolistic regulation of language through the creation of legal superintendents. In a reversal of modern linguistic trends, these guardians would prevent the importation of French words into English. Addison

also attacked the Italian opera that was so popular in London in his day. Unlike many, he did not object to this artistic import for its commercialism or licentiousness. Instead, he criticized the success of Italian opera relative to the native English product, including his own opera, *Rosamond* (music by Thomas Clayton), which proved a dismal failure in 1707.[65]

Alexander Pope also directed his wrath at Italian opera, historically a favorite target of cultural pessimists. The revised edition of *The Dunciad* objected to the bizarreness and perversity of this artistic form. He cited the "affected airs" and "effeminate sounds" of the product, and he referred to operatic performers as "Harlot forms," "Monkey-mimics," and "Brayers." In a manner similar to today's critics of contemporary popular music, Pope lashed out at what he did not understand. Not surprisingly, cultural optimist Charles Perrault defended opera as superior to the works of the ancients.[66]

Samuel Johnson was well aware of the elitist streak in the cultural pessimists of his day, and took them to task in his *Lives of the English Poets*. Johnson praised Pope's work and poetic sense but criticized his misanthropic view of the world. Johnson asked: "How could he despise those whom he lived by pleasing, and on whom he lived by pleasing, and on whose approbation his esteem of himself was superstructured?" Johnson went even further, arguing that Pope was paranoid and had affected a false contempt of mankind out of spite. Johnson offered his description of the pessimistic world view when he wrote:[67]

> In the Letters both of Swift and Pope there appears such narrowness of mind, as makes them insensible of any excellence that has not some affinity with their own, and confines their esteem and approbation to so small a number, that whoever should form his opinion of the age from their representation, would suppose them to have lived amidst ignorance and barbarity, unable to find among their contemporaries either virtue or intelligence, and persecuted by those that could not understand them.

The publishing history of the pessimists revealed the self-contradictory nature of the pessimists' critiques. They relied on a diverse and well-developed literary market. The seminal pessimistic tracts of Swift, Pope, and Goldsmith—*Gulliver's Travels, The Dunciad,* and *Citizen of the World*—were all commercial successes. The earlier literary eras idealized

by these writers did not generate a comparable level of critical reflection. Nor had authors ever been rewarded so lucratively for their satire.

Alexander Pope was a consummate businessman and earned far more money than Samuel Johnson did. Whereas Greek oral poets recited Homer's *The Iliad* freely for centuries, Pope's translation was sold for profit, costing twenty-five times more than Defoe's *Robinson Crusoe*. He received £5,300 by signing up 575 subscribers at six guineas each and then sold the rights for initial sales for 200 pounds per volume. Pope told his friend Joseph Spence that "What led me into that . . . was purely want of money."[68]

This same Pope, opponent of favoritism and corruption, called William Warburton "the greatest general critic I ever knew." Is it mere coincidence that Warburton defended Pope's work in his writings and had edited Pope's collected works?[69]

The Pessimist Critique: The Difficulty of Achieving Fame

The attack on literary commercialization went well beyond the writings of Swift. Other eighteenth-century authors—Oliver Goldsmith, Alexander Pope, Joseph Addison, and William Warburton—also claimed that cultural decline was inevitable. Cultural pessimism found intellectually coherent roots in rational choice theory for the first time in this era. Whereas modern economists focus on monetary profit as a motivating force, eighteenth-century social scientists placed greater emphasis on the desire for fame and approbation. Early theories of cultural pessimism were first and foremost hypotheses of how fame incentives might misfire.

The pessimists claimed that fame no longer motivates great writers in a commercialized world. The massive proliferation of books makes fame too difficult to achieve. Authors will instead take advantage of their new financial opportunities by writing saleable trash for a short-run profit. In economic terminology, fame incentives give creators a lower discount rate, but pecuniary incentives give them a higher discount rate. Critics worsen these tendencies by flattering the wealthy authors and by seeking to beat down innovative literary upstarts.[70]

Thucydides had written that "My work is not a piece of writing designed to meet the taste of an immediate public, but was done to last

forever." In the eighteenth century, best-selling author Laurence Sterne claimed that "I wrote not to be fed, but to be famous." As the literary market developed, the pessimists believed that these motivations were becoming less and less likely.[71]

Alexander Pope, a leading literary pessimist, criticized those who wrote for profit. Pope's poem *The Dunciad* (first edition 1728) vividly protested against writers who sell out for money. His great enemy is "Dulness" [sic], which he associated with literary mediocrity. The obsession with profit and ephemeral fame was generating large numbers of bad books instead of the lasting works of the ancients. William Warburton, Pope's friend, even argued that the "modern" greats of Shakespeare, Otway (!), and Dryden corrupted their work by writing for the market. They suffered from a "want of Elegance and Correctness."[72]

Oliver Goldsmith feared that fame-seeking would no longer motivate quality production. Competition was simply too stiff. He wrote: "Of all rewards, I grant, the most pleasing to a man of real merit, is fame; but a polite age, of all times, is that in which scarce any share of merit can acquire it . . . Those who came first, while either state as yet was barbarous, carried all the reputation away. Authors, as the age refined, became more numerous, and their numbers destroyed their fame." Goldsmith's travel letters *Citizen of the World* extend this concern; they portrayed a Chinaman who visits London to seek out the famous, but concludes that fame is no longer possible in the modern world. Jonathan Swift joined in the chorus with his satirical "Verses on the Death of Dr. Swift" (1731), which predicted how quickly he would be forgotten only one year after his death. Along similar lines, nineteenth-century publisher Archibald Constable remarked that ". . . if you wish to become a great author your chance will be by-and-by when paper gets cheaper."[73]

David Hume also argued that failing fame incentives will induce literary decline: "If his own nation be already possessed of many models of eloquence, he naturally compares his own juvenile exercises with these; and being sensible of the great disproportion, is discouraged from any farther attempts, and never aims at a rivalship with those authors, whom he so much admires." Furthermore, "when the posts of honour are all occupied, [a writer's] first attempts are but coldly received by the public; being compared to productions, which are both in them-

selves more excellent, and have already the advantage of an established reputation."[74]

Hume believed that Italian paintings brought into England discouraged rather than stimulated English art. The Romans labored under the burden of the Greek past and the Germans were shackled by the power and influence of French culture. Hume was grateful that the writings of the ancients were in languages known only to the learned, so they would not discourage future literary production. He might have worried about Alexander Pope's translation of Homer's *Iliad* and *Odyssey,* and John Dryden's translation of Virgil's *Aeneid;* the writings of previous generations now stood as perpetual competitors for the mantle of merit.[75]

For the pessimists, spiteful critics exacerbated the difficulty of achieving fame. Oliver Goldsmith believed fame-seeking induced critics to censure their living competitors. We are reminded of Jonathan Swift's epigram that "Censure is the Tax a Man pays to the Publick for being eminent."[76]

Eighteenth-century authors provided the first formulation of the contemporary postmodern critique that a commercialized culture becomes too fragmented. In their prescient attempt to hold off this dilemma, most eighteenth-century writers were concerned with developing established canons of taste through a philosophy of aesthetics. Today these writings strike us as turgid, but they confronted a burning issue in their time. Objective canons were so eagerly sought precisely because the standardization of taste was unraveling. Facing a growing diversity of both product and criticism, critics and philosophers undertook the futile task of reducing the growing multiplicity of tastes to a single standard.[77]

Should the Government Control Fame?

The literary pessimists were left in a quandary by their belief in a forthcoming cultural decline. Seeking to turn the tide, many of them turned to government control of fame. Oliver Goldsmith argued for a governmental academy charged with evaluating literature and officially commending authors for their merits. William Warburton, another cultural pessimist of this era, struck at literary commercialization with a polemic against the enforcement of literary property and copyright. He argued

that ideas, and writing in particular, should not be subject to the market forces of supply and demand. Without property rights in the written word, authors could not earn money for their writings and the corrupting lure of money would be taken away. Authors would instead be motivated by the incentive of fame, as were the ancients.[78]

Warburton objected to the very notion that ideas could be bought and sold like commodities. He argued that trading literary creations would produce a repugnant world in which: "A Moral Essay might go in Discharge of a Debt contracted in a Bagnio. Philosophy, Poetry, Metaphysics, History and Divinity, would be taken in satisfaction for Stay-Tape, Backram and Canvas, or Legs of Mutton, Calf's-Heads, and other Articles, which usually compose a Taylor and a Butcher's-Bill."[79]

Joseph Addison also drew up a proposal to thwart social and cultural decline; Swift and Pope became convinced of the merits of this idea. Addison felt that the government should control the distribution of fame by placing the portraits of great achievers on coins and medals. When Addison wrote, at the very beginning of the literary revolution, daily newspapers had not achieved their later prominence, books were expensive, and many individuals could not read. Coins and medals, which were handled by all classes of society, were a primary source of information and images, and reached even the illiterate. The pessimists, worried that a new age of barbarism would extinguish civilization, wished to preserve the achievements of their age in durable form for later civilizations, just as the Romans had done.[80]

The pessimists objected to the multiple, uncontrollable, and incommensurable sources of fame that markets create. Addison and others favored a homogeneous rank ordering, defined by central authority. They had figured out who ought to be famous, and wished to implement their views by fiat. Alexander Pope, in the preface to *The Dunciad,* had even noted that only one means remained to hold back the triumph of dullness—Pope's own criticism.[81]

Commerce in Support of Fame

In fact commercialized printing has increased the ease of earning fame. Most of the renowned names from the past, whether they be authors or not, have come down to us through books. The printed word provides

a relatively low-cost means of promoting reputations and spreading knowledge across generations. In earlier times, many writings of antiquity perished because they could not be replicated easily and cheaply. More than three-quarters of the works of the leading Greek dramatists are lost forever. The fate of each work and its survival was sometimes based on chance: a monk in this or that monastery deciding to copy an original text before it was lost, perished through fire, or decayed with age. Even if the copy survived, few scholars and fewer laypersons were familiar with these works until they had been translated and widely published.[82]

As early as Richard de Bury, the literary optimists understood that books made fame more likely and more durable. De Bury wrote: "In books I find the dead as if they were alive . . . pope or king [cannot] find any means of more easily conferring the privilege of perpetuity than by books. The book that he has made renders its author this service in return, that so long as the book survives its author remains immortal and cannot die . . ."[83]

Fame remains possible in the modern world, even if the deluge of books and paper has exceeded expectations. This flood of writings makes the achievement of fame easier, not harder. The competitive market in the written word brings creators in contact with their fans and their natural constituencies. Vast quantities of print have been generated precisely because readers demand to learn more about other people and ideas. The increase in supply, rather than swamping readers in a tide of paper, has been largely demand-driven.

The literary pessimists overemphasized the zero-sum nature of fame. Fame is zero-sum to the extent that one individual's recognition takes away from another's. To the extent this assumption is true, any single individual will find fame harder to achieve in the modern world. The greater number of individuals striving after a fixed reward, the smaller the chance of any single individual receiving a pay-off. Only a single individual can hold the title "best writer ever," for instance. Fame-seekers will supposedly turn away from the arts over time.

The zero-sum conception of fame is linked closely to the idea of a homogeneous rank ordering of merit. If fame does in fact consist of the appellation "best writer ever," recognition is strictly rivalrous across writers. Once we allow for diversity of opinion and diversity of achievement, however, markets tend to augment the quantity of avail-

able fame. Not all artists work in the same genre or attempt to communicate in the same way. Markets match fame-givers—consumers and critics—to fame-receivers in new and changing ways. The marketing of artistic innovations brings a continual rearrangement of genres, niches, consumer loyalties, and rivalries. Cultural markets will tend to increase the quantity of fame and recognition that is produced over time. Contrary to the well-known claims of Fred Hirsch's *Social Limits to Growth,* status and recognition are subject to augmentation in supply over time.

The number of possible artistic niches is extremely large, and typically more fame is created in new niches than is destroyed in old ones. Despite his "Roll Over Beethoven," Chuck Berry did not send the reputation of Ludwig van to the grave. Instead, Berry created fame for himself by reaching and educating a new audience. He took away from the previous fame of the mediocre Pat Boone, not from the fame of the great classical composers of the past. Similarly, James Joyce's *Ulysses* contributes to the fame of Homer rather than diminishing it.

The increasing difficulty of achieving fame in a well-traversed area will prompt fame-seeking artists to seek out new paths. Bach, Mozart, and Beethoven do hold preeminence in classical music composition, but many fame-seeking successors have cultivated alternate musical forms, such as rock and roll and jazz. Competition for Hume's posts of honor thus helps drive the diversity of market culture. The ancient Roman historian Velleius Paterculus made this point first: "And as in the beginning we are fired with the ambition to overtake those whom we regard as leaders, so when we have despaired of being able either to surpass or even to equal them, our zeal wanes with our hope; it ceases to follow what it cannot overtake, and abandoning the old field as though pre-empted, it seeks a new one."[84]

Many of the ancients, such as Virgil, believed in the notion of literary production as a healthy competition and rivalry. Rather than fearing Homer, Virgil sought to emulate him. Dante later used Virgil as a model. Longinus, the ancient theoretician of aesthetics, stressed the favorable consequences of the desire to emulate. Rather than setting up the older greats as perpetual judges of present authors, he portrayed literature as a collaborative enterprise across generations. Newer authors draw upon the best in their predecessors while adding innovations of their own.[85]

Eighteenth-century Scottish commentators on David Hume emphasized innovation, rather than emulation, as a response to an apparently declining pool of fame. Yet some of these writers, such as Alexander Gerard, cited induced innovation as a cause of corruption in the arts. According to this view, only certain kinds of artistic production are aesthetically worthwhile; more specifically, art should resemble nature. Once the posts of honor have been filled for naturalistic art, fame-seeking induces frivolous and overly mannered innovations. To rephrase the critique in more contemporary language, fame-seeking induces creators to stray from "superior" forms, such as the beauties of the classical symphony, into "inferior" forms, such as the inaccessible language of atonal music.[86]

William Hazlitt produced yet another critique of fame-seeking in a market economy. Hazlitt, in his 1814 essay "Why the Arts are not Progressive—A Fragment," argued that the early creators in the history of a genre will be the most accomplished. He voiced a common view when he wrote: "Homer, Chaucer, Spenser, Shakspeare [sic], Dante, Ariosto (Milton alone was of a later age, and not the worse for it), Raphael, Titian, Michelangelo, Correggio, Cervantes, and Boccaccio—all lived near the beginning of their arts—perfected, and all but created them. These giant sons of genius stand, indeed, upon the earth, but they tower above their fellows, and the long line of their successors does not interpose anything to obstruct their view, or lessen their brightness."[87]

Hazlitt defends his claim by invoking two arguments based on incentives. First, these creators worked for a very small audience with minds of superior refinement, whereas later creators strive to please a more diffuse and inferior set of tastes—"The highest efforts of genius, in every walk of art, can never be properly understood by the generality of mankind . . ." Second, in earlier times men of genius faced little competition and were virtually assured of achieving great fame. Later creators are "lost in the crowd of competitors," and are discouraged by their much smaller chance of achieving due recognition.[88]

Hazlitt's critique, however, is vulnerable on several points. First, today's creators still hold the option of working for a smaller audience of refined minds. Many writers, composers, and painters target precisely such audiences in the contemporary world of culture. Hazlitt's argu-

ment emphasizes that the very greatest artists do not work for money; he cannot invoke the claim that top creators will sell out for money and work for the masses.

Second, intensified competition for fame may encourage effort and genius rather than discourage them. Even if we treat fame-seeking as a zero-sum game, Hazlitt's pessimistic conclusion about fame-seeking does not follow. If we think, for instance, of sports tournaments (which do have unambiguous winners), we do not typically believe that the best players try harder when the field is weak. Rather, we find that intense competition spurs on the best to higher levels of achievement. The concentration of artistic achievements in particular points of space and time (e.g., Periclean Athens, the Florentine Renaissance, the Parisian art world, etc.) implies that rivalry promotes rather than discourages quality. The rivalry between Paul McCartney and John Lennon encouraged each to best the other with successively more innovative songs; once the Beatles split up neither composer could match his previous best efforts.

Third, artists of true genius do not always arise at the beginning of a genre. The Italian artists cited by Hazlitt, for instance, followed hundreds of years of medieval art. Shakespeare came out of a long tradition of English drama. Dante, the epic poet, post-dated Homer, another name on Hazlitt's list of great creators, by approximately two thousand years. Artists of genius appear to arrive at the birth of a genre only because we sometimes identify the birth of the genre with those very artists. A long string of lesser achievements, however, typically precedes most masterworks.

Bernard of Chartres, who died in 1126, described the individuals of his time as dwarfs standing on the shoulders of giants. The same metaphor was later used by Swift, although we do not know if he borrowed the metaphor with deliberate irony. I suggest the alternative metaphor that the creative artists of any age are giants standing on the shoulders of other giants. At no point has the writer become a dwarf or a minor figure. In fact, the twentieth century has produced many more literary giants. Consider the 1920s alone. In 1922 Eliot's *The Waste Land* and Joyce's *Ulysses* appeared. Rilke's *Duino Elegies* were published in 1923. In 1924 came Mann's *The Magic Mountain*. Kafka's *The Trial* and *The Castle* were published in 1925 and 1926 respectively. William

Butler Yeats was active in this decade as well, and between 1920 to 1927 the last four volumes of Proust's six-volume *Remembrance of Things Past* were presented to the world.[89]

To the extent the modern world does offer inferior fame rewards, cultural pessimism itself is partly to blame. Contemporary writers have no trouble establishing their fame with readers, but many writers struggle to achieve recognition from professional critics. Commentators like Swift, Hazlitt, and many modern cultural pessimists label them as dwarfs and lesser figures. Chapter 5 considers the motivations behind cultural pessimism in detail, but I close this chapter by noting a potential paradox in the cultural optimist position, to which I return in the final chapter: to the extent that writers work to achieve the approval of critics, cultural pessimism may prove a partially self-fulfilling prophecy. Belittling contemporary creators may lower their fame rewards and discourage their efforts.

❸ The Wealthy City as a Center
for Western Art

Three features distinguish the economics of the visual arts from other artistic endeavors with particular prominence. First, most artworks, apart from prints, cannot be reproduced without a significant decline in the value of subsequent units. A sketch or color plate of a painting sells for much less than the original. The costs of reproduction therefore partially insulate painting and sculpture from the mass market. Most renowned artists support themselves by selling unique creations to the wealthy, rather than by selling reproductions to the masses. The art market, at its highest levels, tends to flourish in commercial societies with wealthy merchant collectors and patrons.[1]

Second, painting and sculpture tend to be concentrated in cities, even more than other artistic forms. A relatively small number of focal cities—such as Florence, Amsterdam, Paris, and New York—have played central roles in Western art history. The city encourages a concentration of wealthy buyers with sophisticated tastes. Clustered networks of distribution, such as galleries, dealers, and auction houses, aggressively market artworks to these buyers. Artists move to cities not only to sell their wares but also to learn from other creators. Especially in earlier eras, the difficulty of accurate pictorial reproduction induced artists to move to cultural centers to study older paintings and to study with and work for successful artists.

Third, painting and sculpture depend heavily on the physical materials of creation. Many kinds of artwork, from oil painting to bronze casting to marble quarrying to the bright colors of the impressionists, came to fruition only with technological progress. Technological revolutions often have preceded and stimulated artistic revolutions.

Although these features have characterized art markets for centuries, growing wealth and decreasing materials costs have changed the visual arts over time. Renaissance artists oriented their works towards establishment taste to satisfy their primary customers; the most successful artists became a part of that establishment themselves. Social commentary consisted largely of religious, nationalist, and regionalist sentiment. Portrayals of sexual perversion tended to be subtle rather than blatant. Artists achieved considerable creative freedom for the content of their work, but they usually accepted the social values of their time for the sake of their place in the establishment and the interests of their customers.

The growth of art markets, occurring over a centuries-long stop-and-start process, has weakened the establishment orientation of artists. Larger markets and lower costs supported more diversity and decreased the need for patrons and large-scale commissions. In the twentieth century, many leading artists moved in the direction of the avant-garde, far removed from mainstream taste. Modern artists flirt with socialist and anarchist ideas, and many do not flinch at producing highly provocative or X-rated works.

To illustrate how markets have influenced artistic creativity over time, I focus on Florence, Amsterdam, Paris, and New York in their respective golden eras—four critical episodes in the development of art markets. The historical evidence, as illustrated by these case studies, shows a positive impact of commerce and commercialization on the most prestigious eras of Western artistic creation. I also consider how changes in the market and changes in technology have influenced the substance of artistic creation over time, and how prominent artists have arisen from highly competitive popular milieus.

The Roots of the Renaissance

The rise of Renaissance art starts with a commercial revolution. Western European cities had contracted dramatically after the fall of the Roman Empire, but urbanization proceeded once again in late medieval times. Increases in commerce, revolutions in energy production (e.g., the water wheel), and renewed interest in learning can be traced

back to the eleventh century, and by the thirteenth century a revival of European culture was well underway.[2]

Paris had been the cultural center of the medieval world, but by the thirteenth and fourteenth centuries the Italian city-states assumed the economic and cultural leadership of Europe, along with the Flemish cities of Bruges and, later, Antwerp. In these areas the medieval era grew into the Renaissance.

Of the Italian city-states Florence has left the most renowned artistic heritage. The artistic successes of Florence resulted from the combined influence of many factors—wealth, a tradition of manufacturing expertise, thick markets in commercial crafts, decentralized buying interest, a favorable system of government, and the prevalent philosophy of Renaissance humanism. These features converged to provide a strongly favorable environment for the cultivation and support of artistic talent.

The Florentines themselves recognized the benefits of commerce. The fifteenth-century humanist and architect Leon Battista Alberti argued that commerce creates prosperity and employment, serves the needs of buyers, secures the strength of the republic, and motivates and finances painters, sculptors, and musicians. Vasari and Cellini, both prominent artists, portrayed the creators of their time as calculating businessmen who sought wealth. Business activity was widely respected; in Boccaccio's *Decameron* tales, the merchant characters are, more often than not, heroes or sympathetic figures. Poggio Bracciolini, another humanist, presented the extreme view that: "[Without avarice] every splendor, every refinement, every ornament would be lacking. No one would build churches or colonnades; all artistic activity would cease . . . [the avaricious] have often brought great ornament and embellishment to their cities."[3]

The Florentine artistic breakthrough came in the fifteenth century. Brunelleschi the architect, Donatello the sculptor, and Masaccio the painter built on the works of Giotto a century earlier to initiate the artistic Renaissance of Florence. Ghiberti, Botticelli, Fra Angelico, Fra Filippo Lippi, Leonardo, Raphael, Michelangelo, and others followed in later generations.

The cultural achievements of Florence were not restricted to the visual arts. Michelangelo and Leonardo were "universal men" with genius in writing, poetry, design, architecture, engineering, optics, and

85

anatomy. In literature Florence produced Dante, Petrarch, Boccaccio, and Machiavelli. The sculptor Benvenuto Cellini penned vivid memoirs and the painter Giorgio Vasari produced a seminal history of Italian Renaissance architects, painters, and sculptors.

Florentine successes illustrate the commercial factors behind the rise of Western art more generally. Florence was one of the wealthiest cities in Europe from the early to mid-Renaissance. The commercial expertise of the town produced the wealth to spur market demand, provided a wide and decentralized network of buyers, and supported skills of craftsmanship that later blossomed into artistic genius. The Florentine experience reflected the virtues of modernity in their nascent form.

Supply-Side Forces Favoring Creativity

Florentine economic success stemmed from textile manufacture (first wool, then silk), trade in textile products, and banking. Florentine banks and financial institutions led Europe and laid the foundations for modern practices. Double-entry bookkeeping gave Florentine merchants a competitive edge as early as the mid-fourteenth century. The Medici bank, probably the largest bank in Europe, invested funds from local and foreign merchants as well as from the papacy. The Medici bank held branches throughout Europe, overseeing an extensive network of investments. The Medici and other banking families became good customers of Florentine artists.[4]

Florence specialized in quality manufacturing based on technical knowledge and skills of workmanship. The cloth industry exhibits the superior standard of Florentine workmanship. Untreated Florentine wool was of inferior quality. In response textile workers developed special skills for finishing cloth, removing knots and imperfections, and dyeing in a rich color spectrum. Florentine cloth manufacture necessitated twenty-six different operations, each performed by a specialist. As their expertise developed, the Florentines began to import choice wool from abroad for finishing in Florence and for export throughout Europe. In similar fashion, the Florentines made their drugs purer, their furs finer, and their silk more attractive. Florentine entrepreneurs set high standards for working with decorative stone, marble, gold, jewels, wood, and inlay.[5]

These superior standards for craftsmanship supported the quality of Florentine art. Florentine artists were commercial craftsmen who drew upon marketable skills that local creators had been refining for centuries. August Krey remarked that "Every one of the Florentines who became famous as an artist after 1300, including Leonardo da Vinci and Michelangelo, Cellini and Vasari at the very end of the period, had been trained as a craftsman prepared to make small articles for sale just as their predecessors had been trained before 1300. Furthermore, each of them continued to be a craftsman to the end of his days, and most of them, despite one or two interesting exceptions, were also good businessmen."[6]

Renaissance artists tended to come from merchant and commercial families rather than from the nobility. In a sample of 136 Italian artists from the years 1420–1540, ninety-six were the sons of artisans or shopkeepers. Writers, who did not have a well-developed market and required independent support from patrons or family wealth, were far more likely to come from the secure homes of the nobility.[7]

Thriving markets for small artistic commissions and crafts were essential for training and supporting budding artists. The goldsmith and metal-working trades, prominent in Florence, supported and trained many artistic talents of the Italian Renaissance. In the Renaissance, Florentine wealth led to a favorable balance of payments on the gold florin and a continual inflow of gold. Goldsmithing activity was prevalent, and by the middle of the fourteenth century, forty-four goldsmiths' shops lined the Ponte Vecchio.[8]

Many Florentine artists started out as goldsmiths or studied with goldsmiths to acquire the necessary technical skills. The list includes Orcagna, Andrea Pisano, Ghiberti, Brunelleschi, Donatello, Michelozzo, Luca della Robbia, Cellini, Antonio Pollaiuolo, Verrocchio (Leonardo's teacher), Leonardo, Ghirlandaio (Michelangelo's teacher), Botticelli, Andrea del Sarto, and Vasari. If we include those who studied with a goldsmith (Michelangelo) or whose father was a goldsmith (Raphael), we nearly exhaust the roster of prominent Florentine artists. Later and further north, the goldsmith's trade provided a breeding ground for German Renaissance artists, including Albrecht Dürer and Hans Holbein.[9]

Goldsmiths worked with a variety of forms, including gold, silver, bronze, marble, wood, clay, and textiles. Many of the objects made by

goldsmiths, such as shrines and reliquaries, took on architectural forms and required drawing and design abilities. Goldsmiths also acquired expertise in casting metals, setting jewels, and engraving. Sometimes goldsmiths were required to paint inlays on the pieces they set. They also studied the use of color and had a strong working knowledge of geometry. These skills accounted for the versatility of the Renaissance artist.[10]

Artists with goldsmith backgrounds satisfied commercial craft commissions through workshops, studios, and partnerships. These businesses served as earlier versions of today's housewares stores. Customers bought glazed pottery, chest and backrest panels, wooden trays, small bronzes, salt-cellars, wine chalices, portable devotional pictures, small diptychs and triptychs, small altarpieces, tabernacles, flags, woodcarvings, shop signs, bells, boxes, bowls, doorknockers, inkwells, plates, banners, drapery, and bronze oil-burning lamps. The burgeoning commercial class demanded attractive household objects and wedding gifts in growing quantities.

These workshops also churned out uncommissioned paintings, knowing they could find a ready market for pictures of Madonnas, Virgins, Crucifixions, or St. John the Baptists. Florentine carnival celebrations generated demands for masks, disguises, and stage sets for the public festivities.[11]

Forces Encouraging Creativity from the Demand Side

The large-scale Renaissance masterworks grew out of the craft and workshop markets between middle-class artists and bourgeois merchant customers. The stimulus of capitalist wealth, combined with commissions from guilds and churches, brought these skills to grander, more public undertakings.

Most artists found their start in the workshop, producing items for household and other practical uses. Workshops pooled talent and expertise, generated commissions, taught young artists, and spread the risk of potential failure. Over time, however, the importance of the workshop decreased. The creative artist, whose individual reputation was attached to each work, was born. Florentine artists struck out on their own and achieved creative freedom. High wages, a prosperous merchant class, and the growing ethic of consumption contributed to a

growing market for artistic works and decorative products. Artists exploited the numerous sources of available financial support to assume greater control of their time and resources.

Many writers describe the prime financiers of Florentine art as patrons, but these financiers were first and foremost paying customers. They procured artworks for their own pleasure and glory—not to support the artist, to maintain the artist in a position of servitude, or to guide Florentine artistic development.

The most renowned Renaissance artists were not court artists or kept men of some noble or prelate. Andrea Mantegna, not even a Florentine, was the only notable Italian court painter of this era. He spent forty-six years working for the Gonzaga at Mantua. But even Mantegna did not accept this post until three years after the offer was made. He finally accepted, but only with reservations and against the advice of his friends. Leonardo was attached to the court of Milan, working on military engineering, but only because he refused to accept or complete artistic commissions.[12]

Florentine artists sold their works to a wide variety of buyers in their home city, throughout the Italian peninsula, and even to parts of Europe further north. These buyers included rich merchants, church committees, monasteries, nunneries, the commercial guilds, municipal governments, and upper-middle-class homeowners. Even artists as successful as Raphael produced altarpieces, portraits, and religious images for private homes. Botticelli's famous *Primavera* painting was originally the back piece for a large household bench.[13]

Changes in artistic forms accompanied the growth of the art market. The growing network of market exchange caused the immobile church fresco to lose favor to painting and sculpture. Buyers sought artistic works that could be owned, transported, and resold as commodities. The private palazzo, the result of Florentine wealth and building booms, became a secular repository for these forms of art. Thirty palazzi were built between 1450 and 1478 alone.[14]

The boom in church and monastery construction provided additional venues for new artworks. At the same time churches were "privatized" by their increasing reliance on donor funding. Wealthy families gave money to churches so that artistic displays could be set up in their names. Donors appropriated church space for competitive private display through their funding of numerous chapels, tombs, and altarpieces.

Prestigious families competed against each other to set up the most beautiful or most impressive church space.[15]

Public exhibitions strengthened the growing interest in owning art by advertising works, attracting buyers, and making artistic reputations. These exhibitions arose as an offshoot of religious festivals, and at first displayed works recently commissioned for churches and cloisters. Over time, however, the exhibitions became purely commercial and marketed secular works, unconnected with religious commissions. The display of art, for reasons of status, evolved into the direct sale of art to interested buyers.[16]

Prints became established as artistic commodities to be collected and traded. Raphael, for instance, worked with the engraver Marcantonio Raimondi. Raphael supplied the drawings on which his paintings were based and Raimondi copied the master's works in larger numbers. The resulting engravings, which increased the size of Raphael's market, were sold to customers who could not afford to buy his original paintings. Like modern artists who make prints, Raphael engaged in price discrimination and market segmentation to increase his profits.[17]

The Growth of Creative Freedom for the Artist

When many buyers seek the product, creators can indulge their artistic desires at lower cost. Artists with financial independence can pick and choose projects to suit their tastes. Growing demand moved the balance of power in Florentine contracts towards the artist, who gained increasing control over the content of his commissions. This trend started in the fifteenth century and came to full flower in the High Renaissance persona of Michelangelo. This growth in artistic freedom does not contradict the economist's notion of "consumer sovereignty," properly interpreted; rather, the artist himself is also a consumer bidding for his own time. If the artist prefers to satisfy his own tastes rather than to receive more money from buyers, this also represents satisfaction of a market demand—the artist's.

Renaissance commissions usually were regulated by contract. Artists and customers wrote well-specified agreements when striking a deal. Customers requested that artists not undertake new projects while working on a commission and that they not assign entire projects to as-

sistants. Raphael once promised to paint all of the figures in a painting and Perugino and Signorelli promised to paint everything from the waist up. Some customers wished to dictate the contents of paintings. The artist was instructed to paint with or without cherubs, to use a particular quality of paint, to send intermediate sketches, or to paint each specified figure a certain number of feet high. When a dispute arose, third-party arbitrators were appointed to judge whether artists had fulfilled their contracts.[18]

As the Renaissance progressed, artists enjoyed increasing freedom to exercise their imaginative faculties. Contracts no longer specified the exact details of a picture but left such contents to the artist. Customers might commission a portrait, a landscape, or a Madonna, but eventually they ceased to command the substance of artistic creation.

The story of the Marchioness Isabella d'Este of the city-state of Mantua illustrates this new balance of power. Isabella was a leading art buyer and patron at the turn of the 1500s but failed to impose her will on several prominent artists. Isabella had signed a contract with Perugino, a notable painter from Umbria who later moved to Florence and taught Raphael. The contract between Isabella and Perugino specified the number of figures in the picture, their size, dress, and the details of the surrounding landscape. Perugino was not to add any figures of his own. Yet when *The Combat of Love and Chastity* was finished, Perugino had painted a nude Venus, much to the displeasure of Isabella, who had wanted a clothed Venus.

Isabella attempted to control other artists but failed repeatedly. She tried to commission paintings from Leonardo, but received only a quick, although brilliant, sketch. He ceased to reply to her requests for more.[19]

Artists outside of the Florentine orbit suffered from the absence of decentralized financial support. The seventeenth-century Spanish painter Velázquez did not enjoy comparable artistic freedom. He relied primarily on King Philip and his court for his financial support. For this reason, he spent much of his time painting Philip IV and his children. One catalog lists eighty-one portraits of Philip alone. Velazquez had a patron but not enough customers.[20]

Even the other Italian city-states could not match Florentine market conditions. Naples, Milan, Ferrara, and Mantua centralized artistic commissions in the hands of the state, or in the case of Rome, finance

was dominated by the papacy. These locales commissioned works from outside but they produced little home-grown talent. The papal government made Rome a world center for art in the High Renaissance only by hiring many Florentine talents. Rome was primarily a city of politics and religion, not manufacturing or commerce, and Rome did not have the indigenous talent to compete with Florence.[21]

Milan was much larger than Florence and possessed more military power, but its arts did not benefit accordingly. Milan did not have a comparably diversified background in commercial crafts. Milanese culture was based around a princely court, especially during the reign of the Sforza family. The Sforzas spent large sums trying to rival the Medici but they could not recreate the underlying conditions behind Florentine art. Most of the painters hired by the Sforzas were mediocrities who curried political favor. The Sforza court did import notable outsiders towards the end of the century—Leonardo and Bramante. Consistent with their political goals, the Sforzas encouraged Leonardo to design military fortifications rather than to create art. Bramante designed some notable buildings in Milan, but, like Leonardo, once he left town the surge of creativity was over.[22]

Florentine customers, who were especially sophisticated and perceptive, often supported artists in their struggles to create masterworks. Artists held a higher public status in Florence than in the other Italian city-states, or in other parts of Europe. High respect for the artist, which dated from mid-fourteenth-century Florence, hearkened back to the days of antiquity. Florentine writers, such as Filippo Villani, Dante, and Boccaccio all cited the brilliance and fame of Giotto. Ghiberti attributed the quality of his Baptistry doors to the artistic freedom he was granted by his commissioners.[23]

Vasari recounts several stories of how the Florentine sculptor Donatello stubbornly fought for his artistic independence and creative vision. In one case Donatello destroyed an artwork rather than accede to a customer's demand. Whether or not Vasari fabricated these particular anecdotes is beside the point—the Florentines self-consciously promulgated an ideal of artistic freedom. Florentine artists, customers, and writers saw their city as a special enclave, nominated by destiny to restore the beauty and freedom that had been lost with the decline of the classical world.

When Lorenzo Ghiberti produced his second Baptistry door, he conspicuously included a sculpture of himself on the trimming of the panels. The door simultaneously glorified the Biblical creation and the individual artist's creation, figuratively placing the artist on a par with God. The self-portrait reflected Renaissance individualism, creativity, and self-awareness. Ghiberti was also the first Renaissance artist to write about himself.

Brunelleschi elevated the status of the artist further. He maneuvered to design and oversee the production of the Dome of Florence almost entirely by himself. This dome, attached to the Santa Maria del Fiore cathedral, dominates the Florentine skyline to this day. Brunelleschi was the most advanced architect of his day and also an engineering genius. He even invented new kinds of barges and hoists to facilitate the construction of the Dome. When the Dome was completed in 1436, observers were rightfully astounded—the Dome commanded the Florentine skyline sublimely. No project of comparable scope had been built since the Roman Pantheon. As early as 1423, Brunelleschi was given a special award of 100 florins and was designated as an inventor by his employers.[24]

The word "inventor" began to take on a new meaning as creator or discoverer. In medieval times the word inventor had meant "delator" or "informer." At the same time the word "artist" was changing to reflect the increasing status of the creative professions. As late as the fourteenth century, the Italian language had no word for artist with a connotation separate from that of "artisan."[25]

Michelangelo turned the artist into a public figure and an object of adoration. He picked his commissions to suit his taste, and ignored the opinions of others. Customers paid fantastic fees for the privilege of hiring Italy's most famous artist. A portrait became a glorification of the artist, not the sitter. When told that his sculptures in the Medici chapel in Florence did not particularly resemble the subjects, Michelangelo replied "No one will know how they looked in a thousand years." Michelangelo knew the work would produce more fame for himself than for the Medici.[26]

Michelangelo even refused to yield to Pope Julius II, one of the most powerful men of the sixteenth century. The strong-willed Pope Julius had hired Bramante, Raphael, and Michelangelo to fill Rome

with artistic riches. But when a dispute about executing a commission arose, Michelangelo bettered Julius. Julius had commissioned Michelangelo to design his marble tomb and Michelangelo accepted the assignment, moving from Florence to Rome to do the work. He was offered an extravagant commission that ensured his future financial security. Michelangelo, however, also cared about art for its own sake. He rebelled when the Pope was distracted by plans to rebuild St. Peter's basilica, causing Michelangelo's project to run short of money for materials. Michelangelo turned his back on the Pope, left Rome, and returned to his native Florence, abandoning the work. It was the Pope who made concessions to Michelangelo to ensure his return to the project.[27]

The artist was now emancipated and sovereign in a manner far beyond his predecessors. Michelangelo refused public honors and titles and was simply referred to as the "Divine." He intended the *Pietà* to adorn his own tomb but he abandoned the idea because of defects in the stone. When Michelangelo died in 1564, a massive funeral service was held for him with effusive orations from leading Florentine citizens. He was a hero to all Florentines, not just to the rich. The working classes saw his *David* statue regularly in the course of their daily lives.[28]

Of all the great Florentine creators, Leonardo da Vinci was the furthest removed from the art market. He produced fewer than fifteen paintings (the exact number depends on attributions) and no sculptures. Many of the paintings were never even properly finished. Leonardo felt most comfortable in the realm of science and devoted the bulk of his time to his sketchbooks and imaginary inventions. He served two extended stints in Milan, working for Ludovico Sforza and Cesare Borgia, both tyrants. There he designed waterways, bridges, and war machines, while pursuing his speculative interests in anatomy and the design of novelties. Leonardo's fertile mind conceived and drafted plans for flying machines, automatic turnspits, parachutes, and unpickable locks.

Leonardo refused to accept or to complete most of the numerous and lucrative artistic commissions he was offered. He was famous for procrastinating but nonetheless attained fame and riches. Leonardo's paintings were worth approximately $1 million (in current dollars) at the time of his death.[29]

Most of the renowned Florentine creators earned a good living. Ghiberti became a rich man with a house and workshop in Florence,

some land and a vineyard in the country, a valuable collection of antiques, and large bank accounts in Florence. Raphael associated with princes and cardinals as equals. When he died at the age of thirty-seven, he left behind a fortune of sixteen thousand florins, including a vineyard, two houses, and a palace in Rome.[30]

The Government as Customer, and the Medici

The Florentine system of government also supported the demand for art. The Florentine economy was organized into seven primary guilds, some of which were responsible for maintaining certain public buildings. The guilds helped select the membership on ruling governmental councils and competed among themselves for status and political influence. The guilds were quasi-private, quasi-public institutions that combined features of market and state. Competition for political influence induced these guilds to commission high-quality art works to promote their reputations.

The commercial guilds exercised their greatest influence on large-scale sculpture, a medium that few private individuals could afford. Both Ghiberti's Baptistry Doors and Brunelleschi's Dome were financed by the wool merchants' guild. Numerous works by Donatello owed their funding to the guilds as well. Until the reign of Cosimo I in 1537, the commercial guilds played a larger role in commissioning great art works than the Medici did.[31]

Artists occasionally received outright subsidies from the Florentine government, but such subsidies were rare throughout the formative period of Florentine art. A needy artist might be granted an old age pension or a tax exemption, but these subsidies seldom promoted artistic innovation or success. The Florentine government played its most important role by encouraging private competition for status and political influence, both among the guilds and among prominent citizens.[32]

The role of the Medici in supporting Florentine art has frequently been misunderstood and overestimated. While many artistic commissions originated from politically well-connected individuals, such as the Medici, these charges did not resemble modern government subsidies. The early Medici played their most beneficial role as private customers of art. In the late fourteenth and early fifteenth centuries, Giovanni and his son Cosimo the Elder spent their money on art through the same

channels that other wealthy families did. Giovanni and Cosimo gave money to several churches, with the understanding that these churches would commission agreeable art works and display the family's emblems and patron saints. Cosimo the Elder, the greatest Medici supporter of art, initiated other commissions for his palazzo with his private funds, not with the funds of the state.[33]

The early Medici did not hold the dominant positions as artistic patrons that are sometimes ascribed to them. Cosimo's greatest interest was architecture, not painting or sculpture. Cosimo's grandson Lorenzo did not foster any school, encourage any particular style, or develop any major artist; he was far more influential in supporting writers and humanists than in supporting artists. The inflated Medici reputation comes largely from Vasari's *Lives,* a book funded by the Medici themselves and full of fabrications in their favor. Vasari's claim that Lorenzo took a young Michelangelo under his wing and fostered his development as part of Lorenzo's "palace school" is a myth. Lorenzo did no more than allow Michelangelo access to his collection of artworks for study. Just as private patrons commissioned artworks to promote their status, they also commissioned literature, often without regard for modern historical standards of truth.[34]

Advances in Materials and Techniques

The commercial revolution of the late middle ages and Renaissance not only stimulated the demand for art, but it also provided the appropriate materials of artistic creation. We often take artistic media, such as marble, bronze, paper, and oil paint, for granted. Yet these materials became available to artists only through technological progress. Economic growth laid the groundwork for Renaissance advances in sculpture, drawing, painting, and crafts.

Marble and Bronze

Economic prosperity and engineering ingenuity made it possible to resume marble and bronze sculpture, both dormant since the days of classical Rome. These renascent forms allowed greater and more ambitious sculptural works to be executed.

Production of marble on a large scale had ceased when the Western Roman empire fell in the fifth century A.D. The Dark Ages saw a contraction of commerce, a decline of cities, and a concentration of activity in feudal country estates—all unfavorable developments for the visual arts and the trade of costly resources. The transport of marble from quarries resumed in 1300, however, spurred by a cathedral building boom. The demand for marble then exploded in the late fourteenth century. By 1450, about twenty quarries had opened in Carrara alone.

Sculptors found it difficult to obtain marble in workable form. Marble was costly to purchase, transport, and verify in quality. The quarrying process itself presented great obstacles. Marble was quarried in huge stepped terraces, often in blocks weighing up to several hundred tons. Extraction involved splitting stone with wedges and cutting it with a saw. Transport by water and land followed. The painstaking labor led to frequent loss of life. In his effort to ensure the delivery of high-quality marble, Michelangelo spent years of his life overseeing quarrying operations.[35]

Marble sculpture required sophisticated engineering techniques for the transport of finished statues. Even if high-quality marble could be delivered to the sculptor, the sculptor still had to move and manipulate the massive stone within the studio. Sending the finished product to the client created other difficulties. Michelangelo's *David* statue, nearly seventeen feet tall, was transported outside only by knocking down the wall. It took four days' work to transport the *David* to the Piazza della Signoria. Placing the piece on the proper terrace involved an additional three weeks. The entire job required forty men and the use of fourteen rollers, and was supervised by leading engineers and mechanists.[36]

Bronze casting also involved commercial and artistic resources on a large scale. Bronze was an expensive medium, costing ten times more than marble, and was a difficult substance to work. Ghiberti's first Baptistry door, the less complex one, cost a total of 22,000 florins, more than one hundred times the value of a good Florentine house, and required twenty-one assistants. Bronze casting itself involved costly equipment, including an oven, a furnace, and a casting pit.

Bronze sculpture dated from antiquity and had become the preferred medium for Greek sculpture by 480 B.C. Entrepreneurial Greeks sold their bronze works in an active market, combining their art with

commercial backgrounds in stonemasonry, the furniture trade, and hardware production. (The development of thick markets for art was one of many ways in which the Renaissance hearkened back to antiquity.) Few Greek bronzes survived intact, however. Art markets dried up with the fall of the Roman Empire. Remaining bronze statues were melted down for their metal content. The growth of Renaissance art markets, however, once again gave bronze higher value in the form of a sculpture than as melted down metal.[37]

Paper and Drawing

The falling price of paper encouraged the use of drawings for preparatory sketches and gave rise to drawing as an independent, full-fledged art form. By the early sixteenth century, drawings were actively marketed, collected, and traded. With the development of the paper market, artists found it cheaper and more convenient to make preliminary sketches and designs for works in sculpture, architecture, and painting. Paper eventually became the medium of choice for drawing and writing.

Paper had been invented in China in 105 A.D., according to dynastic records, and eventually spread westward to the Arabs. One account claims that Chinese prisoners held in Samarkand taught the secret of paper-making to their captors in the eighth century. Cultural exchanges spread the craft of paper-making across North Africa and to Europe through Spain in 1151, and it finally made its way to Italy in 1276.[38]

In medieval times paper drawings were too expensive to use for design or sketches. Instead, the artist did a preliminary outline directly on the surface to be painted. Later, through the early Renaissance, drawings were made primarily on parchment, using a metallic stylus. The art of drawing remained restricted, partly because parchment was such an expensive medium. According to one estimate, production of one Gutenberg Bible with parchment required the skins of more than 300 sheep.[39]

Drawing on parchment was painstakingly tedious and did not allow for spontaneous sketches and experimentation. The process of drawing on parchment resembled careful engraving more closely than it resembled modern sketching. (The mechanics of the stylus technique

presented another reason why a goldsmith background lent itself to drawing expertise.) The introduction of paper was instrumental in developing the art of drawing, and in helping artists prepare their larger works.

The practice of drawing expanded in the Renaissance when paper prices fell and paper began to displace parchment. The transition to paper sketches occurred in the first quarter of the fifteenth century. Young followers of the Florentine artist Masaccio turned to the now-cheaper material while more conservative artists stuck to the medium of parchment. Among these younger artists, sketchbooks became popular but paper remained a precious item. Sketchbooks were used repeatedly until they were worn out. Many early Renaissance drawings were even resold to paper mills for repulping.[40]

Paper production and use exploded after the advent of printing in the mid-fifteenth century. The success of the printing trade also led to better and more durable forms of paper. By the sixteenth century, drawings had become artistic works in their own right to be preserved and sold for profit. Pisanello and Leonardo da Vinci led the way with their brilliant sketches and exercises. In 1501, Florentine crowds flocked to Leonardo's studio to admire his drawing Virgin and the Child with St. Anne. Leonardo and Michelangelo, among others, used and marketed the new method of chalk drawing, which allowed smoother transitions across different tones. Chalk gave the work a subtlety that pencil alone could not provide.[41]

Linear Perspective

The systematic understanding of linear perspective enabled artists to represent distance and depth on a two-dimensional surface. While modern viewers consider the use of linear perspective to be commonplace, the technique was a revelation in the fifteenth century. Medieval pictures appear flat and one-dimensional because they cannot create an accurate sense of depth. Some earlier Florentine artists, such as Giotto, had produced a sense of dimensionality but still had not mastered a full understanding of perspective.

The Florentine Brunelleschi made the first drawings since antiquity to use linear perspective, applying the technique in 1425 to now-lost panels showing the Baptistry and the Palazzo Vecchio. He passed

on the technique to Masaccio, Masolino, and Donatello. The writings of Renaissance humanist Leon Battista Alberti further codified the laws of perspective. Paolo Uccello's grid and vanishing point studies led to his famous paintings revealing the principles of perspective. An artistic revolution was underway.

The exact origins of Brunelleschi's inspiration remain unknown. But the map-making knowledge of antiquity, which used linear perspective to portray a three-dimensional globe onto a two-dimensional map, had recently been rediscovered. The first copy of Ptolemy's *Geographia* world atlas known to the Renaissance world arrived in Florence about 1400. The use of mirrors in everyday life also had become increasingly common. Mirrors, which portray three-dimensional objects on a two-dimensional surface, were prominent in Brunelleschi's initial demonstrations of the technique. The popularity and visibility of sculpture further encouraged artists to think in terms of three dimensions. Brunelleschi had studied with the sculptor Donatello and may have refined his sense of dimensionality there.[42]

Innovation also came to mural painting. Before 1450, the technique of mural painting was fraught with technical difficulties. The artist painted on wet plaster that dried quickly, and rapid execution was required to cover the wet surface before it dried. Early mural painting was a test of virtuosity in speed and improvisation. Giotto often completed large frescoes in no more than ten days. The quality of mural painting improved in the mid-fifteenth century, however, when artists discovered techniques for placing fresco paint upon dry plaster. Fresco painters now had more time and could pay greater attention to detail. Even artists without Giotto's extraordinary level of talent could complete notable frescos.[43]

The technological boom of the Renaissance influenced numerous other artistic areas. The new art of woodcutting expanded greatly from its late medieval origins through the rise of the printing trade. Woodcuts were used to produce illustrations for printed books, a genre mastered by the German Albrecht Dürer. Gutenberg's revolution allowed artistic printmaking to take off, which spread ownership of artworks to large numbers of individuals. Copperplate engraving in Italy originated around 1460, a direct outgrowth of techniques from goldsmiths' workshops. Advances in mining technique also made copper, and thus the technique, more affordable. Medal-making was improved

by Pisanello, who modeled his designs in relief on wax, rather than by carving metal dies. This new approach gave medals a delicacy and fineness not previously possible.[44]

Glazing, an ancient technique from Babylonia and Persia, was adopted enthusiastically in Renaissance Italy. The rising middle class wished to purchase glazed items for the kitchen and the table. Anticipating this demand, Florentine sculptor Luca della Robbia switched to glazed clay from his early work in bronze. Vasari attributed Robbia's innovation to the high costs of bronze: "On the completion of these [bronze] things, he [Robbia] made an estimate of what he had gained upon them, and of the time which he had expended in making them, and came to realise how slight had been his advantage, and how great his labour. Accordingly he determined to abandon marble and bronze, and to see if he could derive greater advantage from other methods. It then occurred to him that clay can be manipulated with ease and little trouble . . ."[45]

The New World of Oil Painting

The two most renowned Florentine painters, Leonardo and Raphael, worked in the medium of oil. Before the advent of oil painting, painters worked with tempera or in the fresco medium. Tempera pigments were derived from natural substances, such as minerals, plants, and roots. These were ground into powder and mixed with egg yolk as a binder. The resulting mixture was highly viscous and quick to dry. Tempera painters had to work slowly, using small brushes to paint carefully delineated shapes with minute and painstaking attention to detail. The long, sweeping brushstroke was not possible.[46]

Oil painting allowed for lusher pictures with a variety of textures. The oil reflects light to a greater degree and produces stronger coloristic effects. Artistic style became more spontaneous and fluid, executed on a large scale with flourish. Mistakes or misbegotten conceptions could be altered with greater ease in oil, whereas tempera paint cannot be removed easily once in place. Artists painting in tempera face higher potential costs when they take chances or experiment. Leonardo used scientific experimentation to find the proper mix of oils; his experiments with paint helped him produce mysterious and imaginative qualities in his pictures.

The exact historical origins of oil painting in Italy remain obscure, but cross-cultural trade with the northern countries appears to have played a crucial role. The Flems had been practicing oil painting techniques with proficiency since the early fifteenth century. The Italians were not completely unfamiliar with oil painting at this time, but Flemish influence improved the Italian use of oils and demonstrated the potential of the medium. After a considerable lag, the Italians picked up on the Flemish technique and adapted it for their own purposes.[47]

Despite the efforts of Leonardo and Raphael, oil painting was slow to catch on in Florence. Even as late as the mid-sixteenth century, Vasari claimed in his *Lives* that the medium of oil was inferior to that of fresco. The Venetian artists—such as Giovanni Bellini, Giorgione, Titian, Veronese, and Tintoretto—eventually made oil painting the dominant medium. These painters demonstrated a mastery of the brush, colors, and shading that allowed the Venetian painters to take the lead from the Florentines.[48]

Of the other Italian city-states, Venice offered artists the best-developed decentralized marketplace. Like Florence, Venice was a highly developed commercial society; one source from the time exclaimed that "here, in Venice, absolutely everyone is a merchant." Drawing upon this base of wealthy customers, Venetian artists sold altarpieces and small paintings to churches and private homes for a living. Their larger works found ready markets both at home and abroad.[49]

When the Habsburg Philip II commissioned Titian for paintings, he had to grant Titian artistic freedom. As in Florence, artists held high public status in Venice. Titian of Venice was made a member of the nobility, was feted in numerous Venetian poems, and received the most prestigious honors of the Venetian republic at his burial. When Albrecht Dürer traveled to Venice, he was amazed at the wealth and social standing of artists there; he noted, "Here I am a lord, at home a parasite."[50]

The Venetian achievements did not exactly match those of the Florentines. Florence, with a strong background in crafts, goldsmithing, and metalworking, produced some of its finest works in the field of sculpture. Venice, more of a trading and maritime city, developed less expertise in this genre. Closer links to the east and the Orient instead provided a background for work in glass and mosaic. Fabrics and carpets imported from the Middle East helped refine the Venetian sense of

color and design, and Venice became the world center for trade in pigments. Venetian art markets specialized in producing and trading paintings to a greater degree than did Florentine markets. Whereas the Florentines had goldsmithing and sculpture-based crafts as their underlying popular arts, the Venetians had glasswork and mosaic.[51]

The Cultural Contradictions of Capitalism?

The economic and artistic revolutions of the Renaissance were based on secular desires for consumption and enjoyment. As David Hume had noted, luxury heightened the gratification of the senses and refined artistic taste. The so-called "Protestant Ethic" of abstinence, which Max Weber later identified with capitalism, was not the predominant worldview of the time.

Florentine experience suggests a more optimistic slant on Daniel Bell's theory of the cultural contradictions of capitalism. Bell, by and large a cultural pessimist, believes that capitalistic culture promotes an irresponsible mentality of consumption. In his view, culture breaks down the Puritan ethic needed to sustain capitalist economics. But in Renaissance Florence, as in eighteenth-century England and in early to mid-twentieth-century America, the observed correlation runs counter to Bell's thesis. We observe relatively healthy capitalist economies on the rise, while at the same time ethics of enjoyment and self-gratification fueled artistic creativity. Typically the ethic of enjoyment has been associated with the rise of capitalism, not with its decline. The Florentine Renaissance was simultaneously a birthplace for early capitalism, and a culture of carnivals, public festivals, dances, and feasts.[52]

Revolting against medieval traditions, Florentine creators painted and sculpted the female body as a sensual object of delight. Medieval pictures had depicted women as sinful corrupters of purity. In contrast, Ghiberti's slim and sensual nude Eve (on his Baptistry Door) was a paean to feminine beauty. Nudes were no longer guilty figures being expelled from Paradise, but instead became celebrations and idealizations of the human body and spirit. The women painted by Botticelli, Fra Filippo Lippi, Fra Angelico, and Raphael are beautiful and alluring. Botticelli paintings show little difference between Venus and the Madonna. Consistent with the content of these pictures, Florentine

women of the fifteenth century were renowned for their stylish fash-
ion, their sparkling jewels, and their provocative dress and make-up.[53]

Florentine art moved in a sharply pagan direction after 1460. The
Italian city-states were rediscovering the legacy of antiquity and artists
suddenly treated ancient themes on an equal footing with Christianity.
Botticelli drew on classical mythology for his *Birth of Venus* and
Primavera. Even loyally Christian artists found themselves implicitly
questioning received doctrine in their creations.

Many Florentine artists, even in the fairly early stages of the
Renaissance, used their artistic freedom to hint at the sexually provoca-
tive. Donatello's David statue (c. 1434) was the first freestanding nude
statue since antiquity. The homosexual sculptor took the liberty of de-
picting David, a heroic youth, as an effeminate queen.[54]

Michelangelo and Leonardo, both believed to be homosexual or
bisexual, suggested homosexuality, androgeneity, and deviance in their
works. Leonardo painted men who looked like women, like his St.
John the Baptist. Michelangelo sculpted and painted women with male
muscles and bodies, with breasts tacked on almost as an afterthought.
The figure Night in the Medici tomb in Florence or the Cumaean
Sibyl in the Sistine Chapel are two examples. Michelangelo also
sculpted fine youths with attractive behinds and sensuous, feminine
breasts, like his *Bacchus* and his *David*. Renaissance Germans used the
word "Florenzer" as a euphemism for homosexual.[55]

Giovanni Rucellai, one of the wealthiest noblemen in late
fifteenth-century Florence, defended consumption without apology.
Rucellai wrote in his diary: "I think I've done myself more honor by
having spent money than by having earned it. Spending gave me a
deeper satisfaction . . ." Rucellai, one of the first art collectors of his
age, was the first to catalog paintings by the artist's name, rather than by
their contents or by their decorative role.[56]

It was the enemy of Florentine art and capitalism, the preacher
Savonarola, who promoted an ethic of austerity. Savonarola, who had
a keen eye for subversion, attacked the growing secularization of
Florentine art. He criticized naturalistic portrayals of saints, fashionably
dressed Madonnas, and the implicit representation of the Holy Virgin as
a whore. He understood that a supposedly religious art actually held the
entirely different agenda of glorifying mankind. Renaissance paintings
and frescoes typified the new cult of material luxury being brought into

the Church. In response Savonarola burned artworks publicly. These huge bonfires included painted nudes, sculpted women, and sculptured portraits by Donatello, in addition to lutes, bagpipes, cymbals, books of music, books of poems, and works by Dante and Petrarch.

Decline of the Florentine Renaissance

The decline of the Florentine Renaissance illustrates the significance of the factors that initially supported Florentine economic and artistic growth. The Italian Renaissance, and in particular the Florentine Renaissance, ended in the sixteenth century. Cellini's autobiography closed with the year 1562, Michelangelo died in 1564, and Vasari issued the last edition of his *Lives* in 1568.

The fate of Florentine art was sealed when Florence and Italy lost their positions of relative economic supremacy. The turning point came in the early to mid-sixteenth century when France and Spain involved Florence in foreign conflicts. After France invaded Italy in 1494, Italy was a battleground for disputes between France and the Holy Roman Empire. Trade routes were cut off, economic warfare was commenced, and the Florentine treasury was drained. More generally, trade routes were shifting away from the Mediterranean and Levant and towards the north Atlantic. The fall of Constantinople in 1453, combined with the discovery of the Americas, initiated this process, which was to continue for centuries. In this new world order Florence had difficulty keeping her best artistic talent. In the sixteenth century Rome became the most important source of commissions, as evidenced by the eventual exodus of Leonardo, Michelangelo, and Raphael.[57]

The arrival of Medici dominance placed further burdens on Florentine creativity. The threat of Spanish rule forced a peace settlement that placed Florence under a centralized Medici autocracy. In 1531 the Medici were given control over the government through a hereditary dukedom. The Medici had often been influential in Florentine governing councils but now they ruled outright. Few traces remained of the earlier Florentine republics, which had distributed power more evenly.[58]

Political centralization brought true Medici dominance over Florentine art. By mid-century Cosimo I (distinct from the earlier Cosimo the Elder) ruled Florence with an iron hand and centralized

the finance of Florentine art in his office. Cosimo funded new projects, drew up town plans to give Florence the atmosphere of a court residence, and redecorated civic buildings. Ironically, the Uffizi museum, today Florence's primary depository of fifteenth-century masterworks, is a legacy of these later centralizing tendencies. Cosimo I did not stop at funding his own projects but also restricted competing sources of patronage from friars, guilds, confraternities, and families. Rights of private patronage over chapels were canceled and artistic commissions were now subject to central regulation. The centralization of patronage was both an effect and a cause of Florentine artistic decline.[59]

The regime of Cosimo I did finance some notable works with public funds, especially paintings in the Mannerist style. Nonetheless, these projects were swan songs of greatness, funded by the same centralization that was associated with the Florentine decline. The competitiveness of the art market and the local artisan tradition had dried up. Many painters joined a political elite, removed from any commercial concerns other than pleasing dukes and popes. With their income largely dependent on political connections, painters were uninterested in passing on their skills to students. Vasari's mural of Cosimo I surrounded by his court painters captured the spirit of this era.[60]

At the same time the changing Italian intellectual climate in the sixteenth century undermined the spirit of the Renaissance. The onset of the Counter Reformation and papal censorship made the Catholic Church more authoritarian and less tolerant of free inquiry and artistic creation. Even Michelangelo's work, instrumental in the rise of artistic freedom, was vulnerable to the new trend. His painting *The Last Judgment* was retouched to cover the genitals of the nudes. When the Venetian painter Veronese was called before the Inquisition for taking artistic license with Christian figures, it was plain, at least to modern historians, that the Renaissance was drawing to a close.[61]

Art in the Low Countries and the Dutch Golden Age

The Italian city-states continued to produce a number of notable artists in the seventeenth and eighteenth centuries, such as Caravaggio and Tiepolo. Other painters, such as the Frenchmen Poussin and Lorrain, moved to Rome to pursue their art. Nonetheless, Italian dominance

was waning. Economic and artistic leadership was shifting further north to the Low Countries.[62]

The artistic flowering of the Low Countries had begun in the fifteenth century. Cities such as Bruges and Antwerp, which enjoyed an especially high standard of living, gave birth to the only artistic tradition to rival the Italians during the Renaissance. Jan van Eyck, Gerard David, Roger van der Weyden, and others developed the medium of oil painting on panels. Hieronymous Bosch and Pieter Brueghel later extended Flemish styles in more surrealistic directions. In the early seventeenth century, the baroque art of Peter Paul Rubens represented the peak of Flemish prominence. Rubens synthesized the artistic contributions of Italy, Germany, France, and the Low Countries into a coherent whole. For the first time a truly European style had emerged. Rubens's cosmopolitan style enabled him to sell his pictures throughout Europe, thereby reaping riches and renown without precedent for an artist of his time.[63]

Most of the prominent Northern painters, up through the age of Rubens, had come from the southern part of the Low Countries. Artistic leadership, however, followed economic leadership and shifted up to the northern Netherlands in the first half of the seventeenth century. In 1556 the Low Countries had become part of the Spanish empire through intermarriage. The northern part of the Netherlands rebelled successfully and received a de facto recognition of independence in the seventeenth century. This new territory became the next European center for art. Painters such as Rembrandt, Vermeer, Hals, Steen, Hobbema, and Ruisdael created a Dutch "Golden Age."

The Netherlands provided favorable conditions for artistic production and art dealing. As in the Florentine Renaissance, a variety of forces converged to produce this result. The Dutch had a strong economy, urbanized centers with large concentrations of wealthy customers, and a cosmopolitan ideology favoring innovation and tolerance. The Dutch had no royal court or monarchy, but instead were ruled by a relatively wide class of prosperous burghers on a decentralized, city-by-city basis.

The Netherlands was the first European country to urbanize. By the time of the Dutch Golden Age of the seventeenth century, more than half of the population lived in cities. Individuals moved in from rural areas or from other parts of Europe to take advantage of burgeoning

Dutch prosperity. To this day the Netherlands remains a country of tightly packed urban areas.[64]

The new Dutch Republic became the richest country in the world, and the world center for trade, in the seventeenth century. Like many of the Italian city-states, the Dutch were relatively poor in natural resources but relied on competitiveness and ingenuity. The commercial orientation of the Dutch Republic led to success in exporting clothing, timber, salt, wine, and flowers, dealing in grain, building ships, trading stock shares, publishing books, and exploiting fisheries. Dutch pictures, prints, and porcelain became major export items through Europe. René Descartes, who had moved to the Netherlands, called Amsterdam "a great town, where everyone, except me, is in business."[65]

The Dutch, the leading publishers of Europe, produced the first full-scale print culture in European history. Their businesses, their bureaucracy, and their military all exploited the organizational advantages of the print medium. In a relatively short time, print helped the Dutch develop multinational corporations, a stock exchange, well-functioning financial markets, a modern army, a federal state, and a reasonably efficient modern bureaucracy. Dutch businesses and bureaucracies used written documents to produce and disseminate information about credit, resource allocation, and profit and loss. The Dutch developed a strong comparative advantage at storing and communicating information.[66]

Amsterdam, which became the greatest port and mercantile city in the world at this time, led the Dutch economic and artistic boom. The population of Amsterdam rose from 30,000 in 1570 to 215,000 in 1630. The new immigrants, who came from all over Europe, gave the city a special atmosphere of cosmopolitanism and tolerance. Amsterdam was renowned for its social mobility, its entrepreneurial spirit, its religious toleration (extending even to Jews), and its freedom of the press. Most of the best Dutch artists were not born in Amsterdam, but they settled there to participate in its well-developed art market and economy.

Dutch capitalism provided a strong upper-middle-class base for the art market. Dutch noblemen, rich merchants, and middle-class burghers all turned their homes into small picture galleries. Even Dutch peasants and farmers bought pictures, although typically of a lower quality. Starting in the 1590s, the buying habits of the Dutch public

drove an unprecedented accumulation of artistic works. By the mid-seventeenth century, in Delft, approximately two-thirds of the 30,000 citizens lived in households with paintings. At least 40,000 paintings hung in the 4,000 houses in the city, and it has been estimated that 10 percent were pictures of quality. Hospitals, inns, banquet halls, and public buildings further fueled the demand for pictures. Neither nobility nor royalty played a significant role in this market.[67]

Rembrandt himself embodied the Dutch mania for art collecting. He owned a wide assortment of Italian and Flemish Old Masters, contemporary Dutch pictures and prints, antique busts, weapons, costumes, musical instruments, and ethnological items from the New World. Rembrandt eventually squandered the fortune that he had earned as a painter, as high prices did not deter him when he wished to buy a work.[68]

The prevalence of merchant and middle-class buyers influenced the content of Dutch pictures. The small interior of the typical Netherlands home lent itself to intimate landscapes and still lifes, rife with detail. These same paintings would have been lost on the walls of Italian villas, which were typically large and spacious. Sculpture, which is often more suited to the public space than to the private home, lagged behind painting in the Netherlands. Dutch buyers also preferred pictures that could be viewed every day. Dutch art was pleasing to the eye rather than disturbing. The fairly conservative tastes of Dutch bourgeois customers encouraged painters to specialize in particular genres or themes, such as interiors, sea paintings, still lifes, or scenes from everyday life.[69]

Contractual relations in the Dutch market differed from those used in Florence. Italian Renaissance art typically was funded by deliberate commission. The Dutch painters, in contrast, usually made the painting first and marketed it afterwards to a general buyership. Paintings were sold at fairs, at public stalls, and through dealers to a wide audience. Only portraits, which required the cooperation of the sitter, provided an exception to this general practice.

Like the Italians, Rembrandt used a strong art market to establish his artistic freedom. He frequently demanded extraordinarily long hours from sitters, even though demand for his portraits fell off as a result. Rembrandt sometimes required his customers to beg for a commission. He finished works when he felt like it, rather than when the

client wanted, and delivered works to his own specifications, rather than to request. Rembrandt once even produced a pen and ink sketch that he titled "The Asinine Art Buyer."[70]

The active Dutch market supported both painters who pandered to market taste and painters who eschewed it. The degree of artistic specialization was high. Pieter de Hooch frequently repeated successful themes, sometimes with only minor variations, knowing he found a ready market for a known product. Vermeer, who created only a small number of paintings, made each creation a unique and special product. His subtle and introspective style made fewer concessions to the masses. Both men made a good living; Vermeer's market collapsed only later during the onset of war against France.[71]

The most successful painters, such as Rembrandt, took in large numbers of students and produced through the collaborative workshop. Modern commentators might see commerce as having had a partially negative effect on Dutch art in this regard. Not all of the paintings sold as Rembrandts were painted fully by the master's hand, if at all. Workshop collaborators allowed Rembrandt to stretch his talents as far as possible, and in this regard produced benefits, but modern viewers and curators still are sorting out the mess of uncertain and controversial attributions.

The middle-class nature of the Dutch art market gave prints an increasing importance. Painters produced works that could be reproduced in great number and marketed to a wide variety of customers. The creations of the best artists were no longer locked up in the private collections of the wealthy. Prints, which can be transported more easily and more cheaply than paintings, allowed styles and innovations to spread throughout Europe. Rembrandt owned and studied numerous Italian and German prints. Prints increased the exchange of artistic ideas across nations: the costly artistic pilgrimage to Italy, once considered a necessary part of a painter's education, declined in importance. The European art market became more integrated, for both buyers and creators.

Like the Florentine Renaissance, the Dutch Golden Age fell victim to war and economic decline. The Dutch Republic was too small to compete militarily with England or France; the wars of the 1670s against France and England brought economic stagnation and high taxes. The art market collapsed, prompting many painters to take non-

artistic jobs to make ends meet. Many painters were either ruined or uprooted; even through the 1680s and 1690s the Dutch art market did not recover. It is estimated that artistic production in the 1670s was only one quarter of artistic production in the 1650s.[72]

The Dutch art world did stage a recovery but never reattained its former level of achievement. The Netherlands were on a long and slow path of economic and cultural decline. Other countries, such as England, mimicked Dutch innovations and took over as economic leaders. Many critical Dutch industries, such as the fisheries, tobacco processing plants, linen production, salt and wine exports, shipbuilding, the timber trade, and the carrying trade, began to experience unfavorable long-run shifts in the terms of trade. Jonathan Israel describes the decline of Dutch art as "a process moving together with the decline of the trading system, industries, and civic vitality."[73]

The Growth of French Art Markets

The eighteenth century saw the establishment of active art markets in a variety of European cities, but no dominant center or style emerged. Rome, London, Paris, and Venice, among other locales, all supported painters of note. The growing wealth of the New World gave birth to artistic traditions throughout North, Central, and South America. The importation of Chinese porcelain and styles led to a resumption of cross-cultural artistic exchange with the East. With the beginnings of the Industrial Revolution, the middle class took on a growing role in art markets, as exemplified by Josiah Wedgwood's campaign to market pottery to the English middle class.

The rococo styles of the eighteenth century shared themes with the contemporary postmodern. Creations from this time—whether in the visual arts, literature, or music—tended to be playful, self-referential, and ironic. Rococo painters reversed and equalized the qualities of high and low, light and dark, and male and female. Jonathan Swift and Lawrence Sterne brought self-referential styles to literature; Mozart quoted his own *Marriage of Figaro* in *Don Giovanni*.[74]

Unlike the contemporary postmodern, which is primarily a creation of the market, the eighteenth-century baroque and rococo arts embodied both market and governmental influences. The vibrancy and

splashiness of the new styles pleased large numbers of consumers. Fragonard and Boucher appealed directly to the senses and the viewer's sense of fun. At the same time frilly and elaborate styles played to royal courts and to a nobility with increasing purchasing power. European royalty used art to demonstrate power, wealth, and splendor.[75]

Market-sponsored styles outcompeted government-sponsored styles only with nineteenth-century French art and the impressionist movement. Ironically, the French government had attempted to centralize French artistic taste since at least the seventeenth century. The Académie des Beaux-Arts—the locus of governmental control—ran the official art school, the French Academy in Rome, the public Salon exhibitions, and the major network for picture sales. The Superintendent of Buildings, Arts and Manufactures bought many Salon pictures for government buildings and public spaces.[76]

The French Salon did support a number of notable painters, such as Delacroix, and we should not view the Salon in wholly critical terms. Even some of the more controversial Salon painters, such as Alexandre Cabanel, have experienced a partial revival in reputation. Furthermore, the ability of the Salon to "centralize taste" was due partly to the excessive conformity of market opinion at that time, and cannot be attributed solely to government pressure. Nonetheless the Salon was revealed as a fundamentally harmful institution when the new style of impressionism led to a critical shift in the art market. The Salon fought for established interests and refused to promote or sanction the most significant artistic revolution of the nineteenth century.

The Barbizon School, the impressionists, and the post-impressionists, now France's most illustrious painters, found the Salon to be a hostile opponent. French painters of the nineteenth century had to rebel against the Salon, and to make a living they helped create the modern art market, with its galleries, dealers, and aggressive marketing and distribution. The French cultural blossoming of the nineteenth century—impressionism, post-impressionism, Ravel and Debussy, Balzac, Hugo, Zola, and Proust—met with explicit opposition from the governmental academies, or at best, was ignored. Impressionist painting prospered only once it established its own independent networks of marketing and distribution.

French painters liberated themselves from the Academy and Salon only slowly. Partial independence came in the mid- to late eighteenth

century when some painters found independent commissions without government assistance. Chardin found enough private commissions to stick with his passion for still lifes. By 1765, Fragonard, no longer wishing to paint historical scenes for the Academy, turned to private commissions. He then enjoyed greater freedom to paint the dreamy and sensuous pictures for which he became famous, as well as a variety of landscapes, portraits, and sketches.[77]

The nineteenth-century Barbizon School moved away from the old order a bit more. Painters such as Daubigny, Théodore Rousseau, Millet, and Corot—all working outside the artistic establishment—pioneered a novel use of light and shade in their landscapes, and laid the foundations for the later impressionists. Many of these painters pursued active careers producing small decorative items, such as prints, lithographs, and porcelain decorations, for a growing middle class. The Barbizon school was rooted squarely in popular culture. Meanwhile, Gustave Courbet drew on the Dutch landscape tradition and took the best from the earlier Salon works. His pictures appear conservative to the modern eye, but in their time they helped give birth to the artistic avant-garde.[78]

The Academy opposed the Barbizon School. The Superintendent of Fine Arts had noted: "This is the painting of democrats, of people who don't change their linen . . . this art disgusts me." The Barbizon school nonetheless obtained a foothold in the art world. When the Academy lost some of its control over the Salon, some Barbizon paintings were admitted. For the most part, however, the Barbizon School artists, like Courbet, turned to the growing independent art market. Courbet even organized a one-man show of his own works, held in the shadow of the government's Universal Exhibition of 1855. When these painters could not find buyers in Paris, they sent pictures to foreign exhibitions and promoted their works abroad.[79]

Some artists, such as Honoré Daumier, used the print market to reach customers. The growing ability to sell to a mass audience expanded the artist's role as social critic and champion of the oppressed. Daumier, who produced an average of two lithographs a week, did not depend upon the very wealthy or upon the government for his sustenance. He was free to mock the upper classes, rather than paying homage to them. Anarchist and socialist artists became commonplace.[80]

Despite these decentralizing trends, the absence of an established network of dealer galleries made the Salon the center of Parisian art life. The persecuted painter Gustave Courbet noted: ". . . to make a name for oneself one must exhibit, and, unfortunately, that [the Salon] is the only exhibition there is." The Salon selected paintings for display at periodic exhibits, usually held yearly. The French government tried to centralize market taste, and private customers acceded rather than resisted.[81]

The biases of the Salon shaped the art of many inferior French painters. Salon judges preferred large canvases, with stuffed, overfilled portrayals of historical and mythological scenes. Landscapes and still lifes were frowned upon. Prevailing canons of taste were highly centralized. The impressionists and post-impressionists were turned away, not only because of their choice of subject matter, but also because their use of color, light, and space ran contrary to prevailing conventions. Cezanne, for instance, was accepted by the Salon only once in his career, despite his persistent attempts.[82]

At times the government-run art establishment relented in its opposition to the new styles, such as when Napoleon III helped organize the Salon des Refusés in 1863. Yet subsequent governments returned to their openly hostile attitude. The impressionist works accepted in the 1860s stood only halfway between the new artistic revolution and the older, more academic styles. Some could be tolerated by the critics. By the 1870s, however, the impressionist style was fully formed and stood as a slap in the face to the establishment. The Salon jury made no secret of its dislike of these works. The Salon also discouraged other (non-impressionist) innovators, such as Henri Rousseau, Odilon Redon, and Auguste Rodin.

Paul Gauguin wrote bitterly about the centralist tendencies of the Salon and government art funding:

. . . Happy were the painters of ancient times who had no Academy. For the past fifty years things have been different: the State increasingly protects mediocrity and professors who suit everyone have had to be invented. Yet alongside those pedants, courageous fighters have come along and dared to show: painting without recipes. Rousseau, whom they jeered at, is now in the Louvre in spite of them; Millet too, and what insults didn't they

heap on that great poet who nearly died of hunger. Remember the Exhibition of 1867: Courbet and Manet put on a show at their own expense on the Champs-Elysées. Again it is they who are the winners, always they who stand tall alongside the Institute. Where are the artistic glories on which France can pride itself? Among that Pleiades of unsung thinkers with royal instinct: Rousseau, Delacroix, Millet, Corot, Courbet, Manet—all of them scorned in their own day.

Gauguin later added: "The talent of the independents and the example they set suffice to show the uselessness of a budget and the futility of an official Department of the Arts. Courier's words are still true: 'What the State encourages languishes, what it protects dies.'"[83]

The rejected impressionist outsiders began to organize their own marketing and exhibitions. In 1873 Monet suggested a show of "independent art." Pissarro, Renoir, Sisley, Degas, and Morisot responded enthusiastically. Only Manet, the oldest of the group, still attempted to achieve Salon acceptance. The first independent exhibition failed to draw large crowds or to generate profitable sales, partly because of the economic depression of the early 1870s. Nonetheless the group persisted and organized several more exhibitions over the next few years. The fourth display in 1879, and three succeeding shows, were a success. Degas, Pissarro, Monet, and Gauguin, among others, turned a profit on their sales.

Despite these achievements, the ranks of the independent exhibitors dwindled due to defections and squabbles. By the time of the fourth show, Cézanne, Sisley, and Renoir had left in desperation and attempted to join the Salon. Cézanne and Sisley were rejected and Renoir was accepted only because he moderated his style. Monet also failed in his later attempts to rejoin the Salon, receiving only one acceptance.[84]

Just as these defections were occurring, French artists discovered that Salon acceptance was becoming less important. The art market began to change in the 1870s. Artists could now live, and indeed prosper, by selling paintings to private buyers outside the Salon network.

Entrepreneurial art dealers founded the modern art market. They bought directly from artists, built up a stock of an artist's work, and commissioned monographs on the works and lives of the artists they

promoted. Art marketing advanced to a degree that the Florentines or the Dutch would not have imagined. In the 1880s successful exhibitions of the "independents" were held in America and throughout Europe. The dealer Durand-Ruel staged exhibitions in Rotterdam, Berlin, London, and in New York's Madison Square Garden. The Americans, new buyers in the market for European art, were especially keen on Monet's haystacks and cathedrals. Shortly thereafter, Russian businessmen became loyal customers as well.[85]

Paul Durand-Ruel led the new breed of entrepreneurial art dealers. Taking over his father's business, the young Frenchman staked his career and livelihood on the Barbizon School and on Courbet before they were widely accepted. Durand-Ruel later dealt in Manet and in the impressionists. For many years he was the sole prominent buyer of impressionist paintings, and he supported many artists single-handedly, such as Monet. Monet quickly became a wealthy man, enjoying a yearly income several times that of a doctor's. Durand-Ruel's gamble paid off in the 1880s when the impressionists were recognized as the cutting edge of the artistic world. By this time both he and Monet had become the equivalent of multi-millionaires.[86]

Other dealers bid up rewards as well. Paul Gauguin started in the art world by serving as a middleman for Pissarro. Dr. Gachet, immortalized in the van Gogh painting that in this century sold for $76 million, was an early customer of Cézanne's. Vincent van Gogh's brother Theo dealt in impressionist paintings and used his earnings to help support his brother. Ambroise Vollard bid up picture prices by breaking down the exclusive dealership of Durand-Ruel. These dealers resold impressionist paintings to stockbrokers, department store owners, businessmen, and industrialists of the nouveau riche. By the 1880s, the Salon had lost its privileged status.[87]

Capitalist wealth lent support to the new artistic revolution in yet another way. Many prominent French artists lived off family funds for part of their careers. The list includes Delacroix, Corot, Courbet, Seurat, Degas, Manet, Cézanne, Toulouse-Lautrec, and Moreau. Monet also received initial financial support from his family, although his father cut off the stipend when he learned that Claude refused to break with his pregnant mistress. Auguste Renoir, who came from a working-class background, was one French artist who did not receive financial aid from his family. When Auguste died, however, he left a

considerable stock of his pictures to his son, Jean. Jean used this accumulated capital to support himself while becoming one of France's greatest film directors (e.g., *The Rules of the Game, The Grand Illusion*).[88]

France's new wealth brought unprecedented opportunities for public entertainment. The growing art market was accompanied by a plethora of fairs, circuses, cabarets, casinos, skating rinks, dance halls, race tracks, pleasure boats, seaside vacations, and cafes. The world's first department store, the Bon Marché, allowed customers to make all of their basic purchases under one roof.[89]

Modern techniques for painting display were in fact taken from the practices of department stores. Department stores offered attractive merchandise displays to lure buyers into the store and increase the visual appeal of their products. Art dealers observed the success of these methods and began to follow suit. Dealers, eager to make a profitable sale, suddenly hung art in spacious, luxurious settings. Prior to this time, the prevailing practice was to cram as many pictures on a wall as possible.[90]

The impressionists saw the new world of French leisure as a subject to be painted rather than as a symbol of decadence. The early rebellions against the historical and military paintings of the Academy had produced still lifes and landscapes. The impressionists, in contrast, portrayed the delights of the leisure time afforded by capitalism, now being enjoyed by a growing middle class. Renoir painted the cafe, the garden, and the boating trip; Degas painted horseriding and the dance; Monet painted the railway station and the trip to the countryside; and Seurat painted the outing to the park. Toulouse-Lautrec, Degas, Manet, and Renoir were all enamored of depicting "ladies of the evening." As with the Florentines and the Dutch, the vitality of art was linked to a capitalist culture of wealth and conspicuous consumption.

New capitalist technologies gave further support to French painting and the impressionists. The tin paint tube, introduced in the 1840s, allowed the artist to bring his or her work outside and leave behind the falseness of studio light. (Before the invention of the tube, paint was transported awkwardly in small laced bags made from pig bladders.) Paint preparation ceased to be a major chore requiring specialized expertise, and prepared canvases became available. Business entrepreneurs packaged arts materials in ready-to-use form—artists could now buy an outdoor painting kit, complete with easel, colors, and parasol. The

Barbizon School painters were among the first to take advantage of the new equipment, and the impressionists picked it up with even greater enthusiasm. Jean Renoir had quoted his father Auguste as saying: "Without paints in tubes, there would have been no Cézanne, no Monet, no Sisley or Pissarro, nothing of what the journalists were later to call impressionism."[91]

Industrial technology led to the discovery of new pigments. The impressionist palette used pigments based on synthetic inorganic materials, such as chromium, cadmium, cobalt, zinc, copper, and arsenic. The materials for these colors came from the expanding chemical and metallurgical trades in France and Germany. The complexity of color manufacture led to the rise of specialist manufacturers, whom the impressionists patronized eagerly. They could now fill their paintings with bold blues, reds, yellows, and purples—colors that were previously unavailable.

The new technologies strengthened decentralist tendencies in the art world. Painting was no longer tied to an expensive and well-maintained studio. The bohemian artist, who now needed little more than a temporary space or a small room, was liberated further from the establishment.

Burgeoning art markets supported a growing diversity of style over the next several decades. After impressionism came post-impressionism (Gauguin and Cézanne), pointillism (Seurat), the "Nabis" (Bonnard and Vuillard), poster art (Toulouse-Lautrec), the fauvists (early Matisse, Derain, and Vlaminck), and eventually cubism (Picasso and Braque), surrealism (Dali, Ernst, and Magritte), abstraction (Kandinsky and Miró), and new varieties of figurative painting (Balthus). Painters from all over Europe flocked to the rapidly growing Parisian art market. The artists who emigrated to Paris in the early years of this century include Gris, Braque, Mondrian, Brancusi, Picasso, Ernst, Dali, Chagall, Miró, and Giacometti.[92]

Parisian dealers aggressively promoted these artists and helped them earn a living. Daniel-Heinrich Kahnweiler had one of the most successful stables of artists; in 1913, for instance, he was the primary dealer for Picasso, Braque, Derain, and Gris. He marketed these artists not just in Paris, but also through Europe and in the Americas. Picasso even once remarked: "What would have become of us if Kahnweiler hadn't had a business sense?"[93]

The World of Modern and Contemporary Art

The institutions of the modern art world, as we know them, were largely in place by the 1920s. Picasso, perhaps more than any other artist, embodied the new approach to marketing. He attained riches and fame early in his career, and spent the remainder of his life painting when and what he chose. Picasso used dealers, auctions, and public events to orchestrate well-designed campaigns of self-promotion. Picasso was the first painter to be a media celebrity throughout the Western world. Rather than selling out, he used the mass media to cement his artistic freedom.[94]

Modern Western art was by no means restricted to Paris. The Russian constructivist movement in the visual arts (e.g., Malevich, Rodchenko) developed abstract painting and poster art in new directions. Constructivism, commonly believed to be a product of the Bolshevik revolution, already had flowered in Tsarist Russia. The Communists funded this movement at first but smashed it shortly after they consolidated their power. Similarly, German and Austrian art flourished in the teens and twenties, although they were later crushed by the Nazis.[95]

The early wave of the American avant-garde, such as Marsden Hartley, John Marin, and Thomas Hart Benton picked up Continental influences during their travels to Europe. The famous show at the New York Armory in 1913 spread the influence of modern art more widely in America. Monet, Cézanne, van Gogh, Gauguin, and others were largely unknown in the U.S. until this show arrived. Viewers found the works of the surrealists, such as Duchamp, to be even more daring. Most of the press and public regarded the works as pathologies, but it appealed to many of the more insightful American collectors and painters. The American contribution to modern art was rooted in this show.[96]

Market demand was shifting more and more to the United States. America's industrial wealth created a new class of collector—the private businessman who amassed collections comparable to or better than those of earlier kings. Barnes, Hearst, Mellon, Morgan, Frick, Gardner, Rockefeller, Whitney, Kress, Dale, Clay, Carnegie, Widener, Quinn, Freer, Walters, Guggenheim, and others spent their money on a wide variety of artworks, including those from Asia, Africa, and the

Americas. Many of these names are now attached to America's leading museums. The Mellon, Kress, Dale, and Widener collections form the bulk of the National Gallery in Washington.

American painting led the art world in the 1950s, after the second World War removed Paris from its role as the center of Western art. New York City, and Manhattan in particular, became the new focal point. Mondrian, Léger, Chagall, Gropius, Moholy-Nagy, Mies van der Rohe, Ernst, Tanguy, Breton, and Duchamp—all Europeans—had fled to New York to escape the war and chaos. Today many French commentators and politicians complain that Americans "dump" their movies in France, but at that time the French and European painters invaded the American market in large numbers and sold their paintings at relatively low prices. The American painters benefited from the cross-cultural trade in ideas.

The growing prestige of American painters secured New York's place as center of the art world. The cutting edge was abstract expressionism, a new approach to painting drawn from French surrealism, abstract art, the Mexican muralist tradition, and earlier American styles. Pollock, de Kooning, Rothko, Kline, and Newman, poor bohemians, became world celebrities in the 1940s and 1950s. When *Life* magazine publicized Jackson Pollock and suggested he might be the world's greatest painter, American art had linked its future to media promotion. From the beginnings of abstract expressionism, the mass media, in the form of national magazines, proved to be strong boosters.[97]

Pop art followed in the late 1950s and 1960s, again centered in New York. Many of the pop artists drew directly on their commercial backgrounds. Andy Warhol started in fashion illustration and commercial art. In addition to creating advertisements, he arranged window displays at department stores, designed a record jacket for RCA, and designed stationery for Bergdorf Goodman and Christmas cards for Tiffany's. James Rosenquist drew on his experience in publicity graphics, shop window design, and billboards, which he made for both Hollywood movies and for Hebrew National hot dogs. Robert Rauschenberg and Jasper Johns arranged shop windows for Tiffany's, often working together under the single name of Matson Jones. They also collaborated to design an award-winning cover for a medical magazine. Tom Wesselman dabbled in cartoons and advertisements, and Claes Oldenburg worked for an advertising agency. Roy Lichtenstein

borrowed from the comic book designs sold to children. These artists, well aware of their roots, paid homage to modern commercial society with both ironic and serious intents.[98]

Like Picasso, Warhol shamelessly manipulated the media to his own career advantage. Warhol marketed images, including his own. He was prominent in movies, television, and print media once he reached stardom. Warhol even called his studio The Factory, to point out the link between industrial and artistic production. He was obsessed with obtaining fame in a modern commercial society, and considered Marshall Field—the entrepreneur behind the department store—to be his benchmark standard for national recognition.[99]

The Dominance of Distribution

Today's contemporary art scene places marketing and distribution at the forefront. The Florentine and Dutch practices of direct sale to buyers, attenuated by the rise of French art dealers, have dwindled even further. Artists now connect with buyers by first placing their works in galleries and museums. Galleries aggressively promote the artists in their stable. We rely increasingly on distributors and intermediaries to forecast, and indeed shape, future market demands.[100]

Art critics and journalists have assumed roles of increasing influence. As the number of artists, intermediaries, and active art scenes grows, no single buyer or gallery owner can survey the entire market on his or her own. When deciding what to look at, we place increasing weight on reviews and outside third-party opinions. The reviewers themselves rely on other third-party opinions when choosing what to review. Buyers ultimately rely on a complex network of decentralized scouting to push information about the best to the top.

The growing strength of distributors and intermediaries, despite its drawbacks, has improved the art market in most respects. Intermediaries have strong pecuniary incentives to spot the underappreciated in advance. Large numbers of galleries, auction houses, museums, art magazines, and professional and part-time critics search for the best works and publicize them. Buyers at the top end of the market have a better eye for quality than ever before. The case of van Gogh, who was largely unknown for most of his artistic career, has become increasingly unlikely in today's art world.

Modern marketing and distribution networks, by expanding the eligible market, have increased the fame and money that accrue to successful creators. Today most young up-and-coming artists command high prices, supporting themselves through their art with increasingly greater ease. Even painters of only moderate renown commonly break six figures for selling a work. Jean-Michel Basquiat, an unorthodox graffiti artist of Haitian and Hispanic background, became an art world craze in his early to mid-twenties.

The most established painters and sculptors produce for an international clientele; the New York auction houses use electronic boards to immediately convert auction bids into the world's major currencies. Japanese buyers, although they concentrate their attention at the top end of the market, have bid up returns for artists across the spectrum.

The upper middle class participates in the art world more extensively than ever before. Beautiful contemporary prints by the world's leading artists can be bought for no more than a few thousand dollars. Most artists practice extensive price discrimination—they carve out separate bodies of work, such as prints, that can be sold at lower prices to the less wealthy. Art world distributors do not aim to sell exclusively to the most wealthy clients. Most of the items auctioned at Christie's or Sotheby's sell for no more than a few thousand dollars.

Contemporary art markets support a wide variety of styles, even in a supposed age of "mass culture." Soho galleries promote work that appeals to the tastes of specialized minorities, rather than to the average viewer. More accessible modern styles, such as Chagall or Picasso, are presented on New York City's 57th Street or Madison Avenue. At the popular end of the market, works by Norman Rockwell and Leroy Nieman are widely available. Both purely abstract and representational art have managed to flourish and grow at the same time.

The pressure of mass culture has not dented the continued progress of avant-garde styles. Morley Safer, in his 1993 "60 Minutes" segment on modern art, ridiculed Robert Ryman for his "excessive" use of the color white and Cy Twombly for his pencil-like scribbles. Safer proposed that the entire enterprise was a fraud. Although most of the American public probably holds Safer's attitude, a first-rate Twombly painting nonetheless sells for several million dollars. Twombly won his artistic independence long ago, despite standing outside the bounds of mass taste. Even a Twombly sketch can cost more

than most people earn in a year. Those, like Safer, who believe that "anyone could make a picture like that" cannot explain why competitors have not pushed down profits. Modern abstract art requires both inspiration and technical abilities of a very high order.

The contemporary art world has intertwined art preservation and aggressive commercial marketing like never before. Museum exhibits of art, often funded by corporate sponsors, are marketed with an unabashed commercialism. Endowments and fundraising campaigns have brought excellent museums to even many smaller American cities, such as Minneapolis, Indianapolis, or Buffalo. The traveling exhibit of the Barnes collection sold tickets through Ticketmaster outlets, as a rock concert would do. The apogee of the commercial art exhibit has been reached in modern Japan, where nearly half of all art exhibits are held in department stores. The exhibits bring in customers and provide advertising and favorable public relations. In Japan golf courses serve as sculpture gardens and corporations provide art galleries for their employees. In Germany hotel proprietors use their space to provide galleries of contemporary art.[101]

Art marketing has taken on an increasingly pluralist and multicultural emphasis. Women's quilts, African-American folk painters, "outsider art," and "naive" art now form an important part of the market. The coffee-table art book, with its vivid color plates, has broadened our appreciation of diverse artistic traditions. The ethnic arts of non-European cultures, from the early pre-Columbians to the modern Inuits, are achieving long overdue recognition. As the cost of travel falls and many art-lovers go to Tokyo and Taipei, Westerners are learning that the Eastern traditions of painting, printmaking, and calligraphy are not inferior to the Western visual arts. The myth that Asian artists merely copied their predecessors for hundreds of years is finally dying, largely due to the lower costs of reproducing and disseminating art.

The status and participation of women in the art market has risen steadily throughout this century. Prior to the rise of impressionism, few female painters or sculptors were critically ranked with their strongest male counterparts. Today, Georgia O'Keeffe, Frida Kahlo, Barbara Hepworth, Louise Nevelson, Eva Hesse, and Susan Rothenberg, among others, have all received critical recognition at the highest levels. Women's growing role in art markets has resulted in part from the greater availability of birth control, the possibility of economic and

social self-sufficiency, and from the greater ease of obtaining artistic training from outside the family. Prior to the rise of art schools in the late nineteenth century, nearly all prominent female artists had artists as fathers or close relatives, unlike their male counterparts. The pool of potential female artists was restricted largely to those who remained un- married, could not have children, and grew up in artistic families.[102]

Insiders commonly criticize the trends, the favoritism, the fawn- ing, and the sexual politics found in the contemporary art world. The prevalence of distributional networks does produce at least one system- atic disadvantage—the system selects against artists who are unskilled at promoting themselves or at navigating the appropriate distributional obstacles. A greater absolute number of artists will be discovered, but some particular kinds of artists will fall through the cracks. Either some artists cannot cope with the system or they are discouraged from ever trying in the first place. Not all creators have the self-promotional ener- gies of Andy Warhol or the business acumen of Roy Lichtenstein.

In appraising the contemporary art world, however, we must consider whether feasible alternatives to commercialization could give shy and retiring artists a stronger chance. The presence of aggressively commercial intermediaries, such as dealers, on net tends to relieve artists of self-promotional burdens. The rise of the dealer represents an increase in the division of labor, thereby unbundling the functions of creator and marketer to a greater degree. Artists must still promote themselves to dealers, but dealers, a relatively well-identified group, provide an easier target than an anonymous mass of art buyers. Furthermore, the dealer has a profit incentive to seek out the artist. Without dealers, artists who shy away from self-promotion probably would never come to the attention of potential buyers. With dealers, artists can withdraw from the everyday struggles of the commercial mi- lieu, if they so choose. Willem de Kooning, for example, continued to paint even after contracting Alzheimer's disease, and his dealers contin- ued to promote his works.

A second and related criticism of the contemporary art world cites the increasing difficulty of becoming a successful artist. Most painters— in fact the overwhelming majority of those who try—lose rather than make money. Large numbers of individual failures, however, do not necessarily indicate a problem with the system. The massive number of forgotten painters reflects the large number of individuals who, seeking

profit and fame, have striven to become eminent artists. Naturally most of these individuals fail, giving rise to a skewed distribution of returns. The largest prizes accrue to a very small percentage of the contestants, as in professional sports. The huge number of failures shows that the process is sampling a very large pool of potential talent.

The difficulty of breaking into the market reflects the more competitive conditions of a larger and more lucrative market. We find a greater number of individuals who work as professional artists than ever before; the absolute quantity of successes has risen rather than fallen. Success nonetheless appears more difficult because the number of competitors has risen even more rapidly than the number of winners. Free and wealthy societies allow a very large number of would-be artists to make a stab at their aspirations. A progressing culture often will exhibit a simultaneous increase in the number of artistic successes and the number of artistic failures.

More artists make it than ever before, but it is harder than ever before to make it as an artist. This apparent paradox can be illuminated by an analogy from professional sports. In the last decade it has become harder for any single individual to succeed as a professional athlete than ever before. An individual with a given level of skill had a better chance of playing a sport at the major league level in 1950 than today. At that earlier time pro leagues were less competitive. Today the struggle to reach the top of the sporting world is much tougher, but this indicates the growth and success of sports, not their decline. The number of players, the number of stars, and the overall quality of play all have risen. The increased difficulty of "making it" often indicates that a talent sampling mechanism is working rather than failing.

The marketing efforts of distributors and intermediaries provide further benefits by helping refine market taste. Dealers, gallery owners, art critics, and the auction houses spend much of their time in dialogue with buyers and viewers. Intermediaries use their specialist knowledge to cajole, explain, and illustrate the virtues of diverse artistic styles. The modern art market not only brings art consumers in touch with the artworks that will please them, but also has achieved remarkable successes in educating buyers towards new tastes. Each set of new styles, although regarded as inaccessible by the previous generation, has been embraced by the next. Contemporary art, while still a minority taste, commands a large and growing following. Jasper John's *Out the Window*

sold for $2,250 in 1960 and $3.63 million in 1986. His *False Start,* a work that puzzled viewers at first, later auctioned for $17 million. Cindy Sherman, Eric Fischl, Julian Schnabel, and Robert Gober are among the more recent notable artists who have relied heavily upon the propagandizing efforts of their dealers.[103]

The marketing of art arguably has not proceeded far enough. $17 million for a Jasper Johns, or $53.9 million for a van Gogh *(Irises),* strikes many observers as exorbitant, but consider these figures in context. Taking the richest 480 individuals in the world, $17 million accounts for about two percent of the average net worth. The entire auction market for the fine arts accounts for only one-half of one percent of the wealth of these individuals, taken as a whole. The marketing of art, despite its advances in recent decades, still has an immense pool of wealth to tap into.[104]

Current and Future Trends

The contemporary world of art has begun to diminish its reliance on geographic centralization. Art distributors and intermediaries perform many of the art support functions that once required proximity to a central city. Advertising, with its global reach, spreads the word of artistic success at progressively lower costs. Falling costs of transportation and high-quality color plate reproductions have reduced the need for geographic centralization. Artists can now learn from each other, even if they live at great distance. Fax machines, electronic technologies, and falling costs of communication decrease the costs of doing business outside of an economic center. As a result of these and other factors, New York has lost its previous position as the undisputed center of the art world. Competitors such as London, Cologne, and Los Angeles have carved out substantial niches and have revised our notion of an art world center. Agnes Martin and Georgia O'Keeffe moved to the American Southwest to paint, with no great damage to their careers.

The trend towards art world decentralization mirrors analogous trends in business (suburbs are replacing the center city), finance (off-floor trading is replacing centralized exchanges), and banking (regional centers and securitization are replacing big banks). Competitive forces tend to break down concentrations of economic activity, whether in art or in business defined more narrowly. In the art world the decentraliz-

ing factors have progressed more rapidly than the centralizing factors in recent years.

The development of new artistic media has contributed further to the decline in geographic centralization. Robert Smithson and Andy Goldsworthy have sculpted nature by producing large-scale works out of rocks, branches, and other outdoors materials. Christo wraps large-scale public objects, such as the Reichstag or the islands in Biscayne Bay of Miami; he sells his own prints and drawings to finance these multi-million dollar projects. These artworks are all tied to geographically favorable locations, rather than to the urban centers of the art world.

In the realm of photography, computer-aided processes for transforming and manipulating images are giving the "photographer" a more creative role. In the nineteenth century it had been predicted that photography would destroy drawing and painting, but now photography is starting to mimic them. Many photographers have started to pursue the artistic appeal of shaping and interpreting the images they have produced. This genre likely will be dominated by individuals with strong technical skills in digital technology, rather than by the established centers of photographic art.

Video art crosses the boundaries between mass media and the traditional visual arts. We typically think of television as a medium for situation comedies and mass culture, rather than a vehicle for the avant-garde. Nonetheless television, through the accompanying video cassette recorder, has given video art easy dissemination to its target audience. Not surprisingly, video art has flourished in Los Angeles, where many individuals possess the requisite skills of cinematography and film editing.

In the longer term, increasing ease of reproducibility may prove the most significant trend in the art market. The art world will undergo fundamental shifts once fully accurate three-dimensional reproductions become possible. Today prints and photographs can be reproduced with relative ease but we cannot yet capture paintings with equal verisimilitude. Holographic arts, digital computer arts, and CD-ROM reproductions of museum catalogs, however backward in their current state, hint at the future possibilities. Perhaps later generations will be able to own copies of their favorite artworks, visually indistinguishable from the originals, just as runs of a print resemble each other.

Universal art reproduction would prove a boon for art lovers and would revolutionize the market for new art. Artists could sell a given painting to large numbers of individuals, just as current prints are sold. Painting as a whole might become less avant-garde and more accessible, as painters strove to meet a broader market demand.

The world of art would both gain and lose, as implied by Walter Benjamin in his essay, "The Work of Art in an Age of Mechanical Reproduction." On one hand, original artworks would lose their unique aura. The visual arts, unlike music and literature, have never been dominated by technologies of easy reproduction. Even if reproduction technologies have generally favorable effects in the cultural realm, we may wish to have at least some genres, such as painting and sculpture, that are not dominated by reproducibility. Most ardent fans of contemporary art appreciate its refusal to bend to the tastes of a mass audience.[105]

On the other hand, art purchasers would face a much richer menu of choice. Everyone could own a visually faithful Cézanne painting or work of their choice. Contemporary artists would face stiffer competition from past masterpieces, but they would innovate and shift the terms of competition. Just as printing has not stifled the development of literature, or recording has not spoiled music, we should not expect fully accurate reproductions to ruin the market for painters. Even the artistic avant-garde can be expected to flourish, just as the printing press has stimulated the development of esoteric and less popular written styles.

From Bach to the Beatles:
The Developing Market for Music

The music market has been marked by extremes of fame, riches, and styles. Multiple and changing sources of funding have encouraged the diversity of the field. Churches, concertgoers, sheet music sales, radio, and sales of electronic reproductions (LPs, cassettes, and CDs) all have played central roles in supporting musical production. Each means of product distribution, by appealing to different market segments, has heralded economic and stylistic revolutions in the music market. The family evening performance of the string quartet induced one set of styles; Top 40 radio induced another.

New media of presentation also have supported ongoing musical innovation. The Beatles, whose work is built upon the technology of recording, joined a music market that included Beethoven, whose genius is captured largely by notation on paper. The printing press gave us sheet music to disseminate classical compositions, electricity gave us rock and roll. Contemporary techniques of electronic sampling have given us rap music and Karlheinz Stockhausen. Musicians, like some artists but unlike most writers, often create products that were simply technologically impossible for the previous generation.

Multiple and changing means of product delivery distinguish the history of the music market from the history of literature or art markets. Throughout Western history most literary creations have been consumed through borrowing or purchasing books, or through visiting the theater. In the visual arts we purchase pictures and sculpture, or we publicly view the purchases made by others. Advanced computer technologies may revolutionize these markets at some time in the future, but the basic means of product delivery have remained broadly constant

for many centuries. We cannot make the same claim for music, where the means of product delivery have changed radically and repeatedly.

Music also differs from painting or literature in its potential accessibility. Many individuals do not buy many books or go to many art museums, but the passion for music is widespread and nearly universal. Almost everyone is at least a casual listener and buyer, and large numbers of individuals are dedicated collectors of their favorite musical products. We can work, drive, or carry on a conversation while listening to music; these activities are more difficult when we are reading a book or viewing a painting. The auditory nature of (some kinds of) music can be enjoyed at a less demanding level of concentration, implying that a good song can be consumed more easily than a good painting or novel. Music therefore has assumed a larger role in popular culture than literature or painting has, and individuals are more likely to have strong opinions about music than about other cultural fields.

Yet not all music is easy to enjoy. Composers have used musical languages of extreme complexity to produce some of our least accessible cultural creations. Many compositions cannot be comprehended without special training or many hours of repeated listening. Even highly educated consumers who enjoy modern art and read James Joyce often find Elliott Carter and Pierre Boulez to be puzzling or perhaps even painful to listen to. Composers of contemporary "classical" music have not made the headway that their peers in literature or painting have enjoyed. Contemporary music, depending on genre, is either the most or the least popular of the these three arts.

The quantity and diversity of musical production skyrocketed once the technologies of recording and radio lowered the cost of disseminating music. We have seen a simultaneous spurt in new, popular genres (e.g., rock and roll), the preservation of older styles (e.g., Bach), and the exploration of new, often obscure facets of composition (e.g., Milton Babbitt). Each branch has been able to pursue its own internal logic of innovation, bringing about an especially pronounced split between high and low musical culture.

Robert Frank and Philip Cook, in their recent book, *The Winner-Take-All Society,* associate an increase in reproducibility with a decline in diversity. Building on Sherwin Rosen's seminal article, "The Economics of Superstars," Frank and Cook argue that the ability to reproduce and sell a "superstar" (e.g., Michael Jackson) to all listeners al-

lows consumers to cease purchasing the product of lesser musicians. As the history of recording has developed, however, consumers have not been discouraged from supporting "lesser" artists. Rather, listeners have different tastes and disagree about which artists are the lesser ones; recording has allowed non-mainstream musicians to reach larger audiences and support themselves with greater effectiveness. In contrast to Frank and Cook, I present reproducibility of the product as a force supporting cultural diversity.[1]

This chapter also provides support for the basic themes of commerce and cultural optimism, and illustrates the mechanisms through which markets influence culture. In addition to examining the role that markets have played in supporting notable music, I focus on two further themes. First, differences in markets have proven significant in shaping music, both across countries and across eras. Second, economic forces have played a prominent role in the split of high and low culture that marks the contemporary musical world.

The Rise of Western Music

Like many artistic forms, the history of Western music has deep roots in the Renaissance. Renaissance music flowered first through the church music of northern France and the Low Countries. Dufay, Ockeghem, Desprez, Isaac, and others developed musical polyphony—the simultaneous presentation of more than one musical line. Franco-Flemish polyphony flourished in the most commercially and intellectually vibrant centers of medieval culture, such as Paris and Burgundy. Active traditions of church and court patronage supported composers and placed musical resources in their hands. Working within the constraints placed by the church, these composers laid the melodic and rhythmic foundations for the later works of Monteverdi, Bach, Mozart, and Beethoven.

The rise of literature and the rise of polyphony were intertwined from the beginning. The preservation and dissemination of polyphony required advances in notation and printing; the new music was too complex to be preserved by memory. Western classical music therefore had to stake its fortunes on the ability of notation to capture and transmit the composer's ideas. First the copyist and then the printing press

helped market and disseminate European music. These institutions took musical ideas out of the church and allowed them to be shipped and traded to cities and into the home.[2]

Financial support for musical composition developed more slowly than for the visual arts. Renaissance musicians usually depended upon churches, courts, or municipal governments for their support. They could not sell their product in a market thick with wealthy private buyers.

Economic factors help explain the slower growth of the music market. Early music, as a commodity, was neither durable or reproducible. Printed sheet music remained costly and did not successfully penetrate the music market until the eighteenth century. The performance could be sold in lieu of the composition, but performances tended to be expensive, unique events. Unfortunately for the composers of the time, wealthy Renaissance merchants were more likely to commission a painting than a composition. The painting could be owned, repeatedly shown off, and later resold, unlike the music. The financial incentive to commission a composition, which can be enjoyed by any audience member, was weaker. Paintings were closer to private goods, and musical performances were closer to public goods.

The most prominent early composers earned less than their peers in painting or sculpture, and enjoyed lower social status. Claudio Monteverdi was considered by many to be the best composer of the late sixteenth and early seventeenth centuries, but he could not dictate his terms to patrons. He left the Mantuan court a poor man, despite twenty-one years of service. Only at the age of forty-six did he achieve financial security by obtaining an appointment at Venice.[3]

Renaissance and baroque composers relied upon geographic mobility to achieve a moderate degree of creative freedom. No single market was competitive but a well-known composer and performer could choose among markets. Many of the best Franco-Flemish composers were bid away to foreign courts, especially to Italy, in search of higher pay and greater job security. The mobility of composers spread polyphony throughout Europe. Dissemination of Franco-Flemish innovations formed the basis of Italian vocal music (Palestrina and Monteverdi), English Tudor music (Taverner, Tallis, Byrd, and Gibbons), and Germanic music (Schütz, Buxtehude, Telemann, and J. S. Bach).[4]

By baroque times, the Germanic lands, with their hundreds of autonomous localities, had become an especially important locale for itinerant musicians. Whereas cultural life in France and England was centered in Paris and London, the politically decentralized German-speaking lands were dotted with points of musical activity. Musical jobs were more plentiful and offered better working conditions. The influence of the Lutheran religion, which favored music as a source of religious edification, also gave musicians higher status and influence in Germany than they found elsewhere.[5]

Schütz, J. S. Bach, and Telemann all took advantage of Germanic music decentralization and moved several times to seize superior opportunities. Johann Sebastian Bach's first church post, at Arnstadt, eventually proved burdensome. The choir was poor, the other musicians were uncultivated, and one irate musician even attacked Bach with a stick. Bach soon moved to another church post in Mühlhausen. But there the pay was low and the prevailing faith was pietistic, which conflicted with Bach's Lutheranism. Bach moved to the ducal court of Weimar in 1708, thereby doubling his salary, achieving higher social status, and gaining the freedom to compose Lutheran church and organ music.

When the rulership of Weimar changed in 1715, Bach found his influence and freedom diminished. In 1717 he moved again to the principality of Cöthen, where he devoted his efforts to instrumental music, such as the Brandenburg Concerti. The new ruler of Weimar had Bach thrown into prison, hoping to prevent his departure. Bach did not concede and obtained his release after nearly a month of enforced confinement. Earlier, Johann Sebastian's father Ambrosius and kinsman Johann Christoph, both musicians, had been forced to stay on in Eisenach against their will, but the freedom of the musician was now somewhat improved.

After Cöthen Bach jumped to Leipzig in 1723, accepting a court post that placed him in charge of the church music for the entire city. There he composed his magnificent *St. Matthew Passion* and his *Mass in B minor*, large-scale works that required the musical resources of his new employment. Even at Leipzig, however, Bach was not fully happy, although he did not move again. At Leipzig Bach complained about his non-musical duties, having to flatter the local nobility, the musical ignorance of his employers, and the poor quality of the local singers.

Nonetheless Bach's Leipzig years were artistically and financially successful. Each of Bach's moves brought him an increase in pay and an improvement in working conditions.[6]

Musicians sought greater rewards and creative freedom by promoting the for-profit public concert. The Germanic lands were prominent in the rise of concert life. Frankfurt, Leipzig, Augsburg, Dresden, Strasbourg, Hamburg, Lübeck and other cities grew rapidly and developed a thriving commercial middle class in the eighteenth century. As part of a general cultural boom, regular public concerts arose as offshoots of church activities, theater performances, comedies, and operas. Lübeck merchants, for instance, began to fund organ concerts independently of the church. Lübeck citizens frequently went to these concerts on their way to trade in the stock market.[7]

J. S. Bach took advantage of the growing concert market only in his later years. When Bach felt frustrated with the Leipzig court and church, he turned to the Collegium Musicum, a private organization that gave public concerts. Without leaving his Leipzig post, Bach found in the Collegium another outlet for his enormous creative energies. He used the Collegium to premiere his secular compositions, such as his Peasant and Coffee Cantatas, and his effervescent pagan operatic cantata *The Fight between Phoebus and Pan*. By this time, Bach no longer needed to switch cities to augment his creative freedom.[8]

Bach pursued money with great fervor throughout his life. By the time had moved to Leipzig, his income was about 700 Thalers, which has been estimated as close to $70,000 in 1995 dollars. In addition to fulfilling his musical duties, Bach was paid to conduct musical services at funerals; in one of his letters he even complains about a decline in the city's death rate. Bach eagerly pursued outside income by conducting music for wedding ceremonies and dealing in musical instruments. Bach used some of the extra money to buy himself out of burdensome instructional duties, including a class of Latin that he was obliged to teach: Bach hired a stand-in teacher to cover the class.[9]

Georg Friedrich Telemann led the commercialization of German music with his frequent public concerts. The energetic Telemann presented secular works, sacred works, and commercial operatic productions in great number. Telemann targeted upper-middle-class audiences in Frankfurt and Hamburg, and did not rely on patrons. Telemann initiated the commercial emancipation of the German musician that

Beethoven was to complete. His catchy themes, encouraged by his desire to reach a large audience, make him a continuing favorite on classical radio stations today.[10]

Carl Philipp Emanuel Bach (son of Johann Sebastian), Johann Stamitz, and the Mannheim school composers also succeeded in writing full-time for public audiences. These musicians were not attached to a court or church authority, but relied on concerts for their income. Using their newly found freedom, they moved beyond the baroque, developed the form of the modern symphony, and paved the way for the musical breakthroughs of Haydn and Mozart.[11]

Composing for money was held in no shame, and the public concert spread throughout Europe. Wealthy countries that did not groom their own composers, such as England, imported them from outside with lucrative offers. Handel and Haydn were their two most notable imports. British conductor Roger Norrington said of Handel: "[the *Messiah*] was written for money . . . he was a commercial composer; if he were alive today, he'd be doing jingles for radio and television."[12]

Italian operas were among the most successful early public concerts. Commercial opera took off in seventeenth-century Venice, where the first opera house was built in 1637. It was followed shortly by others. Performances were staged for profit and the government provided no subsidy. As early as the seventeenth century, a city of 125,000 inhabitants supported more than six opera houses operating from twelve to thirty weeks per year. Opera became a spectacle and a public event, comparable to the role that cinema played in American life in the 1920s and 1930s.[13]

In contrast to the commercialized classical music of Italy, Germany, and Austria, French music throughout the seventeenth century and much of the eighteenth century was controlled by the state. The French musical Academy, established in 1570, enforced official canons of style and promoted works that glorified the King. The exclusive right to print musical manuscripts was awarded to a single firm, which choked off output. The composer Lully, appointed head of the musical Academy in 1672, shut down performances of those works he did not favor and subsidized works by himself and his friends. Whereas Venice usually had a dozen or so new operas a year, Paris had only one, usually by Lully himself.[14]

The Rise of Publishing and Sheet Music

The rise of music publishing transformed the music market in the eighteenth century. At first music printing had been slow to develop. Printing served as a means of preserving scores more than a means of marketing them. The complicated notation of composition kept costs high and caused music publishing to lag far behind book publishing. Renaissance music publishing often sought to glorify a patron with a special edition rather than to disseminate a composition. Even well into the eighteenth century, it was often cheaper to commission a new work than to obtain a copy of an old one.[15]

Only in the second half of the eighteenth century did publishing become the standard means of transporting and copying musical ideas. Technological advances made chordal figures easier to print, the falling price of paper made sheet music cheaper, and new methods of movable type, combined with improvements in engraving technique, made musical parts easier to reproduce and read. Before the end of the century, the publisher had replaced the copyist, dramatically lowering the costs of musical reproduction. It is no coincidence that the classical music revolution coincided with the rise of the book trade and the professional author.[16]

Telemann and C. P. E. Bach sold their scores to amateur musicians to play at home. They wrote for voice and keyboard with this amateur audience in mind; the main themes were easy to play and understand. Telemann even brought out a musical newspaper that offered new compositions and songs to private households on a subscription basis. Growing wealth increased the demand for musical instruments and sheet music, providing these entrepreneurial composers with a good living. Other composers earned their support by giving lessons.[17]

The rise of a bourgeois middle class in the eighteenth century brought classical music into many homes. Family members played music together after dinner, mixing piano, voice, and small string ensembles. Learning how to sing and play an instrument was a normal part of one's upbringing and started at a very young age. These family musical evenings provided a market for sheet music and a training ground for the next generation of composers.

Piano purchases helped sustain the new audience for classical music. As early as the mid-eighteenth century, most piano orders were

for middle-class households, not for the rich. Pastors, postal secretaries, managers, aldermen, bookkeepers, and other individuals from a growing middle class ordered pianos for their musical enjoyment. Pianos, like most other musical instruments in this era, were falling in price and improving in quality. The nineteenth-century German saying "Every house has its piano" was a considerable exaggeration, but it reflected the growing importance of domestic music-making.[18]

The Hausmusik tradition was strongest in the Germanic lands. Germanic culture, with its especially tight family structure, placed great importance on home activity. Compared to other European cultures, the Germanic family paid less heed to servants, neighbors, or even to extended relations. The family was a private sphere that provided friendship, socialization, and entertainment, especially through music. German and Austrian families provided the initial training grounds and audiences for the composers who later became prominent.[19]

Many generations of prominent Germanic composers—Bach, Haydn, Mozart, Beethoven, Schubert, Brahms, and others—started their musical training through their families. These individuals typically had extensive musical experience and practice by their tenth birthday. By the time they reached maturity, they were ready to walk into musical jobs and assume places as leading composers and instrumentalists. Music, like mathematics, usually requires a start at a young age, which gave an advantage to those cultures, such as Germany and Austria, which stressed home music-making.

The Economics of Mozart and Haydn

The careers of Mozart and Haydn illustrate the growing audience for classical music and the subsequent increase in creative musical freedom. Private commissions were replacing the old patronage system throughout eighteenth-century Europe. Princes, civil servants, concert entrepreneurs, parishes, and musical amateurs demanded compositions for festivals, peace-treaties, changes of council, marriages, and funerals. Composers stepped into this void to earn a living independent of patronage.

Early in his career Franz Joseph Haydn served the Austrian estate of Prince Esterházy. In return for a steady salary and quarters, Haydn

had to provide compositions and musical entertainment on a regular basis. But he also was obliged to wear white stockings and powdered hair, and he could not travel without his employer's approval. A previous post had forbidden Haydn to marry.

Although the Prince gave Haydn the opportunity of having his music performed, the position stifled Haydn's creativity. Haydn often tempered the innovativeness and the dissonance of his works to assuage his supporters. His brilliant *Sturm und Drang* period came to an end because the Prince told him to moderate his music. Haydn's compositions suddenly became less tragic and, to many, less interesting. Patronage also influenced Haydn's choice of musical forms. His many compositions for the baryton, an early and awkward variant of the viola de gamba, stem from the Prince's desire to play the instrument. When asked once why he had written no quintets, Haydn replied "Nobody has ordered any."

Since 1761 the Prince had held an exclusive dealing clause that prevented Haydn from working for others. But Haydn renegotiated his contract in 1779 and moved into a new world of commercial music. He was now a free agent who could sell to the highest bidder. His earnings skyrocketed and he reached a much wider audience, winning renown throughout Europe. When the Prince died in 1790, Haydn left the Esterházy estate and made the first of his concert trips to London to promote his music. The success of these ventures gave Haydn financial security equivalent to that of a modern-day millionaire.

Upon his later return to Vienna, Haydn again had patrons, but now with a new balance of power. One such patron, Nicolaus II, son of the earlier Esterházy, criticized Haydn's conducting. Haydn replied "Your Highness, that is my business." The Prince left the room furious but Haydn's position was secure.[20]

Like Haydn, Wolfgang Amadeus Mozart started his career in the remarkably fertile musical environment of Vienna. Vienna, probably the wealthiest and largest Germanic city at that time, supported a large number of professional musicians. The theater, courts, churches, dance-resorts, restaurants, and marching bands all supported an active and decentralized musical scene. Austrian Catholicism contributed to this climate by embracing a positive, life-affirming aesthetic. Salon demand spurred Viennese musical life even further. The especially cultured

Viennese nobility centered its social life around concerts in private homes. Many of the wealthier nobles even maintained their own orchestras and employed personal composers. Music-making was the center of Viennese social life from the lowest of social classes to the highest.[21]

Mozart, like Haydn, liberated himself from the constraints of patronage. Mozart was Konzertmeister at Salzburg from 1772–1781, but he made the time to write for numerous private commissions. Mozart eventually left the security of his city appointment to pursue lucrative market commissions full-time. After departing from Salzburg, most of Mozart's income came from piano concerts, for both the general public and for the nobility. He supplemented these receipts by piano and composition lessons, and by publishing his music.

Mozart enjoyed an upper-middle-class income throughout most of his life, and his career belies the myth of the starving artist. Mozart's financial "crises" came in the late 1780s when a variety of unfavorable factors converged. Mozart and his wife fell ill, and the Viennese economy was wrecked by the Turkish war, disastrously pursued by the emperor Joseph II. Many of the nobility—Mozart's customers—left Vienna or curtailed their demand for music. At the same time, inflation rose precipitously because the currency was debased to pay for the war. Even then Mozart's letters exaggerated his poverty. In Mozart's poorest year his income was nonetheless three times greater than that of a head physician at a Viennese hospital. Mozart lived in the best Vienna neighborhood, and neither he nor Constanze had to give up their personal servants. Insofar as Mozart suffered financial hardship, it resulted from his irresponsible spending habits. When Mozart died in 1791 he was receiving offers from London, Russia, Amsterdam, and Hungary. Mozart had become one of the most renowned composers in Europe and was on the verge of earning far greater wealth, just as Haydn did in London. Contrary to widely repeated myths, Mozart was not buried in a "pauper's grave," but rather he received the standard burial practices as had been dictated by the Emperor Joseph.[22]

Not all of Mozart's later income came through the market. In the last few years of his life, from 1787 to 1791, Mozart once again assumed an official post. He served as imperial *Kammermusicus* in Vienna, but

with modest obligations and a small salary. For the court he produced his minuets, German dances, and contradances—charming works, but hardly his best material. His greater works at this time, such as *The Magic Flute* and the *Requiem,* came from private commissions. Mozart directed his works to the audiences most likely to appreciate them and most likely to pay more in the future.

Most well-known composers distributed their works through sheet music by the 1770s. Mozart was slow to follow, partly because his father, who belonged to an earlier era, discouraged him from seeking these outlets. Many of Mozart's early compositions, especially the larger-scale works and symphonies, had not been published. Mozart shifted course in the 1780s when he decided to publish his material widely. Only then did his renown as a serious composer displace his reputation as a child prodigy and concert artist.[23]

Music publication was catching up with concerts and operas as a source of income. For his six quartets dedicated to Haydn Mozart earned as much—450 Gulden—as for his *Marriage of Figaro,* a very popular opera in its day. The purchasing power of this sum was very roughly $4500, or in relative terms had the pull of $31,500 today, if we again adjust for the greater difficulty of earning money in that era. The growing returns to writing chamber music encouraged composers to reach out to the audience that stayed at home and played its own music.[24]

Mozart's success, both in his lifetime and posthumously, paved the way for other composers. The demand for sheet music grew rapidly in the nineteenth century. Even though no copyright law was in place, the sale of published sheet music became more profitable. Music publishers in Paris, London, and the German cities bid competitively for composed works or even commissioned works in advance. Selling sheet music by subscription became widespread.[25]

Musicians of Mozart's time did face a serious economic problem with regard to copyright enforcement. Commissioned compositions would have provided more income had copyright been enforced. Even as late as Mozart, composers were seldom rewarded for any performance beyond the initial one. Likewise, music publishers paid composers for the first printing only. Other publishers then picked up the work, frequently obtaining the copy fraudulently from the engravers. Superior copyright protection was not available until the next century; Beethoven himself led a campaign on its behalf.[26]

Beethoven and the Triumph of Creative Freedom

Beethoven became the archetypical romantic hero of the nineteenth century. Secure in his financial position, he delighted in insulting the nobility, even though he sometimes received stipends from private benefactors. J. S. Bach had once addressed a petition to an aristocrat with "Your most exalted magnanimous sublime Highness's ever obedient servant and slave." In contrast, it is reported that Beethoven once said to Prince Lichnowsky, "There have been thousands of princes and will be thousands more; there is only one Beethoven!"[27]

Beethoven earned considerable income from three sources: concerts, grants, and the sale of sheet music. Beethoven established himself as an active concert performer and instrumental virtuoso in his early twenties. He traveled across Germany, contacted agents who rented halls, sold concert tickets, and advertised his arrival. Beethoven marketed himself as composer, conductor, and performer. Later, he consciously manipulated his public reputation and his standing among the social elite of Vienna. His services as a pianist were in high demand, both for his own music and for the music of others.[28]

The pursuit of concert income, however, limited the amount of time Beethoven could devote to composing. In 1809 Beethoven sought and received a steady annuity from Archduke Rudolph, Prince Lobkowitz, and Prince Kinsky. In an unprecedented recognition of the growing importance of the individual composer, they pledged their money and wrote: "The undersigned have decided to place Herr Ludwig van Beethoven in a position where the necessaries of life shall not cause him embarrassment or clog his powerful genius." Beethoven was threatening to take a Kapellmeister position in Kassel, and the annuity was awarded to keep him in Vienna. The value of the stipend declined over time with inflation, but for several years it gave Beethoven more than enough money to live from.[29]

Beethoven also used sheet music sales to the public to cement his reputation and his creative freedom. He wrote a wide variety of chamber works and vocal pieces with an eye on the home market. Beethoven was well aware of the special market position that he derived from his reputation: "My compositions bring me a fair sum, and I may say that I have more commissions than it is possible for me to fill. Besides, I have six or seven publishers after each piece and might have more if I chose; people no longer bargain with me; I ask and they pay."[30]

The sheet music market had risen swiftly. When Beethoven was born, in 1770, music publishers typically held between 100 and 1500 scores in their catalogs. Shortly before Beethoven died, in the year 1830, one Leipzig firm was offering 44,000 different items for sale. Beethoven reaped the financial benefits of this market expansion.[31]

Beethoven succeeded in all three areas of finance: concertizing, patronage, and sheet music sales. His partial financial difficulties later in his life were caused by an Austrian hyperinflation, not because the market failed him. In fact Beethoven was a tightwad and even at times a liar when it came to money. Near the end of his life his letters pled for money from his friends, but at this time Beethoven owned a large secret stash of money and shares. The value of his estate would have sufficed to support a middle-class existence for thirteen years, according to one estimate.[32]

Like Mozart, Beethoven used his financial independence to flirt with politically radical ideas. Mozart had set a precedent with the *Marriage of Figaro,* which lampooned the aristocracy, and his *Magic Flute,* which upheld a Masonic ideal of a harmonious, liberal society. Beethoven went further with his opera *Fidelio,* a paean to liberty and a critique of unjust government imprisonment. The onset of romantic music, combined with a widening middle-class audience, brought the composer a new role as social critic and defender of human rights.

High and Low Musical Culture

The eighteenth- and nineteenth-century musical worlds combined compositional depth and accessibility in the same products. Despite significant stylistic developments, classical compositions from Bach to Mahler shared two common features—they met a certain standard of compositional excellence on the printed page *and* they delighted a reasonably large general audience. Unlike in today's world, high and low musical culture had not split.

The Hausmusik tradition gave the composer and the audience a similar musical background. Budding composers were trained by the family, played for the family in their formative years, and later wrote for sale to other families. The composer and the audience thus were strongly linked. The importance of public concerts as a source of in-

come further strengthened tendencies towards musical accessibility. Classical compositions had to please the ear on first or second listening, as repeated listenings were not available. The classical composers geared their work towards an audience of moderate, but not immense, musical sophistication.

The decision to purchase music was made, not by teenagers, but by elder family members, who often belonged to the same generation as the composer, or perhaps even to an older generation. The music market was largely insulated from the issues of generational conflict that drove the rise of rock and roll in the twentieth century. The taste of the "establishment," operating through the medium of parental purchases, exercised more influence over the music market than the taste of youth.

The split between high and low musical culture starts with the late works of Beethoven, such as the late string quartets and piano sonatas. Although Beethoven usually kept close to his melodic roots, his later works made daring forays into musical modernism. These works (such as the string quartet op. 132) are now considered Beethoven's most significant achievements, but at the time they baffled most listeners. Beethoven's accumulated wealth had allowed him to pursue his own vision and to neglect market demand.

The permanent split between high and low musical culture, however, had yet to come. The classical style evolved into the romantic, and composers pursued a diversity of styles. The German and Austrian romantics drew their inspiration from the better-known works of Beethoven. Rossini, Bellini, Donizetti, and Verdi pursued the Italian tradition of capitalist opera. French music took off, aided by Berlioz, as well as Chopin and Liszt, two emigrés from eastern Europe. The best nineteenth-century composers made a good living in a well-developed market that Mozart would have envied. Liszt became one of the heroes and superstars of European culture, creating a career path that presaged the later phenomena of Beatlemania, Michael Jackson, and Prince.

The increasing diversity of the nineteenth-century music market supported the resurrection of past styles. Mendelssohn and Zelter staged a revival of Bach's *St. Matthew Passion* in 1829, taking the piece out of the church and bringing it into the concert hall. Starting in the 1830s, Liszt included historical pieces in his concert programs, an innovation at the time. By the 1850s, audiences had grown accustomed to the idea

that the music of the present did not necessarily dominate the music of the past. Whereas the Leipzig Gewandhaus Orchestra of 1781–1785 took 87 percent of its repertoire from live composers, by 1850–1855 the percentage had fallen to 39 percent.[33]

The songs and chamber music of Brahms represent a turning point in the nineteenth-century style. Many of Brahms's best pieces were too complex to be played by amateur musicians at home. His publishers complained, but Brahms stuck with his style. Brahms continued to produce for the home audience, but like Beethoven in his later years, he did not restrict his artistic vision to the family and concert markets. Schoenberg insightfully described Brahms as the first modernist composer and as one of his closest precursors.[34]

At the same time, government support (from Prince Ludwig of Bavaria) gave Richard Wagner a platform for his operatic visions. Unlike his romantic predecessors, Wagner wrote music that was meant to be played by specialist musicians, sung by specialists, and performed on only a single stage, that of Bayreuth. Wagnerian music provided an autonomous religion that stood apart from church, market, or family. Liszt, the former popular idol, took up the cause of Wagner, gave up concertizing, and retreated to Weimar to compose obscure religious music. The break with musical accessibility was only a short step away.

The next generation of composers, led by Stravinsky and Schoenberg, turned music upside down. Schoenberg struck down tonality and Stravinsky constructed music out of throbbing, pulsating blocks of sound. "Classical" music had demonstrated its ability to pursue its own aesthetic logic with relatively little regard for economic constraint.

Schoenberg did not live by trying to sell his music. He first worked at a bank, then as a conductor, but spent most of his life as a composition teacher, for which he became justly renowned. Foundation grants provided further assistance, allowing him to neglect the middle-class market that the classical and romantic composers had served. This same Schoenberg wrote: "Concert life must gradually cease to be a commercial business." He argued not for government subsidy, but rather for a cultural meritocracy devoid of destructive competition. His own Society for Musical Performances held unpublicized concerts for a hand-picked elite. Schoenberg did not invite all comers; audience members had to show identification at the door to

get in. Audience reactions, such as applause or visible disapproval, were not allowed.[35]

Contemporary American composer John Cage exemplified the new independence of composer from audience when he said: "If my work is accepted, I must move on to the point where it isn't."[36]

The Rise of Recording and Radio

The compositional innovations of Schoenberg and Stravinsky were accompanied by technological revolutions in the musical world. Musical recording began in the late 1870s and phonographs were widely available after 1910. Record companies sprung up quickly, and by 1909, over 27 million phonograph records and cylinders were manufactured yearly. In the 1920s, radios first became a common household item.[37] Recording and radio helped finance and disseminate new genres of music. The advent of electronic reproduction—the ability to copy a performance and distribute that performance to a large audience— caused high-brow and popular music to split drastically. At the same time that traditional composition had broken free of the family music market and turned towards the esoteric, entirely new popular music forms arose that could be reproduced and sold en masse.

The rise of recording and radio enabled performer-based musical genres to displace composition-based genres as the center of musical innovation. A performer-based genre, like rock and roll or country and western, transmits its musical and aesthetic vision through personalities and talents of specific music-makers. The specific interpretation is paramount.

Electronic reproduction is required for performer-based genres to flourish. Our fascination with the Queen song, "Bohemian Rhapsody," lies in the particular production and presentation of that piece. These features cannot be replicated at home, on paper, or by another group in the studio. Queen even closed its concerts by walking off stage and playing a tape of the recorded song. They could not reproduce their creation accurately on stage.[38]

Classical music is a composer-based genre. Its greatness is captured by markings on the printed page, that is, by the composition. Without access to electronic reproduction, earlier composers were required to

emphasize those musical elements that can be transmitted through no-
tation. Classical music, based on these visual representations of melody
and harmony, rose hand-in-hand with paper production, the book
trade, and the printing press.

Performer-based genres took off when electricity provided a new
means of communicating ideas. Recording and radio broadcast in-
creased the rewards for musicians who entertained listeners through
their performance and through their personality. Nascent forms of the
blues had been around since the late nineteenth century, but only when
recording became commonplace did they take off. Recording gave
bluesmen the means to preserve and market their unique creations.

The relative eclipse of "classical" music by "popular music" is
really a shift towards performer-based music. Whether we like it or not,
most customers prefer performer-based music when it is available at
low cost. It is well suited to products that are accessible, direct, and tied
to a charismatic personality. Recording has consigned classical music to
be a minority taste. The classics now account for about 4 percent of all
compact disc purchases in the United States, and this state of affairs
shows no signs of reversing itself.

The renowned British "punk violinist" Nigel Kennedy represents
the dilemma of classical music today. Kennedy has consciously tried to
make the classics more appealing to the consumer. He supplements his
recordings with a star persona—dressing up in flamboyant costumes,
making scandalous remarks, and cultivating groupies. Although Ken-
nedy hopes that the classics can compete in a performer-based me-
dium, he cannot reverse the trend of the age. Few who buy Kennedy's
recordings could identify his playing as distinct from Perlman,
Zukerman, or Chung. A scintillating performance adds much to a con-
certo, but the key contribution comes from the composer. Hundreds of
violinists throughout the world can delight us with their renditions of
the Beethoven concerto. Rock and roll, in contrast, offers a far more
distinct sound for each performer. Unlike the case of Nigel Kennedy,
most fans can tell the Rolling Stones from Led Zeppelin without a sec-
ond thought.

Most performer-based music of recent origin was made to be
recorded. Starting in the 1960s, rock and roll turned to sound effects,
overdubs, reverbs, multi-tracking, and later sampling. The Beatles
album *Sgt. Pepper's Lonely Hearts Club Band,* replete with brilliant sonic

effects, took over 700 hours to make and consumed more than £40,000 in production costs. The most prominent musical instrument today is the recording studio.[39]

Live rock and roll performances attempt to mimic recorded versions, and most rock concerts presume knowledge of the performer's records. Recordings of classical music, in contrast, attempt to mimic concert performances. The basic product remains rooted in the earlier age of live music-making. Many of the preeminent classical artists early in this century, such as Toscanini, usually disliked or even feared making discs. It required them to step outside their usual bounds of expertise. But jazzmen, country and western artists, bluesmen, and crooners welcomed the new technology with open arms. They recorded frequently and enthusiastically, and they tailored their music to suit the new marketing environment.

Recording changed the nature of musical genius. No rock star can match the lifetime achievements of Bach or Beethoven. Most accomplished modern stars produce only a small body of important work. The Beach Boys's "Good Vibrations," a three-and-a-half minute song, took six months of studio time and ninety hours of tape to produce. The use of modern recording facilities, while enabling performer-based music to reach a greatly expanded audience, sorely limits the quantity of their output. Brian Eno, with four seminal early albums in the 1970s, each less than an hour long, marked his place as one of the musical giants of our age. More recently, Kurt Cobain of Nirvana committed suicide after only four albums, secure in his expectations of artistic immortality. Compare these artists to Johann Sebastian Bach, who wrote on average twenty pages of finished music a day for decades, an amount that even a full-time copyist would have been hard pressed to match.[40]

The importance of personality in performer-based music makes creativity and innovation highly unreliable. The quality of the music tends to wax and wane unpredictably with the emotional condition of the performer. Musicians in the performer-based genres rely more on inspiration and less on acquired compositional skills that can be summoned up at will. Contrary to the best classical composers, only a scant few of the leaders in performer-based genres—such as Paul Simon—have become better with age. Most rock stars burn out and their popularity declines within ten years, rapidly creating room for their successors and accelerating the pace of cultural change.

These tendencies account for some of the common perceptions that today's musical world is inferior to the world of Mozart or Beethoven. Cultural pessimists sometimes compare one musical figure against another, and find that no one of today's creators can match the output of Beethoven, either in terms of quantity or quality. Nonetheless we should not leap to the unjustified conclusion that the musical world as a whole has declined in quality. Today's world has *many* more musical figures than the world of 1820 had. Once we get past a few leading classical composers, the musical world of 1820 was relatively thin. The last fifty years, in contrast, have seen jazz, rock and roll, blues, soul, reggae, country and western, contemporary composition, and a variety of other fields, each of which has produced many notable figures.

The production of jazz offers a hybrid between performer-based and classical composer-based methods. On one hand, jazz is largely a modern twentieth-century product, transmitted by recording rather than by notation on paper. On the other hand, recording has done relatively little to transform the kind of jazz that is made. Most jazz is still defined by the technique of live music-making; recording merely transmits that product to a broader audience. For this reason many jazz composers/improvisers can produce more than rock stars. Art Tatum needed only sit down at the piano, turn on the microphone, and play to make a good or even great record; he did not need to bother much with the workings of the studio. Many jazz players do not even compose the basic songs they improvise upon, but rather draw upon a multitude of worthy composers for their basic material. Although jazz players have a high level of productivity in terms of hours of output, the continuing links of jazz to live performance also limit its audience appeal. Michael Jackson and Madonna, who allow their products to be shaped by the medium of recording, can communicate more marketable personalities than could John Coltrane or Charlie Parker.

Recordings and radio altered music further by increasing the diversity of our musical education. When Beethoven studied Bach, he had only a printed score—from paper alone he gleaned the compositional secrets of *The Well-Tempered Klavier*. Mozart could study only a limited range of musical styles: those he could hear in live performance, and those sufficiently well known to have their scores reprinted. This narrower musical education kept classical music pure for a relatively long time. Performer-based music cannot be learned in the same man-

ner and could not spread easily until electronic reproduction. Bix Beiderbecke and Benny Goodman picked up their jazz and swing styles by listening to phonograph records. British rock groups, such as the Rolling Stones, built their sound around the Mississippi Delta blues, music that was not written down at all and whose essence could never be captured on paper.[41]

Today's composers and performers can hear an enormous variety of styles from recordings. Some of the most interesting composers of today, like Philip Glass and Steve Reich, borrow from rock and roll, jazz, Indian music, and Pygmy music from the jungles of central Africa. Performer-based music, in turn, draws upon the output of contemporary classical composers. The studio experimentation of the Beatles was presaged by Stockhausen, whom they put on the cover of their *Sgt. Pepper* album. Minimalist LaMonte Young served as muse for the Velvet Underground. The alternative tunings used by Sonic Youth and My Bloody Valentine show the influence of Glenn Branca and Harry Partch. The resulting hybrid syntheses have infused both classical music and its performer-based successors, and have allowed the so-called "classics" to develop in new directions. It is no surprise that the resulting efforts bear so little resemblance to the style of Beethoven.

Recording frees creators from conceiving only what others can perform or understand. Musicians can experiment with radical styles and innovations, without fear that performers will misunderstand their intentions or directions. Brian Wilson recorded his conception of *Pet Sounds* directly onto tape, which was then turned into a reproducible disc. But Beethoven's ninth symphony and late string quartets were not played properly for many decades after their composition. These masterpieces were neglected because few musicians understood how they should sound. Even today, the first movement of Beethoven's *Hammerklavier* piano sonata is rarely played at the breathtaking tempo the composer had intended.

"Classical" Music in Today's World

Although classical music has lost its place as an economic leader of the music industry, classical music—of both the older and newer sorts—is by no means dead. The sound of classical music today flourishes like

never before. The works of Bach, Mozart, and Beethoven have never before been so accessible, through both concerts and recordings.

Today's concert halls are far more pleasant than the venues of the past. Not all early performances were wondrous events. Audience members, who often traveled for hours to reach the concert, expected a large chunk of music for their trouble; concerts in Beethoven's day were frequently five or six hours long. Listeners and their animals would come and go in the middle of symphonic movements. Seats often failed to meet minimal standards of comfort. Food, drink, and conversation would be shared during performances, which were interrupted by bouts of clapping and booing. Conductors frequently played individual movements or medleys of well-known melodies and themes, in lieu of presenting entire works. The conductor served as more of a time-keeper than as a leader who imparted a musical vision to the performance.[42]

The proliferation of recordings also testifies to the health of today's musical world. Even a moderately well-known piece will have been recorded at least a half-dozen times; standards such as the Brandenburg Concerti are available in dozens of versions, including minor labels, historical reissues, and imports. The megastore chains are spreading amazing CD selections around the world; the largest offers over 22,000 titles. Classical CDs also can be ordered by mail, through CD clubs, or over the Internet.

Compact disc prices have fallen in real terms since their inception; some are as inexpensive as a sandwich. Recordings are increasing not only in number, but also in diversity. Renaissance and medieval music have become far more accessible than ever before. The works of obscure composers—such as Aho, Pousseur, and Scelsi—are now for sale in stores in American suburbs, supposedly an arid wasteland for culture.

The primary economic problem in today's recording industry is an enviable one—the glut of first-rate recordings available to the consumer. Companies now balk at recording yet another cycle of Brahms symphonies, and they prefer to concentrate their marketing resources on vocal music sung by stars, or on CDs with potential in music markets other than classical, such as Górecki's third symphony or the well-known *Chant* CD, both bestsellers. We are witnessing a breakdown of the categorical distinction between the classical and pop charts. Economic imperatives are forcing classical marketing to focus on new

products, just as pop music has always done, and as classical performers had done in centuries past. The focus on new products is no guarantee of future aesthetic success, but overall it represents a healthy development and it may restore the link between contemporary composition and a wide public audience. Although many sophisticates adopt a scornful attitude towards the "Three Tenors" approach to recording and marketing, similar forces for innovation also support the increasingly frequent appearance of contemporary compositions on orchestral programs and on the classical charts.

Many of the "new" classical products hearken back to much earlier styles of music. A rich variety of original instruments presentations—now a significant portion of today's menu of classical recordings—attempt to recapture previous styles. Resurrecting old styles is not new, but bringing a hard-to-reproduce performance to a large audience requires recording. Original instruments recordings show how performer-based musical marketing has spread to the classics. By placing the choice of instruments and performance practice in the hands of the conductor, the recording captures an identifiable Gardiner, Herreweghe, or Harnoncourt sound. Like Nigel Kennedy, these artists use modern technology to market the classics. Original instrument recordings are first and foremost hypermodern innovations. In previous ages conductors did not hesitate to rescore compositions to meet the prevailing mass taste of the age. When Bach performed the music of Palestrina, he added wind instruments, double bass, and organ. Brahms tampered with Renaissance and baroque music, and Haydn played around with the numerous operas he conducted. Reverence towards past music, and towards authenticity of the score, are modern concepts.[43]

Today's musical riches are by no means limited to composers of the distant past. Contemporary compositions provide a rich variety of stimulating styles and aesthetics. Those who condemn such works as worthless—a surprisingly large number of educated classical listeners—are misjudging the present by the standards of the past.

Few older operas are more dramatic and pulsating than Philip Glass's *Einstein on the Beach*. Glass's work synthesizes choreography, stage design, and stream-of-consciousness narration, while electric organ and violin replace the classical orchestra. Robert Ashley's operas also integrate music with the spoken voice rather than with singing. His

Perfect Lives provides a rich vision of America in the tradition of Whitman or Faulkner. The music draws upon jazz, boogie-woogie, and piano bar musings, leaving us with a sense of the transcendent beauty and mystique of ordinary life.

Modern percussive works, such as Stockhausen's *Schlagtrio,* Xenakis's *Rebonds,* or Cage's works for prepared piano go beyond earlier rhythmic compositions. Stockhausen and Xenakis use percussion to explore the bruising power of sound, while Cage's works communicate the dreamlike and the exotic. These composers draw on Indian, African, and Indonesian influences for their development of rhythm. Stockhausen, probably the most versatile of these composers, also has pioneered the technology of musical sampling in a variety of media, including vocal pieces and works for tape.

Steve Reich and Morton Feldman explore alternative musical traditions and develop the art of subtly changing patterns. Reich's *Music for Eighteen Musicians* and Feldman's *For John Cage* use intriguing musical progressions to produce a deep sense of satisfaction and calm in listeners.[44]

Contemporary composers do not possess the melodic gifts of their most illustrious predecessors, but we should not damn them for this reason. Mozart did not have the contrapuntal skills of J. S. Bach, and Beethoven did not have the effortless charm of Mozart. Elliott Carter cannot create the melodies of Schubert, but he possesses a superior sense of orchestration and texture. Stockhausen understands the organizing principles of pitch and rhythm better than did Tchaikovsky.

Some cultural pessimists argue that classical composers have ceased to compose popular, melodic music because our age lacks a refined aesthetic. Composers supposedly turn to scratchy and "negative" atonal music in despair. This characterization is dubious. The modern aesthetic has not hindered the rise of celebratory, life-affirming art in literature, the movies, or popular music. If we look to contemporary compositions, we find this same energy and optimism in Harry Partch's *Revelation in the Courtyard Park,* Conlon Nancarrow's works for player piano, or John Cage's *Roaratorio.*

Twelve-tone music and serialism, bugaboos of the average Haydn fan, are but one trend in late twentieth-century music. But even serialism has produced a variety of diverse sounds and moods; it does not fit the caricature its opponents have created. Stockhausen's serial works

and Boulez's *Pli Selon Pli* provide great fun for those listeners who find the musical language familiar. Perhaps ironically, many of the listeners who value repetitiveness in the classical symphony (serialism strikes down musical repetition) simultaneously object to popular music and rap for their supposed extreme repetitiveness.

To some, listening to a new piece by Poul Ruders, a contemporary Danish composer, is more rewarding than hearing a Mozart string quartet once again. Not everyone need prefer current styles, but for those who wish to move beyond the old, the modern musical world offers a vast array of choice.

Why Contemporary Compositions Fail to Command the Market

The inability of the market to support our contemporary composers ranks as the most serious problem with today's musical culture. Of all the "classical" music publicly performed, recorded, and broadcast throughout the West, nearly 90 percent was composed before 1900. Even within our century most of the widely beloved composers— Mahler, Bartók, Strauss, and Stravinsky—produced their best-known works before 1940. Contemporary compositions, unlike the works of Haydn, Mozart, and Beethoven in their day, attract little public attention. The relatively well-educated segment of the classical music audience will experiment with newer works out of a mix of guilt and duty, but most are relieved to return to Mozart. What Babbitt and Boulez have to say interests only a few.[45]

Today's composers do not write for the family musical evening. Capitalism has created alternative forms of family entertainment—rather than making music at home, most of us go for a drive in the car, shop, go to the movies, or take vacations. The home has lost its place as a center of entertainment and instruction, except for television, which has displaced music-making even further. And when we wish to listen to music, we can put on a compact disc rather than sitting down at the piano. The decline of church membership intensified this loss of informal musical education, as liturgical music has dropped out of many lives.

Instead of receiving their formative musical training at home in the family, contemporary composers are trained by specialists in a conservatory or university. Composers play to please professors, fellow musicians, and truly dedicated fans. In today's wealthy world they can (sometimes)

survive by writing for other specialists alone. They receive much of their income from universities and foundations. Contemporary works need not make sense on first listening, because recordings allow the committed few to listen many times.

For better or worse, contemporary composers have become removed from a general audience, both in terms of their training and in terms of their customers. Composers, in their quest to push out the barriers of art, have sought out exotic and bizarre musical languages. They have experimented with the abandonment of tonality, the abandonment of traditional Western scales and intervals, the abandonment of meter as an organizing principle, and the construction of new electronic instruments.

Today's compositional achievements are spread more democratically than in earlier eras. We cannot stumble upon one or two contemporary Mozarts or Haydns, and buy up their entire oeuvre. The best works of the moderns are spread across dozens of composers, many of whom are unknown outside a relatively small circle of admirers. In today's contemporary classical world, listeners must hunt for the proverbial needle in the haystack, without an established canon of great works to follow. No wonder that most of us buy Mozart's *The Marriage of Figaro,* or perhaps Nirvana's *Incesticide,* rather than experiment with a few untried contemporary classical CDs.

The two dominant features of today's classical musical world—successful preservation of older styles and the oft-baffling nature of the newer styles—are actually two sides of the same coin. When we have easy access to the titans of the past, musicians have greater incentive to try something completely new, to shift the terms of competition.

Classical listeners are saturated in the treasures of past greats. Few of us are intimately familiar with all of Beethoven's thirty-two piano sonatas, Bach's twenty hours of organ music or several hundred cantatas, or the 180-CD edition of Mozart's collected works. Prospective musical creators find it increasingly imperative to pursue new approaches if they wish to capture an audience. Either they pursue the more commercial performer-based route, or they produce contemporary innovations and eschew a large commercial audience.[46]

The contemporary musical world is the logical culmination of a growing specialization in production. Milton Babbitt's seminal article, "The Composer as Specialist," is a manifesto for this new world; his

title, of course, can be applied to virtually any aspect of capitalist production. (Babbitt protested vehemently when an editor anthologized his essay, "The Composer as Specialist," and retitled it, "Who Cares If You Listen?")

Babbitt's essay announced that contemporary compositional music has become an elitist product accessible only to a few. While we should regret the weak popular status of contemporary composers, we should resist the temptation to treat Babbitt's elitism with scorn. Only the modern world can support so much fascinating production for the tastes of a small minority. Recordings of elitist contemporary compositions can be supported only because recording brings both Mozart and the Rolling Stones to larger audiences.

The Musical Revolution from Africa

The twentieth century has seen world musical leadership switch from the Germanic lands to the New World. Cultural interchange with Africa provided the decisive boost. Slavery was a disaster for its victims, but it revolutionized world music. This barbaric form of forced cultural contact paved the way for later, more beneficial voluntary contacts through the music industry. Most contemporary popular musical forms—blues, rhythm and blues, rock and roll, soul, jazz, swing, be-bop, boogie, ragtime, calypso, samba, forro, son, ska, reggae, salsa, merengue, plena, and rap—were created by Africans in the New World or were derived from African influence.

The unwilling African migrants reinvented some of their musical instruments in the New World, such as certain kinds of drums and marimbas. More important, they carried over African styles, a strong musical emotionalism, and an African sense of the all-embracing importance of music. Native African music tended to be percussive, vocal, celebratory, and designed for dance. These traits, transmitted through oral culture from one generation to the next, showed up in the rhythm and blues of the United States, the Son dance music of Cuba, the Forro music of Brazil, and numerous other New World manifestations of African music. Differing parts of the Americas developed distinct African-based musical traditions, depending upon which tribal cultures were enslaved and which European influences were mixed in.[47]

155

The African-American music of the United States, which has achieved such prominence on world markets, provides the next link in our story. Antonín Dvořák noted prophetically in the late nineteenth century: "In the Negro melodies of America, I discover all that is needed for a great and noble school of music."[48]

Origins and Spread of the Blues

Like the Germanic classical composers, African-American musicians needed to establish markets, overcome resistance to new musical sounds, and develop innovative means of distributing their creations. Blues and its offshoots rose to the top because, regardless of the uphill fight, musicians had access to numerous and decentralized outlets for marketing their products. The Mississippi Delta was hardly capitalistic, but the rise of the blues nonetheless illustrates how markets have benefited musical culture.

Charlie Patton, Robert Johnson, Mississippi John Hurt, Son House, Big Bill Broonzy, Tommy Johnson, and Skip James—the first prominent bluesmen to be recorded—were remarkably versatile. These artists were not restricted to blues, but could handle a wide range of musical forms, including church songs, dance pieces, ragtime, waltzes, ballads, breakdowns, and folk songs.

The Mississippi Delta, the origin of the blues, had the greatest concentration of blacks in America—blacks outnumbered whites by ratios of about seven to one in the late nineteenth century. James C. Cobb titled his book on the Delta *The Most Southern Place on Earth,* referring to its extreme legacies of slavery, cotton plantations, poverty, illiteracy, and racial tension.

The Delta inherited a strong indigenous oral culture from its African and slave background. Segregation and poor institutions for formal instruction, combined with African-American storytelling ingenuity, allowed the oral nature of black culture to survive intact. From an early age, black children were immersed in an informal oral education. They learned narrative, rhymes, ring games, verbal rhythms, and humorous insults. African-American musical traditions were transmitted through work songs, field hollers, folk songs, religious rituals, and group dances. Markets allowed black musicians to take these traditions, develop them, and market them for sale to the outside world. African-

American oral culture spread through local performances, churches, minstrel shows, and, later, recording.[49]

Other musical centers of the Western world were preoccupied with transmitting music through paper (i.e., sheet music), but early bluesmen used memory, imitation, and performance. The emphasis on personality and story-telling, rather than on notation, helped make blues suitable for the medium of recording. The absence of sheet music and notational skills, initially the result of deprivation, proved to be a blessing in disguise.

Encouraged by an oral culture, blues music has not been restricted to the sighted. Ray Charles and Stevie Wonder are the two best-known blind stars, but they stem from a long tradition. Prominent blind bluesmen include Blind Lemon Jefferson, Blind Boy Blake, Blind Boy Fuller, Blind Willie McTell, Blind Willie Johnson, Reverend Gary Davis, and Sonny Terry, as well as the gospel groups the Five Blind Boys of Alabama and the Five Blind Boys of Mississippi.

The first references to the blues, as we know it, date from the 1890s, when the blues evolved from earlier musical forms. Neither African music nor its New World offshoots were ever set or fixed styles; even tribal African music produced frequent changes and innovations. Similarly, African-American musicians were creative artists of the first rank. Lawrence W. Levine reproduces a remark of a freedman on the Sea Island during the Civil War. When asked where the slaves got their songs, the freedman replied: "They make them, sir."[50]

Blues artists typically got their start by playing at plantation dances, picnics, fish fries, road houses, levee and logging camps, and parties. The earliest blues artists usually performed solo. In this regard they parted from African tradition, which emphasized collective singing and music-making. Only later did bluesmen form regular groups and bands. Individual performance was motivated by the need for mobility and low cost travel, common necessities in African-American history.

Many black artists intermingled the themes of religion and sex, borrowing from one realm to sing about the other. Unlike white Protestantism, most branches of African-American religion never accepted the strain of Christian doctrine that emphasized the sinfulness of sex and bodily enjoyment. Instead, sex is to be enjoyed, celebrated, and sung about. This more liberal view of sex influenced the lyrics, the rhythms, and the aesthetics of black music.

The dominant early blues instrument was the acoustic guitar, which was sold and marketed through mail order catalogs. African-Americans were not initially enamored of the guitar, but adopted the instrument when it fell in price and became easier to obtain. In the late nineteenth century, the mail order business developed as a primary means of distributing consumer goods to isolated rural areas. Most guitars were ordered by rural whites and later found their way into the hands of blacks through market resale.[51]

The blues started as a local folk tradition, but bluesmen quickly sought out a wider audience and drew on outside influences. The blues became a music of migration and travel. Economic growth and the increasing demand for labor, spurred especially by the two World Wars, gave blacks the opportunity to escape the Delta. Blacks left the deep south in large numbers in the 1930s, 1940s, and 1950s.

The westward blues infiltration of Texas followed the railway lines, cattle markets, oil towns, and lumber camps. Texas bluesmen included Blind Lemon Jefferson, Leadbelly, T-Bone Walker, Josh White, and Lightnin' Hopkins. Blacks from Oklahoma, Texas, and the Southwest also went to California, where they created the T-Bone Walker tradition of honky-tonk and jazz combo blues. The northeast received most of its emigrant blacks from the Atlantic seaboard, where the blues tradition was less strong. The Atlantic bluesmen, such as Blind Boy Fuller, Willie McTell, Reverend Gary Davis, and Blind Boy Blake, drew more heavily from black gospel, ragtime, and popular song.

Blacks from the Delta tended to move northward along the Mississippi transportation corridor through Memphis, Chicago, and Detroit, bringing electric blues with them. Muddy Waters, Howlin' Wolf, Fred MacDowell, Elmore James, and John Lee Hooker were part of this wave of migration. During the 1950s alone, over a third of the 900,000 blacks in Mississippi left, usually traveling up the Mississippi river to work in northern factories. As the next large port up the Mississippi from New Orleans, Memphis was a center of black culture and a springboard for the birth of rock and roll.[52]

The Blues Develops into Diverse Musical Forms

The diverse strands of the blues gave rise to a variety of musical branches and offshoots. Blues music invaded the African-American churches in

the form of gospel music, enthusiastically promoted by the bluesman Thomas Dorsey in the 1930s. Dorsey proselytized church conventions, toured with public concerts, and sold sheet music and recordings.

From the beginning, black churches had stressed vocal music, which could be produced more cheaply than instrumental music. Dorsey took the earlier tradition of hymns and spirituals, and moved it in a more emotional and commercial direction. Gospel played up harmonies, tension between beats, vocal moaning and shouting, emphasis on dance and bodily movement, clapping, the tambourine, the steady four beats to the bar, the call-and-response, and most important, a soulfulness, sense of freedom, and emotionalism. Many later black stars, such as Sam Cooke, James Brown, most of the Motown stable, Ray Charles, and Donna Summers found their musical inspiration from a childhood exposure to gospel.[53]

Increasing competition among black churches and denominations gave gospel its initial inroads. Entrepreneurial and charismatic ministers used quality music to attract and retain members. Gospel obtained its initial foothold in small, upstart storefront churches and basement congregations, moving to the big churches once it was a proven moneymaker.[54]

Not surprisingly, gospel music met with strong opposition. Gospel opponents cited Thomas Dorsey's background in blues music and his erotic songs, such as his 1928 hit, "It's Tight Like That." Dorsey himself noted that gospel and blues differed only in their lyrics. In other cases preachers resented gospel because choirs and musicians assumed some of the influence and popularity previously enjoyed by ministers. The commercialism of gospel provided another target. As late as 1964, Joseph R. Washington Jr. denounced gospel music in his study of the black church, claiming it was "sheer entertainment by commercial opportunists," and "crass commercialism."[55]

Jazz was another offshoot of the early blues tradition. Early Delta music, when it moved into the city of New Orleans, intermingled with Creole culture. Prospective jazzmen devoted their time and attention to the instruments of the marching band, rather than to the acoustic guitar. Market demand spread jazz from its New Orleans origins to the eastern part of the United States, where it blossomed into a variety of diverse forms. New York and Chicago became meccas for jazz and swing in the 1920s and 1930s.

Ragtime arose from a synthesis of blues piano and classical style. Scott Joplin took classical piano lessons from a German teacher but infused the music with the syncopated rhythms used by black banjo players at the time. His works successfully fused high and low culture by echoing Chopin, Debussy, and the barroom entertainers of the day.[56]

The influence of the blues even extended into supposed bastions of "whiteness," such as country and western music. Country and western mixed American black blues with British folk song, filtered through Appalachian and southern life. American country and western music is regional white soul, built on partly black foundations. Jimmie Rodgers, Hank Williams Sr., Johnny Cash, Bob Wills, and Bill Monroe and other prominent country and western artists all drew much of their inspiration from the blues.[57]

The Rise of Rock and Roll

The most commercially successful offshoots of the blues were rhythm and blues and rock and roll. Rhythm and blues evolved from amplified, small group blues combos; rock and roll is a more general term that also covers the later progressions of the R&B style, starting with Elvis Presley and going through classic 1960s rock and the innovations of the 1970s, 1980s, and 1990s.

Rock and roll arose when black blues fed into white music in Memphis and Chicago after the second World War. The early white rock and roll pioneers at Sun Records in the 1950s were the most prominent figures of a 1950s Memphis blues resurgence. Robert Pattison has aptly remarked that: "Rock begins in the imposition of white Romantic myth on black southern music." Many of the rock and roll pathbreakers, such as Bill Haley, Buddy Holly, Gene Vincent, and Roy Orbison also drew their inspiration from black music. Bill Haley's "Rock Around the Clock" was a cover of the original by Sonny Dae, a black artist. Upon refusing to play "Whole Lotta Shakin'" by Jerry Lee Lewis, one Texas station manager told Sam Phillips of Sun Records that he "didn't play songs by niggers on our stations."[58] Despite this initial opposition, overwhelming consumer demand, especially from the younger generation, ensured that rock and roll would not be a passing phenomenon.

The rise of rock and roll relied on growing market support for alternate forms of music. Public concerts provided rhythm and blues artists with means of marketing their work, earning a living, and sharpening their skills. Widespread national touring became profitable with the development of the electric guitar. Amplification allowed blues music to be marketed live to large numbers of people in clubs, concert halls, and noisy bars.

Muddy Waters bridged the acoustic and electric eras. Field agents recorded Muddy with acoustic guitar when he worked as a sharecropper in Mississippi. Muddy bought his first electric guitar only when he moved north and played in Chicago. He favored the purer sound of the acoustic guitar, but he also realized that an unaided guitar could not be heard in the larger, noisier Chicago taverns. An amplified guitar could play leads and runs, whine, bellow, and provide rhythmic accompaniment like never before. The electric guitar quickly became a staple of the blues and rhythm and blues repertoire.[59]

Unlike the acoustic guitar, the electric guitar could be combined with other instruments without being overpowered. Amplification also made the new music ideally suited for the car radio. Delta blues developed into more advanced forms of rhythm and blues and set the rock and roll revolution on its path.

Chuck Berry pioneered the use of electric guitar in rock and roll. His music brought together a blues background, a country and western sense of openness, the humor and storybook approach of black bandleader Louis Jordan, the clear diction of Nat King Cole, and a "talking" electric guitar style with riffs drawn from jazz and blues. Berry's interplay of vocals and talking guitar extended the call-and-response black gospel tradition. After Berry, few rock songs were considered complete without an electric guitar solo.

Elvis Presley, a musical mimic and synthesizer par excellence, brought the songs, sneers, vocal styles, and pelvic thrusts of risque black bluesmen to the mass market of white teenagers. The King picked up blues and gospel through black radio stations and through record collecting, despite strong opposition from his family. Early in his career, Elvis stated: "The colored folks been singing and playing it just like I'm doing now, man, for more years than I know. They played it like that in the shanties and in their juke joints and nobody paid it no mind until I goosed it up. I got it from them."[60]

The Rise of the Independent Record Labels

Public concerts, despite their importance as a source of income for performers, provided only part of the market for the new performer-based music. Recording eventually drove the industry. The phonograph gave each listener the opportunity to hear music of his or her choice and allowed performers to develop new and diverse musical forms.

The advent of electric recording technology in 1923 proved to be a boon for many kinds of music. Electric recording could pick up blues growls and accents, as well as the nuances of a non-amplified guitar. The earlier acoustic recording techniques could only pick up a limited range of sounds—they were best suited for loud voices that could belt out a tune. These techniques also required the artist to come to the studio and huddle around a small horn when performing. The new electric technology, in contrast, made southern "field recordings" possible. Record companies were no longer restricted to those blues artists who migrated northward. Instead, they sent numerous agents into the field to comb the south for the best blues talent. Most of the early Delta artists relied on such field recordings for exposure, or in the case of Muddy Waters, discovery. Field trips remained an established practice as late as the 1950s.[61]

By the end of the Second World War, the major record companies lost interest in the blues and demoted their race labels to a secondary position. The majors decided to drop or deemphasize their fringe businesses when a wartime shortage of shellac cut into production. The so-called "independent" record labels stepped in to fill this vacuum. Of the fifty best-selling rhythm and blues records between 1949 and 1953, only four were from the major labels.

In the 1940s over 400 independent record companies had been founded. In the 1950s, Modern picked up B. B. King, Atlantic gave us Ray Charles, Specialty recorded Little Richard, Imperial offered Fats Domino, and King marketed James Brown, the Godfather of Soul. Other notable independent labels included Beacon, Savoy, Keynote, Varsity, DeLuxe, National, Duke, Vee-Jay, and Peacock.[62]

The most influential entrepreneurial independent labels were Sun Records (Memphis), Stax (Memphis), Chess Records (Chicago), and Motown (Detroit). They laid the groundwork for modern soul as well as rock and roll. Sun recorded Howlin' Wolf, Bobby Bland, Little Milton, Sleepy John Estes, and B. B. King, as well as seminal white

artists—Elvis Presley, Carl Perkins, Jerry Lee Lewis, and Johnny Cash. Stax marketed a grittier soul sound with Otis Redding, Sam and Dave, and Booker T. and the MGs. Chess, which peaked in the 1950s, counted Bo Diddley, Howlin' Wolf, Muddy Waters, and Chuck Berry on its roster of stars, with Willie Dixon as songwriter and bass player extraordinaire. Motown, the last of these labels to bloom and the most popular, developed and promoted the music of Smokey Robinson and the Miracles, Marvin Gaye, Diana Ross and the Supremes, the Jacksons, the Isley Brothers, the Temptations, the Four Tops, Marvin Gaye, and Stevie Wonder.

Many musicians usually associated with major record labels actually started with the independents. Hank Williams, America's most prominent country musician, released his first record in 1947 with the independent company of Sterling, located in New York. The Beatles' first American records were released not by Capitol, but rather by Vee-Jay, the black-owned Chicago R&B label.

Rhythm and blues and rock and roll received little support from the major record companies in the 1950s. The leading musical executives regarded rock and roll as a shoddy and transient fancy that would soon disappear, much as rap was regarded in the early 1980s. The major record companies had not foreseen the massive shift of purchasing power to American youth. The anti-rock conviction was reinforced by the executives' scorn for the individuals who created and patronized the music—blacks and wild, crude southerners.

The independent record companies that stepped into this void started as shoestring operations. Chess Records used their toilet as an echo chamber and Atlantic recorded in a fourth-floor New York office, after pushing the desks out of the way. The major record companies had more capital, more advertising, better retail connections, and greater technical expertise. They used these advantages to push Broadway songs, crooning, and the dying medium of big band. The independents had better music and better ideas. In the years 1948 through 1955, the four largest record companies (Columbia, Capitol, Decca, and RCA Victor) accounted for 78 percent of the records on the Billboard Hit Parade, but by 1959, this percentage had fallen to 34 percent.[63]

Advances in recording technology further fueled the rise of the independents. The reel-to-reel tape recorder was brought back from Germany after the Second World War. This portable tape machine,

163

which replaced the earlier glass-based master recordings, made editing easier. Tape equipment fell in price and new recording studios sprang up. By the mid-1950s, cutting and pressing five thousand disks cost no more than $1,200. The costs of recording in nightclubs, concert halls, and even at home fell also.[64]

The spread of radio induced record companies to innovate. Like network television in more recent times, radio in this age often appealed to mass taste, giving rise to worries about the "blockbuster phenomenon" that would shut out diversity and quality. Radio indeed threatened to dominate the musical market. The medium offered better sound than the record players of that era, did not require discs to be changed every several minutes, and, once a radio was purchased, listening time was free.

Record companies had to be creative to survive. They responded by producing niche records in small quantities for target audiences. "Hillbilly" music, now called country and western, and "race" music received special emphasis. These forms fared better on the more decentralized medium of records than on the radio, which served mass taste to a larger degree. The threat of cultural domination by the medium of radio induced new products to serve the neglected fringes. These new products, such as hard blues, transformed the market and increased the importance of alternative listening media.[65]

The Rise of the Jukebox

The greater diversity offered by records, compared to radio, provided many avenues for the propagation of new music. The jukebox brought otherwise neglected records to a large public audience.

The marketing of the electronically-amplified jukebox in 1927 initiated the heyday of this medium. Suddenly the jukebox could be used to entertain large groups of people in dance halls, bars, and clubs. By 1939 approximately 300,000 jukeboxes were in use, with 30 million records produced for jukebox use each year. By the middle of the 1940s, jukeboxes absorbed three-quarters of the records produced in America.

The rise of the jukebox boosted musical genres that were removed from the mainstream. Country music and especially rhythm and blues benefited most from the new means of product delivery. Many

listeners could not afford radios and enjoyed music only by visiting public places of entertainment. Furthermore, most radio stations were beholden to commercial sponsors and shied away from risque or innovative music. The raw, sexually charged blues sung by Arthur Crudup, Tampa Red, and Muddy Waters relied on the jukebox for its dissemination.[66]

Rhythm and blues first obtained widespread radio airplay in the early-to-mid 1950s. Birmingham, Memphis, Nashville, Atlanta, and other southern cities broadcast this music to both black and white musical audiences. Radio gave whites and blacks a shared experience. Both law and custom held back formal desegregation but no one could control radio listening. Many white teenagers, including Elvis Presley, used R&B stations as a source of musical inspiration and education.[67]

The new musical forms made further broadcasting inroads with the later development of the transistor and the car radio. The transistor was invented in 1947 in the New Jersey Bell Laboratories and was first marketed to the public in 1953. By 1965 more than 12 million transistor radios were sold a year. At the same time, miniaturization made car radios affordable. In 1963, there were 50 million car radios in the U.S. alone. These innovations supported many more radio stations and helped increase musical diversity. The growing number of listeners shifted the balance of power to local radio stations and away from the megawatt large broadcasters. Again, fringe tastes scored a victory over mass taste. Rock and roll received a special boost from the new technologies. Car radio and portable transistors were suited to strongly rhythmic forms of music that carried well over background noise.[68]

The Clash between Old and New Musical Worlds

Prior to the rock and roll revolution of the 1950s, popular music was still dominated by Tin Pan Alley and show tunes. When Elvis first hit the charts, three big hits were Mitch Miller's "Yellow Rose of Texas," an Oscar-winning ballad "Love is a Many-Splendored Thing," and Roger Williams's piano version of "Autumn Leaves." Sheet music publishers still played a role in making hits. The major old-line music publisher, ASCAP, ignored small radio stations and independent record labels.

In the new musical world that followed, local radio programmers, disc jockeys, and independent record companies assumed an increasing role in marketing hits. BMI (Broadcast Music Incorporated), the upstart music publisher, used these new methods of distribution to promote blues, rhythm and blues, and country music.

The old musical establishment initiated legal persecution against their new rivals in the 1950s. An ASCAP-controlled group called "Songwriters of America" filed an antitrust suit in 1953 against BMI. The suit alleged that BMI had attempted to monopolize the market by keeping ASCAP music off the air. Yet ASCAP was much larger and more monopolistic than BMI, accounting for 85 percent of all television music and 70 percent of all radio music. ASCAP sought to increase its market share further by leading an alliance of parents, politicians, and music producers against the new musical innovations. This alliance portrayed rhythm and blues as lewd, unskilled, and a threat to Western values. When the antitrust suit was announced at a press conference, the plaintiffs announced that they would restore the "good music of the past." BMI, however, managed to avoid prosecution.[69]

How Payola Promoted Cultural Diversity

The payola scandals provided the next episode in the clash of musical worlds. Independent record companies frequently used payola to promote rock and roll on American radio. Payola occurs when a disc jockey is paid by record companies or music publishers to play certain recordings. This practice, usually considered scandalous, in fact helped new musicians gain airplay. Payola combated conformism and racism in the music business. Nonetheless rock and roll opponents succeeded in making payola a dirty word akin to bribery or money laundering.

The first documented instances of payola date from England in the 1860s. The publishers of sheet music paid vaudeville artists to sing and popularize their songs. Payment of these fees was a normal marketing procedure for publishers and a significant source of income for performers; payola occasioned no political scandal. Prior to the payola scandals, payola had been an accepted and legal business practice used to promote new products for many decades. In the case of rhythm and blues, the independents lacked the reputations and marketing power to place their artists through name alone, and were forced to rely on payola.[70]

Chuck Berry's "Maybellene," his first hit and still one of his most popular songs, was given initial airplay because of payola. Leonard Chess of Chess Records (Berry's record company) went to well-known disc jockey Alan Freed with a large catalog of material. Chess offered Freed partial songwriting credits on any song of his choice, provided that he would play and promote the song. Freed now had a stronger incentive to pick the best song and to promote it. After listening to hundreds of recordings, Freed picked "Maybellene." Berry became a star, and the Freed estate continues to receive royalties (check your record label). When record companies believed they had a sure-fire hit by an unknown singer, they used payola to buy air-time for the record.

Payola does not differ from the ordinary purchase of advertising time. Instead of hearing a jingle, we hear a song. The song itself, and the performer, is being advertised. Outlawing payola kept radio stations from advertising music, the commodity of greatest interest to their audiences.

Payola also encouraged disc jockeys, the individuals who knew most about music, to discover new talent. The station owners were not as well informed as the disc jockeys and did not have the same ground-level contacts in the musical world, especially for rock and roll. The proliferation of independent record companies made new stars harder to find, increasing the importance of disc jockey middlemen. If a disc jockey found a new star, the disc jockey would receive some of the benefits in the form of payola income.[71]

Payola income decreased disc jockey favoritism and racial discrimination. When disc jockeys receive additional income from playing the more popular product, they are less inclined to indulge their own personal and racial biases, and more inclined to heed the wishes of consumers. The value of giving airplay to a good song, and thus its payola value, is usually higher than the value of promoting a bad song. Record companies were not interested in paying to procure airtime for likely duds.

Critics of payola argued (correctly) that payola gave a special boost to rock and roll. Outlawing payola increases the importance of advertisements as a source of radio station income. The radio station will play music to attract listeners who purchase advertised products—middle-class and upper-class Americans. When payola is legal, the desire to increase payola income encourages the station to attract listeners

who will buy *records*. Payola gave record buyers—the young, the die hard music fans, and the followers of rock and roll—greater influence over station programming.

The payola scandals were part of the ASCAP campaign against BMI and rock music. After the ASCAP antitrust suit against BMI failed, the music publishers sought another legal weapon to use against their competitor. ASCAP also wished to strike out against the disc jockeys who had neglected to promote their music. In late 1959, ASCAP persuaded Congress to launch an investigation of payola for rock and roll, rhythm and blues, and soul music.

The discriminatory nature of the payola hearings belies their origins. Responding to ASCAP pressure, the House Committee examined payola for rock and roll only, not payola for classical music. The government came down much more heavily on "black payola" than "white payola." Alan Freed, the deejay who pushed gritty rock and roll and raucous black music, was prosecuted and found his entire career ruined. Dick Clark, of American Bandstand fame, used payola to promote more respectable forms of white pop. Clark's "violations" were more striking but he was left with his career and media empire intact.

At the end of the Committee hearings, Congress outlawed payola, with a jail term of up to one year and a $10,000 fine for convicted offenders. Earlier, the Federal Communications Commission had threatened to suspend the license of any radio station found guilty of accepting payola. Amazingly, when the payola hearings started, payola was not in violation of any Federal law. The investigations were primarily a witch hunt directed against particular kinds of music that did not meet with universal approval.[72]

The Development of Rock and Roll as a Dominant Style

Rock and roll survived these attempts at legal persecution and accounted for successively larger percentages of the total number of records sold. Rock grew in fits and spurts, but by the 1960s it had established itself as a dominant musical style. Other styles (e.g., Herb Alpert and the Tijuana Brass) sometimes topped the charts, but 1960s music *was* rock music. The Woodstock, Altamont, Monterey, and other music festivals of the 1960s and early 1970s institutionalized the new youth culture.

The Motown empire reflected the entrepreneurial spirit of the rock and roll explosion. Motown, short for Motortown, or Detroit, deliberately reached out to white audiences by synthesizing black music with white pop. Building on gospel roots, Motown produced an identifiable and infectious sound. The headquarters of the grittier Stax record label were called "Soulsville," but Motown headquarters were called "Hitsville."

Motown was the creation of an ambitious black entrepreneur named Berry Gordy. The son of a successful businessman, Gordy started as a boxer, moved to the Ford Motor Company, and eventually began writing songs. Gordy became tired of selling his work to others and in 1959 he founded Tamla records, later part of Motown, in Detroit. Although Gordy started by borrowing $800 from his family, by the end of the 1960s, Motown had made twenty-two number one pop hits, ninety-four top ten pop hits, forty-eight number one R&B hits, and 174 top ten R&B hits. By 1973 Motown had become the largest black-owned company in America. Black Motown artists made it onto mainstream white television, such as the Ed Sullivan show, and broke down segregation on the touring circuit. Gordy once noted, "We don't have any more power than our power to make a better product."

Gordy, realizing that the home played a shrinking role in music listening, designed Motown music to be heard over a car radio. Gordy used an artificially constructed car radio to test all Motown releases. If the song did not sound right when heard over a car radio, Gordy wanted changes. After a test run, Gordy frequently asked his employees the question: "Would you buy this record for a dollar or would you buy a sandwich?"[73]

The exploding market for rock music was driven by the growing purchasing power of young consumers. Increasing proportions of America's postwar wealth found their way into the hands of teenagers, who purchased music in great numbers. Word of mouth among this clientele could suddenly make or break a release. American popular music moved away from show and movie tunes and towards more raucous styles that older generations and critics found puzzling.

The newly potent mass media supported this growth of popular music culture. Radio, television, and movies helped the creators of performer-based music manufacture images and stars. Beatlemania put

Lisztomania to shame. Michael Jackson achieved record sales and a worldwide following without precedent; his *Thriller* album has sold approximately 50 million copies. Mass media favors those musicians whose creativity is expressed through their presence rather than through their pen.

In the 1960s the British assumed some of the musical leadership from the Americans. Class-ridden British society was well-suited for producing a rebellious youth culture that defied the wishes of older generations. The British have been especially strong in new wave, punk, techno, and other anti-establishment genres.

The Beatles combined the English music hall tradition with African-American rhythm and blues. The *White Album,* the Beatles' roots album, brings out their sources most clearly. The conservative music hall, the indigenous British tradition, emphasized skills of song and charm. McCartney brought this background to Lennon's more caustic taste for hard rhythm and blues. Their producer, George Martin, came from the classical world and taught them how to orchestrate and work the studio. Like Beethoven in the nineteenth century, the Beatles exercised a dominant aesthetic influence over their peers and successors.[74]

The Rolling Stones, who cultivated a bad boy image, revitalized and popularized the blues. Later British contributors included Queen, David Bowie, XTC, Eric Clapton, and Led Zeppelin, all of whom combined the music hall tradition and the blues to varying degrees. Punk, as exemplified by The Clash and the Sex Pistols, emphasized the anti-establishment style and image of the British lower class. Despite these considerable successes, Cyril Ehrlich, a British cultural pessimist, remarked on twentieth-century British music history: "The ravages of the market were only partly offset by belated and inadequate State patronage." What would Mick Jagger say to this?[75]

Whereas Germanic Hausmusik had encouraged skills of composition that could be reproduced on paper, the British music hall tradition stimulated entertainment skills based on performance and personality. Indigenous British musical expertise swept the world in the twentieth century, once recording and radio elevated performer-based genres to the musical lead.

The Beatles heralded a fundamental change in how music was produced. They started as a British skiffle band, using scraped corru-

gated washboards for a rhythm section and plucking "bass" strings at-tached to tea-chests and broom handles; the British lower classes could not afford the electric instruments that drove American rock and roll. By the end of their tenure, however, the Beatles had copied Stock-hausen and ushered in the era of electronic experimentation.

The Beatles and many other new groups worked in small, inte-grated teams that took responsibility for the entire production process and assembled a musical vision from start to finish. Prior to the Beatles, most of the music industry used a hierarchical model of production, found in its most extreme form at Berry Gordy's Motown. The record company laid out singing, playing, songwriting, and production roles to be executed by separate musicians. This hierarchical method did not allow for complex masterpiece albums such as the Beatles' *Sgt. Pepper* or the Rolling Stones' *Aftermath*.

Ironically Motown, based in Detroit, continued to use the same model of factory production that hurt the American automobile manu-facturers of Detroit. Gordy, a former assembly-line worker at Ford, had even advertised Motown as "Detroit's other world-famous assembly line." Motown met with great initial success, but eventually lost market share when rock music became more complex. The competing method of integrated production teams resembled the Japanese approach to auto manufacture, which also conquered its market. The one Motown artist who maintained a Beatlesque approach to production, Stevie Wonder, continued to have a successful career through the 1970s and beyond. Marvin Gaye's *What's Goin' On,* arguably the best Motown album, also used integrated production to great effect. Gordy, who held faith in earlier production methods, did not like the album and released it only on Gaye's insistence.[76]

Rock and roll, originally a mix of Western and African influences, has continued to develop and draw inspiration from music around the world. Jamaica, Africa, Cuba, and Brazil have proven especially influen-tial. Paul Simon, one of the most successful musical synthesists, has drawn from Andean, Jamaican, South African, Brazilian, and Cameroonian sources with great facility and inventiveness. The international exchange of ideas has driven many subsequent developments of original rock and roll styles.

Ironically, Simon's South African borrowings (the *Graceland* album) have earned him the charge of exploiter and cultural imperialist.

But the South African sources for Simon's inspiration—acrobatic vocal ensemble music and jazzy mbaqanga—were themselves derived from the commercial Western penetration of jazz, swing, gospel, minstrel music, and doo-wop into South Africa. South African musical forms, in their early days, were criticized for ripping off Western styles and for their lack of authenticity. The development of rock and roll is a story of trade among diverse cultures.[77]

The New Cutting Edges: Rap, Industrial, House, and Techno

Music in the late 1970s and 1980s once again moved into new territory. Technological advances have increasingly liberated music from constraints of instrumentation. New musical forms—rap, industrial, house, ambient, and techno—have now assumed the musical lead, often to the consternation of classic rock fans.

Rhythm and blues and rock and roll, like most other cultural forms, now have been captured by the cultural pessimists and have become a kind of high culture. The blues and its offshoots are no longer targets of attack; they are now the lost musical paradise of the past. Today's baby boom generation laments the loss of classic 1960s rock. The new musical targets have become heavy metal, punk, house and techno, and above all, rap music. We hear the same criticisms that once had been levied at rock and roll—contemporary musical forms are supposedly repetitive, noisy, drug-laden, and causes of violence and social disorder. Martha Bayles, who presents articulate criticisms of contemporary popular music in her book *Hole in Our Soul,* presents one of the most influential statements of this view.[78]

Cultural pessimists typically classify rock and its offshoots into one of two categories: accessible rather than deep, or obviously unlistenable. Musical pessimists typically are not very familiar with the genres they criticize, and therefore they find that most or all of the new creations fall into one of these categories. If they can enjoy the music right away, it is overly accessible and therefore it will not pass the test of time. When the pessimists find the latest music baffling, they adopt the self-reinforcing attitude that the creations are simply unlistenable. In fact, most of today's "popular" music (a misleading term) is a highly refined product that targets specialized minorities. Many cultural pessimists

simply cannot fathom that other individuals, especially the younger and less educated, might in fact have superior "human musical capital" for appreciating the works of Sonic Youth, Beck, or Polygon Windows.

Rap music has received special opprobrium, and is commonly associated with riots, murder, and obnoxious boom boxes. But approached from another context and freed from its sometimes threatening tone, rap is a startling musical achievement. Rap interweaves advances in musical technology with the cultural clothing of modern urban black America. Iain Chambers has dubbed rap "sonorial graffiti," and Chuck D of Public Enemy described rap music as "CNN for black people." Unlike traditional poetry, rap is best enjoyed while walking, driving, or sitting in a subway. Motown started a revolution by producing music intended for car radio. Rap goes one step further by offering music that should not be heard while stationary.[79]

The basic technology behind rap, sampling, constructs music from the electronic manipulation of sounds, especially other pieces of music. Rap music fulfills the postmodernist and deconstructionist model of a fragmented culture obsessed with its past. Unlike many academic deconstructionists, however, rappers literally deconstruct their source materials and create a final product that entertains.

The Origins of Rap

Rap music arose from the Bronx party culture of the late 1970s. The technology of sampling originated with contemporary classical composers but was rediscovered in the ghetto. One account gives central credit to D. J. Hollywood, a young disc jockey who worked as a "spinner" in low-end black discotheques. Between playing disco records, Hollywood spoke to the audience in jive style, while playing a basic percussive track as a segue from one song to the next. Over time, his verbal style became more complicated, faster, and sported tricky rhymes. Hollywood's routines were taped, put on cassette, circulated, and imitated. Many early rappers, such as Kool Herc, Grandmaster Flash, and Afrika Bambaataa began as party deejays, not as instrumental musicians.

Many early composers of rap songs had little more to work with than a tape player and recorder, often the well-known boom box. These composers could not afford time in a recording studio and in

some cases, could not even afford an electric guitar. For the backing to their cuts, they taped and sliced snippets from other pieces of music to create a homemade background of sound and rhythm. Until 1979, rap existed only on cassette tapes passed back and forth among eager listeners. Rap and its associated hip-hop culture emphasized competition for listeners and the innovative use of limited materials.

Jamaican reggae, itself heavily influenced by New Orleans rhythm and blues radio broadcasts, influenced the early rappers. Kool Herc had come to the South Bronx from Kingston and took his style from Jamaican deejays. Rappers also were influenced by the reggae practice of "toasting," a deejay style that was a half sung, half shouted vocal accompaniment to a rough beat.[80]

Rap was built on numerous other influences of uncertain origin, reflecting its nature as postmodern pastiche. The forefathers of rap include Chuck Berry ("Too Much Monkey Business"), Bo Diddley, bebop singers, the scat singing of Cab Calloway, the spoken rhymes of boxer Muhammad Ali, funk music, prison and army songs, Bob Dylan, Woody Guthrie, and early Delta blues. The sampled materials reveal other cultural influences, including James Brown, speeches of Martin Luther King, Johnny Cash, television and movie theme songs, and the sampled music of other rappers. To add percussive sound and texture, phonograph needles are scratched on records. Along with breakdancing, rap music was an explicit reaction against the glittery unrealism of disco—the music that had dominated urban black musical culture earlier in the 1970s.

The technology of sampling has developed greatly since rap's early days. Sampled materials now can be combined, muffled, speeded up, slowed down, played backwards, or otherwise altered. Modern digital technologies allow music to be massaged in this manner without distortion or hiss. Afrika Bambaataa started as a Bronx street gang leader but ended up as a pioneer of new technologies for electronic music. Later, the advent of low-priced digital samplers in the mid-to-late 1980s allowed advanced sampling techniques to spread to even beginning rappers.[81]

When rap musicians brought their new sound to the major companies, it was initially rejected as unsalable. Rappers were forced to establish their own labels or sign with unknown companies. But like their rhythm and blues precursors, rappers eventually penetrated the market

and garnered major offers from mainstream companies. "Rapper's Delight" by The Sugarhill Gang broke through in 1979 and sold more than two million copies on an independent label. "The Message," released in the summer of 1982 by Grandmaster Flash and the Furious Five, was also a smash success and remains one of the best rap songs.

Hard and Soft Rap

Bringing rap to a larger market has increased its diversity. Just as the gritty Stax soul and the more popular Motown sound reflected different sides of the black experience of the 1960s, different kinds of rap reflect the variety of black experience in the 1980s and 1990s. Soft rap plays up melody, changing syncopated rhythms, and verbal puns and patter. Like Andy Warhol and the Pop Art of the 1960s, the soft rappers revel in commercial society. Soft rappers of the 1990s, sometimes called "suburban rappers," include De La Soul, P.M. Dawn, Arrested Development, Digable Planets, Basehead, Wyclef Jean and the Fugees, and Divine Styler. These musicians belie the common association of rap with violence. Many of these rappers use their craft to convey positive messages about drugs, racial equality, and achievement.

The more controversial hard rap has a meaner beat and presents life in the ghetto, confrontations with the police, arguments with women, and drugs. Hard rap, a music of conflagration, portrays life as an ongoing series of hostile and violent encounters. Schoolly-D, with his *Adventures of Schoolly-D* album, created a rhythmic mini-opera that extended the work of Stravinsky and Varèse. The now-defunct NWA (Niggaz with Attitude), with their *Straight Outta' Compton,* wrote the seminal hard rap lyrics, presenting a harshly masculine worldview in a brilliantly daemonic setting. They inject irony and self-clowning for contrast. The Geto Boys, Public Enemy, Dr. Dre, and the Wu-Tang Clan have contributed to the genre. Anyone can write inflammatory lyrics, but these artists have achieved their reputations through the quality of their music.

Hard rap forces us to encounter contemporary music and poetry at their most barbaric. It uses violence in the artistic tradition of Shakespeare, Bosch, and Verdi to create an entrancing fervor. Nineteenth-century literary critic William Hazlitt, a favorite of many cultural pessimists, wrote words that critics of hard rap should ponder:

"The principle of poetry is a very anti-leveling principle. It aims at effect, it exists by contrast. It admits of no medium. It is everything by excess. It rises above the ordinary standard of suffering and crimes."[82]

Music of the Future?

Rap is by no means the only product of the new musical technologies. House and techno music combine a throbbing beat with the digital and computer construction of sound. The best techno groups, such as Eon and Orbital, produce song-suites of symphonic complexity. The ambient genre relaxes the rhythm and spaces out the sound, as found in the musical landscapes created by Richard James and Orb. Rave speeds up the beat to unprecedented levels, sometimes more than 150 per minute. Tribal combines the basic techno approach with influences drawn from non-Western music around the world. Often we hear the electronic music literally breaking down and decomposing into its constituent "tribal" or ethnic parts.

Industrial music uses artificially created sounds as well but draws its rhythms and sounds from the *Klang* of everyday life, with a further inspiration from Muzak. Laibach rerecorded the Beatles songs from "Let It Be" in industrial garb, portraying the contrast between the "ugliness" and the striking beauty of rock. Skinny Puppy, with their albums *VIVIsect VI* and *Fold, Spindle, and Mutilate* extended the informational complexity and the rhythmic crunchiness favored by many contemporary classical composers.

These new forms hint at an eventual reconciliation between contemporary classical music and the offshoots of rock and roll. Like classical music, these new genres are rooted in composition rather than in the performance of a specific artist; the music is not "performed" at all but is constructed in the studio. With modern technology, any musical sound, even the sounds of rock and roll, can be constructed by composition rather than by individual performance. This development, which constitutes today's "music of the future," will shift the musical balance of power for years to come. The composer will again become primary, and the role of the performer will diminish.

The Germanic composers ruled classical music, and the British led popular music; techno, industrial, and ambient bring these two influ-

ences together. Germany has had a strong presence in house, techno, and industrial since the 1970s, when the groups Kraftwerk and Can drew upon the ideas and techniques of Stockhausen. One of the most creative European bands, Laibach, hails from Slovenia, formerly a part of the Austro-Hungarian empire. They sing much of their material in German and integrate modern musical technology with influences from the Beatles and from Wagner and Bruckner.[83]

The British contributions draw less on a strong compositional tradition and draw more on influences from British popular music and especially from Jamaica. The Caribbean, the richest laboratory for musical ideas per capita in the post-war era, developed the form of "dub" in the early to mid 1970s. Jamaican reggae artists stripped down the A-sides of their singles and presented minimalist instrumental versions on the B-side. Eventually the A-sides were subject to progressively greater electronic deconstruction. King Tubby, the father of dub, separated out different musical lines, spaced out the beats, and added additional syncopation and large amounts of echo. Scientist, Lee Perry, Linton Kwesi Johnson, and Burning Spear, among others, extended the genre. These electronic and musical innovations continue to inform British house, techno, and rave. The replacement of instrumental performance with the studio creation of music shows modern music coming full circle and returning to its compositional roots.

Capitalist Values and Contemporary Music

Many cultural pessimists, such as Allan Bloom, insist on linking contemporary music to depravity and disorder—Bloom refers to "hymns to the joys of onanism or the killing of parents." He also tells us that in rock and roll: "These are the three great lyrical themes: sex, hate and a smarmy hypocritical version of brotherly love." This description demonstrates the lack of familiarity with contemporary music shown by most cultural pessimists.[84]

Contemporary music offers a startling diversity of directions. Chuck Berry sings about the pleasures and freedom of commercialized society, the Byrds uphold Apollonian ideals with the motif of flight, Bruce Springsteen has moved from romantic yearnings to postmodern

bleakness and resignation, Van Morrison is a Celtic mystic, James Brown flaunts pride and self-assertion, the Louvin Brothers sing "Tragic Songs of Life," David Bowie portrays a glittering androgynous world, and Hole offers a fully realized feminist rock mini-opera. The Beatles, with their amazing versatility, offer a miniature worldview in each song, focusing on nostalgia, longing, and the richness of the past. Techno music promulgates a cyberpunk aesthetic, and bebop jazz is based on freedom and spontaneity. The range of available aesthetics and visions is vast, corresponding to our conception of a liberal capitalist society.

Contemporary music, for the most part, encourages freedom, nonconformism, and a skeptical attitude towards authority. The totalitarian states of Nazi Germany and the Soviet Union did not hesitate to permit Bach, Mozart, and Beethoven. Jazz, swing, and blues were banned. The free and vital sense of joy communicated by these musical forms clashed too obviously with adherence to totalitarian ideals. Similarly, the communist and socialist leaders in the Eastern bloc saw rock and roll as a special threat to their authority, precisely because it was based on the personality of the individual performer. Totalitarian leaders were understandably wary of artistic forms that allow other individuals to command the allegiance and affection of large segments of the population.

Just as Savonarola was one of the most perceptive viewers of Florentine art, so were the Soviet apparatchiks among the most perceptive analysts of rock. They understood that rock was pro-capitalist, pro-individualist, consumerist, and opposed to socialism and state control. In Czechoslovakia, the government concluded that punk rock was a manipulative tool used by capitalists to convince young people to identify with life under capitalism. The oppressed citizens loved punk music precisely for these reasons. After the anti-communist revolutions behind the Iron Curtain, many former dissidents pointed out that rock music was a vital means for spreading pro-Western, pro-capitalist ideas. John Lennon, a self-professed collectivist, in fact proved to be a superb propagandist for the Western economic system. It is appropriate, and not merely ironic, that the Nordstrom department store chain plays Muzak versions of Lennon's supposedly communist hymn "Imagine."[85]

Cultural pessimists frequently link classical music with cultural health and rock and roll with social collapse, but the historical data sug-

gest the opposite. Classical music, a favorite of most cultural pessimists, arose from the same societies that later gave rise to Nazi totalitarianism and to the second World War. Mozart and Mahler are hardly to blame for Hitler, but we do not find an empirical correlation between support for classical music and the subsequent healthy development of a culture. In fact, we know very little about what kinds of cultural products make for beneficial social foundations.

We do know, however, that the most thoroughly commercialized and liberal environments, such as England and the United States, have proven fertile ground for the diverse forms of performer-based music. The compatibility between the performer-based musical forms and liberal capitalist democracy is no accident. The technologies that underlie modern capitalism and modern democracies—easy electronic reproduction and dissemination of information—are precisely those that have allowed performer-based forms to compete with classical music.

The musical skills cultivated in the Germanic lands have been less successfully employed in genres based largely on performer personality and talent. Germanic society, more conducive to private life in the home, did not have a strong music hall or vaudeville tradition. The cabaret, a breeding ground for arch humor and the avant-garde, showed much promise in the 1920s, but it was shut down by the Nazis, who connected it with decadence. Totalitarian states typically do not like public expressions of burlesque fun. German musical performers were not permitted to cultivate the skill of entertaining an audience through the free expression of their thoughts, opinions, and overall personality.

Musical pessimists also have claimed that contemporary music provides an aesthetic that is overly accessible and directed at the lowest common denominator. They view rock and roll and other genres as a succession of pop songs, well suited to catch the ear of the casual listener but of little lasting value. We should keep in mind, however, that many modern creations have stood a test of time, one of the most significant indicators of cultural quality and depth. It has now been more than forty years since the release of some of the early classic works of rock and roll, such as Chuck Berry and James Brown. These works continue to attract large numbers of intelligent listeners, continue to receive high acclaim from critics who study the period, and perhaps most important, continue to exercise seminal influence on notable musicians

of the current day. The best contemporary musical creations from twenty years ago, for example, show every sign of following the same path. Ironically, the same commentators who lambaste contemporary music for its accessibility often will turn around and in the next sentence confess that they do not like or enjoy it at all.

The use of the misleading phrase "popular music" to describe modern or contemporary creations sums up a variety of misconceptions, and often serves as a slur for an underlying bias against modernity. Mozart and Beethoven were themselves very popular, and took pride in that fact, yet we do not place them under the "popular music" designation. In the modern musical world, many of the highest quality products (e.g., the Velvet Underground, My Bloody Valentine) have never been very popular at all, and often have failed to hit the charts. Much of today's good music does not appeal to most listeners and requires highly specialized musical human capital for its appreciation. Many pessimists try to paint such music as popular so they can dismiss it as a kind of lollipop for today's youth. They do not, however, endorse the analogous argument when partisans of Hindustani classical music claim that Western classical creations are less complex or less deep than their favored ragas, despite the presence of some musicological foundations for this claim.

The premise that the creations of twentieth-century music are less complex than the classics is dubious, just as we do not fault Beethoven for failing to present the kind of complexity found in ragas. Twentieth-century music has brought new complexity into rhythms, studio production, instrumentation, and a variety of other features that were uniform, less varied, or nonexistent in previous music. Modern compositions, even in narrow musicological terms, do not necessarily provide less depth than their predecessors. The songs of Jerome Kern, Duke Ellington, Thelonious Monk, or the Beatles are arguably no less compositionally complex (and perhaps more complex) than the lieder of Schubert. Schubert wrote about 700 songs, most of which no one ever listens to or analyzes. Many of these songs are technically and compositionally undistinguished, and tend to be formulaic in their melodic treatment. Are "Bill," "Take the A Train," "Crepuscule with Nellie," and "A Day in the Life" really inferior or lesser products?

5

Why Cultural Pessimism?

How do we know that cultural optimism is warranted? I have attempted to approach this question from several angles. The opening chapter presented a number of mechanisms through which a healthy, growing economy will support culture. The subsequent empirical chapters have outlined the relatively successful operation of these mechanisms in the past, and have shown that criticisms of contemporary culture strongly resemble the criticisms leveled at past masterworks. I have addressed many of the arguments used to argue for corruption of our culture, and tried to chip away at their premises, chains of reasoning, and empirical validity. In addition, the preceding chapters have presented some healthy and creative developments in our contemporary culture.

Western culture has been on a general upswing since at least the year 1000, a fact neglected by many cultural pessimists. We should view the twenty-first century with anticipation, not dread. I eagerly await further development of computer graphics, digital photography, house and techno music, the World Wide Web and information superhighway, and interactive television. Consumers will continue to choose from a festive bazaar combining new creations with successive reinventions of the past. The parade of successful and diverse cultural products is not about to grind to a sudden halt.[1]

None of these arguments, however, can prove the case for cultural optimism. It remains possible that cultural decline is incipient, or even now in progress. History often judges a culture differently than do critics or participants of that time, a theme that I emphasize later in this chapter. Furthermore, our assessment of a culture contains a significant element that is irreducibly subjective. For these reasons, it is not

possible to present a knockdown argument for cultural optimism, but I have tried to strengthen the plausibility and the persuasiveness of that position.

In this chapter I also deconstruct cultural pessimism by examining its sources and motivations. By accounting for the widespread popularity of cultural pessimism, and redescribing it in my own terms, I show why that position will appear persuasive even when it is unwarranted. Why has pessimism proven so enduring in a civilization that has seen millennium-long trends of economic, technological, and cultural progress? I provide at least a partial answer to this question.

Cultural pessimism cannot be explained in terms of any single or overriding motivation. Like artistic inspiration, cultural pessimism is motivated by a variety of goals, beliefs, and problems. Cultural critics, like artists, seek money, fame, and the joy of creative expression. The philosophy of pessimism has evolved in response to individuals' pursuit of these ends, just as art has evolved. Like artistic inspiration, cultural pessimism is motivated by a confluence of internal and external forces—preferences and constraints.

Cognitive Illusions

Cultural pessimism appeals to immediate observation. Market forces eventually *will* subvert and change any particular artistic form. Sooner or later, favorite styles and genres will cease to grow, and will become part of the preserved past. Cultural pessimists account for these losses with perception and insight. These losses, in turn, make cultural pessimism persuasive.

Many cultural pessimists identify great culture with what they know and have learned to love. But a culture already admired by the establishment usually is a culture whose best days lie in the past. The pessimists focus on the decline of what they like and neglect the nascent forces that will appeal to others. Even if long-term trends are strongly positive, at each point in time the world may appear to be experiencing a cultural downturn.

As cultural commentators, we are like observers on the shoreline, watching ships sail away over the horizon. We can see the departing ships dwindle in size, but we cannot observe the new ships approaching

our field of vision. We have a memory of each ship that has left, but no corresponding marker for those in the early stage of their voyages to us. We see classic rock of the 1960s in decline, but we are much less familiar with the current and future performers who will take its place. Observers in 1963 might have mourned the death of Buddy Holly, but did not yet know much about the Beatles and the Rolling Stones.

The temporal distribution of achievement can aggravate our sometimes biased cognitive perspectives. Cultural achievements often come in short bursts, temporally concentrated when examined in the broad sweep of history. Athenian drama, German lieder, Big Band swing, and many other styles fit this pattern. After each style peaks, we observe a relatively long period of its decay, which provides fodder for pessimism. The temporally concentrated nature of cultural peaks implies that we are more likely to observe appealing styles by looking backwards, rather than by living in the midst of their golden age.

Other cognitive biases occur when we judge present culture against the very best of past culture. The present often appears to be lacking in contrast. Comparing the best of the past against the entirety of the present makes for an unfair test. Cultural optimism does not imply that our favorite novels, movies, and recordings all were produced just yesterday. The 1920s, the favorite literary decade of this cultural optimist, saw the publication of major works by Mann, Proust, Kafka, Joyce, Eliot, and Yeats, among others. A comparison with the last ten years indicates an apparent decline and we might be tempted to embrace pessimism. But this comparison skirts a more appropriate question—overall, is the creation of masterful works slowing down or keeping pace?

Even comparing the very best of the present to the very best of the past can produce misleading support for pessimism. The later we stand in history, the more likely that our favorite cultural products will lie in the relatively distant past. The passage of time implies that the entirety of the past contains an increasing amount of culture relative to any single point of time, such as the present. Cultural pessimism therefore appears increasingly persuasive over time. The present always contains a mere time-slice of achievement, whereas the accumulated past continually grows in weight. William Wordsworth noted: "What can be more inconsiderate or unjust than to compare a few existing Writers with the whole succession of their Progenitors?"[2]

Cultural pessimism also arises from our inferior knowledge of contemporary cultural products. We consume contemporary culture less efficiently than we consume the culture of the past. The passage of time reveals that Haydn and Mozart are superior to Gluck, Cherubini, Cimarosa, and Grétry. Most music critics in the eighteenth century did not understand the categorical distinctions between Mozart and his contemporaries. Recordings, accumulated listening time, and years of critical debate have helped us evaluate the merits of composers. Our contemporary culture has not yet passed through this process of winnowing, sorting, and revaluing.

When new genres and styles arise, without the wheat separated from the chaff, they appear to present a corrupt and degenerate alternative to older cultural achievements. We do not know who will go down in history as the Monteverdi of digitally-sampled music. Similarly, we might conclude that Jasper Johns, Roy Lichtenstein, and Frank Stella were the best American painters of the 1960s, 1970s, and 1980s. It is much more difficult (probably impossible) to find out which artists under forty years of age will someday take their place.

Time improves our perception of cultural aesthetics. Styles that at first appear perverse or destructive often turn out to be positive and uplifting. The modern audience realizes that Joyce's *Ulysses* and Mondrian's painted grids exalt the human spirit. Unlike both advocates and detractors in the 1960s, we now understand that the Beatles were relatively conservative in their musical inspirations and sources. We hear their music as a skilled and seductive tribute to the past, rather than as a shocking revolution. Rap, techno, and other forms of contemporary music likely will sound far different to future listeners than to today's average fan.

The subsequent development of art is perhaps the most important part of this revaluing process. Mondrian's pictures, both deep and delightful, communicate the religion of art more effectively than the work of his peers. Previous artists, critics, and viewers had not imagined that combining primary colors and straight lines could prove so fruitful. Mondrian's strongest and most convincing advocates have been the later abstractionists, such as Barnett Newman, Ellsworth Kelly, Agnes Martin and Robert Ryman. These artists drew upon Mondrian's approach, thereby illustrating its universality and fruitfulness. Truly negative and destructive artists do little to inspire renowned followers, or to encourage works in similar styles.

Many composers of classical music faced obstacles of aesthetic perception in their day. Some of Chopin's contemporaries described his music as "ranting hyperbole and excruciating cacophony," "ear-rending, torturous, and repugnant," "noise, scrambling, and dissonance," "excessive," and "trivial and incoherent." The subsequent development of music developed our listening abilities and belied these charges. Later, Bruckner was charged with being "the greatest living musical peril, a tonal Antichrist . . . [who] composes nothing but high treason, revolution and murder . . . poisoned with the sulphur of Hell." Bruckner now strikes the contemporary listener as relatively conservative in his orchestration and melodies.[3]

Parents and the Elderly as Cultural Pessimists

Parents, in their desire to protect and control their children, tend to oppose new cultural products and influences. For the same reason that the young welcome the culture of their day and age, the older generation usually opposes it. Cultural markets break down the parental grip over information flow and value inculcation. Magazines, television shows, movies, and music all provide young consumers with ideas and attitudes that differ from those of their elders. The older generation, doomed to fight a losing battle in their struggle to maintain influence, sees cultural corruption.[4]

The emotional impact of raising children has a dominant influence on most people's views. Parents, who are entrusted with human lives of their own making, bring their dearest feelings, years of time, and many thousands of dollars to their childrearing efforts. They will react with extreme vigor against forces that counteract such an important part of their life program. The very same individuals tend to adopt cultural optimism when they are young, and cultural pessimism once they have children. Parents often do not understand the new generation of cultural products and therefore see little or no benefit in their children's interest in them. They seek to control the cultural consumption of their children by restricting attendance at rock concerts or at violent and sexually explicit movies.

Despite tendencies towards excess restrictions, older generations are partly correct in their fears that capitalistic culture may corrupt or

damage their children. Product salesmen do not typically have the long-term welfare of children at heart. They often stimulate immediate commercial demands at the expense of thoughtfulness. Rather than trying to refine children's tastes, salesmen and advertisers try to make them and their parents regularized and predictable customers. Parental restrictions on culture consumption do not arise out of mere misguided authoritarianism; parents are responding to some very real problems posed by a profit-oriented culture.

Many cultural producers will even advocate values inimical to a free and democratic society. At the outer fringes, we find creators who make profits by encouraging cop-killing, irresponsible sex, and racial hatred. Such products, an inevitable result of the cultural diversity of modern capitalism, usually are aimed at young audiences.

Baldassare Castiglione, a Renaissance defender of cultural optimism, offered another explanation for the hostility to new culture. He attributed the tendency to overrate the past to the mental constitution of the elderly. When individuals grow old, they sometimes become distressed and melancholy in temperament. They remember happy experiences from their youth and they glorify the times that accompanied these experiences. The present appears deficient by comparison. Castiglione suggests the provocative hypothesis that the person has declined, not the culture.[5]

Many individuals reach their cultural peak in their youth. The ages fifteen to twenty-five often provide a formative period in which cultural tastes are shaped. The mind is receptive to new influences, individuals are searching for their identity and sense of self, and, more often than not, they are rebelling against the values and culture of their elders. Over time, however, commitments to marriage partners, children, and jobs tend to increase, crowding out time spent attending book readings and browsing music stores. In many lives the rate of cultural discovery starts at a high clip and gradually diminishes so that, to the individual, culture appears to be drying up and declining, creating yet another pessimist.

Aristotle, in his *Rhetoric,* provides a critical account of how human psychology changes with age. He views the old as cynical, distrustful, jaded, and less open to new ideas. Richard A. Posner, the modern law and economics theorist, distinguishes between experiential knowledge and fluid reasoning skills. The elderly tend to be strong in the former

but relatively weak in the latter. They have a limited ability to absorb new ideas and innovations in the realm of culture. Along similar lines, marketing studies have shown that elderly consumers are the most reluctant to adopt new commercial products.[6]

Market culture, by promulgating and selling a cult of nostalgia, itself supports the perception that the past may have been better than the present. Contemporary nostalgia is big business. Few topics are more popular in the movies, or in literature, than the glorification of some previous era. "Where were you in '62?" asked *American Graffiti*.

The search for profit-making niches induces cultural suppliers to recycle and glorify the past with increasing speed, narrowing the gap between previous eras and the present. *American Graffiti* came out in 1973, just barely removed from the era it glorified and reified. The classic rock of the 1960s is no longer regarded as a wonderful contemporary creation; it now belongs to a lost era of innocence, far removed from the present. Today we even treat the 1980s and the late 1970s as part of the romantic past. This attitude would have baffled previous generations, who identified nostalgia with temporal distances of lifetimes and generations, not years. The progression of time, however, creates additional prominence for the past, taken as an aggregate. The present appears increasingly empty and inadequate by comparison, and our highly marketed past contains most of what we hold dear.[7]

Cultural Pessimism and the Artist

Creative artists themselves have provided some of the most biting criticisms of capitalism and of the culture of their day. Movie directors complain about Hollywood, writers attack the corporate publishing conglomerates, and artists paint cynical "statements" about the modern world of art. The achievements of these artists, their critical acumen, and their familiarity with the highest echelons of the cultural world all make their complaints especially persuasive.

Artists' dissatisfaction with capitalism often springs from bitter experience. Creative artists rarely see eye-to-eye with distributors and other participants in the artistic world. Capitalism builds in conflicts of interest at fundamental levels of artistic distribution and marketing. Record stores, art galleries, auction houses, Madison Avenue executives,

and other intermediaries tend to prefer the tried and true. They do not wish to invest resources in promoting products, even innovative or worthy products, that do not maximize expected profit. Artists, on the other hand, pursue a complex mix of aesthetic, personal, and financial goals. These individuals are continually frustrated by the narrower perspective of many of the institutions that promote and disseminate their work. Only sometimes will a painter find a gallery to promote his or her best work, rather than the work in highest demand.

Creators typically dislike the commercial compromises that they must make to achieve and maintain market access. It is thus no surprise that so many artists turn against the market and the cultural networks of their day. Even when artists triumph in their fight with the system, the conflicts along the way consume time, energy, and money. Artists of the highest rank, who believe deeply in their personal visions, strongly resist any and all outside forces that hold this vision back. Such creators may not wish to hear that capitalism is the best system for culture, all things considered. Personal experience usually provides the rationale for our most strongly held views.

Thomas Hobbes presented an alternative hypothesis: cultural pessimists are creators who are jealous of their rivals. "Competition of praise inclineth to a reverence of antiquity. For men contend with the living, not with the dead." Writing about cultural pessimism more generally, Nietzsche took this view even further and claimed that "Monumental history is the cloak under which their hatred of present power and greatness masquerades as an extreme admiration of the past."[8]

When Paul McCartney criticizes contemporary rock music, he may fear that newer creators will overturn his achievements and influence. McCartney has less to fear from earlier stars, who he has either comfortably bested or with whom he has managed to coexist. But contemporary creations, which continually change our perspective on the masterworks of the past, threaten any artist with an established legacy. The most prominent artists often live in the greatest fear of posterity.

Most individuals hold worldviews that exaggerate their relative importance. Real estate agents feel that most people should own homes, bankers see the relative merits of finance, and academics believe in the vital importance of scholarly writing. Cultural creators are no exception to this rule. They believe not only in the importance of art in

general, but in the special importance of their era and genre. Competitors, and cultural change, threaten this importance. Many silent movie stars, for instance, maintained that the talkies corrupted a once-noble art form.

Resentment fuels the older artists' fear of the younger generation. The younger creators, fearing the "anxiety of influence," sometimes cover up or refuse to acknowledge their artistic debts. At the same time, younger creators often face easier market conditions and earn considerably more money. Their precursors are understandably peeved. They see their successors earning more money and reaching larger audiences, even when the later products are not superior to the earlier ones.

Composer and artist Arnold Schoenberg rendered a harsher verdict on the artists who support cultural pessimism. He wrote: "The main thing impressing the decline or downfall of our art and culture on all these Spenglers, Schenkers, and so forth, has been an awareness of themselves as totally lacking in creative talent."[9]

Schoenberg's hypothesis may cover some cases, but his charge does not account for the large number of cultural pessimists who were creative innovators. Jonathan Swift, Alexander Pope, Jean-Jacques Rousseau, and T. S. Eliot are but a few names on this lengthy list. Overall the cultural pessimists have been a more creative lot than the cultural optimists.

Innovators may push cultural pessimism as a cover for their revolutionary artistic activities. Aesthetic, marketing, or political reasons may all cause artists to downplay the newness of their creations. Attacking contemporary culture and praising the past gives the artist a safe, conservative appearance. Cultural pessimism provides an ideological smoke screen under which the progress of culture may proceed.

Jean-Jacques Rousseau, in his first *Discourse,* argued against the Enlightenment ideal of progress. His concept of the noble savage remains in the vocabulary of modern cultural pessimism. Rousseau even accepted the pessimist critique of books and publishing. Yet Rousseau's reverence of the past cloaked a radical application of his ideas. Rousseau provided ideological inspiration for the later French revolution. He feared censorship and imprisonment throughout his life, and was even forced to flee France. This same Rousseau was one of the most original authors of his century, and self-consciously so. He

opened his *Confessions* with the following: "I am forming an undertaking which has no precedent, and the execution of which will have no imitator whatsoever. I wish to show my fellows a man in all the truth of nature; and this man will be myself."[10]

The cloaking of innovation under the invocation of past cultural glories was particularly common during the Renaissance. Creators often represented their work as resurrections of the great traditions of antiquity. Vincenzo Galileo (father of the astronomer) headed a musical group called the Camerata, which protested against the growing polyphonic tradition from the northern countries. These musicians staged performances combining monodic singing and instrumental accompaniment. Galileo presented the product as a recreation of the Greek musical tradition, but in fact Camerata musicians were developing the original and revolutionary genre of opera. Renaissance painters pretended to be resurrecting the great traditions of antiquity, but most of them were innovators as well.[11]

This Straussian interpretation of cultural pessimism for the sake of a hidden agenda implies that the strongest pessimists often will be the most creative innovators. Swift's *Gulliver's Travels* and Eliot's *The Waste Land* were highly original, unprecedented creations. These works met with criticism and hostility in many quarters. Swift was an eighteenth-century Irish clergyman with no foothold in the literary establishment. His satire lampooned the political and economic sacred cows of Georgian England. The premise of his *Travels* is closer to modern-day science fiction and fantasy than to the mainstream creations of his day. Samuel Johnson referred to the book as "so new and strange . . . written in open defiance of truth and regularity."[12]

Swift could not embark on this innovative crusade without paying a high price. For good reason he feared for his prospects for promotion within the Anglican Church. He published most of his major works anonymously (including the *Travels*) and often hid his satirical polemics behind a barrage of allusions, double meanings, and obscure references. We cannot always take Swift's writings, including his pessimism, at face value.[13]

Allan Bloom, a cultural pessimist and himself an explicit advocate of Straussian interpretation, fits a similar model. His *Closing of the American Mind,* despite its polemics against contemporary culture, is a beautifully written tract, replete with novel and perceptive observa-

tions. Bloom's work on Swift and Rousseau (the two great Straussian pessimists) and his book on friendship further extend his claims to originality.

The cultural optimists can be deconstructed in Straussian fashion as well. Samuel Johnson, although he defended a philosophy of cultural optimism, chose conservative genres for his works. His *Rasselas* gave the fantastic voyage a far more mainstream treatment than did Swift's *Gulliver's Travels*. His *Lives of the English Poets* attempted to establish a canon of past literary glories, just as Harold Bloom does today. The *Dictionary* codified words as others had used them, illustrating Johnson's relative lack of concern with his own originality.

Johnson even criticized the supposedly excess propensity of others to innovate: "Hume, and other sceptical innovators, are vain men, and will gratify themselves at any expense. Truth will not afford sufficient food to their vanity: so they have betaken themselves to error. Truth, Sir, is a cow which will yield such people no more milk, and so they are gone to milk the bull." Perhaps Johnson could afford cultural optimism more easily than Swift—he did not have Swift's foresight to fear the truly radical changes of the future, nor did he have a comparable burden of originality to justify. Johnson himself even noted of Swift: "no writer can easily be found that has borrowed so little, or that in all his excellences and all his defects has so well maintained his claim to be considered as original."[14]

Swift, in his *Tale of a Tub,* offered his own explanation of why creators were more likely to embrace cultural pessimism than cultural optimism. Drawing upon a mix of experience and introspection, Swift characterized great writers as fame-seekers, first and foremost. Yet authors must market a critical stance to achieve a reputation for originality: "Fame and Honour should be purchased at a better Pennyworth by Satyr, than by any other Productions of the Brain; the World being soonest provoked to *Praise* by *Lashes,* as Men are to *Love* . . . the Materials of Panegyrick being very few in Number, have been long since exhausted: For, as Health is but one Thing, and has been always the same, whereas Diseases are by thousands, besides new and daily Additions."

Swift theorized further, in line with Hobbes, that praise will be poorly received by the world. Kind words, which can never be bestowed equally on all persons, are likely to raise envy and rancor from

those who have been neglected. When individuals encounter satire, in contrast, they assume it applies to all others but themselves.[15]

Leo Tolstoy used cultural pessimism to apologize for his own writings; he objected virulently to the amorality of his *Anna Karenina,* for instance. Tolstoy never reconciled his dual roles as dramatic author and Christian ascetic. His critical tract, *What is Art?* condemned the Greek playwrights, Shakespeare, Milton, Goethe, Michelangelo, Raphael, the French impressionists, most of Bach, late Beethoven, Wagner, Brahms, and most of his own works. Perhaps Tolstoy wanted to make sure that he was in good company with his sins.

Sensuality and Depravity

Some critics target the sensuality and supposed depravity of contemporary culture. These polemics tend to be more emotional, more personal, and probably more influential than many of the other arguments made by cultural pessimists.

According to Allan Bloom, rock and roll is a "gutter phenomenon," ruins the imagination, is based upon the sex act alone, is pushed by the "robber barons" of the record companies (note the borrowing from left-wing critiques), and has the "moral dignity of drug trafficking." The "Nihiline" Mick Jagger was king of this genre, says Bloom, but "in the last couple of years Jagger has begun to fade. Whether Michael Jackson, Prince, or Boy George can take his place is uncertain. They are even weirder than he is, and one wonders what new strata of taste they have discovered."[16]

Earlier conservative critics of Enlightenment culture leveled analogous complaints against opera, arguably the most sensual art form of its day. Eighteenth-century German conservatives, for instance, claimed that the ancients would have found the cacophony of opera unimaginable. They attacked the defenders of opera for their supposed beliefs that artistic standards are arbitrary and whimsical. Such criticisms continued throughout the nineteenth century, when the target shifted to the operas of Richard Wagner.[17]

Bloom and his anti-opera precursors oppose the sexuality, the drama, the glamour, the "excessive" romanticism, and the exuberance and exhilaration that rock and opera share. The British rock group

Queen, in their album *A Night at the Opera,* draws the connection be-tween rock and opera explicitly. Their music, like the creations of Verdi and Wagner, highlights how much of notable culture has re-jected the traditional Aristotelian virtues of moderation. Bloom did not point out the irony that he, a gay male, was attacking contemporary culture for its deviance. Art is not only about ideas, it is also about sex.

Bloom's polemic against contemporary culture strongly resembles Max Nordau's *Degeneration* (first edition 1893), although the extraordi-narily well-read Bloom never cites Nordau. A comparison between Nordau's book and Bloom's shows connections strong enough to give us pause.

Bloom and Nordau both wrote best-selling pessimistic tracts, full of persuasive prose, that garnered them worldwide intellectual fame. Both were remarkably well-read, and drew on an extraordinarily wide base of knowledge. Like Bloom, Nordau stresses music as a sign of cul-tural health, although he attacks Wagnerian opera instead of rock and roll. Bloom objects to left-wing multiculturalism; Nordau objects to Ibsen, Tolstoy, and the Pre-Raphaelites. Despite a gap of nearly one hundred years, Bloom and Nordau agree on the ultimate intellectual sources of cultural mischief. They share a hatred of German romantic philosophy and portray Nietzsche as the philosopher-king of egomania and moral relativism.

Both Bloom and Nordau identify cultural decline with moral, cognitive, psychological, and especially erotic degeneracy. The sexual tensions are closer to the surface in *Degeneration,* a work dominated by the metaphor of disease. Camille Paglia might enjoy deconstructing Nordau's claim that fin-de-siècle culture represents "the impotent de-spair of a sick man, who feels himself dying by inches in the midst of an eternally living nature blooming insolently for ever."

Nordau's description of degenerate cultural consumers and pro-ducers resembles nothing so much as the orgasmic human being. These "degenerates" are plagued by hysteria, madness, extreme ex-citability, delirium, and a tendency to fall into raptures. Nordau also directs our "particular attention" to the role of "sexual psychopathy" in the cultural creators whom he attacked. Nordau even attributes Nietzsche's philosophy to his supposed sexual sadism. Commenting on Nietzsche, Nordau writes without irony: "All persons of unbalanced minds—the neurasthenic, the hysteric, the degenerate, the insane—

have the keenest scent for perversions of a sexual kind, and perceive them under all disguises."[18]

Religion as a Source of Cultural Pessimism

Religious authorities have been among the strongest and most influential proponents of cultural pessimism. Cultural products, even when they have a religious orientation, compete with churches and religious figures for the attention of the populace. For centuries, cultural portrayals of the sensual, the heroic, the delightful, and freedom have drawn strong criticism from religious leaders.

The relationship between religion and culture has never been simple; culture and religion have, to a considerable extent, been complements. Calligraphic pages of the Koran have provided some of the world's most beautiful art. Christian churches have commissioned notable art works and musical compositions; even throughout the twentieth century, many of the best abstract artists have drawn upon religion for themes and inspiration. Yet despite the importance of religion as a foundation for culture, organized religion has not allowed culture to coexist peacefully.

Struggles over Iconoclasm, prevalent in Christianity and other religions for centuries, illustrate how deeply culture threatens established religions. Most organized religions have been fundamentally suspicious of the decentralized production of images. In Byzantine times the so-called "cult of images" advocated artistic freedom for placing idols and images in churches and on coins. This movement, when allowed to flourish in the Eastern Roman Empire, challenged Christian religion and the unique role of God. Images, saints, and idols, the result of artistic production, were worshiped in their own right as autonomous gods, rather than as mere messengers of a higher deity. Christian doctrine stood in danger, supporting David Hume's later point that religious and ideological competition tend to turn monotheism into polytheism.[19]

The Iconoclasts argued that the emperor and church should control which images grant fame and how these images should be interpreted. The Byzantine emperor banned the production of such images for over a century, from A.D. 726 to 843. Iconoclasm, in various guises,

also has arisen in ancient Athens, the Puritan and Calvinist churches, and the sermons and bonfires of the Florentine preacher Savonarola. Islam, the most self-consciously monotheistic of the major religions, has placed especially severe restrictions on the depiction of images in the mosque. In each case ancient or modern religious authorities wished to preserve a particular conception of holiness. To do so, they felt the need to restrict the freedom of expression created by market-driven art.

Religion has strengthened the hold of cultural pessimism through abstract doctrine as well. The Old Testament promulgates the myth of an idyllic Eden before the fall. The gnostic tendencies in Christianity and Judaism, which persist to this day, portray the material world as corrupt and degenerative. Throughout the world, religions of many sorts have professed an indifference or sometimes even a contempt for worldly goods. Whereas mythology tended to invoke a circular view of progress, modern religions often postulate some post-apocalyptic state as superior to the world we live in.

Cultural pessimism, insofar as it tries to provide an embracing account of modernity's failures, serves as a competitor to myth and magic. It helps us make sense of the inevitable evils and disappointments of our world. Unlike magic, however, cultural pessimism is not easily accountable to controlled experiment. The magician can be asked to perform, but the cultural pessimist need only point to artistic failures to confirm his or her worldview. The ultimate test—whether total cultural collapse arrives—always can be postponed.[20]

Plato, a fountainhead for many pessimistic doctrines, promulgated a form of cultural pessimism similar to that of many religious thinkers. Plato, in his dialogue *Republic,* writes that poets will be banished from his ideal state. In *Laws* Plato advocates government censorship of artistic production and the enforcement of cultural stasis. An undercurrent of hostility towards the arts can be found throughout his writings, such as in his diatribes against the Greek theater.

Plato shares with religion a hostility towards art from the standpoint of a higher, absolute truth. Plato contrasts poetry with philosophy. Poetry, which is based on lies and deception, holds men back from attaining knowledge of the truth, the Platonic ideal. This supreme form of beauty is too important to be contaminated by man-made creations; "great" art is usually nothing more than an elaborate form of

lying. The artist, who promotes the shadow world of the cave, is simply another form of sophist or relativist. The artist seeks to entertain when he should be praising moral virtue instead.[21]

The targets of such absolutist or religious attacks have changed with each generation, revealing a broader pessimistic suspicion of decentralization. Both public moralists and philosophers from Plato onwards have criticized theater and poetry for their corrupting influence. Books became a popular target after the onset of publishing. In the eighteenth and nineteenth centuries additional targets included novels, epistolary romances, newspapers, opera, the music hall, photography, and the instrumental virtuoso, such as Liszt or Paganini. The twentieth century brought the scapegoats of radio, movies, modern art, professional sports, the automobile, television, rhythm and blues, rock and roll, comic books, MTV music videos, rap music, and electronic video games. Each new art form has been accused of corrupting our nation's youth, and promoting excessive sensuality, political subversion, and moral relativism.[22]

Cultural Pessimism and Politics

The roots of cultural pessimism are not always found in matters cultural; pessimists often criticize contemporary culture to promote political or moral agendas. Although these pessimists are usually sincere in their dislike of modern cultural trends, cultural quality is not always the major concern. Cultural topics are used to market political messages that might be less popular or less palatable if presented on their own terms.

Several distinct messages emanate from that broad amalgam of views that is commonly labeled the right wing. The neo-conservatives, such as Irving Kristol and Daniel Bell, wish to promote the "Protestant" ethics of abstinence, hard work, and community. Market-driven culture, in contrast, supposedly encourages luxury, novelty, and cheap gratification, thus undermining the conservative Western institutions that have allowed it to flourish. Charles Newman has perceptively noted that conservatives consider culture as "something which has failed *them*."[23]

By placing conservative culture at the top of their political agenda, the neo-conservatives risk losing their skepticism about big government. Many neo-conservatives, such as Irving Kristol, pay lip service to the free market but do not accept the artistic revolutions that markets inevitably bring; market-based art often overturns conservative social conventions and morals. Daniel Bell takes a more consistent attitude by calling himself conservative in matters of culture and socialist in matters economic.

Bell started as a left-wing socialist and Kristol was a Trotskyite in his early years. Both have since rejected central planning but they retain their suspicion of the values that result from a purely voluntary civil society. Bell does not endorse government control of the arts, but opts for a religious renaissance to guide our culture along appropriate lines. Irving Kristol takes a more political approach. He wrote, "I will put it as bluntly as possible: If you care for the quality of life in our American democracy, then you have to be for censorship."[24]

Michael Medved, in his book *Hollywood vs. America,* also fails to resolve the tension between what the market produces and what the neo-conservatives want. Medved argues that contemporary moviemakers feed us a continual diet of sex and violence in lieu of defending traditional values. The fault, however, cannot be allowed to lie with the consuming public; that would illustrate the unpopularity of neo-conservative agenda. Nor does Medved, with his considerable libertarian streak, pin his hopes on censorship. Medved instead tells us that moviemakers could earn far greater profits by filming more wholesome themes, if only the Hollywood establishment were not so out of touch with the American people.[25]

The Christian right, which trumpets the theme of family values, damns contemporary culture for undermining older traditions. Yet many individuals from this camp are not concerned first and foremost about family values *per se*. Family is a codeword for constraint; families and family values place constraints on individuals more effectively than any other institution, including government. The Christian right seeks a society in which all are constrained; they reject big government for failing at constraint, and for undermining those institutions, like the family, that have a chance of succeeding.

This hidden agenda helps account for the obsession of the Christian right with homosexuals and homosexual art. Gay males often

have no commitments to children, relatively large disposable incomes, and a well-developed sense of aesthetics. The gay male sexual ideal, in many cases, veers close to promiscuity. No other culture has so proudly paraded a conscious rejection of external constraint. Under the guise of protecting our children from a homosexual future, the Christian right attacks homosexuals, and contemporary culture, for their revolutionary tendencies. The Mapplethorpe controversy, which brought sexual, so-cial, and economic issues together into a neat package, provided the perfect vehicle for Christian right polemics.

The innovations of minorities and outsiders further mobilize right-wing cultural pessimism. Racial and ethnic tensions are virulent in most societies. When minorities offer new cultural products, many object either out of prejudice or simply out of lack of understanding. Yet the market, unlike a state-run apparatus of culture, cannot suppress these new products by force. Social conservatives often will find the latest cultural productions to be distasteful and repugnant. Fans of these new developments tend to be the young and the disenfranchised, who lack comparable social voice and influence.

Sometimes political changes will transform cultural pessimists into cultural optimists. The 1994 Republican majority in Congress, at that time represented most prominently by Newt Gingrich, moved away from its previously pessimistic worldview. These Republicans, who felt vindicated by their landslide in the Congressional elections, expected to preside over the "regeneration" of America. They tended to see con-temporary culture as a bankrupt, elitist product that is irrelevant to the great forward march of the American people. This culture, and the small amount of government funding it receives, was attacked to demonstrate the supposedly populist roots of a party that had lingered in the minority for so long. Many Republicans have turned away from cultural pessimism, at least temporarily, because they see themselves on CNN and C-Span so often.

The latest generation of neo-conservatives also has moved away from a pessimistic message, even though their views contain the seeds of a pessimistic worldview. Like Gingrich, they have become the new establishment and cannot believe that collapse will come under their watch. William Kristol, neo-conservative commentator and son of Irving Kristol, is one prominent member of this group. These neo-neo-conservatives do not always share the stodgy cultural tastes of their pre-

decessors; William Kristol, unlike his father Irving, grew up with rock and roll.

The conservative Republicans have reaped political capital by attacking government arts funding, and they may someday pull the plug, but it is not actually in their interest to eliminate such funding. Given his preference for cultural order, Jesse Helms should place the most radical artists highest on his list of government subsidies. The National Endowment for the Arts (NEA) holds out the promise of controlling artistic revolutionaries by bringing them into the establishment. Robert Mapplethorpe became wealthy as an artist and photographer, but Senator Helms could have tried to reach him early in his career and co-opt him with the promise of government largess. Historically government funding has tended to support the culture of the establishment, and to obstruct or co-opt radical artistic innovations.

Some of the less tolerant members of the political correctness movement now share many positions with the religious right. The puritan feminist Catharine MacKinnon, in her recent book, *Only Words*, argues for censorship by equating sexually explicit literature with the act of rape. The politically correct left and the religious right proved to be allies on the Mapplethorpe issue as well. Politically correct critics attacked Mapplethorpe's sexually explicit photos for being racist and sexist, for reducing the body to an object, for perpetuating a culture of "domination," and for pushing an aesthetic of "colonial fantasy." The right considered the photos to be outright pornography, thus making Jesse Helms and the radical gay left strange bedfellows indeed.[26]

Libertarians hold a dynamic, positive view of markets and capitalism close to my own, yet they often embrace cultural pessimism. Their strong desire to criticize government leads them to place politics above beauty. Government, which has mushroomed in size this century, now consumes at least forty percent of gross national product in most developed countries, even in an era that is relatively sympathetic to the market economy. Given that libertarianism has not succeeded in becoming a political majority, libertarians instinctively feel that something must be wrong with our culture and our art.

Despite their protests, many libertarians are glad to hear that the NEA sometimes funds dubious art. They would rather have their negative view of government confirmed than enjoy a great public mural. Since Mapplethorpe's photos and Serrano's *Piss Christ* give them

marketable fodder for attack, they assume that these artists must be degenerate and low quality.

The idiosyncratic aesthetic writings of Ayn Rand have exercised a particularly strong influence on libertarian attitudes towards art. According to Rand, art ought to reflect how individuals should be, rather than how they actually are. Art is a metaphysical statement that should communicate a positive sense of life. She titled her aesthetic treatise *The Romantic Manifesto*. Hugo, Dostoyevsky, Vermeer, Rachmaninov, Mickey Spillane, and Henryk Sienkiewicz all meet with Rand's approval. Flaubert, Tolstoy, Mozart, and modern art fail the litmus test. Rand saw modern culture as a "sewer," created by "enemies of the mind" to enslave the heroic individual. She had argued eloquently that wealth supports creativity, but she rejected the modern climate of ideas without recognizing its essentially capitalist nature.

Cultural Pessimism on the Left

The right wing is not alone in using cultural arguments to promote a political agenda. The neo–Marxist German Frankfurt School (e.g., Theodor Adorno, Max Horkheimer, Jürgen Habermas, Herbert Marcuse) argued that the bankruptcy of market culture indicts the capitalist system. While these authors offer a variety of perspectives, the school as a whole attacked the shallowness of mass culture.

Twentieth-century Marxist and socialist philosophies, in all their manifestations, faced the question of why the masses were not fighting for the rule of the proletariat. The Italians and Germans even turned to fascism, which succeeded as a European mass movement where communism had not. Later, after the Second World War, the European working class embraced television and American popular culture. Clearly something had gone wrong, and the mass culture of capitalism became the new villain. The Frankfurt School argued that mass culture destroys civil society, "atomizes" the masses (as fascism had), and dupes the citizenry. The theory of mass culture became for the extreme left what the "public choice" theory of special interest groups has become for the extreme right—a logic of excuse, an explanation for why a proffered alternative has found so little favor.[27]

The Frankfurt School even drew on the traditional, right-wing critiques of modernity, just as the Marxist critique of the Industrial

Revolution was gleaned from conservative opponents of the Enlightenment. Common sources for neo-conservative and Frankfurt School criticisms include Friedrich Nietzsche, who argued that the masses destroy excellence, Alexis de Tocqueville and Ortega y Gasset, both critics of democratic mass culture, Oswald Spengler, a conservative prophet of Western decline, and Ferdinand Tönnies, a German sociologist who emphasized the clash between economic development and community. All of these sources fed back into the neo-conservative movement when a young Daniel Bell attended the lectures of the Frankfurt School theorists in New York.[28]

Contemporary left-wing intellectuals, who have rejected many elements of the Frankfurt school approach, are more likely to hold relatively favorable attitudes towards popular culture. Popular culture studies, pursued usually by the left, have drawn critical attention to the detective novel, salsa music, and the blockbuster film. But like many of the neo-conservatives, these individuals promote a cultural agenda at odds with their underlying politics. The progressive left enjoys new artistic revolutions but does not approve of the underlying support system of free markets and capitalism.

Cultural Pessimism and the Multiculturalist Debates

The contemporary debate over multiculturalism exhibits yet other political and cultural motivations behind cultural pessimism. Once again, the right and left wing share important premises while appearing to stake out opposing positions.

The debates over education focus on whether curricula should emphasize the time-honored Western classics or the "multicultural" achievements of non-Western cultures, women, and disadvantaged groups. Many traditionalists believe that third world and indigenous art, supported by a tyranny of political correctness, threatens to engulf the time-honored Western classics. E. D. Hirsch and Harold Bloom have even cataloged their own aesthetic canons. The multiculturalist left, on the other hand, feels that alternative perspectives have been unjustly shut out. The multiculturalists also worry that the global reach of the developed economies will destroy the native creations of non-Western cultures. They see capitalism as threatening cultural diversity.

Both the multiculturalists and their neo-conservative critics implicitly idealize a static culture. Change is seen as a form of corruption, and modernity supposedly threatens to bring cultural decline. Both groups see a preferred culture in danger of corruption, but they disagree about which culture requires preservation. The neo-conservatives support the Western classics and the multiculturalists sympathize with the so-called "indigenous" cultures. Both fear what David A. Hollinger has labeled the "acid of modernity."[29]

Many defenders of the classic curriculum actually promote the premises of the multiculturalists they mean to criticize. The neo-conservatives do not see a "Proust of Papua New Guinea," and thus retreat to the classics of the Western heritage, such as Homer, Shakespeare, and Mozart. By downplaying or even attacking contemporary art, music, and literature, they implicitly communicate a static picture of the world. If capitalism and the Western tradition cannot be defended as agents of innovation and cultural change, they probably cannot be defended at all.

Many of the multiculturalists, in turn, betray an implicit skepticism towards third world and indigenous art. They accept the generally static worldview purveyed by many neo-conservatives, and transport this sense of stasis to the debate over their favored cultures. Non-Western art is portrayed as so weak and fragile that it must be protected against outside influence. Many multiculturalists are slow to recognize the cosmopolitan roots of many third world achievements, or to admit that change and progress can occur in any part of the world but the West.

Multiculturalism, when interpreted in cosmopolitan terms, provides support for cultural optimism. The multiculturalists have gone to great lengths to identify superb artistic achievements of women, ethnic minorities, gays, and other groups. We now know that women's quilts stand among the best American art works of the nineteenth century, and that the Central African pygmies are among the world's most talented musicians. In light of such discoveries, should we not upwardly revalue our estimation of the world's cultural prospects? Multiculturalists typically believe that women could create far more if given the appropriate opportunities, but most multiculturalists do not wish to embrace the natural conclusion of cultural optimism.

Most multiculturalists focus on the negative aspects of globalization and neglect the positive. In fact world culture has flourished as the

reach of the West has expanded. The musical centers of the third world—Cairo, Lagos, Rio de Janeiro, pre-Castro Havana—have been the heterogeneous and cosmopolitan cities that opened themselves to the outside world. New York City, not geographically a Latin metropolis, has been the center for salsa. Western demand has driven the development of Inuit sculpture in northern Canada. Cyberpunk culture, as exemplified in *Blade Runner,* William Gibson's *Neuromancer,* and digitally-sampled "tribal" dance music, directs our attention to the persistence of ethnic identity in a capitalist future. The multicultural movement need not be committed to cultural pessimism as a matter of logic or fact.

Most of the multiculturalists, however, have shied away from the cultural optimist position. Cultural optimism would create the impression that today's world, no matter how imperfect, was somehow on the right track. Embracing cultural optimism might also appear to diminish the moral force of past injustices. Rather than make these intellectual and political concessions, the multiculturalists have resurrected the myth of historical decay, dating back to the Greeks and Rousseau. They portray neglected artistic creations as the product of "indigenous" cultures that flourished by avoiding contact with mainstream Western civilization or that flourished in spite of their contact. Adherence to this myth implies the corresponding worry that globalization will homogenize world culture and destroy remaining pockets of creative vitality.

Some left-wing critiques of market culture are motivated by the desire to defend government funding for the arts. Many modern liberals on the left hold weaker, watered-down versions of Marxist or socialist views. They accept much of the Marxist critique of markets but favor extensive state subsidization, not outright state control.

Neither the advocates nor the critics of government funding have yet to take a consistent line on the minuscule expenditures of the NEA. Consider the funding advocates. On one hand, they try to minimize our perception of the fiscal burden of such support. They point out correctly that the NEA has never spent more than seventy cents per head of the American population; cutting those expenditures would do little to remedy the budget deficit. The American government spends more on military marching bands than on the NEA.

On the other hand, we are told that continuing arts funding is vital for America's cultural future. Yet how can such a small sum of

money reverse general trends? Like the marching band, the NEA cannot simultaneously be harmless and essential to our cultural future. If we use cultural pessimism as an argument for the NEA, we must expand government funding beyond current levels, and even beyond the $3 billion a year and 12,000 cultural bureaucrats employed by the French.

Some defenses of the NEA unwittingly portray government-funded art in a worse light than is intended. Jane Alexander, head of the NEA under the Clinton administration, has responded to conservative criticisms by presenting a bland and universalist conception of artistic merit. Her statements make art sound like a gentle, majoritarian form of social therapy. Alexander tells us that good, government-funded art can elevate a wide variety of tastes without offending anyone—fortunately a claim that could never plausibly be made on behalf of market culture.

Psychological Forces for Cultural Pessimism

Some individuals, both on the right and on the left, support cultural pessimism as a justification for elitist attitudes. Elitists need to feel that they belong to a privileged minority. Contemporary culture, which is massive in size, diverse in scope, and widely disseminated, has to be bankrupt to sustain the elitist self-image. Insofar as we celebrate the dynamism of modern creations, we are ascribing aesthetic virtues and insights to a very large class of artistic producers and consumers, contra elitism.

Elitists wish to see themselves as rising above the crassness of the common man and the leveling tendencies of liberal democracy. Cultural pessimist William H. Gass wrote in 1968 what many more have thought:[30]

> The average man does not want to know how he looks when he eats; he defecates in darkness, reading the *Readers Digest* . . . his work is futile, his thought is shallow, his joys ephemeral, his howls helpless and agony incompetent; his hopes are purchased, his play is mechanical . . . futilely he feeds, he voids, he screws, he smokes, he motorboats, he squats before the tube, he spends at least a week each year in touring . . . and dies like merchandise gone out of season.

Television provides an especially common target for the elitists. Many cultural pessimists, however, do not regret the problems with television but instead seem to enjoy envisioning themselves as superior to the medium. Deep down, an improvement in the quality of television would disappoint them by removing this source of satisfaction. The issue of television brings out an elitist streak even in writers who otherwise avoid that tendency. Neil Postman described the information superhighway as "Buried in a New Kind of Garbage." He notes with disapproval that "Instead of 60 TV channels, we'll have 500, maybe a thousand. We'll have access to more entertainment, more sports, more commercials, more news—faster, more conveniently, in more diverse forms." This may sound good to the naive reader. Unfortunately we do not share in a rich inner life; we are "information junkies who have no sense of purpose and meaning, and who require distractions from confronting emptiness."[31]

Paul Fussell's book *BAD* illustrates the link between elitist strands in cultural pessimism and economic thought. In a book that consists of little more than diatribes against his personal dislikes, Fussell explicitly associates bad culture with capitalism and with increases in the standard of living of the common man. Bad culture, excessive wealth, the decline of good living, and, of course, America are all targets of this Englishman's barbs.

While Fussell likes the American Bill of Rights, he finds American culture hopeless. Early on in his book Fussell tells us that "The great crappiness is essentially American, for reasons that will become clear [sic] as we go along." Treating government as the potential source of creativity, Fussell argues that American culture has slid too far to regain its ground, even if we nationalize the airlines, reinstate the teaching of Latin, develop television into a truly public medium free of commerce, improve the literacy of public signs, improve the taste of public sculpture, and raise the capital gains tax. I am reminded of the ironic statement that America is "the only country that's gone from barbarism to decadence without being civilized in the meantime."[32]

Defenders of government funding for the arts also frequently display an implicit elitism. Advocates of subsidization often envision using the tax money of the movie-going, gum-chewing masses to subsidize opera houses and *Masterpiece Theater*. They complain when the Folger has to cancel a Shakespeare production but they do not

mind that many poorer fans must pay $100 or more to scalp a Rolling Stones concert ticket.

The partisan motivations behind cultural pessimism, whether they serve right or left wing interests, all share a common fear. Culture holds an enormous and sometimes frightening ability to affect our world-views. The culture we consume is arguably more influential than the history we read or the political debates we hear. Yet the influence of culture, which is inherently dynamic, surprising, and revolutionary, cannot be steered or managed in any particular direction. Culture is therefore feared by individuals with a vested psychological or material stake in particular ideas. Those who place politics above art do not wish to come to terms with the defiant and open-ended nature of the human creative impulse. The aesthetic, drive, and insight behind creativity dwarfs partisan battles, thus drawing hostility from those who invest their primary energies in politics.

Cultural Pessimism and Resource Pessimism

Some attractions of cultural pessimism come from the pessimism, rather than from any particular view of culture or politics. Overly pessimistic views are common when individuals contemplate the future rate of economic growth, the trend of social values, or the chances of nuclear war. "Microbe pessimism" is especially in vogue at the moment. A spate of recent books have questioned whether the evolution of viruses might outrace the combined forces of the human immune system and modern medicine, raising fears of a modern plague.

The psychological attractions of these views overwhelm whatever truth they might contain. The pessimistic mindset protects our expectations against the inevitable disappointments that are bound to occur. The better things get, the more we have to lose, and the greater the need for a psychological defense mechanism. Forthcoming losses are easier to deal with the sooner they are internalized. Other individuals find that belief in impending catastrophe actually trivializes and lightens the more mundane psychological burdens they face every day. Freudians might suggest that pessimism sometimes conceals a secret wish for future catastrophe and destruction.[33]

Some kinds of pessimism spring from an inability to imagine future improvements. Cultural pessimism and resource pessimism share

common roots in this regard. For the resource pessimists, we have relatively fixed production technologies and supplies (such as oil and gas), only so many years remaining of these supplies, and thus an impending economic catastrophe. Many cultural pessimists also see production technologies as fixed. We have certain great art forms, such as classical drama, romantic novels, and opera. These forms have been "exhausted," at least in terms of the taste of the pessimist. The absence of further worthwhile styles implies cultural catastrophe.

In 1891, the U.S. Geological Survey announced that there was little or no chance of finding oil in Texas. In 1926 the Federal Oil Conservation Board stated that only seven years of petroleum reserves remained in the United States. In 1939 and 1949, the Department of the Interior predicted that the end to U.S. oil supplies was in sight. In the post-war era we have heard similar claims of impending exhaustion of energy supply, agriculture, and mineral resources. Earlier "crises," which concerned whale oil, rubber, and timber, provided the model for these warnings. Like the cultural pessimists, these predictors underestimated the human ability to invent new ways of solving old problems.[34]

Costs and Benefits of Cultural Pessimism

Cultural optimism implies that the incentives of money, fame, and creative self-expression do not misfire in the arts, at least provided that a market economy operates. Therefore we should not expect these same incentives to ruin the output of cultural critics. Cultural criticism does not differ in kind from artistic production. Every work of art provides implicit commentary on other works and in this regard constitutes criticism; every good critic enriches the works he or she comments on, thus providing a kind of art.

James Ralph, eighteenth-century writer and cultural optimist, attacked cultural pessimism by noting "That whatever Disparity may be betwixt the antient [sic] and modern POETS, I am convinc'd, that in the Way of Comparison of Merits, the Difference is as wide betwixt the Criticks of former Ages."[35]

Ralph's ironic jibe drives to the heart of a tension in both cultural pessimism and cultural optimism. The pessimists, insofar as they defend

the truth of their own proclamations, must believe that mankind has an increasing ability to pinpoint artistic defects. But if cultural criticism has progressed so far, why is culture itself regressing? Coming from the other side, the optimists believe that culture has advanced, but tend to adopt a more skeptical attitude about the progress of criticism. They become frustrated by the carping and negativism exhibited by the cultural pessimists. Yet the optimists cannot explain why the same incentives that produce great art fail to produce adequate criticism.

A consistent optimistic attitude should place cultural pessimism within the cornucopia of modern achievement. The pessimists who question contemporary trends help the modern world sort out good from bad. If no one attacked contemporary culture, our understanding of that culture would remain at a low level. The attacks force us go back and reread, relisten, and reexamine our basic assumptions about art.

The cultural pessimists also enrich the works they attack, although usually unwittingly. Radicals need conservatives and pessimists as foils. Bohemians write or paint in response to the establishment. The criticism they encounter helps them define their roles as outsiders and innovators. Gauguin played off the stuffier Salon painters and exploited their weaknesses to his advantage. We understand Gauguin better by knowing what his work reacted against. The Clash and the Sex Pistols were fortunate to have had Margaret Thatcher in office during a period of resurgent social conservatism.

By means of contrast, cultural pessimism illuminates the strongly optimistic and life-affirming trends in contemporary culture. Even the most positive works of art implicitly stake out a position of opposition against something. George Bernard Shaw made the same observation in his critique of Max Nordau: "To understand a saint, you must hear the devil's advocate; and the same is true of the artist."[36]

A sense of impending decline sometimes will spur cultural creativity. Pessimistic creators wish to capture a mood, spirit, or times before it vanishes. Harold Bloom presumably would not have written his masterful *Western Canon* if he had felt that the classics were firmly ensconced in our culture. Stefan Zweig and Arthur Rubinstein, who portrayed the decline of pre-War Europe in their writings, in fact produced some of the finest portraits of that world. These visions could never have been produced by an optimist. Other cultural producers

may use pessimistic tracts as cloaks or covers for their innovations, as discussed above.

Cultural pessimism also may improve how artists perceive the competition for fame and laurels. Pessimists have frequently argued that artists shy away from competition for the "posts of honor." If we can trick creators into believing that the current posts of honor in an area are empty, perhaps they will try to fill them. The artist can be misled into thinking that monopoly returns are available.

We should not conclude, however, that pessimism is harmless or need not be rebutted. Pessimism falls as a tax on consumers by leading them to neglect contemporary culture. In a world where cultural pessimism had less plausibility, we would read more books, experiment more with new kinds of music, and spend more time looking at modern art. We would enjoy a more diverse menu of consumption. The tax of pessimism falls also on budding creators. Widespread consumer skepticism about contemporary culture increases the difficulty of establishing market footholds. Creators may feel that current posts of honor are unfilled, but they also may conclude that trying to fill such posts will yield neither fame nor profit.

Cultural pessimism harms our polity as well. Excessive pessimism, from both government funding advocates and critics, muddles the debate over the NEA and increases the difficulty of resolving that issue. Most of the NEA debate consists of individuals talking past each other, with few attempts at persuasion. We should reject the arguments that either maintaining or cutting this small amount of funding will bring cultural decline.

Cultural pessimism also lends credence to the movement for censoring art. The American government has suppressed masterpieces from James Joyce's *Ulysses* to the Byrds' song "Eight Miles High." The British government, another democracy, has suppressed Stanley Kubrick's film *A Clockwork Orange* and the Sex Pistols' anthem *God Save the Queen*. Democratic government, inevitably beholden to majority opinion, will never cease to war against controversial cultural innovations. Censorship continues today, targeting movies, sex and violence on television, and rap music. Polls indicate that most Americans support censorship over artistic activity, even when the artists receive no government funds.[37]

Ironically, totalitarian regimes can teach us something about the liberating nature of capitalist art. Totalitarian regimes have perceptively recognized that art is not just another economic product. Both Marxist and fascist governments have repeatedly placed a tight grip on cultural markets. Hitler and Goebbels devoted much of their time to planning the new artistic order of the Reich. Architecture, art exhibitions, musical compositions, and other artistic works were designed to exalt and extend the Nazi point of view. Market-produced art was banned and replaced by contrived totalitarian monstrosities. The Nazi suppression paid an unintended tribute to the connections between free art markets, the beautiful, and individual liberty. The Nazis sought to atomize their populace and break down the cultural communities that capitalist art provides. We, the capitalists, should start viewing the art of a free society in the same liberating terms that the totalitarians recognized long ago.

Perhaps most important, cultural pessimism attempts to deny the rightful pride that we ought to hold in modernity. Appreciation and recognition of the wonderful are ends in themselves, regardless of whether such attitudes bring utilitarian benefits.

All in all, we should welcome a certain amount of pessimism even while recognizing its limitations and disagreeing with its central conclusion. We can accept market-supported art and reject the conclusions of market-supported cultural pessimism without fear of contradiction. The market produces great art, but, as Plato pointed out, it is not the job of art to tell the truth. John Cowper Powys proclaimed that "the whole purpose of culture is to enable us to live out our days in a perpetual under-tide of ecstasy."[38] Let not the differences in our personal tastes or political views dim the chorus of this ecstasy.

Notes
Index

211

Notes

Introduction

1. On matters of aesthetics, I find the following works to be especially enlightening: David Hume, "Of the Standard of Taste," in *Essays Moral, Political, and Literary* (Indianapolis: Liberty Classics, 1985 [1777]), Barbara Herrnstein Smith, *Contingencies of Value: Alternative Perspectives for Critical Theory* (Cambridge, Mass.: Harvard University Press, 1988), Arthur C. Danto, *The Transfiguration of the Commonplace: A Philosophy of Art* (Cambridge, Mass.: Harvard University Press, 1981), Anthony Savile, *The Test of Time: An Essay in Philosophical Aesthetics* (Oxford: Clarendon Press, 1982), and Jan Mukarovsky, *Aesthetic Function, Norm and Value as Social Facts* (Ann Arbor: University of Michigan, Michigan Slavic Contributions, 1970).

2. Cited in Frank Brady, *Citizen Welles: A Biography of Orson Welles* (London: Hodder and Stoughton, 1990), p. 356.

3. See T. S. Eliot, *Notes towards a Definition of Culture* (London: Faber and Faber, 1948), p. 19. On the British conservative tradition of cultural pessimism more generally, see Lesley Johnson, *The Cultural Critics: From Matthew Arnold to Raymond Williams* (London: Routledge & Kegan Paul, 1979). On the tradition of cultural pessimism through antiquity, and in French history, see Koenraad W. Swart, *The Sense of Decadence in Nineteenth-Century France* (The Hague: Martinus Nijhoff, 1964).

4. For an introduction to the so-called "Battle of the Books," as it was dubbed by Swift, see Gilbert Highet, *The Classical Tradition: Greek and Roman Influences on Western Literature* (New York: Oxford University Press, 1949), chapter 14, and A. Owen Aldridge, "Ancients and Moderns in the Eighteenth Century," in Philip P. Wiener, ed., *Dictionary of the History of Ideas: Studies of Selected Pivotal Ideas* (New York: Charles Scribner's Sons, 1968), pp. 76–87.

5. See, for instance, Max Horkheimer and Theodor W. Adorno, *Dialectic of Enlightenment* (New York: Herder and Herder, 1972), and Herbert Marcuse, *One-Dimensional Man* (Boston: Beacon Press, 1964).

6. See, for example, Neil Postman, *Amusing Ourselves to Death: Public Discourse in the Age of Show Business* (New York: Viking, 1985), and Pierre Bourdieu and Hans Haacke, *Free Exchange* (Stanford: Stanford University Press, 1995).

7. See Fredric Jameson, *Postmodernism, or, The Cultural Logic of Late Capitalism* (Durham, N.C.: Duke University Press, 1991), pp. 298–299 and chapter 8. On cultural studies, see Jim McGuigan, *Cultural Populism* (London: Routledge, 1992).

8. On the Birmingham school, see, for instance, Ben Agger *Cultural Studies as Critical Theory* (London: Falmer Press, 1992), Stuart Hall, Dorothy Hobson, Andrew Lowe, and Paul Willis, eds., *Culture, Media, and Language: Working Papers in Cultural Studies, 1972–79* (London: Routledge, 1992), and David Morley and Kuan-Hsing Chen, eds., *Stuart Hall: Critical Dialogues in Cultural Studies* (London: Routledge, 1996).

9. See Camille Paglia, *Sexual Personae: Art and Decadence from Nefertiti to Emily Dickinson* (New York: Vintage Books, 1990), Robert Pattison, *On Literacy: The Politics of the Word from Homer to the Age of Rock* (New York: Oxford University Press, 1982), Robert Pattison, *The Triumph of Vulgarity: Rock Music in the Mirror of Romanticism* (New York: Oxford University Press, 1987), Herbert Gans, *Popular Culture and High Culture. An Analysis and Evaluation of Taste* (New York: Basic Books, 1974), Paul Willis, with Simon Jones, Joyce Canaan, and Geoff Hurd, *Common Culture: Symbolic Work at Play in the Everyday Cultures of the Young* (Boulder, Colo.: Westview Press, 1990), Nelson George, *Where Did Our Love Go? The Rise and Fall of the Motown Sound* (New York: St. Martin's Press, 1985), Nelson George, "Rapping," in *Fresh: Hip Hop Don't Stop,* ed. by Nelson George, Sally Banes, Susan Flinker, and Patty Romanowski (New York: Random House, 1985), pp. 3–27, Wendy Steiner, *The Scandal of Pleasure: Art in an Age of Fundamentalism* (Chicago: University of Chicago Press, 1995), William Grampp, *Pricing the Priceless: Art, Artists, and Economics* (New York: Basic Books, 1989), Terence Kealey, *The Economic Laws of Scientific Research* (New York: St. Martin's Press, 1996), Alvin Toffler, *The Culture Consumers: A Study of Art and Affluence in America* (New York: St. Martin's Press, 1964), and for a survey of French postmodernism, Steven Connor, *Postmodernist Culture: An Introduction to Theories of the Contemporary* (Cambridge, Mass.: Basil Blackwell, 1989). I have drawn from these writers, and others, but I do not mean to suggest that they endorse my views.

1. The Arts in a Market Economy

1. Cited in Alexander Thayer, *Life of Beethoven* (Princeton: Princeton University Press, 1967), p. 500. See also H. L. Mencken, *Prejudices: Third Series* (New York: Alfred Knopf, 1922), pp. 17–18, and the writings of Ayn Rand, such as *Atlas Shrugged* (New York: Random House, 1957). On psychological approaches to creativity, see the survey by Jock Abra, *Assaulting Parnassus: Theoretical Views of Creativity* (Lanham, Md.: University Press of America, 1988).

2. On Williams, see David Perkins, *A History of Modern Poetry* (Cambridge, Mass.: Belknap Press of Harvard University Press, 1976), vol. 1, pp. 544–554. On Ives, see Frank R. Rossiter, *Charles Ives and his America* (New York: Liveright, 1975).

3. On Wallace Stevens, see Peter Brazeau, *Parts of a World: Wallace Stevens Remembered* (San Francisco: North Point Press, 1985), pp. 57, 67. On Stevens's refusal of the Harvard position, see Perkins, *A History of Modern Poetry,* p. 535.

4. Monet also received initial financial support from his family, although his father cut off the stipend when he learned that Claude refused to break with his pregnant mistress. On Delacroix and Courbet, see Alan Bowness, *The Conditions of Success: How the Modern Artist Rises to Fame* (London: Thames and Hudson, 1989), p. 60; on Corot, see Madeleine Hours, *Jean-Baptiste-Camille Corot* (New York: Harry N. Abrams, 1972), pp. 11–30. On Degas's sustenance, see Roy McMullen, *Degas: His Life, Times, and Work* (Boston: Houghton Mifflin Company, 1984), pp. 242, 249, 260, 373. On Seurat's family wealth, see Ralph E. Shikes and Paula Harper, *Pissarro: His Life and Work* (New York: Horizon Press, 1980), p. 209. On Cezanne, see John Rewald, *Studies in Impressionism* (New York: Harry N. Abrams, 1985), p. 99, and Harrison C. White and Cynthia A. White, *Canvases and Careers: Institutional Change in the French Painting World* (Chicago: University of Chicago Press, 1993), p. 129. On Manet, see F. W. J. Hemmings, *Culture and Society in France, 1848–1898, Dissidents and Philistines* (London: B.T. Batsford, 1971), p. 162. On Toulouse-Lautrec, see Riva Castleman and Wolfgang Wittrock, eds., *Henri de Toulouse-Lautrec: Images of the 1890's* (New York: Museum of Modern Art, 1985), pp. 21, 45. On Moreau, see John Rewald, *Studies in Post-Impressionism* (New York: Harry N. Abrams, 1986), p. 256. On Monet's father and his funds, see Jacques Letheve, *Daily Life of French Artists in the Nineteenth Century* (New York: Praeger Publishers, 1972), p. 154. On Verlaine, see Jerrold Seigel, *Bohemian Paris: Culture, Politics, and the Boundaries of Bourgeois Life, 1830–1930*

(New York: Penguin, 1986), p. 249. On Baudelaire, see A. E. Carter, *Charles Baudelaire* (Boston: Twayne, 1977), pp. 30, 36, 52. On Flaubert, see Benjamin F. Bart, *Flaubert* (Syracuse, N.Y.: Syracuse University Press, 1967), p. 7. On the rise of "hobby science" following the wealth of the Industrial Revolution, see Terence Kealey, *The Economic Laws of Scientific Research* (New York: St. Martin's Press, 1996), pp. 75–77.

5. On Proust, see Ronald Hayman, *Proust: A Biography* (New York: Carroll & Graf, 1990), pp. 335, 337, 347, 411. On the role of pecuniary incentives in the life of Gauguin, see Paul Gauguin, *The Writings of a Savage,* ed. by Daniel Guérin (New York: Viking, 1978), and Belinda Thomson, *Gauguin* (London: Thames and Hudson, 1987).

6. Benvenuto Cellini, *The Treatises of Benvenuto Cellini on Goldsmithing and Sculpture* (New York: Dover Publications, 1967 [1568]), p. 165.

7. On Mozart's letter, written in 1781 to his father, see Alan Steptoe, *The Mozart-DaPonte Operas* (Oxford: Clarendon Press, 1988), p. 63. On Chaplin, see James Twitchell, *Carnival Culture* (New York: Columbia University Press, 1992), p. 132.

8. See Nigel Kennedy, *Always Playing* (London: Mandarin Paperbacks, 1992), pp. 52–53.

9. On Beethoven's writing for his friends, see H. C. Robbins Landon, *Beethoven: His Life, Work and World* (London: Thames and Hudson, 1992), p. 87.

10. On Bach's Latin class, see Otto L. Bettmann, *Johann Sebastian Bach as his World Knew Him* (New York: Birch Lane Press, 1995), p. 56.

11. On the rise of commercialized Elizabethean theater, see Gerald Eades Bentley, *The Profession of Dramatist in Shakespeare's Time, 1590–1642* (Princeton: Princeton University Press, 1971), and Douglas Bruster, *Drama and the Market in the Age of Shakespeare* (Cambridge: Cambridge University Press, 1992).

12. On the late nineteenth-century revolution in photography, see C. J. Gover, *The Positive Image: Women Photographers in Turn of the Century America* (Albany: State University of New York Press, 1988).

13. See William J. Baumol, Sue Anne Batey Blackman, and Edward N. Wolff, *Productivity and American Leadership: The Long View* (Cambridge, Mass.: MIT Press, 1989), p. 52.

14. See Tyler Cowen, "Why Women Succeed, and Fail, in the Arts," *Journal of Cultural Economics,* 20 (1996): 93–113.

15. See William J. Baumol and William G. Bowen, *Performing Arts—The Economic Dilemma* (New York: Twentieth Century Fund, 1966), and Baumol, Blackman, and Wolff, *Productivity and American Leadership,* chapter 6. For a related argument about the increased difficulty of en-

joying leisure, see Staffan Burenstam Linder, *The Harried Leisure Class* (New York: Columbia University Press, 1970). For other economic writings on the arts, see Mark Blaug, ed., *The Economics of the Arts* (Boulder, Colo.: Westview Press, 1976), Grampp, *Pricing the Priceless,* Bruno S. Frey and Werner W. Pommerehne, *Muses and Markets: Explorations in the Economics of the Arts* (Cambridge, Mass.: Basil Blackwell, 1989), James Heilbrun and Charles M. Gray, *The Economics of Art and Culture: An American Perspective* (Cambridge: Cambridge University Press, 1993), and Gianfranco Mossetto, *Aesthetics and Economics* (Dordrecht: Kluwer Academic Publishers, 1993). For a more thorough criticism of the cost-disease argument, see Tyler Cowen and Robin Grier, "Do *Artists* Suffer From a Cost-Disease?" *Rationality and Society,* 8 (1996): 5–24, and Tyler Cowen, "Why I Do Not Believe in the Cost-Disease: Comment on Baumol," *Journal of Cultural Economics,* 20 (1996): 207–214.

16. Baumol, Blackman, and Wolff, *Productivity and American Leadership,* pp. 131–135, suggest the contrary.

17. For more detail on Johnson and patronage, see chapter 2 of this work.

18. On market discovery, see, for instance, Friedrich A. Hayek, "Competition as a Discovery Procedure," in *New Studies in Philosophy, Politics, Economics and the History of Ideas* (Chicago: University of Chicago Press, 1978), pp. 179–190.

19. On Brahms, see Malcolm MacDonald, *Brahms* (New York: Schirmer Books, 1990), p. 245. On the idea that artists are held back by their own contributions, see Alexander Gerard, *An Essay on Taste* (New York: Garland Publishing, 1970 [1754]), pp. 115–116. On Beethoven's refusal to hear Mozart, see Landon, *Beethoven,* p. 81. For other examples of this phenomenon, see David Lowenthal, *The Past Is a Foreign Country* (Cambridge: Cambridge University Press, 1985), chapter 2.

20. Walter Jackson Bate, *The Burden of the Past and the English Poet* (Cambridge, Mass.: Harvard University Press, 1970), Harold Bloom, *The Anxiety of Influence: A Theory of Poetry* (New York: Oxford University Press, 1975), and Harold Bloom, *A Map of Misreading* (New York: Oxford University Press, 1975).

21. See Lowenthal, *The Past Is a Foreign Country,* p. 390.

22. On the importance of emulation to the arts, see the discussion in Howard D. Weinbrot, *Britannia's Issue: The Rise of British Literature from Dryden to Ossian* (Cambridge: Cambridge University Press, 1993), chapter 3.

23. On Forster, see Francis King, *E. M. Forster and his World* (New York: Charles Scribner's Sons, 1978), p. 76.

24. On painting and portraiture, see Remi Clignet, *The Structure of Artistic Revolutions* (Philadelphia: University of Pennsylvania Press, 1985), p. 57, and Jean Gimpel, *The Cult of Art: Against Art and Artists* (New York: Stein and Day, 1969), chapter 11.

25. On the charges against Rossini, see Edward J. Dent, *The Rise of Romantic Opera* (Cambridge: Cambridge University Press, 1976), p. 14, and Henry Raynor, *A Social History of Music: Music and Society since 1815* (New York: Taplinger Publishing Company, 1978), vol. 2, p. 72. On *Othello,* see George Steiner, *Real Presences* (Chicago: University of Chicago Press, 1989).

26. Jan Mukarovsky, in *Aesthetic Function, Norm and Value as Social Facts,* argues that effective art must violate previous norms and standards.

27. Cited in Havelock Nelson and Michael A. Gonzales, *Bring the Noise: A Guide to Rap Music and Hip-Hop Culture* (New York: Harmony Books, 1991), p. 261. On the tendency of those at the bottom of the socioeconomic ladder to innovate, see Reuven Brenner, *Rivalry, in Business Science, among Nations* (Cambridge: Cambridge University Press, 1987), pp. 30–33.

28. "Public Television: The Taxpayer's Wagner," *Economist,* May 30, 1992, p. 41. Contrary to some people's impressions, public television is funded primarily by the private sector; government grants account for only 17 percent of the public television budget.

29. See Richard Bolton, ed., *Culture Wars: Documents from the Recent Controversies in the Arts* (New York: New Press, 1992), p. 266. On the success of the private art museum in America, see Perry T. Rathbone, "Influences of Private Patrons: The Art Museum as an Example," in W. McNeil Lowry, ed., *The Arts and Public Policy in the United States* (Englewood Cliffs, N.J.: Prentice-Hall, 1984), pp. 38–56. On the American tradition of privately-funded symphony orchestras, see Philip Hart, *Orpheus in the New World: The Symphony Orchestra as an American Cultural Institution* (New York: W.W. Norton, 1973).

30. On this latter point, see the perceptive analysis of Pauline Kael, "Why are Movies So Bad? Or, the Numbers," in *For Keeps* (New York: Dutton, 1994), pp. 817–829.

31. For the statistic on the decline of the networks' audiences, see Michael Medved, *Hollywood vs. America: Popular Culture and the War on Traditional Values* (New York: Harper and Row, 1992), p. 5.

32. This point is emphasized by Gene F. Jankowski and David C. Fuchs, two cable skeptics, in their *Television Today and Tomorrow: It Won't Be What You Think* (New York: Oxford University Press, 1995).

33. On the rise of cable television and the breakdown of the network oli-
gopoly, see J. Fred MacDonald, *One Nation under Television: The Rise
and Decline of Network TV* (New York: Pantheon Books, 1992). More
generally, see Alvin Toffler's *The Third Wave* on the "de-massification"
of the media.

34. On the role of the steamship, see Norman F. Cantor, *Twentieth-Century
Culture: Modernism to Deconstruction* (New York: Peter Lang, 1988),
p. 30.

35. For a look at these debates, see Bolton, *Culture Wars*.

36. More generally, subsidies from all levels of government in America pro-
vide only 15 percent of the yearly budgets of American arts institutions.
Private and corporate donors give $6.4 billion annually, and many mil-
lions pay the admissions fees. If we look at privately-run museums only,
direct federal support accounts for less than 2 percent of the budget.
American opera productions are growing like never before, due largely
to increasing demand, not increasing subsidies. See Bill Kauffman,
"Subsidies to the Arts: Cultivating Mediocrity," Cato Institute Policy
Analysis no. 137, August 8, 1990, p. 9, and Martin Feldstein, "In-
troduction," in *The Economics of Art Museums,* Martin Feldstein, ed.
(Chicago: University of Chicago Press, 1991), p. 6.

37. On this theme, see Robert Wuthnow, *Communities of Discourse: Ideology
and Social Structure in the Reformation, the Enlightenment, and European
Socialism* (Cambridge, Mass.: Harvard University Press, 1989), especially
pp. 215, 243, 259.

38. For data on French expenditures, see William Drozdiak, "The City of
Light, Sans Bright Ideas," *The Washington Post,* October 28, 1993,
pp. D1, D6. On cultural policies in other European countries, see
Milton C. Cummings Jr. and Richard Katz, *The Patron State: The
Government and the Arts in North America, Europe, and Japan* (New York:
Oxford University Press, 1987). On the ability of government funding
to push out private donations, see Heilbrun and Gray, *The Economics of
Art and Culture,* pp. 241–242.

39. Cited in Kauffman, "Subsidies to the Arts: Cultivating Mediocrity,"
p. 3.

40. For various historical perspectives on the distinction between high and
low culture, see Peter Burke, *Popular Culture in Early Modern Europe*
(Aldershot: Wildwood House, 1988), Lawrence Levine, *Highbrow/
Lowbrow: The Emergence of Cultural Hierarchy in America* (Cambridge,
Mass.: Harvard University Press, 1988), and Joan Shelley Rubin, *The
Making of Middlebrow Culture* (Chapel Hill: University of North Carolina

Press, 1992). David Novitz, in *The Boundaries of Art* (Philadelphia: Temple University Press, 1992), offers one typical claim that the split between high and low culture exemplifies cultural degeneration.

2. The Market for the Written Word

1. See Janet C. Stock, *Marcel Proust: A Reference Guide, 1950–1970* (Boston: G.K. Hall, 1991), p. xiv.
2. For these figures, see Cynthia Crossen, "Put Pen to Paper These Days, You'll Be a Published Author," *Wall Street Journal,* January 10, 1997, p. B1.
3. For figures on book sales, see *Statistical Abstract of the United States,* pp. 235–236; for sales in superstores, see Patrick M. Reilly, "Street Fighters: Where Borders Group and Barnes & Noble Compete, It's a War," *Wall Street Journal,* September 3, 1996, pp. A1, A8.
4. See Anthony Burgess, *You've Had Your Time. Being the Second Part of the Confessions of Anthony Burgess* (London: Penguin Books, 1990), p. 135.
5. On serialization, see Per Gedin, *Literature in the Market Place* (London: Faber, 1977), p. 19.
6. On world literacy, see "World Literacy Rate Rises," *Futurist,* September-October (1991), p. 47. On the positive link between illiteracy and poverty, see Jeanne S. Chall, Vicki A. Jacobs, and Luke E. Baldwin, *The Reading Crisis: Why Poor Children Fall Behind* (Cambridge, Mass.: Harvard University Press, 1990). On general literacy trends in this century, see the data in Harvey J. Graff, *The Legacies of Literacy: Continuities and Contradictions in Western Culture and Society* (Bloomington: Indiana University Press, 1987), pp. 375–380.
7. On the tenfold increase in bookstores, see David Streitfeld, "Books: The Hot New Bestseller," *Washington Post,* November 29, 1993, p. C1. On recent times, see Howard Fields, "Books Outperformed Many Industries in Past Five Years," p. 7. On per capita book purchases see *Statistical Abstract of the United States* (book date and population figures from editions 1950, p. 463, and 1992, pp. 8, 235).
8. See Cynthia Z. Stiverson and Gregory A. Stiverson, "The Colonial Retail Book Trade: Availability and Affordability of Reading Material in Mid-Eighteenth-Century Virginia," in William L. Joyce, David D. Hall, Richard D. Brown, and John B. Hench, eds., *Printing and Society in Early America* (Worcester, Mass.: American Antiquarian Society, 1983), pp. 132–173; the figures are from pp. 169–170.
9. On the history of paperback books, see Kenneth C. Davis, *Two-Bit Culture: The Paperbacking of America* (Boston: Houghton Mifflin, 1984),

who offers a spirited defense of the paperback; data on bookstores in 1931 can be found on p. 16. See also Frank Luther Mott, *Golden Multitudes: The Story of Best Sellers in the United States* (New York: R.R. Bowker, 1947), and Thomas L. Bonn, *Under Cover: An Illustrated History of American Mass-Market Paperbacks* (New York: Penguin, 1982). On the case that America's reading scene has improved over time, see Carl F. Kaestle, Helen Damon-Moore, Lawrence C. Stedman, Katherine Tinsley, and William Vance Trollinger Jr., *Literacy in the United States: Readers and Reading since 1880* (New Haven: Yale University Press, 1991). On the number of books published in 1950, see Lynne Grasz, "Television and the Aliteracy Problem," in Nick Thimmesch, ed., *Aliteracy: People Who Can Read but Won't* (Washington, D.C.: American Enterprise Institute, 1984), pp. 8–11.

10. Thomas Whiteside, *The Blockbuster Complex: Conglomerates, Show Business, and Book Publishing* (Middletown, Conn.: Wesleyan University Press, 1980), provides the clearest statement of this common critique. See also Richard Kostelanetz, *The End of Intelligent Writing: Literary Politics in America* (New York: Sheed and Ward, 1973), and Sherwin Rosen, "The Economics of Superstars," *American Economic Review,* 71 (1981): 845–858.

11. See Alexis de Tocqueville, *Democracy in America,* vol. 2, "In What Spirits the Americans Cultivate the Arts" (New York: Harper & Row, 1969 [1835]), pp. 465–468. For a brief history of "blockbuster" complaints, see Walter W. Powell, "Whither the Local Bookstore?" in Stephen Graubard, ed., *Reading in the 1980s* (New York: R.R. Bowker Company, 1983), p. 52. On Q. D. Leavis, see her *Fiction and the Reading Public* (London: Chatto & Windus, 1932), pp. 134, 145, 152. On winner-take-all effects, see Robert H. Frank and Philip J. Cook, *The Winner-Take-All Society: How More and More Americans Compete for Ever Fewer and Bigger Prizes, Encouraging Economic Waste, Income Inequality, and an Impoverished Cultural Life* (New York: Free Press, 1995).

12. The list is drawn from Twitchell, *Carnival Culture,* pp. 72–73.

13. On the role of superstores in helping independent presses, see Joseph Barbato, "Chain Superstores: Good Business for Small Presses?" *Publisher's Weekly,* November 9, 1992, pp. 50–59.

14. On the publishing history of Foxe's book, see William Haller, *Foxe's Book of Martyrs and the Elect Nation* (London: Jonathan Cape, 1963), pp. 13–14. On the history of Bunyan's book, see Steven Starker, *Evil Influences: Crusades against the Mass Media* (New Brunswick, N.J.: Transaction Publishers, 1989), p. 54, and Monica Furlong, *Puritan's Progress* (New York: Coward, McCann, and Geoghegan, 1975), p. 180.

15. See Samuel S. Vaughan, "The Community of the Book," in Stephen Graubard, ed., *Reading in the 1980s* (New York: R.R. Bowker, 1983), pp. 85–115.

16. On how television affected the magazine market, see James L. Baughman, *The Republic of Mass Culture: Journalism, Filmmaking, and Broadcasting in America since 1941* (Baltimore: Johns Hopkins University Press, 1992), p. 190.

17. On popular eighteenth-century authors, see James Raven, *Judging New Wealth: Popular Publishing and the Responses to Commerce in England, 1750–1800* (Oxford: Clarendon Press, 1992), p. 23, and Leavis, *Fiction and the Reading Public,* p. 134. On the popular literary forms of the eighteenth century, see Leslie Shepard, *A History of Street Literature* (Detroit: Singing Tree Press, 1973) and Margaret Spufford, *Small Books and Pleasant Histories: Popular Fiction and its Readership in Seventeenth-Century England* (Athens: University of Georgia Press, 1981). The quotation is from William Wordsworth, "Reply to 'Mathetes,'" in *The Prose Works of William Wordsworth,* vol. 2, ed. W. J. B. Owen and Jane Worthington Smyser (Oxford: Clarendon Press, 1974), pp. 8–25; the quotation is from pp. 9–10.

18. On de Bury's life, see the foreword to Richard de Bury, *Philobiblon* (Oxford: Basil Blackwell, 1970), by Michael Maclagan.

19. On books as an infinite treasure, see Richard de Bury, *Philobiblon,* p. 19; on books versus oral culture, see de Bury, p. 19; on books and war, see pp. 71–79; on books of learning versus books of law, see chapter 11, "Why we have preferred Books of Liberal Learning to Books of Law," pp. 117–121.

20. On the wish for new authors, see de Bury, *Philobiblon,* chapter 9, "How although we preferred the Works of the Ancients we have not condemned the Studies of the Moderns," pp. 99–107; on the defense of secular writings, see p. 129. On copyists, see pp. 48–49; on the desirability of book multiplication, see de Bury, p. 147.

21. On Gutenberg's first book and commercial skills, see Vincent Cronin, *The Florentine Renaissance* (London: Collins, 1967), p. 115. On the goldsmithing backgrounds of early printers, see S. H. Steinberg, *Five Hundred Years of Printing* (Middlesex: Penguin Books, 1969), p. 18; Martin Lowry, *The World of Aldus Manutius: Business and Scholarship in Renaissance Venice* (Oxford: Basil Blackwell, 1979), p. 10.

22. On the commercial nature of early printing, see Lisa Jardine, *Worldly Goods: A New History of the Renaissance* (New York: Doubleday, 1996), chapter 3.

23. François Rabelais, *The Lives, Heroic Deeds & Sayings of Gargantua and his Son Pantagruel,* translated by Sir Thomas Urquhart and Peter Le Motteux (London: Chatto and Windus, n.d.), p. 222. For a later Augustan paean to printing, see Joseph Addison in *The Spectator,* no. 367, May 1, 1712 (Oxford: Clarendon Press, 1965), vol. 3, pp. 379–382.

24. See William Wotton, *Reflections upon Ancient and Modern Learning* (London: Tim Goodwin, 1705 [1694]), pp. 173–174. Similar arguments had been made by the seventeenth-century English writer George Hakewill, in a tract on cultural and historical optimism with the lengthy title *An Apologie or Declaration of the Power and Providence of God in the Government of the World, Consisting in An Examination and Censure of the Common Errour Touching Natures Perpetuall and Universall Decay, Divided into Six Bookes* (Oxford: William Turner, 1635); see pp. 316–319.

25. On Perrault's life and his writings of cultural optimism, see Jeanne Morgan Zarucchi's Introduction to Charles Perrault, *Memoirs of My Life* (Columbia: University of Missouri Press, 1989 [1759, composition finished 1703]), pp. 1–25. On the role of his fairy tales, see the *Memoirs,* p. 120.

26. On Filippo's views, see Lowry, *The World of Aldus Manutius, Business and Scholarship in Renaissance Venice,* pp. 26–27. On the pen and printing press statement, see Yves Castan, François Lebrun, and Roger Chartier, "Figures of Modernity," in Roger Chartier, ed., *A History of Private Life,* vol. 3, *Passions of the Renaissance* (Cambridge, Mass.: Belknap Press of Harvard University Press, 1989), p. 123.

27. Harold Innis, *The Bias of Communications* (Toronto: University of Toronto Press, 1951) and *Empire and Communications* (Toronto: University of Toronto Press, 1972), Walter J. Ong, *Orality and Literacy: The Technologizing of the Word* (London: Methuen, 1982), Marshall McLuhan, *The Gutenberg Galaxy: The Making of Typographic Man* (New York: Signet Books, 1969), Frances Amelia Yates, *The Art of Memory* (Chicago: University of Chicago Press, 1966), Elizabeth L. Eisenstein, *The Printing Press as an Agent of Change* (Cambridge: Cambridge University Press, 1979), vols. 1–2, and Henri-Jean Martin, *The History and Power of Writing* (Chicago: University of Chicago Press, 1994) have studied the revolution in human affairs brought about by the rise of print culture. Rudolf Hirsch, *Printing, Selling and Reading, 1450–1550* (Wiesbaden: Otto Harrassowitz, 1967) analyzes the economics of the early printing trade. Robert Escarpit, *Sociology of Literature* (London: Frank and Cass, 1971), treats the social context of literary production.

On the durability and dissemination of ideas, see Hakewill, *An Apologie or Declaration of the Power and Providence of God in the Government of the World,* pp. 316–319.

28. On the link between literacy and printing, see Leonard M. Dudley, *The Word and the Sword: How Techniques of Information and Violence Have Shaped Our World* (Cambridge, Mass.: Basil Blackwell, 1991), chapter 5. On spectacles see John Larner, *Culture and Society in Italy, 1290–1420* (New York: Charles Scribner's Sons, 1971), pp. 161–162 and Edward Rosen, "The Invention of Eye-Glasses," *Journal of the History of Medicine and Allied Sciences* (January 1956): 13–46. On how increasing leisure time influenced the literary market, see J. H. Plumb, *The Commercialization of Leisure in Eighteenth-Century England* (Reading: University of Reading, 1973). On the development of writing implements and the difficulty of writing on parchment, see Innis, *Empire and Communications,* pp. 137–138.

29. On the contrast between earlier and later libraries, see J. H. Plumb, "The Public, Literature, & the Arts in the 18th Century," in Paul Fritz and David Williams, eds., *The Triumph of Culture: 18th Century Perspectives* (Toronto: A.M. Hakkert, 1972), pp. 27–48, especially p. 28.

30. On Cervantes, see Richard L. Predmore, *Cervantes* (New York: Dodd, Mead, and Co., 1973), pp. 176–178, 204–205. For a general history of authors' remunerations, see Walter Krieg, *Materialien zu einer Entwicklungsgeschichte der Bücher-Preise und des Autoren-Honorars vom 15. bis zum 20. Jahrhundert* (Vienna: Herbert Stubenrauch, 1953).

31. On the growth of consumer society in the Industrial Revolution, see Neil McKendrick, John Brewer, and J. H. Plumb, *The Birth of a Consumer Society: The Commercialization of Eighteenth-Century England* (Bloomington: Indiana University Press, 1982).

32. On the sale of publication rights to plays, see Gary Taylor, *Reinventing Shakespeare: A Cultural History from the Restoration to the Present* (New York: Weidenfeld and Nicolson, 1989), p. 68.

33. On the commercial and consumer revolution of eighteenth-century England more generally, see McKendrick, Brewer, and Plumb, *The Birth of a Consumer Society,* and Lorna Weatherill, *Consumer Behaviour and Material Culture in Britain, 1660–1760* (London: Routledge, 1988). On literacy rates, see Pat Rogers, "Books, Readers, and Patrons," in Boris Ford, ed., *From Dryden to Johnson,* vol. 4 of the *New Pelican Guide to English Literature* (London: Penguin Books, 1991), pp. 214–227 (see especially p. 220), and David Vincent, *Literacy and Popular Culture: England 1750–1914* (New York: Cambridge University Press, 1989), on the development of British literacy more generally. On Burke's esti-

mate, see Richard D. Altick, *The English Common Reader: A Social History of the Mass Reading Public, 1800–1900* (Chicago: University of Chicago Press, 1957), p. 49.

34. On Gibbon and copyright, see Jane Aiken Hodge, *Only a Novel: The Double Life of Jane Austen* (New York: Coward, McCann, and Geoghegan, 1972), p. 122. On authors' dealing with publishers in the nineteenth century, see J. A. Sutherland, *Victorian Novelists and Publishers* (Chicago: University of Chicago Press, 1976). On the copyright history and debate, see A. S. Collins, *Authorship in the Days of Johnson, Being a Study of the Relation Between Author, Patron, Publisher and Public, 1726–1780* (London: R. Holden, 1927), chapter 1, and Martha Woodmansee, "The Genius and the Copyright: Economic and Legal Conditions of the Emergence of the Author," *Eighteenth-Century Studies,* 17 (1984): 425–448.

35. On the increase in novel publication, see James Raven, *Judging New Wealth,* p. 31. On magazines more generally, see Robert D. Mayo, *The English Novel in the Magazines, 1740–1815* (Evanston, Ill.: Northwestern University Press, 1962). See John Feather, "The Commerce of Letters," *Eighteenth-Century Studies,* 17 (1984): 405–424, on the commercialization of eighteenth-century English literature. On the rise of the literary profession more generally, see the bibliography given in James Hepburn, *The Authors' Empty Purse and the Rise of the Literary Agent* (London: Oxford University Press, 1968). On the history of book reviewing, see Leo Lowenthal and Marjorie Fiske, "The Debate Over Art and Popular Culture in Eighteenth-Century England," in Mirra Komarovsky, ed., *Common Frontiers of the Social Sciences* (Glencoe, Ill.: Free Press, 1957), pp. 33–112, especially pp. 54–55, and Frank Donoghue, *The Fame Machine: Book Reviewing and Eighteenth-Century Literary Careers* (Stanford: Stanford University Press, 1996). For a survey of literary criticism in the eighteenth century, see A. Bosker, *Literary Criticism in the Age of Johnson* (Cambridge: W. Heffer and Sons, 1954). On British exports, see Howard D. Weinbrot, *Britannia's Issue: The Rise of British Literature from Dryden to Ossian* (Cambridge: Cambridge University Press, 1993), p. 23. On the French market, see John Lough, *Writer and Public in France: From the Middle Ages to the Present Day* (Oxford: Clarendon Press, 1978).

36. On libraries, see Starker, *Evil Influences,* p. 63, Thomas Kelly, *Early Public Libraries: A History of Public Libraries in Great Britain Before 1850* (London: Library Association, 1966), chapter 6, and Lee Erickson, *The Economy of Literary Form: English Literature and the Industrialization of Publishing, 1800–1850* (Baltimore: Johns Hopkins University Press,

1996), chapter 5. On book clubs, see Lowenthal and Fiske, "The Debate Over Art and Popular Culture in Eighteenth-Century England," p. 47. On translations, see Josephine Grieder, *Translations of French Sentimental Prose Fiction in Late Eighteenth-Century England: The History of a Literary Vogue* (Durham, N.C.: Duke University Press, 1975).

37. Lackington is the bookseller's name; the quotation is cited in Lowenthal and Fiske, "The Debate Over Art and Popular Culture in Eighteenth-Century England," p. 35.

38. Robert Darnton's essay "Readers Respond to Rousseau: The Fabrication of Romantic Sensitivity," in Robert Darnton, *The Great Cat Massacre and Other Episodes in French Cultural History* (New York: Basic Books, 1984), pp. 215–256, analyzes the emotional novelty of the Romantic novel. On the "epidemic of emotion," see Darnton, pp. 243–244. On the relationship between romanticism and the ethic of consumption, see Colin Campbell, *The Romantic Ethic and the Spirit of Modern Consumerism* (New York: Basil Blackwell, 1987). For the development of British Romanticism through the eighteenth century, see Henry A. Beers, *A History of English Romanticism in the Eighteenth Century* (New York: Dover Publications, 1968 [1899]).

39. On the eighteenth-century breakthrough, see Joyce M. S. Tompkins, *The Popular Novel in England, 1770–1800* (Lincoln: University of Nebraska Press, 1961), chapter 4; Janet Todd, *The Sign of Angelica: Women, Writing, and Fiction, 1660–1800* (New York: Columbia University Press, 1989), Jacqueline Pearson, *The Prostituted Muse: Images of Women and Women Dramatists, 1642–1737* (New York: St. Martin's Press, 1988), Jane Spencer, *The Rise of the Woman Novelist: From Aphra Behn to Jane Austen* (New York: Basil Blackwell, 1986), and Cheryl Turner, *Living By the Pen: Women Writers in the Eighteenth Century* (London: Routledge, 1992). On the increase in women's leisure time, see Linda C. Hunt, *A Woman's Portion: Ideology, Culture, and the British Female Novel Tradition* (New York: Garland Publishing, 1988), p. 20.

40. On the rise of women novelists in the nineteenth century, see Merryn Williams, *Women in the English Novel, 1800–1900* (New York: St. Martin's Press, 1984), especially pp. 13–15, or Virginia Woolf, *A Room of One's Own* (New York: Harcourt Brace Jovanovich, 1989 [1929]).

41. The history of opposition to the novel is detailed in John Tinnon Taylor's *Early Opposition to the English Novel: The Popular Reaction from 1760 to 1830* (New York: King's Crown Press, 1943). On criticisms of novels for their effects on parental and sexual obedience, see pp. 75, 79, 101, and 107–108. On boarding school attacks, see pp. 60–62; for the

dram-drinking quotation, see p. 105. On the issue of health, see Alvin Kernan, *The Death of Literature* (New Haven: Yale University Press, 1990), pp. 130–131. On opposition to the novel, see also Starker, *Evil Influences,* chapter 4.

42. On the criticisms of libraries, see Taylor, *Early Opposition to the English Novel,* chapter 2. For the Mangin quotation, see p. 27; for a discussion of the satirical attacks, see p. 34.

43. On Johnson societies, see W. Jackson Bate, *Samuel Johnson* (New York: Harcourt Brace Jovanovich, 1975), p. 3.

44. On the circle, see James Boswell's *Life of Johnson* (London: Oxford University Press, 1966 [1799]), p. 339, and Bate's *Samuel Johnson,* pp. 366, 504–505.

45. Dustin Griffin, *Literary Patronage in England, 1650–1800* (Cambridge: Cambridge University Press, 1996), chapter 9, provides the most up-to-date account of Johnson's views on patronage, and how patrons can benefit authors.

46. Cited in J. W. Saunders, *The Profession of English Letters* (London: Routledge and Kegan Paul, 1964), pp. 142–143. The letter dates from 1755. Johnson's claim of financial independence is presented in Boswell's *Life of Johnson,* p. 313. On Johnson's literary earnings, see J. D. Fleeman, "The Revenue of a Writer: Samuel Johnson's Literary Earnings," in R. W. Hunt, I. G. Philip, and R. J. Roberts, eds., *Studies in the Book Trade in Honour of Graham Pollard* (Oxford: Oxford Bibliographical Society, 1975), 211–230. On Johnson's own history as literary patron, see Gae Holladay and O. M. Brack Jr., "Johnson as Patron," in Paul J. Korshin and Robert R. Allen, *Greene Centennial Studies* (Charlottesville: University of Virginia Press, 1984), pp. 172–199.

47. James Boswell, *Journal of a Tour of the Hebrides with Samuel Johnson* (London: J.M. Dent & Sons, 1935 [3rd ed. 1786, 1st ed. 1785]), Thursday, 19 August, pp. 40–41.

48. On Johnson, see Boswell, *Journal of a Tour of the Hebrides,* Monday, 18 October, p. 272, and the dialogue presented in the paragraph above. See also Boswell's *Life of Johnson,* p. 514. For Scottish views, see Adam Ferguson, *An Essay on the History of Civil Society* (New Brunswick, N.J.: Transaction Publishers, 1980 [1767]), the section entitled "Of the History of Literature," pp. 171–179. For a survey of different views on commerce, see Albert Hirschman, *Rival Views of Market Society and Other Recent Essays* (New York: Viking, 1986). See Adam Smith, *Lectures on Rhetoric and Belles Lettres* (Edinburgh: Thomas Nelson and Sons, 1963), pp. 131–132 on this theme as well.

49. On print culture and language, see Samuel Johnson, *A Journey to the Western Islands of Scotland,* in *The Yale Edition of the Works of Samuel Johnson,* vol. 9 (New Haven: Yale University Press, 1971 [1775]), pp. 114–119; the above quotation is taken from pp. 115–116. On Johnson's views of antiquity, see Boswell, *Life of Johnson,* pp. 477, 742–743.

50. On Johnson's approval of the paperback and street literature, see Lowenthal and Fiske, "The Debate Over Art and Popular Culture in Eighteenth-Century England," p. 41, and Samuel Johnson, *Introduction to Harleian Miscellany,* in Allen T. Hazen, ed., *Samuel Johnson's Prefaces and Dedications* (New Haven: Yale University Press, 1937 [1744]), pp. 50–59.

51. On booksellers and the dictionary, see Boswell's *Life of Johnson,* p. 217. In this day the word "bookseller" also referred to publishers.

52. On the story of the *Dictionary,* see Bate, *Samuel Johnson,* chapter 15.

53. On early dictionaries, see Bate, *Samuel Johnson,* p. 241, and for some other definitions of Johnson's, see p. 250.

54. On this episode, see Alvin Kernan, *Samuel Johnson and the Impact of Print* (Princeton: Princeton University Press, 1987), pp. 39–40, and Boswell's *Life of Johnson,* pp. 381–384. On bookseller support of Johnson's project, see Steinberg, *Five Hundred Years of Printing,* p. 229. For a history of other literary histories written during this era, see Rene Wellek, *The Rise of English Literary History* (Chapel Hill: University of North Carolina Press, 1941). Lawrence Lipking, *The Ordering of the Arts in Eighteenth-Century England* (Princeton: Princeton University Press, 1970), surveys eighteenth-century attempts to provide comprehensive histories of the arts.

55. On Johnson's income from the government and the pension, see Paul J. Korshin, "Types of Eighteenth-Century Patronage," *Eighteenth-Century Studies,* 7 (1974): 453–473. Bate, *Samuel Johnson,* pp. 354–356, and Griffin, *Literary Patronage in England,* chapter 3. For Boswell's account of the pension, see *Life of Johnson,* pp. 264–265, 1153–1154. On Johnson's definition of pension, see Bate, *Samuel Johnson,* p. 354. On Johnson's view of the pension as unconditional and his later disillusionment, see Donald Greene, *The Politics of Samuel Johnson* (Athens: University of Georgia Press, 1990), pp. 189–191. The evidence differs on whether Johnson favored absolute freedom of speech. See Johnson's early pamphlet, *A Compleat Vindication of the Licensers of the Stage,* in *The Yale Edition of the Works of Samuel Johnson,* vol. 10 (New Haven: Yale University Press, 1977 [1739]) for a defense of free speech; his *Introduction to Harleian Miscellany* [1744] also defended freedom of speech in radical terms. Boswell's *Life of Johnson* (e.g., pp. 539, 1232) portrays

Johnson as an opponent of absolute free speech; see Greene, *The Politics of Samuel Johnson* for a critique of Boswell's portrayal.

56. On the Brobdingnags and the Houyhnhnms, see Jonathan Swift, *Gulliver's Travels,* in *Gulliver's Travels and Other Writings* (New York: Random House, 1958 [1726]), pp. 104, 191, 204–205, 218, 223, 229. For a treatment of Swift's analysis of books and language, see Terry J. Castle, "Why the Houyhnhnms Don't Write: Swift, Satire and the Fear of the Text," *Essays in Literature,* 7 (1980): 31–44.

57. On the print machine of Lagado, see Swift, *Gulliver's Travels,* pp. 145–146.

58. On this proposal, see Swift, *Gulliver's Travels,* pp. 148–149.

59. On Swift's political views, see F. P. Lock, *Swift's Tory Politics* (Newark, Del.: Delaware University Press, 1983). For an analysis of Swift's views on the English language, outlined primarily in *A Proposal for Correcting, Improving, and Ascertaining the English Tongue,* see Deborah Baker Wyrick, *Jonathan Swift and the Vested Word* (Chapel Hill: University of North Carolina Press, 1988), pp. 40–41.

60. For background material on Sturges, see James Harvey, *Romantic Comedy in Hollywood: From Lubitsch to Sturges* (New York: Alfred A. Knopf, 1987).

61. For Johnson on Swift, see Johnson's *Lives of the English Poets* (New York: Oxford University Press, 1952 [1779, 1781]), p. 198.

62. On the politicization of patronage in Elizabethan times, see Phoebe Sheavyn, *The Literary Profession in the Elizabethan Age* (Manchester: Manchester University Press, 1967). On patronage in antiquity, see the remarks of Juvenal, *Satire VII,* in *Juvenal and Persius,* Loeb Classical Library no. 91 (Cambridge, Mass.: Harvard University Press, 1961), pp. 137, 143. On patronage in antiquity more generally, see the essays in Barbara K. Gold, ed., *Literary and Artistic Patronage in Ancient Rome* (Austin: University of Texas Press, 1982).

63. On the history of government subsidization of these figures (and others), see Fredrick Seaton Siebert, *Freedom of the Press in England, 1476–1776* (Urbana: University of Illinois Press, 1965), pp. 330–335, and David Harrison Stevens, *Party Politics and English Journalism, 1702–1742* (New York: Russell & Russell, 1967).

64. On Walpole's policies, see Bertrand A. Goldgar, *Walpole and the Wits: The Relation of Politics to Literature, 1722–1742* (Lincoln: University of Nebraska Press, 1976), Collins, *Authorship in the Days of Johnson,* chapter 1, and Rogers, "Books, Readers, and Patrons," p. 218.

65. On the regulation of language, see *The Spectator,* no. 165, September 8, 1711, in vol. 2, pp. 149–153. On Addison's opera, see Eric Walter

White, *The Rise of English Opera* (London: John Lehmann, 1951), p. 47. Even cultural mercantilism, however, did not induce English music to thrive. From 1737 to 1834, for instance, only one theater (Her Majesty's, formerly called the King's Theatre) was allowed to present Italian opera productions in England. English opera still did not catch on, and remained dominated by the creations of a foreigner, Handel. On English licensing, which extended also to drama, see White, pp. 108–109. For an overview of Addison's life, see Robert M. Otten, *Joseph Addison* (Boston: Twayne Publishers, 1982).

66. For a survey and analysis of Pope's views on opera, see Pat Rogers, *Literature and Popular Culture in Eighteenth-Century England* (Totowa, N.J.: Barnes and Noble Press, 1985), chapter 4, and Robert Ness, "*The Dunciad* and Italian Opera in England," *Eighteenth-Century Studies,* 20 (1986/1987): 173–194. On Perrault, see Alfred Richard Oliver, *The Encyclopedists as Critics of Music* (New York: Columbia University Press, 1947), p. 12; this book also surveys anti-opera sentiment in eighteenth-century France. For a survey of moral attacks on the oratorio, see Robert Manson Myers, *Early Moral Criticism of Handelian Oratorio* (Williamsburg, Va.: Manson Park Press, 1947).

67. For Johnson on Pope, see *Lives of the English Poets,* vol. 2, pp. 315–316; the quotation is from p. 316.

68. On the sale of Pope's translation, see Kernan, *Samuel Johnson and the Impact of Print,* p. 10. On Pope's earnings versus Johnson's, see Victor Bonham-Carter, *Authors by Profession* (London: Society of Authors, 1978, 1984), vol. 1, p. 24. On the relative price of Pope's *Iliad* and Defoe, see Raven, *Judging New Wealth,* p. 57. On Pope's conversation with Spence, see Alexandre Beljame, *Men of Letters and the English Public in the Eighteenth Century, 1660–1744: Dryden, Addison, Pope* (London: Kegan Paul, Trench, Trubner, 1948 [1881]), p. 368n.

69. On the praise from Pope, see Robert M. Ryley, *William Warburton* (Boston: Twayne Publishers, 1984), pp. 1, 37. On Warburton's links to Pope, see Maynard Mack, *Alexander Pope, A Life* (New York: W.W. Norton, 1985), pp. 741–745, 802.

70. Seventeenth- and eighteenth-century writers stressed the desires for praise and fame as human motivations. See, for instance, Francis Bacon, Thomas Hobbes, David Hume, Adam Smith (at least in the Moral Sentiments), Bernard Mandeville, Richard Steele, Joseph Addison, Christian Wolff, Montaigne, Blaise Pascal, Voltaire, Jean-Jacques Rousseau, John Adams, and Thomas Jefferson. Typical of this time is the poem by Edward Young entitled "Love of Fame, the Universal Passion." On the views of these thinkers on fame, see Arthur

O. Lovejoy, *Reflections on Human Nature* (Baltimore: Johns Hopkins University Press, 1961), pp. 169–231, and Douglass Adair, "Fame and the Founding Fathers," in Trevor Colburn, ed., *Fame and the Founding Fathers: Essays by Douglass Adair* (New York: W.W. Norton, 1974), pp. 3–26. For citations on the role of fame in seventeenth-century English literature and dating back to Chaucer, see Geoffrey Tillotson's introduction to Pope's "The Temple of Fame" in *The Poems of Alexander Pope* (London: Methuen, 1963), vol. 2, especially pp. 216–219. On the role of fame in the literature of antiquity, see Piero Boitani, *Chaucer and the Imaginary World of Fame* (Cambridge: D. S. Brewer, 1984). On fame more generally, see Leo Braudy, *The Frenzy of Renown* (New York: Oxford University Press, 1986), and William J. Goode, *The Celebration of Heroes: Prestige as a Control System* (Berkeley: University of California Press, 1978). Modern economic analyses of fame incentives are few and far between. David Levy's *The Economic Ideas of Ordinary People: From Preferences to Trade* (London: Routledge, 1992) has influenced this chapter. See also Robert H. Frank, *Choosing the Right Pond: Human Behavior and the Quest for Status* (New York: Oxford University Press, 1985). I am currently working on a manuscript entitled *The Economics of Fame and Approbation,* which will treat these issues more systematically.

71. For the Thucydides quotation, see his *History of the Peleponnesian War* (London: Penguin Books, 1972), p. 48. The Sterne quotation is cited in Saunders, *The Profession of English Letters,* p. 149.

72. In addition to Pope's *Dunciad,* see *An Essay on Criticism,* in *The Poems of Alexander Pope,* vol. 1, ll. 418–423. On the views of Warburton, see *An Enquiry into the Nature and Origin of Literary Property,* in *Horace Walpole's Political Tracts, 1747–1748* (New York: Garland Publishing, 1974 [1762]), pp. 18–20. For two nineteenth-century literary critiques of commercialization, see George Gissing, *New Grub Street: A Novel* (London: Smith, Elder, 1891) and Honoré Balzac, *Lost Illusions* (London: Penguin Books, 1971 [1837–1843]).

73. See Oliver Goldsmith, *The Citizen of the World* in Arthur Friedman, ed., *The Collected Works of Oliver Goldsmith* (Oxford: Clarendon Press, 1966 [1762]), Letter XXV, pp. 312–313. On Goldsmith's conflicting attitudes about commercialization, see Lowenthal and Fiske, "The Debate over Art and Popular Culture in Eighteenth-Century England," pp. 52–53, 68–69. The story of the Chinese scholar is presented in Goldsmith, *Citizen of the World,* Letter CIX, "The Chinese philosopher attempts to find out famous men," pp. 422–425. Frank Donoghue, in *The Fame Machine,* chapter 3, provides a recent treatment of Goldsmith's thought

on fame. For Swift's poem, see Swift, *Gulliver's Travels and Other Writings,* p. 533. Also see Archibald Constable, *Archibald Constable and His Literary Correspondence* (Edinburgh: Edmonston and Douglas, 1873, 3 vols.), vol. 1, p. 270.

74. For the quotations, see David Hume, *Essays Moral, Political, and Literary* (Indianapolis, Ind.: Liberty Press Classics, 1985 [1777]), pp. 135–136. For other proponents of this view, see David Lowenthal, *The Past Is a Foreign Country* (Cambridge: Cambridge University Press, 1985), chapter 3, especially p. 93.

75. David Hume, *Essays,* pp. 136–137.

76. See Goldsmith, *Citizen of the World,* Letter LVII, p. 236, Goldsmith, *An Enquiry into the Present State of Polite Learning in Europe,* in *The Collected Works of Oliver Goldsmith,* p. 287, and Goldsmith, *The Bee and Other Essays by Oliver Goldsmith Together with the Life of Nash* (Oxford: Oxford University Press, 1914), pp. 40–41, pp. 54–55. For a similar polemic against critics, see Laurence Sterne, *The Life and Opinions of Tristram Shandy, Gentleman* (Oxford: Oxford University Press, 1983 [1759, 1760]), vol. 3, chapter 12, pp. 143–145. For the epigram, see Swift, *Thoughts on Various Subjects,* in *Gulliver's Travels and Other Works,* p. 418. Ironically, James Boswell had leveled the charge of critical spitefulness against Goldsmith himself. See his *Life of Johnson,* pp. 295, 545.

77. On aesthetics in the eighteenth century, see Lipking, *The Ordering of the Arts in Eighteenth-Century England.*

78. See Goldsmith's *Citizen of the World,* Letter LVII, entitled "The difficulty of rising in literary reputation . . ." Warburton (1698–1779), now largely forgotten, was one of the best-known scholars and critics in Europe in his day. Warburton started as a clergyman and theologian but he also wrote literary criticism, including commentaries on Pope and Shakespeare. His neglected writings on copyright anticipate much of the theory of "public goods and externalities" found in modern economics. Today, Warburton is best known for *The Divine Legation of Moses,* which attacked the Enlightenment philosophy of deism. On Warburton's life see Ryley, *William Warburton.* Boswell reported that Samuel Johnson had effusive praise for Warburton's learning, although he disagreed with most of his conclusions. See Boswell's *Life of Johnson,* pp. 381–382.

79. Warburton, *An Enquiry into the Nature and Origin of Literary Property,* p. 35.

80. Unlike most of the literary pessimists, who disliked commerce, Addison saw the monetary nexus as a potential ally of cultural achievement. Money, fame, and printing needed only to be regulated properly by the

government. Addison's *Dialogue Upon the Usefulness of Ancient Medals* (New York: Garland Publishing, 1976 [1726]), p. 147, tells us "formerly there was no difference between Money and Medals." On the durability of medals, see pp. 20–21. On Pope's poem in support of Addison, see Mark Jay Levin, *Literature and Numismatics in England, 1650–1750* (Ann Arbor, Mich.: University Microfilms, 1974), p. 81 and Pope, vol. 6, "To Mr. ADDISON, Occasioned by his Dialogues on MEDALS," *The Poems of Alexander Pope,* pp. 202–204. On co-authorship with Swift, see Levin, p. 118. The case for centralized government management is especially clear in Addison's piece with Swift in *The Guardian,* no. 96, Wednesday, July 1, 1713. Author Henry Fielding opposed Addison's medals proposal. In his satiric commentary on Addison's *Dialogues,* Fielding pointed out that the government restricts the freedom of the press when they use their money monopoly to distribute images and messages. He felt we should not compliment the prince or the government for mending ports and making highways. The citizenry is doing the work and bearing the expenses. See Fielding's "Addison's Dialogues Upon Medals," in Martin C. Battestin, ed., *New Essays by Henry Fielding* (Charlottesville, Va.: University of Virginia Press, 1989), p. 402. (Note that this piece was published anonymously and has not been attributed to Fielding with certainty.)

81. On Pope's self-appointed role as savior, see *The Dunciad,* in *The Poems of Alexander Pope,* p. 50.

82. For a fascinating treatment of the precariousness of survival for the great works of antiquity, see L. D. Reynolds and N. G. Wilson, *Scribes and Scholars: A Guide to the Transmission of Greek and Latin Literature* (Oxford: Clarendon Press, 1974).

83. De Bury, *Philobiblon,* pp. 17–19.

84. See Velleius Paterculus, *Compendium of Roman History,* Loeb Classical Library no. 152 (Cambridge, Mass.: Harvard University Press, 1967), pp. 45–47.

85. See Weinbrot, *Brittania's Issue,* pp. 99–101; on emulation more generally, see chapter 3.

86. On the tendency to innovate, see the works of Scottish Enlightenment figures Lord Kames, John Millar, Archibald Alison, and Alexander Gerard. John D. Scheffer, "The Idea of Decline in Literature and the Fine Arts in Eighteenth-Century England," *Modern Philology,* 34 (1936): 155–178 surveys this tradition.

87. See William Hazlitt, "Why the Arts Are not Progressive—A Fragment," in Geoffrey Keynes, ed., *Selected Essays of William Hazlitt, 1778–1830* (London: Nonesuch Press, 1948 [1814]), p. 605.

88. Ibid., pp. 607–609.
89. On the development of the dwarves and giants metaphor, see Matei Calinescu, *Five Faces of Modernity* (Durham, N.C.: Duke University Press, 1987), pp. 14–92.

3. The Wealthy City as a Center for Western Art

1. On art collecting and art markets, see Francis Henry Taylor, *The Taste of Angels: A History of Art Collecting from Rameses to Napoleon* (London: Hamish Hamilton, 1948), Maurice Rheims, *Art on the Market: Thirty-Five Centuries of Collecting and Collectors from Midas to Getty* (London: Weidenfeld and Nicholson, 1961), John Walker, *Expert's Choice: 1000 Years of the Art Trade* (New York: Stewart, Tabori & Chang, 1983), Joseph Alsop, *The Rare Art Traditions: The History of Art Collecting and Its Linked Phenomena Wherever These Have Appeared* (London: Thames and Hudson, 1982), and Peter Watson, *From Manet to Manhattan: The Rise of the Modern Art Market* (New York: Random House, 1992).

2. On the commercial and industrial revolutions of the Middle Ages, see, for instance, Jean Gimpel, *The Medieval Machine: The Industrial Revolution of the Middle Ages* (London: Victor Gollancz, 1977), Robert S. Lopez, *The Commercial Revolution of the Middle Ages, 950–1350* (Englewood Cliffs, N.J.: Prentice-Hall, 1971), and Mary Hollingsworth, *Patronage in Renaissance Italy: From 1400 to the Early Sixteenth Century* (Baltimore: Johns Hopkins University Press, 1994).

3. Alberti's views on wealth can be found in Leon Battista Alberti, *The Family in Renaissance Florence* (Columbia, S.C.: University of South Carolina Press, 1969 [1441]), pp. 142–145. See also Poggio Bracciolini, *On Avarice,* in Benjamin G. Kohl and Ronald G. Witt, with Elizabeth B. Welles, eds., *The Earthly Republic: Italian Humanists on Government and Society* (Philadelphia: University of Pennsylvania Press, 1978), pp. 241–289, quotation is from pp. 260, 263. For a survey of other humanist views on wealth, see Lauro Martines, *Power and Imagination: City-States in Renaissance Italy* (New York: Alfred A. Knopf, 1979), chapter 11, although Martines suggests that these writers were cynical apologists for the ruling class. On Florentine humanism more generally, see J. G. A. Pocock, *The Machiavellian Moment: Florentine Political Thought and the Atlantic Republican Tradition* (Princeton: Princeton University Press, 1975), and Michael Levey, *Florence: A Portrait* (Cambridge, Mass.: Harvard University Press, 1996). For commentary and a survey of the literature, see Kohl, Witt, and Welles, *The Earthly Republic,* p. 234. Poggio was also a noted art collector; see Walker, *Expert's Choice,* p. 28. The

driving role of commerce behind Renaissance culture and art also was emphasized in the eighteenth-century English and Scottish Enlightenment. See, for instance, John Millar, *An Historical View of the English Government* (London: J. Mawman, 1812), vol. 4, p. 369, and Herbert Weisinger, "The English Origins of the Sociological Interpretation of the Renaissance," *Journal of the History of Ideas,* 11 (1950): 321–338. For a modern treatment of this theme, see Richard A. Goldthwaite, *Wealth and the Demand for Art in Italy, 1300–1600* (Baltimore: Johns Hopkins University Press, 1993). For a critique of the now unpopular view that the Renaissance was an era of economic depression, as exemplified by Robert S. Lopez, "Hard Times and Investment in Culture," in *The Renaissance: Six Essays* (New York: Harper Torchbooks, 1962), pp. 29–54, see Judith Brown, "Prosperity or Hard Times in Renaissance Italy?" *Renaissance Quarterly,* 62 (1989): 761–780.

4. On accounting in households, see Richard A. Goldthwaite, *Private Wealth in Renaissance Florence: A Study of Four Families* (Princeton: Princeton University Press, 1968), p. 5. On the Medici bank, see J. R. Hale, *Florence and the Medici: The Pattern of Control* (Plymouth: Thames and Hudson, 1977), pp. 32–33 and Raymond de Roover, *The Rise and Decline of the Medici Bank, 1397–1494* (New York: W.W. Norton, 1966).

5. On wool-making in Florence, see Gimpel, *The Medieval Machine,* pp. 102–105. On Florentine competitiveness in the wool trade and other industries, see August C. Krey, "A City that Art Built," in *History and the Social Web* (Minneapolis: University of Minnesota Press, 1955). On Florentine art works placed on fabrics, see Andre Chastel, *The Golden Age of the Renaissance: Italy, 1460–1500* (London: Thames and Hudson, 1965), p. 304. For an overview of Florentine prosperity, see Goldthwaite, *Wealth and the Demand for Art in Italy.*

6. Krey, "History and the Social Web," in *History and the Social Web,* p. 171.

7. On the origins of artists, see J. R. Hale, ed., *The Thames and Hudson Encyclopaedia of the Italian Renaissance* (London: Thames and Hudson, 1981) under the entry, "Artist, status of the," p. 37. On the origins of authors, see Peter Burke, *Culture and Society in Renaissance Italy, 1420–1540* (New York: Scribner, 1972), pp. 46–47.

8. On the number of goldsmith shops, see Sidney J. A. Churchill and Cyril Bunt, *The Goldsmiths of Italy: Some Account of Their Guilds, Their Statutes, and Work* (London: Martin Hopkinson, 1926), p. 37. On the goldsmith guild, see Richard A. Goldthwaite, *The Building of Renaissance Florence* (Baltimore: Johns Hopkins University Press, 1980), p. 415.

235

9. On these goldsmith backgrounds, see Bonnie A. Bennett and David G. Wilkins, *Donatello* (Oxford: Phaidon Press, 1984), pp. 37, 103; Giorgio Vasari, *The Lives of the Painters and Sculptors and Architects* (London: J.M. Dent & Sons, 1927, 1963), vol. 1, p. 80, vol. 2, pp. 84, 301; Rosa Maria Letts, *The Renaissance* (Cambridge: Cambridge University Press, 1981), pp. 56–64; Joan Evans, *A History of Jewellery 1110–1870* (London: Faber and Faber, 1953), p. 82, Glenn Andres, John M. Hunisak, and A. Richard Turner, *The Art of Florence* (New York: Abbeville Press, 1987), vol. 1, pp. 138–139, James Beck, *Leonardo's Rules of Painting* (New York: Viking, 1979), p. 17, Benvenuto Cellini, *The Treatises of Benvenuto Cellini on Goldsmithing and Sculpture* (New York: Dover, 1967), pp. 1–6, and Krey, *History and the Social Web*, pp. 156–161. On Raphael's father, see A. P. Oppè, *Raphael* (London: Elek Books, 1970), p. 13. On the goldsmithing influence in Ghiberti's work, see the study of Charles Avery, *Florentine Renaissance Sculpture* (New York: Harper & Row, 1970), pp. 36–37. Albrecht Dürer was a goldsmith apprentice under his father; see Peter Strieder, *The Hidden Dürer* (Chicago: Rand McNally, 1976), p. 27. On the link between goldsmithing and German art more generally, see Joseph Meder, *The Mastery of Drawing* (New York: Abaris Books, 1978), vol. 1, p. 259.

10. On the development of art from the goldsmith trade, see Goldthwaite, *The Building of Renaissance Florence,* pp. 304–305, 414–415, and Krey, *History and the Social Web,* pp. 156–165. On the versatility of skills required by the goldsmith, see Cellini, *The Treatises of Benvenuto Cellini on Goldsmithing and Sculpture.* On goldsmithing, see Churchill and Bunt, *The Goldsmiths of Italy;* Ulrich Middledorf, "Zur goldschmiedekunst der toskanischen Frührenaissance," *Pantheon,* 16 (1935): 279–282; Werner Haftmann, "Italienische Goldschmiedarbeiten," *Pantheon,* 23 (1939): 29–34; Erich Steingräber, "Studien zur Florentiner Goldschiedekunst I," *Mitteilungen des Kunsthistorischen Institutes in Florenz,* 7 (1955): 87–110, and Erich Steingräber, *Der Goldschmied: Von alten Handwerk der Gold-und Silber-Arbeiter* (Munich: Prestel Verlag, 1966).

11. On these items, see Bruce Cole, *Italian Art, 1250–1550: The Relation of Renaissance Art to Life and Society* (New York: Harper & Row, 1983), chapter 1, p. 70 and Bruce Cole, *Masaccio and the Art of Early Renaissance Florence* (Bloomington, Ind.: Indiana University Press, 1980), p. xix. On portable devotional pictures, see Alsop, *The Rare Art Traditions,* p. 44. On altarpieces, see Ferdinand Schevill, *The Medici* (New York: Harcourt, Brace, 1949), p. 41. On wedding gifts, see Jacob Burckhardt, "Die Sämmler," in Heinrich Wöfflin, ed., *Beiträge zur Kunstgeschichte von Italien, Gesamtausgabe 12* (Stuttgart: Deutsche Verlags-Anstalt, 1930),

pp. 293–496, especially pp. 296–309. See Martin Wackernagel, *The World of the Florentine Renaissance Artist: Projects and Patrons, Workshop and Art Market* (Princeton: Princeton University Press, 1981), p. 316 on studios and their prominence. On uncommissioned productions, see Burke, *Culture and Society in Renaissance Italy,* p. 119. On carnival demand, see Serge Bramly, *Leonardo: Discovering the Life of Leonardo da Vinci* (New York: HarperCollins, 1991), p. 89.

12. On Mantegna see Martines, *Power and Imagination,* p. 265, and on Mantegna's reluctance, see Martin Warnke, *Hofkünstler: Zur Vorgeschichte des modernen Künstlers* (Cologne: DuMont Buchverlag, 1985), p. 79.

13. On private sources of artistic commissions in Florence, see Wackernagel, *The World of the Florentine Renaissance Artist,* chapter 6, and Hollingsworth, *Patronage in Renaissance Italy.* Jacob Burckhardt's early essay "Die Sämmler," written in the 1860s, offers an early study of private art collecting. On Raphael's production for the home, see Bram Kempers, *Painting, Power, and Patronage: The Rise of the Professional Artist in the Italian Renaissance* (London: Allen Lane/Penguin, 1987), p. 271; on Botticelli's *Primavera,* see Goldthwaite, *Wealth and the Demand for Art in Italy,* p. 229.

14. On the palazzi boom, see Bramly, *Leonardo: Discovering the Life of Leonardo da Vinci,* p. 55, and Hollingsworth, *Patronage in Renaissance Italy,* part I.

15. On the boom in Florentine churches and the privatization of church space, see Goldthwaite, *Wealth and the Demand for Art in Italy,* p. 131; see also Hollingsworth, *Patronage in Renaissance Italy,* part I.

16. On the rise of the Florentine exhibit, see Meder, *The Mastery of Drawing,* vol. 1, p. 198.

17. On the dealings between Raphael and Raimondi, see Susan Lambert, *The Image Multiplied: Five Centuries of Printed Reproductions of Paintings and Drawings* (London: Trefoil Publications, 1987), pp. 147–148, 156, and David Landau and Peter Parshall, *The Renaissance Print, 1470–1550* (New Haven: Yale University Press, 1994).

18. On artists' contracts, see Burke, *Culture and Society in Renaissance Italy, 1420–1540,* pp. 104–105; Michael Baxandall, *Painting and Experience in Fifteenth-Century Italy: A Primer in the Social History of Pictorial Style* (Oxford: Clarendon Press, 1972), chapter 1; D. S. Chambers, ed., *Patrons and Artists in the Italian Renaissance* (London: Macmillan, 1970); Hannelore Glasser, *Artists' Contracts of the Early Renaissance* (New York: Garland Publishing, 1977); and Hanna Lerner-Lehmkuhl, *Zur Struktur und Geschichte des Florentinischen Kunstmarktes im 15. Jahrhundert* (Wattenscheid: Karl Busch Verlag, 1936).

19. See Chambers, *Patrons and Artists in the Italian Renaissance,* pp. 135–140 on this episode. A copy of the contract between Isabella and Perugino can be found in Charles Hope, "Artists, Patrons, and Advisers in the Italian Renaissance," in Guy Fitch Lytle and Stephen Orgel, eds., *Patronage in the Renaissance* (Princeton: Princeton University Press, 1981), pp. 293–343, especially pp. 293–294. On Isabella and Leonardo, see Francis Ames-Lewis and Joanne Wright, *Drawing in the Italian Renaissance Workshop* (London: Victoria and Albert Museum, 1983), p. 284. See also H. W. Janson, "The Birth of 'Artistic License': The Dissatisfied Patron in the Early Renaissance," in Lytle and Orgel, *Patronage in the Renaissance,* pp. 344–353.

20. On Velazquez and his work for Philip, see Jonathan Brown, *The Golden Age of Painting in Spain* (New Haven: Yale University Press, 1991). A comprehensive catalogue of Velazquez's work is provided by José López-Rey, *Velazquez: A Catalogue Raisonné of his Oeuvre* (London: Faber and Faber, 1963); for portraits of Philip see pp. 186–226. Not all of these attributions have stood the test of time, however.

21. On these other areas, see, for instance, Werner L. Gundersheimer, *Ferrara: The Style of a Renaissance Despotism* (Princeton: Princeton University Press, 1973), and Jerry H. Bentley, *Politics and Culture in Renaissance Naples* (Princeton: Princeton University Press, 1987), especially p. 49. On papal commissions for Florentines, see Bernhard Schimmelpfennig, *The Papacy* (New York: Columbia University Press, 1992), pp. 241–242. Hollingsworth, *Patronage in Renaissance Italy* provides the most comprehensive treatment.

22. On Sforza patronage, see Gregory Lubkin, *A Renaissance Court: Milan under Galeazzo Maria Sforza* (Berkeley: University of California Press, 1984), chapter 4.

23. On artistic fame, see Lionell Venturi, *History of Art Criticism* (New York: E.P. Dutton), pp. 72–74, E. Falaschi, "Giotto: The Literary Legend," *Italian Studies,* 27 (1972): 1–27, and Alsop, *The Rare Art Traditions,* pp. 285–289. On Ghiberti's artistic freedom, see Gene A. Brucker, *Renaissance Florence* (New York: John Wiley and Sons, 1969), p. 248, who cites Ghiberti himself.

24. On Brunelleschi's fight to work alone, see Vincent Cronin, *The Florentine Renaissance* (London: Collins, 1967), pp. 166–175.

25. On medieval linguistic conventions, see Cronin, *The Florentine Renaissance,* pp. 175–176. On the Italian conventions, see Larner, *Culture and Society in Italy, 1290–1420,* p. 264. For an historical account of the changing status of the artist, see Rudolf Wittkower and Margot Wittkower, *Born under Saturn. The Character and Conduct of Artists: A*

Documented History from Antiquity to the French Revolution (New York: W.W. Norton, 1969). Jean Gimpel, *The Cult of Art: Against Art and Artists* (New York: Stein and Day, 1969), provides running commentary on changes in the meaning of the word artist over time.

26. On the Medici tomb, see Howard Hibbard, *Michelangelo: A Brilliant Biography of the Magnificent Renaissance Artist* (London: Penguin Books, 1985), p. 188. On the Sistine Chapel, see Wackernagel, *The World of the Florentine Renaissance Artist,* p. 312.

27. See Herbert von Einem, *Michelangelo* (London: Methuen, 1959), pp. 39, 75, and Wittkower and Wittkower, *Born under Saturn,* pp. 39–40.

28. On the abandoned tomb plans, see Leo Braudy, *The Frenzy of Renown: Fame and its History* (New York: Oxford University Press, 1986), p. 287. On Michelangelo's funeral service, see Rudolf Wittkower and Margot Wittkower, eds., *The Divine Michelangelo: The Florentine Academy's Homage on His Death in 1564* (London: Phaidon Press, 1964).

29. Serge Bramly's *Leonardo* provides the best introduction to the artist's life. See Watson, *From Manet to Manhattan,* p. 432 on the value of Leonardo's paintings.

30. On Ghiberti, see Charles Krautheimer, in collaboration with Trude Krautheimer-Hess, *Lorenzo Ghiberti* (Princeton: Princeton University Press, 1970), vol. 1, pp. 7–8. On Raphael, see Arnold Hauser, *The Social History of Art,* vols. 1–4 (New York: Vintage Books, 1957), vol. 2, p. 67; Wittkower and Wittkower, *Born under Saturn,* p. 265.

31. On the role of competition between the guilds, see Charles Avery, *Florentine Renaissance Sculpture* (New York: Harper &Row, 1970), p. 3, Andres, Hunisak, and Turner, *The Art of Florence,* vol. 1, pp. 397–398, and Hollingsworth, *Patronage in Renaissance Italy,* chapters 2 and 3. On how guilds assigned project responsibilities and rights to their members, see Lerner-Lehmkuhl, *Zur Struktur und Geschichte des Florentinischen Kunstmarktes im 15. Jahrhundert,* p. 10. On Florentine guilds see Alfred Doren, *Das Florentiner Zunftwesen vom 14. bis zum 16. Jahrhundert* (Darmstadt: Scientia Verlag Aalen, 1969), and Edgcumbe Staley, *The Guilds of Florence* (New York: Benjamin Blom, 1967). Lauro Martines, in *Power and Imagination,* argues that Florentine art was a creature of the state and the desire for political power. See also Larner, *Culture and Society in Italy, 1290–1420,* especially p. 353, and Warnke, *Hofkünstler.*

32. On government subsidies, see Wackernagel, *The World of the Florentine Renaissance Artist,* p. 210.

33. On these early forms of Medici patronage, see Kempers, *Painting, Power, and Patronage: The Rise of the Professional Artist in the Italian Renaissance,* pp. 192–194. On the merchant finance through churches for non-Medici

families, see pp. 184–185. On the works for Cosimo's Palazzo, see Alsop, *The Rare Art Traditions,* p. 367. J. R. Hale, *Florence and the Medici: The Pattern of Control* (Plymouth: Thames and Hudson, 1977), p. 41, wrote that: "[Cosimo] did not create the conditions that produced the marvellous efflorescence of early *quattrocento* [fifteenth-century] humanism and art. He responded, he encouraged, but, save in the scale of his building programme, he did not initiate, nor was his patronage different in kind from that of other individuals and groups."

34. On Cosimo's patronage, see Hale, *Florence and the Medici,* p. 29–32. On the hesitancy and piecemeal nature of the patronage of Cosimo and Lorenzo, see also E. H. Gombrich, "The Early Medici as Patrons of Art," in E. F. Jacob, ed., *Italian Renaissance Studies* (London: Faber and Faber, 1960), pp. 279–311. On Lorenzo and Michelangelo, see E. B. Fryde, "Lorenzo de Medici: High Finance and the Patronage of Art and Learning," in A. G. Dickens, ed., *The Courts of Europe: Politics, Patronage and Royalty, 1400–1800* (New York: McGraw-Hill, 1977), pp. 77–97, especially pp. 83–84.

35. On the marble trade, see Goldthwaite, *The Building of Renaissance Florence,* pp. 212–230, and William E. Wallace, *Michelangelo at San Lorenzo: The Genius as Entrepreneur* (Cambridge: Cambridge University Press, 1994). On the economics of cathedral building, see Henry Krause, *Gold Was the Mortar: The Economics of Cathedral Building* (London: Routledge & Kegan Paul, 1979). On marble cutting, see Linda Murray, *Michelangelo: His Life, Work, and Times* (London: Thames and Hudson, 1984), pp. 41, 99. On the costliness of transporting marble, see Bruce Cole, *The Renaissance Artist at Work: From Pisano to Titian* (New York: Harper & Row, 1983), pp. 114–115. On the location of marble sites and marble transport, see Charles Seymour Jr., *Sculpture in Italy, 1400–1500* (London: Penguin Books, 1966), pp. 15–17.

36. On the engineers behind the transport of David, see Bertrand Gille, *Engineers of the Renaissance* (Cambridge, Mass.: MIT Press, 1966), pp. 118–119. On knocking down the wall to transport David, see Andre Chastel, *A Chronicle of Italian Renaissance Painting* (Ithaca, N.Y.: Cornell University Press, 1983), p. 149.

37. On the melting down of bronze statues, see Avery, *Florentine Renaissance Sculpture,* p. 5. On the price of bronze, see Cole, *The Renaissance Artist at Work,* p. 123, and Frederick Hartt, *History of Italian Renaissance Art: Painting, Sculpture, Architecture* (Englewood Cliffs, N.J.: Prentice-Hall, 1969), p. 25. On Ghiberti, see Charles Seymour Jr., *Sculpture in Italy, 1400–1500* (London: Penguin Books, 1986), p. 14, Krautheimer, *Lorenzo Ghiberti,* pp. 108, 369n. See Bennett and Wilkins, *Donatello,*

p. 114, and Cole, *The Renaissance Artist at Work,* pp. 123–125 on the difficulties of bronze sculpture. On the rise of Greek art markets and the later melting down of sculpture, see Andrew Stewart, *Greek Sculpture: An Exploration* (New Haven: Yale University Press, 1990), vol. 1, pp. 24, 56–57, 62–68.

38. See Dard Hunter, *Papermaking: the History and Technique of an Ancient Craft* (New York: Dover Publications, 1978), p. 2, on the arrival of papermaking in Italy, and Thomas Francis Carter, *The Invention of Printing in China and its Spread Westward* (New York: Ronald Press, 1955), on the spread of paper from China, especially pp. 133–135.

39. For the sheep estimate, see Hunter, *Papermaking,* p. 16.

40. On the costs of paper, see Larner, *Culture and Society in Italy, 1290–1420,* pp. 180–182. On the stylus, see James Watrous, *The Craft of Old-Master Drawings* (Madison, Wis.: University of Wisconsin Press, 1957), pp. 3–6, and Francis Ames-Lewis, *Drawing in Early Renaissance Italy* (New Haven: Yale University Press, 1981), chapter 1. On the origin of drawing, see Cole, *The Renaissance Artist at Work,* pp. 99–100, Harald Keller, *The Renaissance in Italy* (New York: Harry N. Abrams, 1969), pp. 178–181, and Meder, *The Mastery of Drawing,* pp. 138–139. On repulping, see Francis Ames-Lewis and Joanne Wright, *Drawing in the Italian Renaissance Workshop,* p. 15. On the role of paper in encouraging the development of printing, see Carter, *The Invention of Printing in China and its Spread Westward,* p. 132.

41. On Leonardo's drawing, see Ames-Lewis, *Drawing in Early Renaissance Italy,* p. 13; on chalk drawing, see chapter 3, pp. 167–171.

42. For a contrast between two pictures of Florence, one drawn with knowledge of linear perspective (1480) and one drawn without (1350), see pp. 8–9 of Samuel Y. Edgerton Jr., *The Rediscovery of Linear Perspective* (New York: Basic Books, 1975). On Giotto, see pp. 14–15; on Brunelleschi's first drawings, see pp. xvii, 125–129; on the dissemination of linear perspective, see p. 5; on Ptolemy's atlas, see pp. 93–94; on other potential sources for the perspective revolution, see pp. 95, 134–135. See also John White, *The Birth and Rebirth of Pictorial Space* (Cambridge, Mass.: Harvard University Press, 1987), on precursors of linear perspective. See also the later work by Edgerton, *The Heritage of Giotto's Geometry: Art and Science on the Eve of the Scientific Revolution* (Ithaca, N.Y.: Cornell University Press, 1991). On the link between perspective and the sculptural tradition, see Andres, Hunisak, and Turner, *The Art of Florence,* vol. 1, p. 219.

43. On Giotto's fresco technique, see Bramly, *Leonardo,* p. 297. On later changes, see Andre Chastel, *The Studios and Styles of the Renaissance:*

Italy, 1460–1500 (London: Thames and Hudson, 1966), p. 209, and Eve Borsook, *The Mural Painters of Tuscany: From Cimabue to Andrea del Sarto* (Oxford: Clarendon Press, 1980), pp. xxiv–xxv.

44. On woodcutting, see Peter Strieder, *The Hidden Dürer* (Chicago: Rand McNally, 1976), p. 128; on the origins of engraving more specifically, see Arthur M. Hind, *A History of Engraving and Etching From the 15th Century to the Year 1914* (Boston: Houghton Mifflin, 1923), p. 36. On Pisanello's innovation, see C. H. V. Sutherland, *Art in Coinage: The Aesthetics of Money from Greece to the Present Day* (London: B.T. Batsford Ltd., 1955), pp. 135–137, and G. F. Hill, *Pisanello* (New York: Charles Scribner's Sons, 1905). On all of these developments, see Keller, *The Renaissance in Italy,* pp. 182–190.

45. Vasari, *The Lives of the Great Artists,* vol. 1, pp. 226–227. For a criticism of the details of Vasari's anecdote of Robbia, especially Robbia's priority in the technique, see John Pope-Hennessy, *Luca della Robbia* (Oxford: Phaidon Press, 1980), pp. 33–35. On the role of demand and consumer culture in these markets, see Richard A. Goldthwaite, "The Economic and Social World of Italian Renaissance Maiolica," *Renaissance Quarterly,* 17 (1989): 24–27.

46. On tempera style, see Cole, *The Renaissance Artist at Work,* p. 68. On tempera technique more generally, see Daniel V. Thompson, *The Practice of Tempera Painting* (New Haven: Yale University Press, 1936).

47. On the origins of oil painting, see David Rosand, *Titian* (New York: Harry N. Abrams, 1978), p. 9. For evidence on the prior use of oil painting in Italy, see Cole, *The Renaissance Artist at Work,* p. 71, Daniel V. Thompson, *The Materials and Techniques of Medieval Painting* (New Haven: Yale University Press, 1936), pp. 67–68, and Sir Charles Lock Eastlake, *Models and Materials of Painting of the Great Schools and Masters,* vols. 1-2 (New York: Dover Publications, 1960). On Leonardo and oils, see Bramly, *Leonardo,* pp. 102–103.

48. For a discussion of Vasari's views on oil painting, see Kempers, *Painting, Power, and Patronage,* p. 297. The Venetians also innovated by employing canvas as a base, rather than using panels; see Rosand, *Titian,* pp. 10–11 and Cole, *The Renaissance Artist at Work,* pp. 72, 75.

49. On the commercial nature of Venetian society, see Lisa Jardine, *Worldly Goods: A Worldly History of the Renaissance* (New York: Doubleday, 1996), chapter 2; the quotation about merchants is from p. 132. On altarpieces, see Norbert Huse and Wolfgang Wolters, *The Art of Renaissance Venice: Architecture, Sculpture, and Painting, 1460–1590* (Chicago: University of Chicago Press, 1990), pp. 225–240, 279–291. On prominent Venetian art buyers, see Oliver Logan, *Culture and Society in*

Venice, 1470–1790 (London: B.T. Batsford, 1972), pp. 295–321; on Venetian commissions with the Mantuan court, see pp. 39, 42.

50. See Harold E. Wethey, *The Paintings of Titian* (London: Phaidon Press, 1969), vol. 1, p. 11, and vol. 2 passim, for information about Titian's various commissions. On Titian's income and status, see Rosand, *Titian,* p. 26; Hauser, *The Social History of Art,* vol. 2, p. 67; Logan, *Culture and Society in Venice, 1470–1790,* p. 132, and Charles Hope, "Artists, Patrons, and Advisers in the Italian Renaissance," in Lytle and Orgel, eds., *Patronage in the Renaissance,* pp. 304–306. The Dürer quotation is from Meder, *The Mastery of Drawing,* p. 199.

51. See, for instance, Keith Christiansen, *Italian Painting* (New York: Hugh Lauter Levin Associates, 1992), p. 96.

52. On the role of consumption in the Renaissance, see Jardine, *Worldly Goods.* On the role of consumption in the rise of capitalism, see Colin Campbell, *The Romantic Ethic and the Spirit of Modern Consumerism* (New York: Basil Blackwell, 1987), and also Tyler Cowen, "Self-Constraint versus Self-Liberation," *Ethics,* 101 (1991): 360–373. On David Hume's view of luxury, see his essay "On Luxury," reprinted in his *Essays, Political, and Literary* (Indianapolis: Liberty Classics, 1985 [1777]). For a treatment of Florentine culture as a consumer culture, see Goldthwaite, *Wealth and the Demand for Art in Italy.*

53. On Florentine fashion, see Andres, Hunisak, and Turner, *The Art of Florence,* vol. 1, pp. 104–105, and Christopher Hibbert, *Florence: The Biography of a City* (New York: William Morrow, 1975), pp. 111–113.

54. On the change in themes, see Keller, *The Renaissance in Italy,* pp. 61–70. On the secular in Botticelli, see Ronald M. Steinberg's debunking of these claims in his *Fra Girolamo Savonarola, Florentine Art, and Renaissance Historiography* (Athens, Ohio: Ohio University Press, 1977), chapter 4. On David, see Bennett and Wilkins, *Donatello,* pp. 32, 218, Camille Paglia, *Sexual Personae: Art and Decadence from Nefertiti to Emily Dickinson* (New York: Vintage Books, 1990), chapter 5, and Janson, *The Sculpture of Donatello,* p. 85.

55. See Paglia, *Sexual Personae,* chapter 5, for a discussion of the homosexual elements in the art of the Florentine Renaissance. On the use of "Florenzer," see Georges Duby, Dominique Barthélemy, and Charles de La Roncière, "Portraits," in Georges Duby, ed., *A History of Private Life,* vol. 2: *Revelations of the Medieval World* (Cambridge, Mass.: Belknap Press of Harvard University Press, 1988), p. 296.

56. The quotation from Rucellai is cited in Brucker, *Renaissance Florence,* pp. 125–126. On Rucellai's collection, see Niels von Holst, *Creators, Collectors, and Connoisseurs: The Anatomy of Artistic Taste from Antiquity to*

the Present Day (New York: G.P. Putnam's Sons, 1967), p. 61, and Baxandall, *Painting and Experience in Fifteenth-Century Italy,* p. 2.

57. See, for instance, Andres, Hunisak, and Turner, *The Art of Florence,* vol. 2, chapter 7, and Melissa Meriam Bullard, *Filippo Strozzi and the Medici: Favor and Finance in Sixteenth-Century Florence and Rome* (Cambridge: Cambridge University Press, 1980), pp. 13–17.

58. On the decline of the Florentine republic and political developments in sixteenth-century Florence, see Andres, Hunisak, Turner, *The Art of Florence,* vol. 2, chapter 7, and Martines, *Power and Imagination,* chapter 14. On the Florentine acceptance of Medici rule as a buffer against Spanish occupation, see R. Burr Litchfield, *The Emergence of a Bureaucracy: The Florentine Patricians, 1530–1790* (Princeton: Princeton University Press, 1986), p. 26.

59. On the regime of Cosimo I, see Kempers, *Painting, Power, and Patronage,* pp. 275–286.

60. On the court painting tradition, see Kempers, *Painting, Power, and Patronage,* pp. 269–270, and p. 286 on Florentine stagnation more generally. On the centralization of the late Medici bureaucracy, see Litchfield, *The Emergence of a Bureaucracy.* On the centralization of taste, see Francis Haskell, *Patrons and Painters: A Study in the Relations Between Italian Art and Society in the Age of the Baroque* (New Haven: Yale University Press, 1980), p. 3. On the role of Rome in drying up the Florentine local artisan tradition, see Goldthwaite, *Wealth and the Demand for Art in Italy,* p. 42.

61. On Michelangelo, see Linda Murray, *Michelangelo: His Life, Work, and Times* (London: Thames and Hudson, 1984), p. 166. On the Veronese episode, see Chastel, *A Chronicle of Italian Renaissance Painting,* chapter 10.

62. On seventeenth- and eighteenth-century Italian art, see Rudolf Wittkower, *Art and Architecture in Italy, 1600–1750* (London: Penguin Books, 1982). On the international nature of the seventeenth-century art market, see Jonathan Brown, *Kings and Connoisseurs: Collecting Art in Seventeenth-Century Europe* (Princeton: Princeton University Press, 1995).

63. See Craig Harbison, *Jan van Eyck: The Play of Realism* (London: Reaktion Books, 1991), chapters 3, 12, and Diane Wolfthal, *The Beginnings of Netherlandish Canvas Painting, 1400–1530* (Cambridge: Cambridge University Press, 1989), p. 19. On the fragmentary nature of the available evidence, see Lorne Campbell, "The Art Market in the Southern Netherlands in the Fifteenth Century," *Burlington Magazine* (1976): 188–198.

64. On early Dutch urbanization, see Herbert I. Bloom, *The Economic Activities of the Jews of Amsterdam in the Seventeenth and Eighteenth Centuries* (Port Washington, N.Y.: Kennikat Press, 1969), p. xiv.

65. The Descartes quotation is from Charles L. Mee, *Rembrandt's Portrait: A Biography* (New York: Simon and Schuster, 1988), p. 44; the book also provides a useful survey of the Dutch Golden Age. The most comprehensive history of the Netherlands is Jonathan Israel's *The Dutch Republic: Its Rise, Greatness, and Fall, 1477–1806* (Chicago: University of Chicago Press, 1995).

66. On Dutch capitalism, see, for instance, Violet Barbour, *Capitalism in Amsterdam in the 17th Century* (Ann Arbor: University of Michigan Press, 1976), and especially Leonard M. Dudley, *The Word and the Sword: How Techniques of Information and Violence Have Shaped Our World* (Cambridge, Mass.: Blackwell Publishers, 1991), chapter 5.

67. See Israel, *The Dutch Republic,* chapter 23 and p. 555, Taylor, *The Taste of Angels,* p. 254, and John Michael Montias, *Artists and Artisans in Delft* (Princeton: Princeton University Press, 1982), p. 220. Especially useful on general economic matters is John Michael Montias, "Socio-Economic Aspects of Netherlandish Art from the Fifteenth to the Seventeenth Century: A Survey," *Art Bulletin,* 72 (1990): 358–373.

68. On Rembrandt's collecting, see Taylor, *The Taste of Angels,* chapter 11.

69. On how the economics of the Dutch market influenced the content of pictures, see J. L. Price, *Culture and Society in the Dutch Republic During the 17th Century* (New York: Charles Scribner's Sons, 1974), chapter 6.

70. See Svetlana Alpers, *Rembrandt's Enterprise: The Studio and the Market* (Chicago: University of Chicago Press, 1988), p. 91; on the sketch, see Mee, *Rembrandt's Portrait,* p. 215. On the diversity of Rembrandt's customers, see Gary Schwartz, *Rembrandt: His Life, His Paintings* (London: Penguin Books, 1985).

71. On the degree of specialization, see Israel, *The Dutch Republic,* p. 556, and on Vermeer, see pp. 881–884.

72. See Israel, *The Dutch Republic,* chapter 33, especially pp. 881–884.

73. See Israel, *The Dutch Republic,* chapters 37, 39, and p. 1051 for the quotation. Frans Grijzenhout, "A Myth of Decline," in Margaret C. Jacob and Wijnand W. Mijnhardt, eds., *The Dutch Republic in the Eighteenth Century* (Ithaca, N.Y.: Cornell University Press, 1992), pp. 324–337, questions how much the quality of Dutch art declined in the eighteenth century.

74. On the link between the postmodern and rococo, see William Park, *The Idea of Rococo* (Newark, Del.: University of Delaware Press, 1992).

75. See Fiske Kimball, *The Creation of the Rococo* (New York: W.W. Norton, 1943), Park, *The Idea of Rococo,* and Rémy G. Saisselin, *The Enlightenment Against the Baroque: Economics and Aesthetics in the Eighteenth Century* (Berkeley: University of California Press, 1992) on conflicting market and governmental forces behind baroque and rococo art.

76. For an overview of this system, see Patricia Mainardi, *The End of the Salon* (New York: Cambridge University Press, 1993), and Roger L. Williams, *The World of Napoleon III, 1851–1870* (New York: Free Press, 1957), chapter 9. On the office of the Superintendant, see Elizabeth Gilmore Holt, "Introduction," in *The Art of All Nations, 1850–1873: The Emerging Role of Exhibitions and Critics* (Princeton: Princeton University Press, 1981), p. xxvi. On the history of the French art Academy, see Nikolaus Pevsner, *Academies of Art Past and Present* (Cambridge: The University Press, 1940).

77. On Fragonard, see Thomas Gaehtgens, "The Tradition of Antiacademism in Eighteenth-Century French Art," in June Hargrove, ed., *The French Academy: Classicism and its Antagonists* (Newark, Del.: University of Delaware Press, 1990), pp. 206–218, especially pp. 210–211, and Dore Ashton, *Fragonard in the Universe of Painting* (Washington, D.C.: Smithsonian Institution Press, 1988), pp. 103–104, 225. On Greuze's fight against the Academy, see Anita Brookner, *Greuze: The Rise and Fall of an Eighteenth-Century Phenomenon* (Greenwich, Conn.: New York Graphic Society, 1972), p. 72.

78. On the commercial and popular culture roots of the Barbizon School, see Steven Adams, *The Barbizon School and the Origins of Impressionism* (Hong Kong: Phaidon Press, 1994). On the attitude of the Academy towards the Barbizon School, see Ralph E. Shikes and Paula Harper, *Pissarro: His Life and Work* (New York: Horizon Press, 1980), p. 39.

79. On the Academy's partial loss of control, see Holt, "Introduction," in *the Emerging Role of Exhibitions and Critics,* p. xxv-xxvi. On Courbet, see Sarah Faunce and Linda Nochlin, *Courbet Reconsidered* (New Haven: Yale University Press, 1988), p. 12, and Jacques Letheve, *Daily Life of French Artists in the Nineteenth Century* (New York: Praeger, 1972), p. 125.

80. On Daumier, see Ralph E. Shikes, *The Indignant Eye: The Artist as Social Critic in Prints and Drawings from the Fifteenth Century to Picasso* (Boston: Beacon Press, 1976), pp. 157–178; Shikes also treats the link between printmaking the artist's growing role as social critic.

81. See Gustave Courbet, *Letters of Gustave Courbet,* edited and translated by Petra ten-Doesschate Chu (Chicago: University of Chicago Press,

1992), p. 70. On the nineteenth-century world of French painting before the impressionist breakthrough, see Letheve, *The Daily Life of French Artists in the Nineteenth Century,* and John Milner, *The Studios of Paris: The Capital of Art in the Late Nineteenth Century* (New Haven: Yale University Press, 1988). On the importance of the Salon, see F. W. J. Hemmings, *Culture and Society in France, 1848–1898: Dissidents and Philistines* (London: B.T Batsford, 1971), pp. 90–91.

82. On the Salon rejections of the French impressionists and post-impressionists, see Harrison C. White and Cynthia C. White, *Canvases and Careers: Institutional Change in the French Painting World* (Chicago: University of Chicago Press, 1993), pp. 53, 142–143.

83. See Paul Gauguin, *The Writings of a Savage,* edited by Daniel Guérin (New York: Viking, 1978), pp. 29, 32. Note that Gauguin intended to refer to Theodore Rousseau, not Henri Rousseau.

84. On the failures and subsequent successes of these exhibitions, see Roy McMullen, *Degas: His Life, Times, and Work* (Boston: Houghton Mifflin, 1984), pp. 243–259, 322–342, and Charles Moffett, *The New Painting, Impressionism, 1874–1886* (Seattle: University of Washington Press, 1986). On the role of the depression, see Shikes and Harper, *Pissarro,* pp. 112–113, 135–136, 154, and John Rewald, *Studies in Impressionism* (New York: Harry N. Abrams, 1985), pp. 203–208.

85. On the changing French art market, see White and White, *Canvases and Careers,* chapter 4, Anne Higonnet, *Berthe Morisot* (New York: Harper & Row, 1990), pp. 87–88, 180–181, and Virginia Spate, *Claude Monet: Life and Work* (New York: Rizzoli, 1992). On the break in the 1880s, see McMullen, *Degas,* p. 379. On Durand-Ruel's exhibitions, see Shikes and Harper, *Pissarro,* pp. 184, 213, 258–259. On the sale of Cezanne in America, see John Rewald, *Cezanne and America: Dealers, Collectors, Artists and Critics, 1891–1921* (Princeton: Princeton University Press, 1989).

86. On the Durand-Ruels, see, for instance, Pierre Cabanne, *The Great Collectors* (New York: Farrar, Straus, 1963), pp. 63–82, Higonnet, *Berthe Morisot,* pp. 87–88, 162, 180, and Albert Boime, "Entrepreneurial Patronage in Nineteenth-Century France," in Edward C. Carter II, Robert Forster, and Joseph N. Moody, eds., *Enterprise and Entrepreneurs in Nineteenth-and Twentieth-Century France* (Baltimore: Johns Hopkins University Press, 1976). On Monet's income, see Spate, *Claude Monet,* pp. 79, 100–101, chapter 4, p. 201.

87. On other art dealers, see Shikes and Harper, *Pissarro,* pp. 118–119, 135–136, 149, 273, Sylvie Patin, "The Collectors of Cezanne's Early Works," in *Cezanne: The Early Years, 1859–1872,* Lawrence Gowing,

ed., (New York: Harry N. Abrams, 1988), pp. 54–65, Rewald, *Studies in Post-Impressionism,* pp. 7–115, Spate, *Claude Monet,* pp. 100–101, chapter 4, p. 201, and Cabanne, *The Great Collectors,* pp. 45–122. The best overall survey is Anne Distel, *Impressionism: The First Collectors* (New York: Harry N. Abrams, 1990). On the importance of business-men as buyers of innovative nineteenth-century French art, see Boime, "Entrepreneurial Patronage in Nineteenth-Century France." On the sales of Cezanne's works to wealthy businessmen in America, see Rewald, *Cezanne and America.* On the purchases of department store owners, see Eugen Weber, *France: Fin de Siècle* (Cambridge, Mass.: Harvard University Press, 1986), p. 158.

88. On Delacroix and Courbet, see Alan Bowness, *The Conditions of Success: How the Modern Artist Rises to Fame* (London: Thames and Hudson, 1989), p. 60; on Corot, see Robert L. Herbert, *Barbizon Revisited* (New York: Clarke & Way, 1962), p. 84, and Madeleine Hours, *Corot* (New York: Harry N. Abrams, 1981), pp. 11, 30; on Degas's sustenance, see McMullen, *Degas,* pp. 242, 249, 260, 373; on Seurat's family wealth, see Shikes and Harper, *Pissarro,* p. 209; on Cezanne, see Rewald, *Studies in Impressionism,* p. 99 and White and White, *Canvases and Careers,* p. 129; on Manet, see Hemmings, *Culture and Society in France,* p. 162; on Toulouse-Lautrec, see Riva Castleman and Wolfgang Wittrock, eds., *Henri de Toulouse-Lautrec: Images of the 1890s* (New York: Museum of Modern Art, 1985), pp. 21, 45, and on Moreau, see Rewald, *Studies in Post-Impressionism,* p. 256. On Monet's father and his funds, see Letheve, *The Daily Life of French Artists in the Nineteenth Century,* p. 154. On Renoir, see Alan Williams, *Republic of Images: History of French Filmmaking* (Cambridge, Mass.: Harvard University Press, 1992), p. 136.

89. On the market for public entertainment, see Charles Rearick, *Pleasures of the Belle Epoque: Entertainment and Festivity in Turn-of-the-Century France* (New Haven: Yale University Press, 1985). On the growing cult of consumption in late nineteenth-century France, see Rosalind H. Williams, *Dream Worlds: Mass Consumption in Late Nineteenth-Century France* (Berkeley: University of California Press, 1982).

90. On picture hanging, see Patricia Mainardi, *The End of the Salon* (New York: Cambridge University Press, 1993), pp. 109–110.

91. On materials, see White and White, *Canvases and Careers,* p. 83, Maurice Grosser, *The Painter's Eye* (New York: Mentor Books, 1955), Letheve, *Daily Life of French Artists in the Nineteenth Century,* p. 149, and Higonnet, *Berthe Morisot,* p. 14. The most complete work on the new technologies of paint is David Bomford, Jo Kirby, John Leighton, and Ashok Roy, *Art in the Making: Impressionism* (New Haven: Yale

University Press, 1990), pp. 21–26, 30, 34–37, 39–41, 51–52, 55–56. The Renoir quotation is from p. 41.

92. On the breakdown of the Salon, see Mainardi, *The End of the Salon*. On the blossoming of art advertising in Paris in the early twentieth century, see Grosser, *The Painter's Eye,* pp. 157–158.

93. See Pierre Assouline, *An Artful Life: A Biography of D. H. Kahnweiler, 1884–1979* (New York: Grove Weidenfeld, 1990), frontispiece, pp. 100–101 passim.

94. See Michael C. Fitzgerald, *Making Modernism: Picasso and the Creation of the Market for Twentieth-Century Art* (New York: Farrar, Straus and Giroux, 1995).

95. On the fate of Russian constructivism, see Richard Grenier, *Capturing the Culture: Film, Art, and Politics* (Washington, D.C.: Ethics and Public Policy Center, 1991), pp. 291–294, Brandon Taylor, *Art and Literature under the Bolsheviks* (London: Pluto Press, 1991), Christopher Read, *Culture and Power in Revolutionary Russia* (New York: St. Martin's Press, 1990), and Sheila Fitzpatrick, *The Cultural Front: Power and Culture in Revolutionary Russia* (Ithaca, N.Y.: Cornell University Press, 1992).

96. On the Armory show, and the influence of Europe on the early American avant-garde, see Abraham A. Davidson, *Early American Modernist Painting, 1910–1935* (New York: Harper & Row, 1981).

97. On the changing market for abstract expressionism, see Deirdre Robson, "The Market for Abstract Expressionism: The Time Lag Between Critical and Commercial Acceptance," *Archives of American Art Journal,* 30 (1990): 113–118. On magazines and abstract expressionism, see David and Cecile Shapiro, *Abstract Expressionism: A Critical Record* (Cambridge: Cambridge University Press, 1990), p. 21.

98. On the commercial backgrounds of pop artists, see Bevis Hillier, *The Style of the Century, 1900–1980* (New York: E.P. Dutton, 1983), p. 185, and Christin J. Mamiya, *Pop Art and Consumer Culture: American Super Market* (Austin, Tex.: University of Texas Press, 1992), pp. 137–139. On the role of commercial art in supporting culture, see Michele H. Bogart, *Artists, Advertising, and the Borders of Art* (New Haven: Yale University Press, 1986).

99. See Andy Warhol, *The Philosophy of Andy Warhol (From A to B and Back Again)* (New York: Harcourt, Brace, Jovanovich, 1975), p. 78.

100. On intermediaries and the collective production of the final product, see Howard S. Becker, *Art Worlds* (Berkeley: University of California Press, 1982).

101. See Thomas R. H. Havens, *Artist and Patron in Postwar Japan: Dance, Music, Theater, and the Visual Arts, 1955–1980* (Princeton: Princeton

University Press, 1982), p. 141, Watson, *From Manet to Manhattan,* p. 393, and John Dornberg, "A King-size Bed and a Baselitz," *ARTnews,* April 1996, p. 45.

102. For documentation of the importance of changes in birth control technologies and training opportunities, see Tyler Cowen, "Why Women Succeed, and Fail, in the Arts," *Journal of Cultural Economics,* 20 (1996): 93–113.

103. On Jasper Johns, see Mamiya, *Pop Art and Consumer Culture,* p. 13.

104. See Watson, *From Manet to Manhattan,* p. 480.

105. Walter Benjamin, "The Work of Art in the Age of Mechanical Reproduction," in *Illuminations,* edited by Hannah Arendt (New York: Schocken Books, 1968), pp. 217–252.

4. From Bach to the Beatles

1. See Robert H. Frank and Philip J. Cook, *The Winner-Take-All Society: How More and More Americans Compete for Ever Fewer and Bigger Prizes, Encouraging Economic Waste, Income Inequality, and an Impoverished Cultural Life* (New York: Free Press, 1995) and Sherwin Rosen, "The Economics of Superstars," *American Economic Review,* 71 (1981): 845–858.

2. On the role of notation in Western music, see Michael Chanan, *Musica Practica: The Social Practice of Western Music from Gregorian Chant to Postmodernism* (New York: Verso Books, 1994), chapters 3 and 5.

3. On Monteverdi's history at Mantua and poverty, see Henry Raynor, *A Social History of Music: From the Middle Ages to Beethoven* (New York: Taplinger Publishing Company, 1978), pp. 93–96, Leo Schrade, *Monteverdi: Creator of Modern Music* (London: Victor Gollancz, 1964), p. 248, and Hans Ferdinand Redlich, *Claudio Monteverdi* (London: Oxford University Press, 1952), pp. 21–23.

4. On the higher pay available in Italy, see Louis Cuyler, *The Emperor Maximilian I and Music* (London: Oxford University Press, 1973), p. 42. On the origins of musical commercialization, see Chanan, *Musica Practica,* chapter 5.

5. On the artistic benefits of political decentralization, see David Hume, *Essays Moral, Political, and Literary* (Indianapolis: Liberty Press Classics, 1985 [1777]), pp. 119–120. For a more modern discussion, see Andre Chastel, *The Golden Age of the Renaissance: Italy 1460–1500* (London: Thames and Hudson, 1966), p. 8. Dean Keith Simonton, *Genius, Creativity, and Leadership: Historiometric Inquiries* (Cambridge, Mass.: Harvard University Press, 1984), offers statistical evidence that political

decentralization favors artistic innovation. On the German tradition of musical decentralization, see Giorgio Pestelli, *The Age of Mozart and Beethoven* (Cambridge: Cambridge University Press, 1984), p. 4. See also the remarks of Eberhard Preussner, *Die bürgerliche Musikkultur* (Kassel and Basel: Bärenreiter, 1950), p. 74.

6. On Arnstadt and Mühlhausen, see Karl Geiringer, *Johann Sebastian Bach: The Culmination of an Era,* written in collaboration with Irene Geiringer (New York: Oxford University Press, 1966), chapter 2. On the move to Weimar, see chapter 3. On Cöthen and Leipzig, see chapters 4, 5, and 6, and Otto L. Bettmann, *Johann Sebastian Bach: As His World Knew Him* (New York: Birch Lane Press, 1995), pp. 121–126. On the moves of other German musicians of the time, see, for instance, Richard Petzoldt, *Georg Philipp Telemann* (London: Ernest Benn, 1974). On Bach's pay raises, see Bettmann, *Johann Sebastian Bach,* pp. xxiv, 131.

7. On German economic growth and the rise of a bourgeois middle class, see Leo Balet, *Die Verbürgerlichung der deutschen Kunst, Literatur und Musik im 18. Jahrhundert* (Leipzig-Strassburg-Zürich: Heitz, 1936), pp. 18–19, and Eberhard Rebling, *Die Sociologischen Grundlagen der Stilwandlung der Musik in Deutschland um die Mitte des 18. Jahrhunderts* (Saalfeld: Günthers Buchdrückerei, 1935). The best overall survey of the rise of the concert is Preussner, *Die bürgerliche Musikkultur,* chapter 1; see also William Weber, *Music and the Middle Class: The Social Structure of Concert Life in London, Paris, and Vienna* (New York: Holmes & Meier Publishers, 1975) and Chanan, *Musica Practica,* chapter 5. On the Lübeck concerts, see Howard E. Smither, *A History of the Oratorio: The Oratorio in the Baroque Era, Protestant Germany and England* (Chapel Hill: University of North Carolina Press, 1977), vol. 2, chapter 3; Keral J. Snyder, *Dietrich Buxtehude: Organist in Lübeck* (New York: Schirmer Books, 1987), pp. 56–58, and Preussner, *Die bürgerliche Musikkultur,* pp. 11–12.

8. On Bach and the Collegium, see Bettmann, *Johann Sebastian Bach,* pp. xxi, 39, and Christoph Wolff, *Bach: Essays on His Life and Music* (Cambridge, Mass.: Harvard University Press, 1991), pp. 30–31, 227.

9. On Bach's Latin class, see Bettmann, *Johann Sebastian Bach,* p. 56; on Bach and money matters, see pp. 131–133.

10. See Petzoldt, *Georg Philip Telemann.*

11. See, for instance, Percy M. Young, *A History of English Music* (London: Ernest Benn Limited, 1967), chapter 12.

12. Cited in Joseph McLellan, "*Messiah* According to Norrington: The Conductor's Views on the Handel Muse," *Washington Post,* December 2, 1992, p. C2.

13. On the capitalist nature of Italian opera, see John Rosselli, *The Opera Industry in Italy from Cimarosa to Verdi: The Role of the Impresario* (Cambridge: Cambridge University Press, 1984), Ellen Rosand, *Opera in Seventeenth-Century Venice* (Berkeley: University of California Press, 1991), and Simon Towneley Worsthorne, *Venetian Opera in the Seventeenth Century* (Oxford: Clarendon Press, 1968).

14. See Robert M. Isherwood, *Music in Service of the King: France in the Seventeenth Century* (Ithaca, N.Y.: Cornell University Press, 1973), pp. 73–75, Frances A. Yates, *The French Academies of the Sixteenth Century* (Nendeln, Lichtenstein: Kraus Reprint, 1973 [1947]), and Lorenzo Bianconi, *Music in the Seventeenth Century* (New York: Cambridge University Press, 1987), p. 152.

15. On the early history of music publishing, see D. W. Krummel, "Music Publishing," in D. W. Krummel and Stanley Sadie, eds., *Music Printing and Publishing* (New York: W.W. Norton, 1990), pp. 79–132, especially p. 95. On commissioning new works in lieu of reproducing old ones, see Adam Carse, *The Orchestra in the XVIIIth Century* (New York: Broude Brothers Limited, 1969), p. 7. See also Chanan, *Musica Practica,* chapter 5.

16. See Arthur Loesser, *Men, Women, and Pianos* (New York: Simon and Schuster, 1954), pp. 67–68, Krummel, "Music Publishing," chapter 8, and William Weber, "Mass Culture and the Reshaping of European Musical Taste, 1770–1870," *International Review of the Aesthetics and Sociology of Music,* 8 (1977): 5–22.

17. On the sale of Telemann's compositions, see Petzoldt, *Georg Philip Telemann,* pp. 60, 94–106.

18. On piano orders, see Loesser, *Men, Women, and Pianos,* p. 57. On the piano saying, see Preussner, *Die bürgerliche Musikkultur,* p. 197. On piano orders in Austria, see John Reed, *The Master Musicians: Schubert* (London: J.M. Dent and Sons, 1987), p. 18.

19. On the German Hausmusik tradition, see Carl Ferdinand Becker, *Die Hausmusik in Deutschland in dem 16., 17. und 18. Jahrhunderte* (Leipzig: Fest'sche Verlagsbuchhandlung, 1840), Walter Salmen, "Haus- und Kammermusik: Privates Musizieren im gesellschaftlichen Wandel zwischen 1600–1900," in Heinrich Besseler and Werner Bachmann, eds., *Musikgeschichte in Bildern,* in the series Musik der Neuzeit, vol. IV/3 (Leipzig: VEB Deutscher Verlag für Musik, 1982). See also August Reißman, *Die Hausmusik* (Berlin: Verlag von Robert Oppenheim, 1884), W. H. Riehl, *Die Familie* (Stuttgart and Berlin, 1925 [1855]), pp. 195–196, and Alfred Szendrei, *Rundfunk und Musikpflege* (Leipzig: Kistner and Siegel, 1931), p. 66. On German family structure, see Heidi

Rosenbaum, *Formen der Familie: Untersuchungen zum Zusammenhang von Familienverhältnissen, Sozialstruktur und sozialem Wandel in der deutschen Gesellschaft des 19. Jahrhunderts* (Frankfurt: Suhrkamp Taschenbuch, 1982), pp. 301–314, Ingeborg Weber-Kellermann, *Die deutsche Familie: Versuch einer Sozialgeschichte* (Frankfurt: Suhrkamp, 1974), and Helmut Möller, *Die kleinbürgerliche Familie im 18. Jahrhundert* (Berlin: Walter Gruyter, 1969). On the German house as a medium for passing down family traditions and culture, see Karl- S. Kramer, "Das Haus als geistiges Kraftfeld im Gefüge der alten Volkskultur," in *Rhein.- Westfällische Zeitschrift für Volkskunde,* 11 (1964): 30–43. On German amateur musical associations, see Preussner, *Die bürgerliche Musikkultur,* pp. 36–37. For an extensive bibliography on relevant sociological and economic aspects of music, see Ivo Supicic, *Music in Society: A Guide to the Sociology of Music* (Stuyvesant, N.Y.: Pendragon Press, 1987), pp. 363–476.

20. On the restrictions placed on Haydn, see H. C. Robbins Landon, *The Mozart Compendium: A Guide to Mozart's Life and Music* (New York: Schirmer Books, 1990), pp. 68–69. On the kept status of other musicians during this time, see Andrew Steptoe, *The Mozart–Da Ponte Operas* (Oxford: Clarendon Press, 1988), pp. 33–34. On the influence of patronage, see H. C. Robbins Landon and David Wyn Jones, *Haydn: His Life and Music* (Bloomington: Indiana University Press, 1988), p. 108. On the quintets anecdote, see Eduard Hanslick, *Geschichte des Konzertwesens in Wien* (Vienna: Wilhelm Braumüller, 1869), p. 40. On the baryton, see Landon and Jones, *Haydn,* p. 169; on the change in Haydn's contract, see p. 183; on Haydn's trips to London, see chapter 7 of this same work. For the comparison of Haydn's London income with that of a modern-day millionaire, see William J. Baumol and Hilda Baumol, "On the Economics of Musical Composition in Mozart's Vienna," *Journal of Cultural Economics,* 18 (1994): 171–198. On the last episode cited, see Landon and Jones, *Haydn,* p. 298.

21. On sources of financial support for Austrian music, see Adam Carse, *The Orchestra from Beethoven to Berlioz* (Cambridge: W. Heffer & Sons, 1948), p. 251, and Baumol and Baumol, "On the Economics of Musical Composition in Mozart's Vienna." On the Viennese house music tradition, see Marcel Brion, *Daily Life in the Vienna of Mozart and Schubert* (London: Weidenfeld and Nicolson, 1961), chapter 3. On the Viennese salon tradition, see Volkmar Braunbehrens, *Mozart in Vienna* (Oxford: Oxford University Press, 1991), pp. 146–147, 159, and Alice M. Hanson, *Musical Life in Biedermeier Vienna* (Cambridge: Cambridge University Press, 1985), chapter 5. See also Hanslick, *Geschichte des Konzertwesens in*

Wien, pp. 66–67, and Hector Berlioz, *The Memoirs of Hector Berlioz* (London: Granada Publishing, 1970 [1865]), p. 453. On the role of Viennese wealth, see the words of Johann Reichardt, reproduced in H. C. Robbins Landon, ed., *Beethoven: His Life, Work and World* (New York: Thames and Hudson, 1992), p. 51, and Baumol and Baumol, "On the Economics of Musical Composition in Mozart's Vienna." On the economic growth of the Habsburg empire more generally, see David F. Good, *The Economic Rise of the Habsburg Empire, 1750–1914* (Berkeley: University of California Press, 1978). On the Austrian church tradition more generally, see Bruce C. MacIntyre, *The Vienna Concerted Mass of the Early Classic Period* (Ann Arbor: University of Michigan Press).

22. See Steptoe, *The Mozart–Da Ponte Operas,* pp. 55–67, Andrew Steptoe, "Mozart and Poverty: An Examination of the Evidence," *Musical Times* (1984): 196–201, and Baumol and Baumol, "On the Economics of Musical Composition in Mozart's Vienna." See also Landon, *The Mozart Compendium,* pp. 96–98, 128–129, and Georg Knepler, *Wolfgang Amadé Mozart* (Cambridge: Cambridge University Press, 1994), pp. 288–289. On Mozart's pending invitations, see Braunbehrens, *Mozart in Vienna,* p. 141. On Mozart's European reputation, see Landon, *The Mozart Compendium,* pp. 184, 187. On burial practices, see Braunbehrens, *Mozart in Vienna,* pp. 413–424.

23. On Mozart's slowness to publish, see Landon, *The Mozart Compendium,* pp. 186–187; on music copying in Vienna, see pp. 176–178. On Vienna's rise as a music publishing center, see Hannelore Gericke, *Der Wiener Musikalienhandel von 1700 bis 1778* (Graz-Cologne: Hermann Böhlaus, 1960), and D. W. Krummel, "Music Publishing," in Krummel and Sadie, *Music Printing and Publishing,* p. 106.

24. On Mozart's earnings for his quartets and operas, see Steptoe, "Mozart and Poverty," p. 197. On the growing market for sheet music, see Giorgio Pestelli, *The Age of Mozart and Beethoven* (Cambridge: Cambridge University Press, 1984), pp. 170–171.

25. On the growth of commissions, see Petzoldt, *George Philipp Telemann,* p. 139.

26. On copyright, see Steptoe, *The Mozart–Da Ponte Operas,* p. 41. For a general history, see Hansjörg Pohlmann, *Die Frühgeschichte des musilakischen Urheberrechts* (Kassel: Bärenreiter-Verlag, 1962).

27. Bettmann, *Johann Sebastian Bach,* p. 69.

28. On Beethoven's concert activities, see Maynard Solomon, *Beethoven* (New York: Schirmer Books, 1977). On his Vienna reputation, see Tia DeNora, *Beethoven and the Construction of Genius: Musical Politics in Vienna, 1792–1803* (Berkeley: University of California Press, 1995).

29. See Barry Cooper, ed., *The Beethoven Compendium: A Guide to Beethoven's Life and Music* (London: Thames and Hudson, 1991), pp. 65–70, 110, 121.

30. Beethoven's quotation is cited in Alexander Thayer's *Life of Beethoven* (Princeton: Princeton University Press, 1967), p. 283. The letter is from June 29, 1801.

31. On the growing market for sheet music, see William Weber, "Mass Culture and the Reshaping of European Musical Taste, 1770–1870," *International Review of the Aesthetics and Sociology of Music,* 8 (1977): 5–22, especially p. 10.

32. On Beethoven's later financial difficulties and the Austrian hyperinflation, see Julia V. Moore, *Beethoven and Musical Economics* (Ann Arbor: University Microfilms, 1987); on Beethoven's estate, see vol. 2, pp. 398, 513.

33. See Lydia Goehr, *The Imaginary Museum of Musical Works: An Essay in the Philosophy of Music* (Oxford: Clarendon Press, 1992), p. 246.

34. On the warnings from publishers, see Hanson, *Musical Life in Biedermeier Vienna,* p. 119.

35. See Willi Reich, *Schoenberg: A Critical Biography* (New York: Praeger Publishers, 1971), pp. 5–12, 92, 117, 119–121 passim.

36. David Revill, *The Roaring Silence: John Cage, A Life* (New York: Arcade Publishing, 1992), p. 13.

37. On early recordings, see Robert and Celia Dearling, with Brian Rust, *The Guinness Book of Recorded Sound* (London: Guinness Books, 1984), pp. 21, 28–29, Roland Gelatt, *The Fabulous Phonograph: The Story of the Gramophone from Tin Foil to High Fidelity* (London: Cassell & Company, 1956), and Andre Millard, *America on Record: A History of Recorded Sound* (Cambridge: Cambridge University Press, 1995). For data on records sold, see Russell Sanjek, *From Print to Plastic: Publishing and Promoting America's Popular Music (1900–1980)* (Brooklyn: Institute for Studies in American Music, 1983), p. 8.

38. Group members favored artistic purity and were opposed to the use of backing tapes to make the song come off; see Jimmy Guterman and Owen O'Donnell, *The Worst Rock-and-Roll Records of All Time* (New York: Citadel Press, 1991), p. 197.

39. Russell Miller and Roger Boar, *The Incredible Music Machine* (London: Quartet Books Limited, 1982), p. 262.

40. On the Beach Boys, see Arnold Shaw, *The Rock Revolution* (New York: Crowell-Collier Press, 1969), pp. 8, 148. On the history of recording and the studio, see Michael Chanan, *Repeated Takes: A Short History of Recording and Its Effects on Music* (London: Verso Books, 1994) and Mark

Cunningham, *Good Vibrations: A History of Record Production* (Chessington: Castle Communications, 1996). On the prolific nature of J. S. Bach, see R. Ochse, *Before the Gates of Excellence: The Determinants of Creative Genius* (Cambridge: Cambridge University Press, 1990), p. 99, and Bettmann, *Johann Sebastian Bach,* p. 80.

41. On the spread of musical style through the phonograph, see Miller and Boar, *The Incredible Music Machine,* p. 127, and S. Frederick Starr, *Red and Hot: The Fate of Jazz in the Soviet Union* (New York: Oxford University Press, 1983), pp. 14–15.

42. See, for instance, James H. Johnson, *Listening in Paris: A Cultural History* (Berkeley: University of California Press, 1995).

43. On Bach, see Howard Mayer Brown, "Pedantry or Liberation? A Sketch of the Historical Performance Movement," in Nicholas Kenyon, ed., *Authenticity and Early Music* (Oxford: Oxford University Press, 1988), pp. 27–56, especially p. 34. On Brahms, see Harry Haskell, *The Early Music Revival: A History* (New York: Thames and Hudson, 1988), p. 23. On Haydn, see Landon and Jones, *Haydn: His Life and Music,* p. 12.

44. For biographical and discographical information on these composers, and many others, I recommend Brian Morton, *The Blackwell Guide to Recorded Contemporary Music* (Oxford: Blackwell Publishers, 1996). The music periodical *Fanfare* also is a good source of information and recommendations.

45. The figure of 90 percent is taken from George Steiner, *Real Presences* (Chicago: University of Chicago Press, 1989), p. 66.

46. On the economic effects of greater reproducibility, see Sherwin Rosen, "The Economics of Superstars," *American Economic Review,* 71 (1981): 845–858.

47. The best introductions to the African roots of African-American music are Paul Oliver, *Savannah Syncopations: African Retentions in the Blues* (New York: Stein and Day, 1970), Tilford Brooks, *America's Black Musical Heritage* (Englewood Cliffs, N.J.: Prentice-Hall, 1984), and John Storm Roberts, *Black Music of Two Worlds* (London: Allen Lane, 1973). See also Samuel A. Floyd Jr., *The Power of Black Music: Interpreting its History from Africa to the United States* (Oxford: Oxford University Press, 1995).

48. On the views of Dvořák, see John Rublowsky, *Black Music in America* (New York: Crowell-Collier Press, 1967), p. 118, and John Clapham, *Dvorak* (London: David and Charles, 1979), pp. 197–203.

49. For a general history of the Delta region, see Robert L. Brandfon, *Cotton Kingdom of the New South: A History of the Yazoo Mississippi Delta*

from Reconstruction to the Twentieth Century (Cambridge, Mass.: Harvard University Press, 1967), James C. Cobb, *The Most Southern Place on Earth: The Mississippi Delta and the Roots of Regional Identity* (New York: Oxford University Press, 1992), and Alan Lomax, *The Land Where the Blues Began* (New York: Pantheon Books, 1993). On the importance of oral culture in the African-American world, see Lawrence W. Levine, *The Unpredictable Past: Explorations in American Cultural History* (New York: Oxford University Press, 1993), p. 81.

50. Cited in Lawrence W. Levine, *Black Culture and Black Consciousness: Afro-American Folk Thought from Slavery to Freedom* (New York: Oxford University Press, 1993), p. 25. Levine's transcription is "Dey make em, sah."

51. On the early commercial history of guitar sales, see Bruce Bastin, *Red River Blues: The Blues Tradition in the Southeast* (Urbana: University of Illinois Press, 1986), pp. 17–18 and Ed Ward, Geoffrey Stokes, and Ken Tucker, *Rock of Ages: The Rolling Stone History of Rock & Roll* (New York: Summit Books, 1986), p. 19. On the initial black indifference to the guitar until prices fell, see Charles K. Wolfe and Kip Lornell, *The Life and Legend of Leadbelly* (New York: Harper Collins, 1992), pp. 17–18.

52. On different waves of migration and the weakness of the Northeast in rhythm and blues, see Michael Haralambos, *Right On: From Blues to Soul in Black America* (London: Eddison Press, 1974), p. 42. See also the comments on Jerry Wexler reproduced in Arnold Shaw, *Honkers and Shouters: The Golden Years of Rhythm and Blues* (New York: Collier Books, 1978), p. 341. On different geographic blues traditions, see William Barlow, *"Looking Up At Down": The Emergence of Blues Culture* (Philadelphia: Temple University Press, 1989) and Lawrence Cohn, *Nothing But the Blues: The Music and the Musicians* (New York: Abbeville Press, 1993). On migration from Mississippi, see Samuel Charters, *The Bluesmen: The Story and the Music of the Men Who Made the Blues* (New York: Oak Publications, 1967), p. 26.

53. On Dorsey's history and activities on behalf of gospel, see Michael W. Harris, *The Rise of Gospel Blues: The Music of Thomas Andrew Dorsey in the Urban Church* (New York: Oxford University Press, 1992) and Viv Broughton, *Black Gospel: An Illustrated History of the Gospel Sound* (Poole, Dorset: Blandford Press, 1985), chapters 2 and 3. On the history of gospel more generally, see Tony Heilbut, *Gospel Sound: Good News and Bad Times* (Garden City, N.Y.: Anchor Books, 1975) and Paul Oliver, "Gospel Music," in *The New Grove Gospel, Blues and Jazz with Spirituals and Ragtime* (New York: W.W. Norton, 1986), pp. 189–222. On

Dorsey's commercialization of gospel, see Charles K. Wolfe, *Mahalia Jackson* (New York: Chelsea House Publishers, 1990), pp. 47, 57.

54. On the growing decentralization of black church groups in the 1920s and 1930s, see Hans A. Baer and Merrill Singer, *African-American Religion in the Twentieth Century: Varieties of Protest and Accommodation* (Knoxville: University of Tennessee Press, 1992), chapter 2, especially pp. 52–55. On gospel's initial foothold, see Mahalia Jackson, *Movin' On Up* (New York: Hawthorn Books, 1966), p. 66.

55. On blues and gospel, see Harris, *The Rise of Gospel Blues,* pp. 100–101. On the outcast origins of gospel music, see Broughton, *Black Gospel,* chapter 3. On opposition to Dorsey, see both Harris, pp. 3, 265, and Broughton, chapters 2 and 3. See Joseph R. Washington Jr., *Black Religion: The Negro and Christianity in the United States* (Boston: Beacon Press, 1964), pp. 51–52.

56. Marshall Winslow Stearns, *The Story of Jazz* (New York: Oxford University Press, 1956), provides a good treatment of the links to blues.

57. The best treatment of the black element in country music (and the white country influence upon black music) is Barney Hoskyns, *Say It One Time for the Broken Hearted: The Country Side of Southern Soul* (Glasgow: Fontana/Collins, 1987). See also Bill C. Malone, *Country Music, U.S.A.* (Austin: University of Texas Press, 1985), pp. 4–5.

58. For the quotation, see Robert Pattison, *The Triumph of Vulgarity: Rock Music in the Mirror of Romanticism* (New York: Oxford University Press, 1987), p. 30. On the black influence on Buddy Holly, see John Goldrosen, *The Buddy Holly Story* (New York: Quick Fox, 1979), pp. 14, 166; on Gene Vincent, see Britt Hagarty, *The Day the World Turned Blue: A Biography of Gene Vincent* (Poole: Blandford Press, 1984), p. 14. On the Jerry Lee Lewis anecdote, see Linda Martin and Kerry Segrave, *Anti-Rock: The Opposition to Rock 'n' Roll* (Hamden, Conn.: Archon Books, 1982), p. 75.

59. See Barlow, *Looking Up at Down,* pp. 233, 308, and James Rooney, *Bossmen: Bill Monroe and Muddy Waters* (New York: Dial Press, 1971), p. 112.

60. The quotation is from Colin Escott, with Martin Hawkins, *Good Rockin' Tonight: Sun Records and the Birth of Rock 'n' Roll* (New York: St. Martin's Press, 1991), p. 84. On Elvis's background, see Charlie Gillett, *The Sound of the City: The Rise of Rock 'n' Roll* (New York: Pantheon Books, 1983), p. 28 and Ward, Stokes, and Tucker, *Rock of Ages,* p. 77.

61. On the relevance of electric recording for the blues, see David Evans, *Big Road Blues: Tradition and Creativity in the Folk Blues* (Berkeley: University of California Press, 1982), p. 71. On field recordings, see

Giles Oakley, *The Devil's Music: A History of the Blues* (New York: Harcourt Brace Jovanovich, 1976), pp. 124, 133–134. See also Wolfe and Lornell, *The Life and Legend of Leadbelly,* pp. 90–91. On later field trips, see Charlie Gillett, *Making Tracks: Atlantic Records and the Growth of a Multi-Billion-Dollar Industry* (New York: E.P. Dutton, 1974), p. 47.

62. On the shellac shortage, see Martin and Segrave, *Anti-Rock: The Opposition to Rock 'n' Roll,* p. 9, and Malone, *Country Music, U.S.A.,* pp. 180–181. On the prominence of the independents in the rhythm and blues market, see Philip H. Ennis, *The Seventh Stream: The Emergence of Rocknroll in American Popular Music* (Hanover, N.H.: University Press of New England, 1992), p. 176. On the independent labels, see Arnold Shaw, *Honkers and Shouters: The Golden Years of Rhythm and Blues* (New York: Collier Books, 1978), pp. xvii–xviii, R. M. W. Dixon and J. Godrich, *Recording the Blues* (New York: Stein and Day, 1970), and Louis Cantor, *Wheelin' on Beale: How WDIA-Memphis became the nation's first All-Black radio station and created the sound that changed America* (New York: Pharos Books, 1992), p. 53.

63. On the attitudes of major record company executives, see Gillett, *The Sound of the City,* p. 41. On the shoestring nature of the early independents, see Shaw, *Honkers and Shouters,* p. xviii. On concentration among the majors, see Sanjek, *From Print to Plastic,* p. 39; later Mercury was to count as the fifth major record company. On the eroding competitive position of the major record companies, see Ronald Coase, "Payola in Radio and Television Broadcasting," *Journal of Law and Economics,* 22 (1979): 269–328, especially p. 314.

64. On the falling cost of recording, see Sanjek *From Print to Plastic,* p. 39, and Mary Alice Shaughnessy, *Les Paul: An American Original* (New York: William Morrow, 1993), p. 223.

65. On the role of radio in inducing innovation in records, see, for instance, the remarks of Joe Klein, *Woody Guthrie: A Life* (New York: Ballantine Books, 1980), p. 56, and Malone, *Country Music, U.S.A.,* p. 34.

66. On the history of the jukebox, see Dearling and Dearling, *The Guinness Book of Recorded Sound,* p. 87, Vincent Lynch and Bill Henkin, *Juke Box: The Golden Age* (Berkeley, Calif.: Lancaster-Miller, 1981), pp. 8–10, Ennis, *The Seventh Stream,* pp. 101–102, 124, and Shaw, *Honkers and Shouters,* pp. 128, 179–180, 196. On the relation between the jukebox and rhythm and blues, see Lynch and Henkin, *Juke Box,* p. 10.

67. On the history of WDIA in Memphis, see Cantor, *Wheelin' on Beale.* See also Ennis, *The Seventh Stream,* pp. 57–58, 173–174, and Gerri Hirsey, *Nowhere to Run: The Story of Soul Music* (New York: Times Books, 1984), p. 9.

68. On these developments, see Nelson George, *Where Did Our Love Go? The Rise and Fall of the Motown Sound* (New York: St. Martin's Press, 1985), pp. 113–114, and Russell Sanjek, *American Popular Music and its Business: The First Four Hundred Years,* vol. 3, *From 1900 to 1984* (New York: Oxford University Press, 1988), p. 416.

69. On BMI and the new musical world, see Arnold Shaw, *The Rockin' 50s: The Decade that Transformed the Pop Music Scene* (New York: Da Capo, 1987), p. 8, Cantor, *Wheelin' on Beale,* pp. 52–53, and Ennis, *The Seventh Stream.* On the campaign against BMI, see John Ryan, *The Production of Culture in the Music Industry: The ASCAP-BMI Controversy* (Lanham, Md.: University Press of America, 1985), pp. 83–85, and Ennis, *The Seventh Stream,* chapter 4, on the origins of BMI. On the ASCAP dispute and the initial BMI inroads, see Sanjek, *From Print to Plastic,* pp. 24–26, and Malone, *Country Music, U.S.A.,* p. 179. On the suit, see Sanjek, *From Print to Plastic,* pp. 45–47.

70. On the earlier history of payola, see Coase, "Payola in Radio and Television Broadcasting," and Sanjek, *American Popular Music and its Business,* pp. 16–17.

71. On Freed, see Howard A. DeWitt, *Chuck Berry: Rock 'n' Roll Music* (Ann Arbor, Mich.: Pierian Press, 1985), pp. 25, 82. On the role of disc jockeys in discovering talent before the payola scandals, see Shaw, *Honkers and Shouters,* pp. 465–466. On the importance of payola compensation for disk jockeys, see Nelson George, *The Death of Rhythm and Blues* (New York: Pantheon Books, 1988), p. 55.

72. On ASCAP motivations, see Sanjek, *From Print to Plastic,* p. 51. On ASCAP hostility to disk jockeys, see Ennis, *The Seventh Stream,* p. 262. On discriminatory treatment, see Sanjek, *From Print to Plastic,* p. 52 and Sanjek, *American Popular Music and its Business,* p. 448. On the Motown use of payola, see Peter Benjaminson, *The Story of Motown* (New York: Grove Press, 1979), pp. 50–51. On payola prosecutions as a weapon against black music, see George, *The Death of Rhythm and Blues,* p. 165, Cynthia Rose, *Living in America: The Soul Saga of James Brown* (London: Serpent's Tail, 1990), pp. 105–106, and Sanjek, *American Popular Music and its Business,* pp. 554, 558. On Freed and Clark, see Martin and Segrave, *Anti-Rock: The Opposition to Rock 'n' Roll,* pp. 93–96, and John A. Jackson, *Big Beat Heat: Alan Freed and the Early Years of Rock & Roll* (New York: Schirmer Books, 1991). On the assessed penalties and legal issues, see Sanjek, *From Print to Plastic,* p. 52, Sanjek, *American Popular Music and its Business,* p. 447, and Martin and Segrave, *Anti-Rock,* p. 101.

73. On Motown commercial successes on the charts, see Arnold Shaw, *Black Popular Music in America: From the Spirituals, Minstrels, and Ragtime*

to Soul, Disco, and Hip-Hop (New York: Schirmer Books, 1986), p. 227, George, *Where Did Our Love Go?*, pp. 30–32, Gillett, *The Sound of the City*, p. 213, and Don Waller, *The Motown Story* (New York: Charles Scribner's Sons, 1985), pp. 11, 44. On the size of Motown, see George, *Where Did Our Love Go?*, p. 189. On the role of Motown in breaking down segregated touring, see Dave Marsh, *Trapped: Michael Jackson and the Crossover Dream* (New York: Bantam Books, 1985), p. 65. For the Gordy quotation, see J. Randy Taraborrelli, *Motown: Hot Wax, City Cool, & Solid Gold* (Garden City, N.Y.: Doubleday, 1986), p. 36. See Waller, *The Motown Story*, p. 18 on sandwiches, p. 61 on car radio.

74. On the flourishing of British popular music in the late nineteenth century, see Dave Russell, *Popular Music in England, 1840–1914: A Social History* (Kingston: McGill-Queen's University Press, 1985), pp. 281–344. For a history of the British music hall tradition, see Raymond Mander and Joe Mitchenson, *British Music Hall* (London: Gentry Books, 1974), and D. F. Cheshire, *Music Hall in Britain* (Newton Abbot: David and Charles, 1974). On the strength of the public entertainment tradition in Liverpool, see Sara Cohen, *Rock Culture in Liverpool: Popular Music in the Making* (Oxford: Clarendon Press, 1991), pp. 12–13.

75. The quotation is from the inside jacket of Cyril Ehrlich, *The Music Profession in Britain Since the Eighteenth Century: A Social History* (New York: Oxford University Press, 1985).

76. On Gordy's parallel with automobile production, see Benjaminson, *The Story of Motown*, p. 84.

77. On the South African episode, see Tyler Cowen, "The Myth of the Indigenous Culture: A Look at World Music," unpublished manuscript, George Mason University, 1996.

78. See Martha Bayles, *Hole in Our Soul: The Loss of Beauty and Meaning in American Popular Music* (New York: Free Press, 1994).

79. See Iain Chambers, *Urban Blues: Pop Music and Popular Culture* (New York: St. Martin's Press, 1985), p. 190.

80. On rap origins, see George, *The Death of Rhythm and Blues*, pp. 189–190 and Mark Costello and David Foster Wallace, *Signifying Rappers: Rap and Race in the Urban Present* (New York: Ecco Press, 1990), p. 55. On cassette tape rap, see David Toop, *The Rap Attack 2: African Rap to Global Hip Hop* (London: Serpent's Tail, 1991), p. 78. On the reggae influence upon rap, see Costello and Wallace, *Signifying Rappers*, p. 22, Chambers, *Urban Blues*, p. 156, and Rose, *Living in America*, p. 143.

81. See Dick Hebdige, *Cut 'N' Mix: Culture, Identity, and Caribbean Music* (London: Routledge, 1990), p. 139, and Nelson George, "Rapping," in

Nelson George, Susan Flinker, and Patty Romanowski, eds., *Fresh: Hip Hop Don't Stop* (New York: Random House, 1985), pp. 8–9.

82. Cited in Harold Bloom, *Agon: Towards a Theory of Revisionism* (New York: Oxford University Press, 1982), p. 253. See also Jan Mukarovsky, *Aesthetic Function, Norm and Value as Social Facts* (Ann Arbor: University of Michigan, Michigan Slavic Contributions, 1970), who argues that effective art violates prevailing norms and standards.

83. On the German roots of techno and industrial music, see Pascal Bussy, *Kraftwerk: Man, Machine, and Music* (Wembley: SAF Publishing, 1993).

84. See Allan Bloom, *The Closing of the American Mind* (New York: Simon and Schuster, 1987), pp. 74–75.

85. On the Nazi attack on jazz, see Michael H. Kater, *Different Drummers: Jazz in the Culture of Nazi Germany* (New York: Oxford University Press, 1992). On Iron Curtain views of rock, see Martin and Segrave, *Anti-Rock,* pp. 243–248.

5. Why Cultural Pessimism?

1. On the long-term trends supporting world progress, see Julian L. Simon, ed., *The State of Humanity* (Cambridge, Mass.: Basil Blackwell, 1995).

2. See William Wordsworth, "Reply to 'Mathetes'" in *The Prose Works of William Wordsworth,* vol. 2, edited by W. J. B. Owen and Jane Worthington Smyser (Oxford: Clarendon Press, 1974), pp. 8–25; the quotation is from pp. 9–10.

3. Nicolas Slonimsky's *Lexicon of Musical Invective: Critical Assaults on Composers since Beethoven's Time* (Seattle: University of Washington Press, 1965) catalogs the insults that critics have leveled against great composers for centuries. For the above quotations, see pp. 82–85. On the failures of literary criticism, see Henri Peyre, *The Failures of Criticism* (Ithaca, N.Y.: Cornell University Press, 1967).

4. On parental desires to control the flow of information to their children, and their opposition to new products, see Steven Starker, *Evil Influences: Crusades against the Mass Media* (New Brunswick, N.J.: Transaction Publishers, 1989), chapter 11.

5. See Baldesar Castiglione, *The Book of the Courtier* (London: Penguin Books, 1967 [1528]), pp. 107–111; see also the comments of Richard A. Posner, *Aging and Old Age* (Chicago: University of Chicago Press, 1995), pp. 102–107.

6. See Aristotle, *The Art of Rhetoric* (London: Penguin Books, 1991), Book 2, chapter 12, Posner, *Aging and Old Age,* chapter 5, and Mary C. Gilly and Valarie A. Zeithaml, "The Elderly Consumer and the Adoption of Technologies," *Journal of Consumer Research,* 12 (1985): 353–357. I am currently working on a paper with Alex Tabarrok entitled "Who Benefits from Progress?" that will explore these issues in more detail.

7. On the marketing of the past, and its increasing nearness to us, see Fred Davis, *Yearning for Yesterday: A Sociology of Nostalgia* (New York: Free Press, 1979).

8. See Thomas Hobbes, *Leviathan* (Cambridge: Cambridge University Press, 1991 [1651]), p. 70, and Friedrich Nietzsche, *The Use and Abuse of History* (New York: Macmillan, 1957), p. 17.

9. See Schoenberg's essay "Those Who Complain About the Decline," p. 203, reprinted in his *Style and Idea, Selected Writings of Arnold Schoenberg* (London: Faber and Faber, 1975).

10. Jean-Jacques Rousseau, *The Confessions and Correspondence, Including the Letters to Malesherbes,* in *The Collected Writings of Rousseau,* vol. 5 (Hanover, N.H.: University Press of New England, 1995), p. 5.

11. On Galilei's treatise and the Florentine Camerata movement, see Donald Jay Grout, with Hermine Weigel Williams, *A Short History of Opera* (New York: Columbia University Press, 1988), chapters 3 and 4.

12. For Samuel Johnson on Swift, see his *Lives of the English Poets* (Oxford: Oxford University Press, 1932 [1779, 1781]), the quotation is taken from vol. 2, p. 213.

13. On Swift, see the three-volume biography by Irvin Ehrenpreis, *Swift: The Man, His Works, and the Age* (Cambridge, Mass.: Harvard University Press, 1969), especially vol. 2, 326–338.

14. The first passage of Johnson's is discussed by Daniel Eilon, *Factions' Fictions: Ideological Closure in Swift's Satire* (Newark, Del.: University of Delaware Press, 1991), pp. 120–121. For Johnson on Swift, see his *Lives of the English Poets;* the quotation is from vol. 2, p. 228.

15. On these points, see Jonathan Swift, *A Tale of a Tub,* in *Gulliver's Travels and Other Writings* (New York: Random House, 1958), pp. 274–275.

16. See Allan Bloom, *The Closing of the American Mind* (New York: Simon and Schuster, 1987), pp. 68–81, from his chapter, "Music." The quotations are from pp. 76 and 79.

17. On the opposition to opera, see, for instance, Gloria Flaherty, *Opera in the Development of German Critical Thought* (Princeton: Princeton University Press, 1978), pp. 95–97, and Nicholas Boyle, *Goethe: The*

Poet and the Age, vol. 1, *The Poetry of Desire (1749–1790)* (Oxford: Clarendon Press, 1991), pp. 21–22.

18. For the relevant quotations and references, see Max Nordau, *Degeneration* (New York: Howard Fertig, 1968 [1895]), p. 3, chapter 3, p. 451, among others.

19. On the iconoclastic controversy, see Leo Braudy, *The Frenzy of Renown: Fame and its History* (New York: Oxford University Press, 1986), pp. 201–204. On religion, see David Hume, *The Natural History of Religion* (Stanford: Stanford University Press, 1957 [1757]).

20. On the religious and mythological roots of cultural pessimism, see Frank L. Borchardt, *Doomsday Speculation as a Strategy of Persuasion: A Study of Apocalypticism as Rhetoric* (Lewiston, N.Y.: Edward Mellen Press, 1990), especially pp. 226–227 on magic and myth.

21. On Plato, see Iris Murdoch, *The Fire and the Sun: Why Plato Banished the Artists* (New York: Viking, 1990).

22. On the history of attacks on theater and poetry, see Eric A. Havelock, *Preface to Plato* (Oxford: Basil Blackwell, 1963), Russell Fraser, *The War Against Poetry* (Princeton: Princeton University Press, 1970), and Jonas Barish, *The Anti-Theatrical Prejudice* (Berkeley: University of California Press, 1981). For the history of attacks on mass media, see Starker, *Evil Influences.*

23. See Charles Newman, *The Post-Modern Aura: The Act of Fiction in an Age of Inflation* (Evanston, Ill.: Northwestern University Press), p. 47.

24. For the Kristol quotation, see Steven C. Dubin, *Arresting Images: Impolitic Art and Uncivil Actions* (London: Routledge, 1992), p. 245. On the ideological backgrounds of Bell and Kristol, see Howard Brick, *Daniel Bell and the Decline of Intellectual Radicalism: Social Theory and Political Reconciliation in the 1940s* (Madison: University of Wisconsin Press, 1986), especially chapter 1.

25. See Michael Medved, *Hollywood vs. America: Popular Culture and the War on Traditional Values* (New York: Harper & Row, 1992).

26. On radical left-wing opposition to Mapplethorpe, see Dubin, *Arresting Images,* pp. 173–174.

27. For two good critiques of the Frankfurt School, see Alan Swingewood, *The Myth of Mass Culture* (London: Macmillan, 1977), and Herbert Gans, *Popular Culture and High Culture: An Analysis and Evaluation of Taste* (New York: Basic Books, 1974).

28. For a treatment of the influences on the Frankfurt School, see George Friedman, *The Political Philosophy of the Frankfurt School* (Ithaca, N.Y.: Cornell University Press, 1981). On the conservative origins of the critique of mass culture, on both the left and the right, see Leon Bramson,

The Political Context of Sociology (Princeton: Princeton University Press, 1961). On Bell, see Brick, *Daniel Bell and the Decline of Intellectual Radicalism,* p. 65. For Habermas's criticism of the neo-conservatives, see Jürgen Habermas, "Neoconservative Cultural Criticism in the United States and in Germany," in Shierry Weber Nicholson, ed., *The New Conservatism: Cultural Criticism and the Historians' Debate* (Cambridge, Mass.: MIT Press, 1989), pp. 22–47.

29. See David A. Hollinger's excellent *Postethnic America: Beyond Multiculturalism* (New York: Basic Books, 1995), p. 85. Hollinger's book presents a properly cosmopolitan multiculturalism and surveys anti-cosmopolitan tendencies in contemporary multiculturalism.

30. See William H. Gass, "Even if, by all the Oxen in the World (a polemic)," in Ray B. Browne, Richard H. Crowder, Virgil L. Lokke, and William T. Stafford, ed., *Frontiers of American Culture* (Purdue, Ind.: Purdue University Studies, 1968), p. 196. For an example of conservative elitism, see the remarks in T. S. Eliot's *The Idea of a Christian Society* (New York: Harcourt, Brace, 1939), pp. 39–41.

31. Postman's views, and the views of other pessimists, are offered in George Johnson, "We are the Wired: Some Views on the Fiberoptic Ties that Bind," *New York Times,* October 24, 1993, p. E16.

32. See Paul Fussell, *Bad, or the Dumbing of America* (New York: Touchstone Press, 1991), pp. 200–201. On the "great crappiness," see p. 14. The anonymous source of the quotation on barbarism and decadence is cited in *USA: The Permanent Revolution,* by the editors of *Fortune* and Russell Davenport (New York: Prentice Hall, 1951), p. 221. This book, especially chapter 10, provides a useful survey of the hostility of the European intellectuals to American popular culture.

33. See, for instance, William J. Spring, "Observations on World Destruction Fantasies," *The Psychoanalytic Quarterly,* 8 (1939): 48–56.

34. On these crises, see Charles Maurice and Charles W. Smithson, *The Doomsday Myth: 10,000 Years of Economic Crises* (Stanford, Calif.: Hoover Institution Press, 1984), and the works of Julian L. Simon, such as *The Ultimate Resource* (Princeton: Princeton University Press, 1981).

35. See James Ralph, *Touchstone: or, Historical, Critical, Political, and Theological Essays Upon the Reigning Diversions of the Town* (New York: Garland Publishing, 1973 [1728]), p. 166.

36. See George Bernard Shaw, *The Sanity of Art* (New York: Benjamin R. Tucker Publisher, 1908), p. 7.

37. See Medved, *Hollywood vs. America,* p. 4.

38. See John Cowper Powys, *The Meaning of Culture* (New York: W.W. Norton, 1929), p. 200.

Index

Harvard University Press is a member of Green Press Initiative (greenpressinitiative.org), a nonprofit organization working to help publishers and printers increase their use of recycled paper and decrease their use of fiber derived from endangered forests. This book was printed on 100% recycled paper containing 50% post-consumer waste and processed chlorine free.